Herminie and Fanny Pereire

Manchester University Press

STUDIES IN MODERN FRENCH AND FRANCOPHONE HISTORY

Studies in
Modern French and
Francophone History

Edited by
Julie Kalman, Jennifer Sessions and Jessica Wardhaugh

This series is published in collaboration with the Society for the Study of French History (UK) and the French Colonial Historical Society. It aims to showcase innovative monographs and edited collections on the history of France, its colonies and imperial undertakings, and the francophone world more generally since *c.* 1750. Authors demonstrate how sources and interpretations are being opened to historical investigation in new and interesting ways, and how unfamiliar subjects have the capacity to tell us more about France and the French colonial empire, their relationships in the world, and their legacies in the present. The series is particularly receptive to studies that break down traditional boundaries and conventional disciplinary divisions.

To buy or to find out more about the books currently available in this series, please go to: https://manchesteruniversitypress.co.uk/series/studies-in-modern-french-and-francophone-history/

The Society for the
Study of French History

Herminie and Fanny Pereire

Elite Jewish women in nineteenth-century France

Helen M. Davies

MANCHESTER UNIVERSITY PRESS

Copyright © Helen M. Davies 2024

The right of Helen M. Davies to be identified as the author of this work has been asserted in accordance with the Copyright, Designs and Patents Act 1988.

Published by Manchester University Press
Oxford Road, Manchester, M13 9PL

www.manchesteruniversitypress.co.uk

British Library Cataloguing-in-Publication Data
A catalogue record for this book is available from the British Library

ISBN 978 1 5261 7765 0 hardback

First published 2024

The publisher has no responsibility for the persistence or accuracy of URLs for any external or third-party internet websites referred to in this book, and does not guarantee that any content on such websites is, or will remain, accurate or appropriate.

Typeset
by Deanta Global Publishing Services, Chennai, India
Printed in Great Britain
by TJ Books Ltd, Padstow

To Renee

Contents

List of plates	*page* viii
List of figures	ix
Acknowledgements	xi
Abbreviations	xiv
Pereire family tree	xv
Introduction	1
1 The Rodrigues family	23
2 Herminie and Fanny: mother and daughter	52
3 Relations and relationships	88
4 Sociability, entertainment, real estate, and servants: 'Fêtes, because fortune obliges it'	119
5 Conspicuous consumption, again 'because fortune obliges it'	160
6 *Sedaca*, charity, philanthropy	190
7 Children and marriage: becoming Christian or becoming Jewish?	221
8 Being Jewish	255
Conclusion	286
Select bibliography	297
Index	307

Plates

1. Rachel Herminie Pereire, copy undated C. Brun of portrait by Alexandre Cabanel, 1859. Private collection, photo Christophe Fouin.
2. Emile Pereire, copy 1894 Charles François Jalabert of portrait by Paul Delaroche, 1853. Collection famille Pereire, photo Christophe Fouin.
3. Fanny Rebecca Pereire, portrait by Alexandre Cabanel, 1859. Photo © RMN – Grand Palais (domaine de Compiègne) / Stéphane Maréchalle.
4. Isaac Pereire, Léon Bonnat, 1878. Courtesy Château de Versailles, photo Christophe Fouin.

Figures

0.1 Henry Pereire, c. 1930. Archives de la famille Pereire, photo Géraldine Pereire Henochsberg — 16
2.1 Rachel Herminie Pereire, *carte de visite*, c. 1860, Bayard & Bertall. Archives de la famille Pereire — 72
3.1 Gustave Pereire, photo Fritz Luckhardt, c. 1880. Archives de la famille Pereire — 108
3.2 Henriette and Jeanne Pereire, c. 1860. Photo Robert Jefferson Bingham, collection musée d'art et d'histoire du Judaïsme, Paris, photo © mahj — 109
4.1 Hôtel Pereire, 35–37 rue du Faubourg Saint-Honoré, 1952, *Grand salon* now the British Ambassador's Office. Heritage Image partnership Ltd/Alamy Stock Photo — 125
4.2 Château Pereire, Armainvilliers. Photo, collection the author — 132
4.3 Villa Pereire, Arcachon, photo Alphonse Terpereau, 1863, collection Antoine Desforges — 138
6.1 Fondation Isaac-Pereire, hospital Tournan. Postcard, collection the author — 208
6.2 Fondation Isaac-Pereire, hospital Levallois-Perret, Paris. Postcard, collection the author — 209
7.1 Cécile Pereire Rhoné, portrait by Franz Xaver Winterhalter, collection Francis Desforges — 230

7.2	Fanny Pereire with her family, Paris, 1905. Private collection, photo Christophe Fouin. Source: Jean Autin, *Les frères Pereire: Le bonheur d'entreprendre* (Paris, 1984), 256	244
8.1	Pereire family grave, Montmartre, Paris. Photo the author	262
8.2	Fanny Pereire, 1905. Archives de la famille Pereire, photo Christophe Fouin	267

Acknowledgements

I am indebted first to the present-day descendants of Herminie and Fanny Pereire who, despite the global pandemic, have extended from afar so much courtesy, generosity, and interest in my work.

Géraldine Pereire Henochsberg, great-great-granddaughter of Herminie and Emile Pereire, has been that rare bonus to any historian, a custodian deeply engaged with the archival material in her possession and all its nuances while recognising and respecting the independence and objectivity necessary to the researcher. I am profoundly grateful to her.

I thank Laure Pereire, a descendant of Fanny and Isaac Pereire, for her interest in and appreciation of my contribution to the history of her family, and for her hospitality and kindness.

Antoine Desforges gave generous access to images in his family's possession. Jacques Béjot was similarly helpful.

Since my earlier work on Emile and Isaac Pereire, two people who had been important to its success and thus to this work on Herminie and Fanny, are no longer with us. Géraldine Pereire Henochsberg's mother, Colette Pereire, single-handedly saved the family archive from landfill. Laure Pereire's mother, Anita Pereire, introduced me to the wonderfully fragrant 'Mme Isaac Pereire' rose, among many other kindnesses. It is appropriate that I record my gratitude to them both here.

As mentor and colleague, Peter McPhee encouraged this endeavour from the outset, reading and providing invaluable comment on the manuscript. I am greatly indebted to him.

Pamela Pilbeam has been a tremendously valuable sounding board for which I am grateful. Susan Foley read a chapter and encouraged me in numerous other ways. Alison McQueen helped clarify my thoughts on Chapter 5, 'Conspicuous Consumption'. I thank them all.

For their genial preparedness to give advice, support, or help at various times, I thank Thierry Boccon Gibod, Greg Burgess, Miriam Crenesse, Julie Kalman, Alice S. Legé, Pauline Prevost-Marcilhacy, Kerry Murphy, Ben Newick, and Charles Sowerwine.

I record my debt to special friends. Jane McInnis, Sherrel Djoneff, Michelle Ellis, and Damian Ellis have listened, encouraged, and supported this endeavour and been there for me. My Zoom circle of old Lowther Hall schoolfriends gave a monthly zone of comfort and encouragement. Thank you.

In the practical aspects of producing a book, I have been extremely fortunate. Christophe Fouin in Paris not only provided me with exceptional reproductions of many of the images within its covers, he also assisted in tracing some of them to source. Tony Kelly of Archiva Lucida in Melbourne enhanced many of the images and brought them together masterfully. Dina Uzhegova in Melbourne and Honduras whipped an unruly manuscript into shape. Thank you.

Over the years, the University of Melbourne has provided much-needed financial and academic support. Fellows and Friends of History in the School of Historical and Philosophical Studies have listened with courtesy and generosity to papers that have morphed from the tentative to important components of my book. And during several COVID-19 lockdowns, the staff of the University's Baillieu Library went to great lengths to provide me with even the most obscure resources. I am enormously grateful to you all.

I have paid tribute before to staff in libraries and archives in France who have always treated my work and my needs with respect. I do so again here.

To the Series Editors, I acknowledge the care and attention with which you considered my manuscript. To the peer reviewers, you helped to clarify my purpose and, I hope you agree, your critiquing improved the result. To editorial and other staff of Manchester University Press, especially to Alun Richards, thank you for your constancy and expertise throughout a difficult time.

Acknowledgements

I acknowledge again the affection, support, and generosity of my husband, John Nicholson. In so many ways, this volume is a product of our life together. Thank you.

Finally, in giving me my very first book, my mother, Renee, opened a world of wonder, imagination, and creativity. This one is for her.

All translations from the French are my own.

Abbreviations

ACB	Archives communales de Bayonne
ACCP	Archives du Consistoire central de Paris
ADO	Archives départementales de l'Oise
ADP-O	Archives départementales des Pyrénées-Orientales
AFP	Archives de la famille Pereire
AN	Archives nationales de France
AN/MC	Archives nationales, Minutier central des notaires de Paris
AN/MT	Archives nationales du monde du travail
AP	Archives de Paris
BMBX	Bibliothèque municipale de Bordeaux
BNF	Bibliothèque nationale de France
BNF/A	Bibliothèque nationale Arsenal
BNF/F-M	Bibliothèque nationale François-Mitterand
BNF/R	Bibliothèque nationale Richelieu
INHA	Institut national de l'histoire de l'art
MS/DC	Mémorial de la Shoah, Documentation Centre

Pereire family tree

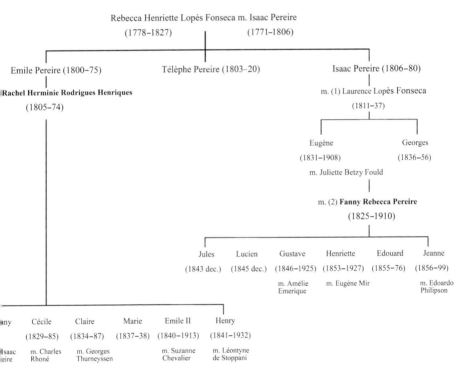

Introduction

This book explores the lives of two remarkable Jewish women in nineteenth-century France: Rachel Herminie Rodrigues, born in 1805, and Fanny Rebecca Pereire, born in 1825. They married respectively Emile and Isaac Pereire, two of the wealthiest and most powerful men in the nation. Emile and Isaac were brothers, Herminie and Fanny as they were known, were sisters-in-law. But Herminie and Fanny were not only married to exceptional men whose deeds were prodigious, they were mother and daughter, a surprising circumstance that encapsulates something about the complications of Jewish lives in nineteenth-century France. Their story has much to tell us about women of the Jewish elite in the *longue durée*.

In the course of writing a monograph on Emile (1800–75) and Isaac Pereire (1806–80), I was drawn to the family context from which these extraordinary men emerged and through which they flourished. Sephardic Jews from Bordeaux, the Pereire brothers have been much discussed, analysed, interpreted, and reinterpreted in their own lifetime and subsequently. In the first fifteen years of this century alone, three biographies have been published, including one by this author.[1] They left a permanent mark on the spatial and financial face of Paris, and their influence was felt as far afield as Bucharest, Istanbul, Madrid, Melbourne, New York, and St Petersburg. Bankers, railway entrepreneurs, urban developers, hotel magnates, department store owners, ship-builders, and owners of utility, transport, and insurance companies, even of sardine canneries among other enterprises, the Pereires did as much as anyone else to shape the nineteenth-century financial, commercial,

and industrial landscape of France and contributed to that of other countries in Europe.

Yet a major element in their success, the significance of their wives and family life, remains largely unexamined. Over a long period, this has led me to a study of the two women who are the subjects of this work.

Other writers have hinted at the family background of Emile and Isaac Pereire, acknowledging in the process the role played by ancestors and extended family alike in the Pereire brothers' progress through life.[2] But Pereire businesses depended on far more than genes and a family history of achievement, unusual as that was for Jews at that time, or relatives in Paris who were in the business of finance and thus able to provide two poor boys from the provinces with an entry to the perfect training environment.

Herminie and Fanny Pereire, Jewish women of Sephardic origin in France, stand at the intersection of multiple strands of history. Herminie was born one year after Napoleon declared himself Emperor, living through the Bourbon Restoration, July Monarchy, Second French Republic, and Second Empire to see the beginning of the Third French Republic. Fanny entered the world in the latter part of the Restoration and lived through all the political regimes which followed into the new century.

They experienced in nineteenth-century France the full range of sentiment, from the heady days post-emancipation, to relative acceptance by non-Jews and governments, to a barely subterranean anti-Jewish propaganda, to the awakening of full-scale antisemitism and the Dreyfus Affair. Over this long period, the lives of Herminie and Fanny were thus touched by writings about gender, family, Jewish history, Sephardim/Ashkenazim communities, emancipation, acculturation and assimilation, *embourgeoisement* (the process of becoming bourgeois), and more. Yet notwithstanding a certain interest in the lives of Jewish women more generally, Sephardic women of France in the process of assimilation through *embourgeoisement* have been relatively neglected in the historiography.

The stories of Herminie and Fanny will also shed light on Jewish women as they confronted and negotiated the demands of civil society and family life, on the bourgeois elite and religious conflicts, from post-revolutionary France to the Dreyfus Affair. In concentrating on women of a Sephardic family, as both women were,

originally the Rodrigues family, this book will augment and illuminate the many significant volumes of historiography on the Jewish community and family in nineteenth-century France.

My study will address multiple questions that concern the personal rather than the general. What was the nature of their relationships with husbands, children, and extended family? What of the relationship between mother and daughter whose individual experiences of life changed and developed over time? How did Herminie and Fanny adapt to a new set of social rules and codes? How did they assert their claim to be *grandes bourgeoises*? As women with a strong attachment to social causes, how did this play out over the century? How did they confront an increasingly virulent antisemitism? And, finally, what did it mean for them to be Jewish?

Over the century bookended by Herminie's birth and Fanny's death, effectively the long nineteenth century, there were many changes in the lives of bourgeois women and even more when they were Jewish. If the process of *embourgeoisement* tended to confine women to motherhood and domesticity, it also led subtly to improved educational opportunities for them and an enhanced role outside the hearth. Women became notably expert in matters to do with maternal health, education, and childhood development – all matters for which their conditioning had prepared them well – and thus they became increasingly able to influence changes in the public sphere to social welfare policy, provisions, and initiatives.[3] This in turn provided the means to essay a path with wider significance than the one in which they had been raised, enabling an influence that was the more powerful when accompanied by great wealth.

A further change concerned the nature of the endogamy which increasingly came into play over the century. Whereas both my subjects entered marriage with other Sephardim as was customary, as the century progressed some elements considered crucial at its beginning, such as the differences between Sephardim and Ashkenazim, began to lose significance. Marriages between Jews of different communities and origins became more common. Endogamy also became economic and social, bourgeois, Susan K. Foley noting that 'there was a high level of professional and social endogamy among the bourgeoisie'.[4] This was the case with marriages contracted by the children of Herminie Pereire in particular. It was also the experience of a growing number of subjects in Cyril Grange's detailed study in

which over the nineteenth century 'upper class' Jews entered mixed marriages with members of the nobility with growing frequency. Nor were the families that became entwined in this way exclusively French; they were also of other European or American origin.[5]

There were some forty-five thousand Jews in France before the French Revolution. They were then concentrated in two regions: Ashkenazim in Alsace-Lorraine, who made up the greater number of approximately forty thousand; and Sephardim in the southwest cities of Bordeaux and Bayonne, who together with the Jews of Avignon numbered close to five thousand. Only five hundred or so lived in Paris.[6] The Sephardic Jews were originally from Spain and Portugal, although well established in Bordeaux by 1789, some families for close to three hundred years. Until the demise of the slave trade on which Bordeaux depended for the produce in which it traded, predominantly sugar and coffee, Bordeaux had been a city looking outward to the New World, and many Sephardic Jews traded successfully around the Atlantic.[7] This international mindset remained significant to their mental outlook.

The fall of the Bastille on 14 July 1789 set off a chain of events that was to materially affect every corner of Jewish life in France. The Déclaration des droits de l'homme et du citoyen the following month laid the framework for an appeal for civic rights, the first by Protestants; the situation of Jews was to take a little longer, hinging as it did on the universalist aspirations of the Revolution and 'any sign of Jewish particularism'.[8] Finally, in January 1790, after heated debate, the new French Assemblée nationale voted for emancipation of the Sephardic and Avignonnais Jews; the decree enabling emancipation of the Ashkenazi Jews of France's northeast was to take well into the next year.[9]

If, during the debate on citizenship and the Jews in December 1789, Stanislas-Marie- Adelaïde, comte de Clermont Tonnerre, famously had cause to demand that 'We must refuse everything to the Jews as a nation and accord everything to Jews as individuals', in their profession of faith to the new Assemblée nationale, the Sephardim hastened to reassure. The Jews were no more 'particular' than were Catholics.

> The Portuguese and Spanish Jews living in France are only Frenchmen
> … Some claim that their religion subjects them to a foreign cult,

which often finds itself in opposition to the duties of citizen ... This is to misunderstand the Jewish religion. Scrupulous observers of their duty, they know what it is to serve heaven, as well as to fulfil those of the state.[10]

Thus did Herminie and Fanny Pereire, born in France among the first generations of emancipated Jews in Europe, know what it was to be both French and members of a minority.

If the lives of Jewish men were changed forever by emancipation, so too were those of Jewish women. The Revolution did not extend citizenship to them, but it did provide subtly different expectations, freedoms, and constraints, channelling and regulating their subsequent actions. Nevertheless, there were certain features to life which remained constant, evolving from a long-established Sephardic cultural foundation. The very significance attached to family, to begin with; their central role in, and construction of, a private family life; their relatively easy adoption of bourgeois values and attitudes; and their position as facilitators in arranging suitable marriages for their children, marriages which began increasingly to involve questions of assimilation and apostasy – all these elements came into play in the lives of Herminie and Fanny Pereire over the nineteenth century.

This century was a period of unprecedented migration, for the Pereire brothers like many others. Jews left small villages and towns across Europe for other cities, other countries, and other continents, all in the hope of finding opportunity and creating better lives for themselves, in combating oppression and an increasing antisemitism. In the process, though, they retained social and cultural links with communities back home that had been forged over centuries. The patterns and interrelationships thus woven between places of origin and places of destination were rich, varied, and complex.

The historian Lee Shai Weissbach's grandfather, Menachem Mendel Frieden, moved from a small village in Lithuania to Norfolk, Virginia and thence to Palestine, remaining a devout Jew throughout.[11] In contrast, the wealthy Hermine and Moriz Gallia of Tim Bonyhady's *Good Living Street*, who were born in small towns in the Austro-Hungarian Empire, in Silesia and Moravia, joined the exodus to Vienna in the latter part of the century. Having then forsaken Judaism for Catholicism, with the advent of Kristallnacht their daughters forsook Europe altogether for a New World in

Australia.[12] In all these cases and whatever the distances travelled, the bonds of family and culture back home remained strong.

For the Rodrigues, too, family and friends in far-flung places occupied a large part of their lives, providing an intricate network of influence. The family itself had links with the New World, an uncle, Abraham Sasportas, having served with the Marquis de La Fayette in the American Revolutionary War. The extended family had also intermarried with the hugely important merchants, the Gradis family, who traded around the Atlantic Coast. Even before they settled in Paris, the Rodrigues had connections with a world larger than simply France's southwest.

Moving to Paris in 1796 they put down roots, establishing a position in the banking and finance sector. Other bankers had made a similar journey from the provinces, notably the Ashkenazi Fould family from Lorraine. Still others moved from elsewhere in Europe – from Frankfurt in the case of the Rothschilds. Meyer Cahen d'Anvers, born in Bonn, became a successful sugar merchant in Antwerp before he moved to Paris in 1849 to become a banker.[13] Later in the century the Camondos left Istanbul and the Ephrussis, Odessa. All these Jewish families prospered in Paris, especially under the July Monarchy and the Second Empire.

Several Ashkenazi families like the d'Eichthals, who were originally from Bavaria, and other European bankers, like the Protestant Thurneyssens of Geneva, recognised the genius of the Pereire brothers early, providing finance and remaining part of the close family circle.[14] Subsequently, they negotiated assistance and connections for the Pereires' international businesses, the brothers receiving introductions to bankers, Jewish and non-Jewish, and politicians in every country in which they did business but particularly in St Petersburg, Vienna, and Madrid. The Pereires were beneficiaries of long-term continued support from other figures among France's minority groups.

While Herminie and Fanny Pereire, the subjects of this book, were born in Paris and lived all their lives in the capital, they were, nevertheless, part of a more extensive and developing international community, subject to a wide coterie of cultural influences. Their circle was cosmopolitan. From the outset also they grew up embedded in a non-Jewish society with which they dealt *au quotidien*. While Herminie and her daughter were not born into the elite as

the industrial development of France gathered momentum over the century, they were swept into that select group. From the relatively modest circumstances of the Rodrigues family into which Herminie was born, the Pereire brothers' economic and financial power took root during the July Monarchy and grew exponentially under the Second Empire. They played a particularly significant part during the reign of Napoleon III and the Empress Eugénie, who created of Paris a city of splendour and radiance, 'fastes et rayonnement'.

How might we make sense of the roles and experiences of Herminie and Fanny across the dramatic decades in the families' lives? An influential argument about public and private spheres would suggest that they were marginal to their husbands' public activities. Elite women as Herminie and Fanny came to be were, according to Susan K. Foley, 'groomed primarily for domestic responsibilities and to seek fulfilment in the family'. Foley described the concept which underlay much of the nineteenth century's gender order in terms of 'separate spheres', in which young women learned to live with constraints on their education, their behaviour, and their expectations, and to seek fulfilment in domesticity. Young men, on the other hand, while groomed along an equally inexorable path, inhabited the world of 'public affairs'.[15] Bonnie G. Smith, whose landmark work on the bourgeoises of the Nord department, *Ladies of the Leisure Class*, presented a complex picture of female participation in business in the early years of the nineteenth century followed by a sudden withdrawal into domesticity, also sets her subjects firmly within the constraints of 'separate spheres'.[16]

There have been challenges to this interpretation of female experience, however. Through archival records in Lille and Tourcoing in the Nord department, for instance, the historian Béatrice Craig has challenged Smith's interpretation of female behaviour, demonstrating that women either owned or participated in businesses in the textiles industry to a larger degree and over a longer period than had been reckoned.[17] This biography of Herminie and Fanny Pereire suggests some surprising nuances to such arguments. The roles they played in the businesses of their husbands, in contrast with the businesswomen of the Nord described by Craig, were by no means so direct. But the effects they had on them were not insignificant either. As sounding boards, *confidantes*, and consumers, the separation of spheres *chez* Herminie and Fanny was in the process

of morphing into a more complex set of social and economic possibilities, chiselling away at the rigid confines of separation.

Aside from international connections, what were some of the intellectual influences that had their effect on Herminie and Fanny? To begin, the religious milieu from which they emerged is important for its social and cultural effects on each of them. Sephardic Jews of France had responded enthusiastically to the act of emancipation passed in January 1790 by the new French Assemblée nationale. Some had already experienced an attraction towards secular intellectual culture through their encounters with eighteenth-century Enlightenment literature. Rousseau, Voltaire, Raynal, and Condorcet, even the Edinburgh philosophers Adam Smith and David Hume, were quite well known to the Jews of Bordeaux, whose libraries were inhabited as much by secular as religious literature. Several learned societies existing in that city and that were open to Jews focused on the study of science, philosophy, and literature.[18]

There was another influence at work, however. The teachings of the Berlin Haskalah, or the Jewish Enlightenment, conveying a dual ambition to marry a closely held Jewish identity with an equally close integration with the host communities in which Jews made their homes, were also known to the Sephardim of Bordeaux.[19] That this should be so is curious since one may have expected a certain diffidence on the part of the Haskalah's Ashkenazi leaders in forming stronger relationships with coreligionnaires, particularly those who had sought to distinguish and distance themselves through very publicly disseminated claims to superiority.[20] Prohibitions existed on the Bordeaux Sephardim consorting with Ashkenazim. Intermarriage was forbidden.[21] Yet even before the Revolution, Bordeaux, as a principal Sephardic Jewish community and a burgeoning international commercial centre, was a city where Jewish merchants and financiers of both denominations could make common cause. The influence among the Sephardim of the Haskalah and its corollary of acculturation, added to the high regard in which German Jews held the Sephardim of the Iberian past, introduced a mutual respect which challenged the divisiveness of previous eras.[22]

These influences were not lost on Sephardic women in France, particularly those from wealthy families where relative freedom of thought and expression and a sophistication enlivened by access to education and Enlightenment literature led to an engagement with

the wider world that perhaps only some of their Ashkenazi sisters, the *salonnières*, had experienced up to that time. And in the case of women in the Rodrigues family, the residual effects of the Haskalah and their close acquaintance with the family of its leader, the philosopher Moses Mendelssohn, exposed them to an environment of considerable richness and vigour.

A corollary to this outward-looking milieu brings us to the heavy emphasis of much writing about Jews in France during the nineteenth century, one that has focused on issues to do with apostasy, acculturation, and assimilation. And here the Sephardim of Bordeaux have come in for some particularly critical treatment. The sincerity and depth of their religious devotion has been questioned with some frequency, and they have been characterised as far too well-assimilated with the Catholic majority, even before emancipation.[23] Received wisdom has it that the Sephardim were thus more easily susceptible to apostasy, encapsulated in Todd Endelman's summing up that 'Acculturated, materially comfortable, secular-minded Jews whose emancipation and integration were partial but not complete were prime candidates for baptism.'[24]

While Sephardic history had been one in which close attachment to the host community, particularly the Spanish, had ensured their survival and security, this had been insufficient to stem the Catholic triumphalism which saw them progressively evicted from Spain from the twelfth century and then definitively with the final Christian *Reconquista* of Ferdinand and Isabella in 1492. Five years later, Portugal also rescinded its invitation to them to seek refuge there. Having been exiled from their home in Jerusalem with the destruction of the Second Temple by the Romans in 70 CE, they were then expelled for the second time from their haven in the Iberian Peninsula.[25]

Certainly, by the time of the French Revolution and as a result of their experiences over the centuries, the Bordeaux Sephardim had worked diligently to forge a place that was integral to the mercantile community. A number provided significant financial services. Some became major economic players themselves – ship-builders, bankers, and merchants. Their circle was notably urban. Yet despite the relatively liberated terms under which successive monarchs had permitted them to live, beginning as early as 1550 with letters patent of King Henri II allowing Sephardim to reside in his Kingdom

and engage in business, none of this was to give them complete legal equality until the revolutionary act of emancipation.[26] Very little of the extensive historiography on acculturation and assimilation has captured the experience of women, however. Never fully citizens of France, attitudes oscillated between quasi-acceptance at various phases of the Revolution to full-scale antisemitism at the end of the nineteenth century. Napoleon's Code Civil of 1804 effectively deprived them of any real independence from their husbands, enshrining male supremacy and legalising the 'separate spheres'. Thus, different political regimes had an impact on how these women behaved, how they developed, and what ambitions in life they could reasonably entertain.

Indeed, the position of women within the Jewish community became increasingly a matter for concern as the process of *embourgeoisement* advanced over the nineteenth century. The role assigned them as teachers of Judaism to their children and keepers of the faith within the home became ever more firmly fixed in Jewish cultural and social practices. It was a point of honour, a selling feature for senior Jewish community leaders, all male, in promoting the Jewish community's compatibility with French citizenship. The Jewish family was also seen to be the bulwark against the dangers posed by the demands of assimilation made explicit in the Revolution's act of emancipation, and the consequent loss of religious authority. The introduction in 1792 of civil marriage presented increasing cause for concern in its affirmation of the legality of mixed marriages.[27] Thus, over the course of the nineteenth century, the risk that Jews could be seduced into apostasy through intermarriage, or marrying out, was a subject that tested the Jewish community.

Placed against this scholarly concentration on how the Jews adapted to their new-found status and the changing circumstances in which they found themselves then, the response of Jewish and, in this case, Sephardic, women in France to the new order calls for some consideration. Indeed, as Renée Levine Melammed wrote in 1998, 'The world of Sephardi women is without a doubt one of the most neglected fields in Jewish history.'[28] Little has changed since. Their history is overshadowed by the knowledge we have of Sephardic men for whom studies have also encompassed a number of biographical and other works about particular individuals, including by this author.[29]

The historiography of Sephardic women is firmly bound to the early modern period, however, to women who were part of the Sephardic diaspora dispersed progressively around the Mediterranean and Atlantic seaboards, which culminated in their final expulsion from Spain in 1492 and from Portugal after 1497. On this reading, the influence of Islam and the imposition of strict rules governing the behaviour of women and men is uppermost: women identified with the home, men with the outside world. This gendered separation of activity and interests was the norm in Sephardic life well before it became codified for the French bourgeoisie after the French Revolution. It was reinforced by the pervasive effects of Portuguese mores resulting from that period in the late fifteenth century when Sephardim briefly sought refuge there. Characterised by overprotection and the enforced seclusion of women, from the early sixteenth century these elements continued to dominate their lives in the European cities where Sephardim finally settled, most notably in Amsterdam but also in Bordeaux and Bayonne.[30]

Sephardic women of the revolutionary and post-revolutionary period have received less attention from historians than their grandmothers and earlier ancestors, however. Gérard Nahon's *Juifs et Judaïsme à Bordeaux* (2003), the authoritative work on the Sephardim of that city, scarcely mentioned women except in the context of a few benevolent 'confréries'.[31] The much earlier but still significant *Sephardic Jews of Bordeaux* by Frances Malino (1978) simply ignored them.[32] *Les Sépharades* (edited by Esther Benbassa, 2016), dealt exclusively with women of the 'Moyen Age'.[33] Endelman's *Leaving the Jewish Fold* (2015), a comparatively recent work on Jewish conversion and assimilation, is similarly lacking any substantial reference to Sephardic women.[34]

Elite Ashkenazi women have received a more extensive treatment than the Sephardim. An early study of bourgeois Jewish life, Deborah Hertz's *Jewish High Society in Old Regime Berlin*, painted a striking portrait of the late eighteenth-century elite Ashkenazi community there and concentrated on the rise of the Jewish *salonnières*, who Hertz saw as personifying a new form of female emancipation.[35] In Berlin, she noted that 'a Jewish community achieved the social glory represented by entertaining and even marrying the cream of gentile society'.[36] Interest in the sociability of the *salon* has given rise to a number of arresting biographies of Jewish women

who were *salonnières* over the late eighteenth and early nineteenth centuries: Henriette Herz, Fanny von Arnstein, Rahel Levin Varnhagen, Dorothea von Schlegel (née Mendelssohn), and Fanny Mendelssohn Hensel among them.[37] The era of the *salonnière* in Berlin (and Vienna) came to an end, however, a result both of changing political circumstances including Jewish emancipation and of different emerging public spaces in which Jews and Gentiles might share ideas and intellectual pursuits. New institutions usurped the role of the salon. And the rising emphasis on domesticity as the accepted and acceptable bourgeois female role rather than the life of independence and the life of the mind that the *salonnières* exemplified was a further impediment to their continued existence.[38]

An equally significant work, *The Making of the Jewish Middle Class* by Marion A. Kaplan, explored the development over the long nineteenth century of the female role within the German Jewish family and emphasised the 'crucial' role women played in creating new bonds of Jewishness. These did not depend on synagogue attendance for their strength and durability but, rather, religious ritual and ceremonies became through changing 'values, beliefs, sentiments, and rituals ... family occasions and community events'.[39]

Writing about Jewish communities of the West (France, Germany, and the USA), Paula E. Hyman noted that 'women were responsible for inculcating moral and religious consciousness in their children and within the home more generally'.[40] In spite of the early acculturation of the family into which Herminie was born, this orthodoxy was to cast a long shadow over her, but it was not entirely lost on Fanny either. Hyman dealt specifically with the role of gender in shaping 'the assimilation process'. She argued that while the twentieth century opened many opportunities to women, they continued to show 'fewer signs of radical assimilation than men'.[41] She contended further that this was 'Because their social life occurred within their domestic context and the religiously segmented philanthropic associations considered appropriate for women of their class, [thus] they initially had fewer contacts with non-Jews and experienced fewer external challenges to their childhood culture than did Jewish men.' [42]

Although apostasy among women is often regarded as relatively uncommon, issues of acculturation and assimilation, so significant as we know in any account of Sephardic men, are as relevant to

Sephardic women. Hyman contended that women's domestic role in the Jewish household effectively precluded 'their opportunities for education and participation in the public realm of economy and civic life', thus limiting their access to triggers of assimilation.[43] Endelman agreed.[44] Both wrote principally about the experience of Ashkenazi women of central Europe; elite Jewish women of Paris escape these assessments.

But as historian Philippe-Efraïm Landau's analysis of conversions to Christianity showed us, 48 per cent of Jewish converts in nineteenth-century France were women. In his explanation, Landau pointed to a comparatively early median age at conversion, suggesting that matrimony was the foremost reason. Landau offered further that few women converted through 'reasons of faith'.[45] In other words, women became Christians because they wanted to marry Christians and their Jewish faith had ceased to hold a pre-eminent or constraining place in their lives. Endelman, who did allow the place of conviction among converts, male and female – that is, that some 'viewed their change of religion as the outcome of spiritual illumination, philosophical reflection, scriptural study, or some combination thereof' – argued that the motivation in cases of 'conversion for conviction' was not far different from that in 'conversion for convenience'. All who chose the path to Christianity, he asserted, were troubled to some degree by 'Christian antipathy' towards Jews and Judaism, the convert seeing her or his decision in a cultural setting of dislike, disdain, and disparagement by fellow citizens who were Gentiles.[46]

At various points in my book, I will take up the matter of apostasy in the context of conversion among members of the Pereire family to highlight the complex reasons why apostasy and/or intermarriage became the norm for some but not for others. At the same time, not every marriage with a Christian entered into by a member of the Pereire family necessarily led to conversion, thus further entangling the picture of Jewish life among the elite in the nineteenth century. Nor does the historiography allow much for a more gradual distancing from Jewish religious practice, one which nevertheless retained to the end a core attachment to a Jewish birth rite.

A somewhat different point of view about women, assimilation, and acculturation has been advanced in the course of a study on marranism, the clandestine practice of Judaism by the Sephardim

of the Iberian Peninsula. Paola Ferruta has canvassed ideas about what she calls the 'New Marranism', arguing that 'Inspired by the universalism of Enlightenment and nineteenth-century political messianism, a mental process, the crystallisation of a new Jewish self-understanding took place. This process', she contended, 'instead of accelerating the assimilation into Gentile society, instigated strategies of resistance and dissimulation.'[47]

The extensive writing of Cyril Grange on the position of elite Jews in Paris under the Third French Republic has informed my own work in many significant ways. While concentrating on a specific period, his book necessarily placed many of the figures he dealt with in the broader historical context of the nineteenth century.[48] He was not concerned particularly with gender, and the greater number of his subjects were male. In writing of those Jews who entered mixed marriages, he concentrated on women who either married into the nobility or whose spouses married them for their wealth.[49] But he also paid considerable attention to subjects which by their nature placed women at centre stage and which concern us here: family, marriage, dynastic alliances, culture, and sociability. Thus, what Grange's work does not address in the intimate detail of personal life it compensates for in its encyclopaedic nature and quantitative approach. This book will add further texture to Grange's ground-breaking work, contributing to an understanding of the elite Jews of France.

Historiography on non-Jewish French women has been far more extensive, and I have highlighted several texts already that have been important to my work, particularly those of Smith, Craig, and Foley. Other historians have also contributed to the development of this book in ways that will become evident in succeeding chapters.[50]

The historiography in which my study is centred is thus disparate, lacunate, and scattered, providing many useful points of comparison while posing questions both of similarity and dissimilarity of life experience among the Jewish *grandes bourgeoises* in France. Very little shines a light directly on women of that elite class. As the study advances, however, concentration on key themes in greater depth will serve to elicit the lessons that can be learned from the historiography and what this work will add to it. The opportunity to draw on the life experiences of other elite Jewish families will also become significant in addressing these themes.

Introduction

Letters are the most significant source of reflection on Herminie and Fanny Pereire and their families. The Archives de la famille Pereire (hereafter AFP) in Paris, which is the repository of this correspondence and other family documents, exists through the careful attention of Henry Pereire, the younger son of Herminie and Emile, who maintained throughout his life a significant store of letters and other material written to him and by him to various family members, as well as a large quantity of correspondence of all sorts relating to the business interests of Emile and Isaac Pereire. Well over one thousand letters, from financial to personal in nature, are extant. Within this correspondence, several caches are to be found, amounting to nearly 50 per cent of the total, in which we gain a record of Herminie's life and significance and those of her family. The archive also contains records relating to the domestic arrangements and circumstances of the family and their properties, crucial in understanding the roles played by both Herminie and Fanny. The archive is a treasure store, encapsulating the life of an extraordinary family over time.

Henry had a long life, born in 1841 and dying in 1932. Indeed, in a contribution to *Correspondence: Models of Letter-Writing from the Middle Ages to the Nineteenth Century*, the epistolary historian Roger Chartier referred to letters collected in this way by a figure he called the family 'record-keeper'. Chartier might have been describing the circumstances of the Pereire family trove, which consists of letters sent by 'close relatives' and maintained by one family member who, for the most part, lived in the same dwelling for a considerable period, all of which Henry Pereire did. Such a collection, Chartier maintained, 'acquired a new function – that of ensuring the continuity and stability of the line. ... Every letter, by describing where and when it was written and by mentioning other letters (received, expected or hoped for), takes as its main topic the pact that binds the correspondents.'[51]

A complication concerns the time span of the documents. While the archive extends over a century, from before the French Revolution until after World War I, it is by no means comprehensive during that time and is more complete at certain eras than at others. Letters were more frequent when family members travelled away from Paris, especially when they were absent for longer periods. Thus, between 1859, when Henry was eighteen years of age, and

1872, he received over one hundred letters from his mother, the greater number when he undertook a Grand Tour to Egypt and the Middle East in 1864–65, and Herminie wrote to him every two to three days. During this time, he also received just under one hundred letters from other members of the family: from his brother Emile II and sister-in-law Suzanne; from each of his sisters, Fanny, Cécile, and Claire; and from their spouses and their children. During the

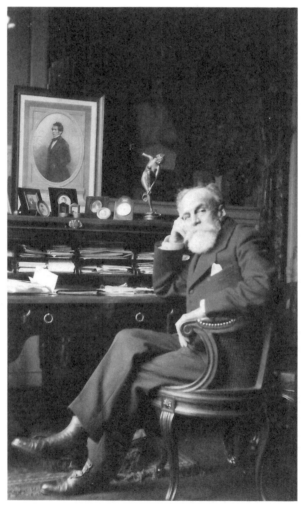

Figure 0.1 The family archivist: Henry Pereire, c. 1930

Introduction 17

Franco-Prussian War and the Paris Commune, the whole Pereire family was separated. Emile, Herminie, their daughters (except for Fanny and her daughters, who were in Pau for a lengthy period), and their grandchildren escaped to Arcachon, the *station balnéaire* established by Emile, while Isaac, Henry, and his brother, Emile II, together with their brothers-in-law Charles Rhoné and Georges Thurneyssen, stayed behind in the hôtel Pereire in Paris to protect their interests. Nearly two hundred letters flowed backwards and forwards between the family as a result of this lengthy absence from each other. Overall, then, the letters do not necessarily represent a sequence, for time and a World War have taken their toll. Nor do we have many 'conversations', with direct and continuing exchange between writer and recipient.

So, there are admittedly some problems in dealing with the letters in this collection, which do not entirely match neatly the pattern advanced by Chartier. That it was Henry who maintained the archive means that it was his family connections, his travels, and his predilections which determined the nature of the documents kept, recalling that there were two branches in the Pereire family: of Herminie and Emile on the one hand, and of Fanny and Isaac on the other. Thus, letters written by Henry's parents to each other or to their children, including to Henry, or by Henry to other family members outnumber those in the archive written by Henry's uncle, Isaac, his wife, Fanny, or any of their children.

The circumstances of their respective lives as I have outlined them thus meant that Henry Pereire collected fewer letters written by or to his sister Fanny Pereire. She had her own family with whom she corresponded, and for a large part of the time under review here, Henry ceased to share the Paris residence and the Château Pereire outside the capital with her family. Fortunately, there has been a comparatively recent addition to the family archive of some two hundred letters provided by a descendant of Isaac Pereire. Some of these give us additional insight into Fanny's family and in particular the relationship between Fanny and her husband.[52] Importantly, however, we also learn about Fanny from others, for she was a constant and significant figure in the letters and lives of her immediate and extended family.

In particular, Fanny was one of the most valued friends of her aunt Félicie, Herminie's sister, and Félicie's husband Charles Sarchi, whose letters to their daughter Hélène in Paris between 1862 and

1878 provide a further invaluable source. Hélène was the wife of Philippe Van Tieghem, a renowned botanist in France, professor in the Muséum national d'histoire naturelle, and member of the French Académie des sciences. The Sarchi correspondence of over one thousand published letters emerged from an increasingly peripatetic life the Italian-born Charles Sarchi and his wife led in various cities in Italy, particularly in Milan, Venice, and Florence following the Risorgimento in 1861, and also when they visited France, where they stayed with relatives. Regular contact with Hélène and her family was crucially important to them since their only other child, their son Augustin, had died before the letters commenced.[53]

The Sarchi letters are not part of the Pereire archive but their importance rests in the commentary they provide on events, or a version of events sometimes alternative to those described in the Pereire family narrative. Altogether, consideration of the Sarchis' *Lettres à Hélène* in what they amplify in the Pereire archive provides sufficient evidence to observe with some confidence the part played by Herminie and Fanny in the Pereire family.

In sum, then, through the Pereire family archive, the Sarchi letters, and further public archival research, when placed in the context of current historiography, my book will shed light on the experience of Jewish women in France's *grande bourgeoisie*. It will draw out the multiplicity of their roles in representing the family name and maintaining the family presence; their significance to the success of their husbands' extraordinary and considerable business interests; their relations with their husbands, children, and extended family; and their experiences of domesticity, of 'separate spheres', and of moving beyond circumscribed roles. In thus illuminating the lives of Herminie and Fanny Pereire, my objective is to overcome the invisibility in the historiography of women of their class, to draw attention to their remarkable qualities, and to bring to light their individuality, giving them definition, form and, most importantly, agency.

Notes

1 Works published this century are Guy Fargette, *Émile et Isaac Pereire: L'esprit d'entreprendre au XIXe siècle* (Paris, 2001); Maurice-Édouard Berthon, *Émile et Isaac Pereire: La passion d'entreprendre* (Paris,

2007); Helen M. Davies, *Emile and Isaac Pereire: Bankers, Socialists, and Sephardic Jews in Nineteenth-Century France* (Manchester, 2015).
2 A significant source here is Simon Altmann and Eduardo L. Ortiz (eds), *Mathematics and Social Utopias in France: Olinde Rodrigues and His Times* (Providence, RI, 2007). Chaps. 2 and 3 by Barrie M. Ratcliffe are especially helpful.
3 See for instance Bonnie G. Smith, *Ladies of the Leisure Class: The Bourgeoises of Northern France in the Nineteenth Century* (Princeton, NJ, 1981), chap. 6.
4 Susan K. Foley, *Women in France since 1789: The Meanings of Difference* (Basingstoke, 2004), 38.
5 Cyril Grange, *Une élite parisienne, Les familles de la grande bourgeoisie juive (1870–1939)* (Paris, 2016), 281–2, and Annexes to chap. 9, 484. It is appropriate and relevant to acknowledge the work of Cyril Grange which culminated in this magisterial volume. His book is foremost in a rich historiography, providing a vast canvas and a formidable challenge in which to situate the lives of two protagonists in the Jewish elite.
6 A good general history is Esther Benbassa, *The Jews of France: A History from Antiquity to the Present*, trans. M. B. DeBevoise (Princeton, NJ, 1999).
7 On this last point see Richard L. Kagan and Philip D. Morgan (eds), *Atlantic Diasporas: Jews, Conversos, and Crypto-Jews in the Age of Mercantilism, 1500–1800* (Baltimore, MD, 2009).
8 Paula Hyman, *The Jews of Modern France: Jewish Communities in the Modern World* (Berkeley, CA, 1998), 32.
9 Benbassa, *Jews of France*, 81–3.
10 'Adresse présentée à l'Assemblée Nationale par le Député des Juifs Espagnols & Portugais, établis au Bourg Saint-Esprit les-Bayonne', January 1790, Paris, in Gérard Nahon (ed.), *Les "Nations" Juives Portugaises du Sud-Ouest de la France (1684–1792), Documents* (Paris, 1981), XCV, 326.
11 Menachem Mendel Frieden, *A Jewish Life on Three Continents* [electronic resource]: *The Memoir of* ... trans., edited, annotated by Lee Shai Weissbach (Palo Alto, CA, 2013).
12 Tim Bonyhady, *Good Living Street: The Fortunes of My Viennese Family* (Sydney, 2014).
13 Nicolas Stoskopf, *Banquiers et financiers parisiens: Les patrons du Second Empire* (Paris, 2002), 109–11.
14 AFP, memorandum unsigned, undated, giving particulars of the financial arrangement between Emile Pereire, d'Eichthal, and Thurneyssen.
15 Foley, *Women in France*, 27 and ff.
16 Smith, *Ladies of the Leisure Class*.

17 Béatrice Craig, *Female Enterprise behind the Discursive Veil in Nineteenth-Century Northern France* (London, 2017).
18 Gérard Nahon, *Juifs et Judaïsme à Bordeaux* (Pamplune, 2003), 187–8.
19 For an excellent biography of its founder, see Shmuel Feiner, *Moses Mendelssohn: Sage of Modernity* (New Haven, CT, 2010).
20 The Pereires' grandfather, Jacob Rodrigues Pereire, was the official representative of the Sephardim of Bordeaux and Bayonne at the court of Louis XV, and during this time he engaged the Amsterdam philosopher Isaac de Pinto to write an *Apologie pour la nation juive ou réflexions critiques sur le premier chapitre du VIIe tome des Oeuvres de Monsieur de Voltaire au sujet des juifs* (Amsterdam, 1762). Here De Pinto unequivocally asserted the superiority of the Sephardic Jews v. the Ashkenazim.
21 Nahon, *Juifs et Judaïsme*, chap. 5.
22 John M. Efron makes this point very well in his *German Jewry and the Allure of the Sephardic* (Princeton, NJ, 2016).
23 See for instance Frances Malino, *The Sephardic Jews of Bordeaux: Assimilation and Emancipation in Revolutionary and Napoleonic France* (Tuscaloosa, AL, 1978).
24 Todd M. Endelman, *Leaving the Jewish Fold: Conversion and Radical Assimilation in Modern Jewish History* (Princeton, NJ, 2015), 56.
25 Nahon, *Juifs et Judaïsme*, chap. 3.
26 Ronald Schechter, *Obstinate Hebrews: Representations of Jews in Eighteenth-Century France, 1715–1815* (Berkeley, CA, 2003).
27 Grange, *Une élite parisienne*, 7.
28 Renée Levine Melammed, 'Medieval & Early Modern Women', in Judith R. Baskin (ed.), *Jewish Women in Perspective* (Detroit, 1998), 128.
29 See for instance Davies, *Emile and Isaac Pereire*; Frances Malino, 'Furtado et les juifs portugais', *Annales historiques de la Révolution française*, vol. 51, no. 235, 1979, 49–66; Renée Neher-Bernheim, 'Un savant juif engagé: Jacob Rodrigues-Pereire (1717–1780)', *Revue des études juives*, CXLII, 1983, 373–451; Salomon Lopès-Dubec, 'L'autobiographie de …', in Jean Cavignac (ed.), *Archives juives*, vol. 19, 1983, 11–28; Dominique Jarrassé, *Osiris [Daniel Iffla]: Mécène juif Nationaliste français* (Brussels, 2008); Altmann and Ortiz (eds), *Mathematics and Social Utopias in France: Olinde Rodrigues and His Times*.
30 Melammed, 'Medieval and Early Modern Women', 130.
31 Nahon, *Juifs et Judaïsme*, 212–13.
32 Malino, *Sephardic Jews of Bordeaux*.
33 Silvia Planas Marcé, 'Filles de Sarah. Les femmes juives dans la Catalogne du Moyen Âge', in Esther Benbassa (ed.), *Les Sépharades: Histoire et culture du Moyen Âge à nos jours* (Paris, 2011), 111–34.

34 Endelman, *Leaving the Jewish Fold*.
35 Deborah Hertz, *Jewish High Society in Old Regime Berlin* (New Haven, CT, 1988).
36 Ibid., 3.
37 There is a sizeable literature on the *salonnières*. Aside from Hertz noted above, a partial (and admittedly subjective) list includes Hilde Spiel, *Fanny Von Arnstein, Daughter of the Enlightenment*, trans. Christine Shuttleworth (New York, 2013); Hannah Arendt, *Rahel Varnhagan: The Life of a Jewess*, trans. Clare Winston and Richard Winston (New York, 1974); R. Larry Todd, *Fanny Hensel: The Other Mendelssohn* (Oxford, 2010). See also Emile D. Bilski and Emily Braun, *Jewish Women and Their Salons* (New Haven, CT, 2005).
38 Hertz, *Jewish High Society*, 278–85.
39 Marion A. Kaplan, *The Making of the Jewish Middle Class: Women, Family, and Identity in Imperial Germany* (New York, 1991), 234.
40 Paula E. Hyman, *Gender and Assimilation in Modern Jewish History: The Roles and Representations of Women* (Seattle, WA, 1995), 27.
41 Ibid., 19.
42 Ibid., 5.
43 Ibid., 18–19.
44 Endelman, *Leaving the Jewish Fold*, 85.
45 Philippe-Efraïm Landau, 'Se convertir à Paris au XIXe Siècle', *Archives Juives*, vol. 35, no. 1, 2002, 30.
46 Endelman, *Leaving the Jewish Fold*, 209.
47 Paola Ferruta, 'Nineteenth-Century "New Marranism" and Jewish Universalism from the French-German Perspective', in Anna-Dorothea Ludewig, Hannah Lotte Lund, and Paola Ferruta (eds), *Versteckter Glaube oder doppelte Identität?/Concealed Faith or Double Identity?* (Hildesheim, 2011), 97.
48 There are several references to Cyril Grange's *oeuvre* in this study, but the principal work cited is *Une élite parisienne*. See note 5 above.
49 Ibid., chap. 11.
50 Studies of non-Jewish women and families that have informed my work significantly are Claire Goldberg Moses, *French Feminism in the Nineteenth Century* (Albany, NY, 1984); Jo Burr Margadant (ed.), *The New Biography: Performing Femininity in Nineteenth-Century France* (Oakland, CA, 2000); Michelle Perrot (ed.), 'De la Révolution à la Grande Guerre', vol. 1 in Philippe Ariès and George Duby (eds), *Histoire de la vie privée* (Paris, 1987); Christopher H. Johnson, *Becoming Bourgeois: Love, Kinship, and Power in Provincial France, 1670–1880* (Ithaca, NY, 2015); and Elizabeth C. Macknight, *Aristocratic Families in Republican France, 1870–1940* (Manchester, 2012).

51 Roger Chartier, Alain Boureau, and Cécile Dauphin, *Correspondence: Models of Letter-Writing from the Middle Ages to the Nineteenth Century*, trans. Christopher Woodall (Cambridge, 1997), 18–19.
52 This cache of two hundred letters does not concern Isaac Pereire and his family solely. There is a quantity of early letters, written to Emile Pereire during the 1820s from friends and relatives in Bordeaux. These are not germane to this chapter.
53 Charles and Félicie Sarchi, *Lettres à Hélène: Correspondance de Charles et Félicie Sarchi à leur fille Mme. Van Tieghem*, Louis Bachy (ed.) (Montpellier, 2006), 3 vols.

1

The Rodrigues family

The extended Rodrigues Henriques family descended from the brothers Abraham (1660–1729) and Moïse (1668–1717), both *négociant*s (merchants) of Bordeaux. Over the century which followed, their descendants became well-integrated commercially, socially, and religiously with Sephardic notables of the city, intermarrying with the increasingly wealthy Azevedo, Furtado, Gradis, and Roblès families, among others. The Rodrigues Henriques were entrenched in the world of *négociants*, *agents de change* (stockbrokers), bankers, and financiers. And one had been *syndic*, community leader in Bordeaux.[1] By the time of the French Revolution, possibly in recognition of their new-found status as citizens of France and as a demonstration of their pride in this, many of them had shed the second part of their name, 'Henriques', which, they reckoned, tied them too closely to their Iberian past. Most of them became known simply as 'Rodrigues'. With that they had already taken a step towards acculturation in the French nation.

Rachel Herminie Rodrigues, known as Herminie, was born in 1805 into a singular family. This chapter will illuminate the influences of the Rodrigues inheritance on her and on her own family, an inheritance that was at once multilayered, for we cannot explore Herminie's life without reference to the Sephardic community from which she emerged nor to the family into which she had been born, at once representative and yet unique. While identifying as Jewish, Herminie's family was in fact not religious and had not practised Judaism for many years. It was an intellectual family, evidently fascinated with Enlightenment literature and philosophy, their religious devotion tempered increasingly by close acquaintance with

the Berlin Haskalah of Moses Mendelssohn. They saw hope and promise in the French Revolution, realising in the universalism legislated by the Assemblée nationale on 28 January 1790 the prospect of full engagement in French citizenship. Growing up in this family, Herminie absorbed many of these rich influences.

Women of considerable independence, achievement, cultural importance, and intellectual capacity emerged from the extended Rodrigues family, whose presence in Herminie's life was not without effect. These women have some affinity with those whose lives historian Jo Burr Margadant explored in her edited work *The New Biography*: 'women from the elite who were determined to have a hearing in the public forum and to liberate themselves from the worst consequences of family law under the Napoleonic Civil Code'.[2] At the same time, these women of the Rodrigues family continued to evince a strong sense of their own Jewishness even as some of them eventually converted. They too aspired to make a contribution to the society which had given their men full citizenship. I will begin my study with them.

An intriguing letter in the Pereire family archive provides insights into the presence of these women in the lives of the Rodrigues family and as possible influencers on Herminie. The letter was written in June 1806 by Nanci Rodrigues (née Roblès, 1779–1843), originally from Bordeaux but at that time living in Paris.[3] She was replying to a letter written by a distant relative in the capital, Jean Isaac Rodrigues, more familiarly known as Rodrigues *fils*, an accountant employed by the Fould bank and who was Herminie's father. He was a man of considerable intellect, an enquiring mind, and cultivated tastes. Nanci Rodrigues was clearly his equal in intelligence, interests, and culture. They were friends.

In the letter, she teased him about whether she should use the intimate *tutoyer* form of address as she would with a friend; she joked about Immanuel Kant and his misogyny; she referred to mutual friends in the Mendelssohn family, the children of Moses Mendelssohn; she mused about which Bordeaux Sephardim might be nominated to Napoleon's Assemblée des notables, who were about to be announced and each one of whom she knew personally. She commented with approval on the comparatively high status of Jews in America following a conversation with Rodrigues *fils*'s uncle, Abraham Sasportas, a recent visitor there.[4]

Nanci Rodrigues was also at that time a woman committed to Judaism, having recently responded publicly in defence of the Jews to an anti-Jewish article published in the *Mercure de France* by the archconservative Louis de Bonald.[5] The hand in this long letter is assured, wry, witty, engaging. It bears little resemblance to the pious, submissive Sephardic women of an earlier period captured in the historiography.

Further research shed light on a life devoted to the education of indigent Jewish girls. Nanci Rodrigues was married to the wealthy Bordelais Benjamin Rodrigues, who, at the beginning of the nineteenth century, established a bank in Paris in partnership with Isaac Patto, which was known as Rodrigues et Patto. Benjamin was also a member of the Consistoire Israélite de Paris initiated by Napoleon to regulate the affairs of his Jewish subjects. From 1821, Nanci presided over the Réunion des dames protectrices des écoles consistoriales Israélites de Paris, a committee under the auspice of the Consistoire. Her self-appointed task was to establish a primary school for poor Jewish girls, the first such school in France.

In 1821, the year in which her Réunion was established, Nanci Rodrigues spelled out the aims of her committee. Above all, Jewish girls were to be taught how to be good wives and mothers, but they were also to be encouraged to love work and education and provided with the means to support themselves. As the historian Jennifer Sartori commented about this school, the teaching was evidently a 'complex mix of Jewish tradition, French influence, and practical realities that shaped the school curriculum'.[6]

Yet what was significant about the school was the remarkable similarity of its curriculum with that of the already existing Jewish boys' primary school in Paris, an element which has largely gone unnoticed: both curricula included Hebrew and French writing and grammar, arithmetic, and history and geography for the older boys and girls. The only exception seems to have been that whereas boys also learned drawing, girls learned sewing, a skill obviously acquired in the interests of domesticity and future employment.[7] That instruction in Hebrew writing and grammar was included, however, sent a strong message, a wish to reinforce the Jewish identity of the young girls in giving them skills they had historically been denied, for instruction in Hebrew had been regarded as part of the sacred education of boys, and girls were for the most part excluded from its instruction.[8]

The school opened in May 1822 and by December of that year was educating fifty-two students.[9] By 1830 it required expansion to accommodate 130 students. By 1832, 150 girls had graduated and there were 140 students enrolled.[10] So successful was it that even King Louis-Philippe's wife, Queen Marie-Amélie, had visited.

The inspiration for Nanci Rodrigues's school in Paris had come from another woman of the Rodrigues family, a leader of the movement to promote education for indigent Jewish boys in Bordeaux. This cause had rapidly come to be regarded by Jewish community leaders and other educational administrators as a necessity in providing gainful employment for young boys other than through 'vagabondage' and hawking. Nanci's sister-in-law, Sophie Roblès (née Rodrigues, d. 1867), founded in 1817 a primary school in Bordeaux under the patronage of a Comité de secours des pauvres Israélites of charitable Sephardic women. In 1826, Sophie Roblès extended her remit and established an apprenticeship school for necessitous Jewish youths to learn a trade, persuading the department of the Gironde to subsidise it. For forty years, she engaged actively in training young Jewish boys for useful employment.[11]

Women of the family mixed in business as well. Nanci Rodrigues's aunt on her mother's side, Léa Azevedo (d. c. 1812), became the first and, for her time, the only independent *négociante* in Bordeaux, a profession which she carried on for at least eight years. Taking advantage of a provision in Napoleon's Code Civil (s. 220) of 1804 permitting women to engage in commerce without the permission of their husbands so long as they were acting on their own account, in the same year she set up in a partnership as la Société Azevedo, Léa & Gomez frères, which existed until 1812.[12]

Another family member, Eugénie Foa (1796–1852), born Esther Eugénie Rodrigues Henriques in Bordeaux, a descendant of Abraham Rodrigues Henriques, has been described as 'the first Jew to write fiction in French and the first modern Jewish writer to write fiction in any language'. Foa wrote among other works *Le Kidouschim* (*The Kiddushim*) (1830) and *La Juive* (1835), novels that evinced a rich Jewish identity and culture in historical and literary terms and that appealed also to a non-Jewish readership.[13] Later, Foa's much younger sister, Hannah Léonie (1820–84), who married Fromental Halévy, the composer of the opera *La Juive*,

became after his death a sculptor and *salonnière*. Her *salon* almost certainly provided the model for her daughter, Geneviève Straus (1849–1926), the celebrated *salonnière* of the Third Republic, who became in her turn hostess to Marcel Proust and one of the models for Proust's duchesse de Guermantes.[14] Both Eugénie and Hannah Léonie were distant cousins of Herminie.

Thus, within this family we find not only considerable complexity in interrelationships from an early stage of the nineteenth century, but we also find ambitious, independent, well-educated, and competent Jewish women. Some eventually converted to Catholicism, like Nanci Rodrigues and Eugénie Foa, while Sophie Roblès and Léa Azevedo remained committed to Judaism. In confronting the paradoxes of their position and engaging in a world outside the *foyer*, they demonstrated a new awareness of the possibilities open to their gender, which they grasped. Their lives thus were again remarkably different from those most often portrayed in the historiography on Sephardic Jewish women.

The greater number had moved to Paris from Bordeaux and, as members of the extended Rodrigues family, were known to and became important figures in the life of that family in Paris. They were all part of the kinship network that enveloped the subjects of this book. The influence they exerted was incalculable.

This then brings us back to the recipient of Nanci Rodrigues's letter, Jean Isaac Rodrigues, or Rodrigues *fils*; to his wife, Sara Sophie Lopès Fonseca (1776–1845); and to their branch of the family who were so important to the lives of my subjects, Herminie and Fanny Pereire.

Rodrigues *fils*'s wife Sara Sophie was a figure central to her own family and to another which is of some significance to this study, the Pereires. She was the mother of ten children, including the Saint-Simonians – Olinde, Eugène, and their sisters Herminie, Mélanie, and Félicie; she was the sister of Rebecca Henriette Pereire, the widow of Isaac Pereire the elder, and thus she was the aunt of Henriette's children, Emile and Isaac. Sara Sophie became the mother-in-law of Emile Pereire. Yet what we know of her comes only through a few archival documents and through letters written much later by her daughter Félicie Sarchi (née Rodrigues, 1811–73) to her own daughter, Hélène Van Tieghem (1843–1900). Piecing these sources together tells us something of a Sephardic

mother who, together with her husband, was in the process of acculturation in France.

Sara Sophie was born into a practising Sephardic family from Bayonne, who had settled in France the previous century following their brief sojourn in Portugal. Bayonne or, more specifically, what is now the suburb St Esprit-lès-Bayonne, was a particularly devout centre of Judaism, taking its lead from the prominent and zealous Sephardic community in Amsterdam and its commitment to an assertive process of 'rejudaisation' among *marrano* communities elsewhere. Sara Sophie was thus raised in an observant religious household.

The poll tax and other financial contributions paid in St Esprit by her father, Mardochée Lopès Fonseca, establish him as comfortable rather than wealthy.[15] He was a *maître de loi* and a significant figure in his community, representing the Jews of St Esprit before the Malesherbes Commission of 1787, established to consider questions of civil rights for French Jews in the light of similar provisions made for Protestants.[16] In 1788, Louis XVI issued an edict calling for a meeting of the Estates General to be convened, commanding each of the Estates – the nobility, the clergy, and the common people, being the First, Second, and Third Estates respectively – to compile a book of complaints, a *cahier des doléances*. Fonseca's standing in his community is thus further attested by his election to carry the community's *cahier* to Tartas.

From the poll tax records, we also learn that the family of her mother, Esther de Daniel Delvaille, was demonstrably more wealthy than her husband. She, too, was from a well-known Bayonnais Sephardic family active in the mercantile world, one which established a bank in Bayonne in the nineteenth century.

Sara Sophie herself was the eldest of four children: her sister, Rebecca Henriette, was born in 1777; a brother, Jacob, in 1779; and another sister, Rachel, in 1780.

It would be many years before the education of Jewish girls became a community concern; indeed, that did not happen until the advent of Nanci Rodrigues's school in Paris. But the significance of books and libraries in the cultural and social development of young Sephardic women in the late eighteenth century is apparent in Sara Sophie's intellectual and educational progress. While there were governesses who taught young girls at home, and some

wealthy Sephardic families also sent their daughters to boarding school,[17] from yet other examples we know that the daughters of those fathers who supported extensive libraries were comparatively well-read and cultivated. In Nanci Rodrigues's childhood home, her father Aaron Roblès's library contained over two thousand volumes, the largest of any *négociant* in Bordeaux. Sara Sophie's father, Mardochée Lopès Fonseca, was also a collector of books, and at his death in 1805, he left a library of 416 volumes, remarkable for its time. It was not nearly as extensive as the Roblès collection, yet impressive in its sophistication and diversity. The library included not only books of a religious nature, key Sephardic texts, but also works of the Enlightenment – including the complete *oeuvres* of Voltaire, others by Rousseau, Raynal, Condillac, Condorcet, Mably, and Fontenelle; history and the classics; more general French literature – Fénelon, Racine, and Mme. de Sévigné among them; and translations of the works of David Hume and Adam Smith.[18] These libraries provided a wealth of fine literature to nourish the minds and shape the tastes of intelligent young girls, also providing models for their own literary expression.

Business reasons probably led to a family move to Bordeaux in 1788 when Sara Sophie was twelve years old. The following year, the French Revolution broke out, a cataclysmic upheaval but one that her family greeted with elation for the liberty and equality it offered them as Jews. An Assemblée nationale of deputies from the Third Estate, predominantly from bourgeois backgrounds, formed in 1789. Jacobins, who were closer to the working and artisan classes, dominated the Assemblée, although the Girondins, representing the wealthier class from large provincial cities like Bordeaux, were for a time a significant opposition.[19] Unusually, however, since the Jews of Bordeaux were generally sympathetic to the Girondin cause, her father was an avowed Jacobin. Indeed, in 1792 he moved from Bordeaux back to Bayonne, where he founded and presided over a revolutionary club in St Esprit, the Société montagnarde et régénérée de la constitution de 1793 de Jean-Jacques Rousseau. With its appeal to Robespierre's legislation of that year, the Société gave overt support to democratic ideals of social benefits for the unemployed, the sick, and the elderly, and universal male suffrage. The name of the town also had been changed to 'Jean-Jacques Rousseau', regarded as 'more in accordance with the circumstances

and that [the Société montagnarde] regarded as more respectful. This change was received with the liveliest acclamation that they recommenced the hymn the Marseillaise.'[20]

When the Jacobins were placing impediments in the way of religious devotion, the family covertly retained its commitment to Judaism throughout its time in Bayonne. Demands that the Société montagnarde surrender the fine Jewish ceremonial silverware in liturgical use were met with deft non-compliance by Lopès Fonseca.[21] In contrast, in celebration of Robespierre's Festival of the Supreme Being in May 1794, he composed a Jewish prayer to be read in the synagogue.

> May the races of the future not lose sight of the dignity of man and their duties towards you and the country. Supreme intelligence, there is only one God! It is only you who reigns over the world; the universe is your temple, it proclaims your marvels and your power! Our hearts are your altars. It is in this sanctuary that your justice makes us abhor crime, cherish virtue and respect the laws! Proceed, proceed, oh divine guardian, to make liberty triumph, and to praise you we shall carry your glorious trophies into the Temple of Reason ... May he preserve us from the flame, this scourge destructive of all property, and may the Supreme Being send us, in his anger, to punish us for neglecting his cult and for having adored the golden calf; and one day, finally, may the universe echo with the sacred names of liberty, equality, and justice.[22]

This prayer so resonates with Old Testament imagery, despite its patriotic republican overtones, it could as easily have been directed to the God of Israel as to a Supreme Being. Perhaps this explains its reception, for the prayer was greeted with acclamation by neighbouring Sephardic communities and pinned up in the temple of the now-renamed town of Jean-Jacques Rousseau.[23]

Sara Sophie was thus reared in a family politically engaged in the great struggles and debates of the revolutionary era while retaining a strong affiliation with Judaism. Some of these experiences were difficult to live through even though they had led to the great event of emancipation. The Spanish invasion of the eastern Pyrenees, where they remained until November 1794, exacerbated the hardships. Nanci Rodrigues, who was of an age, was to write to her granddaughter some years later of the 'bloody epoch' in which she had grown up, and to thank Heaven that her granddaughter had never

seen 'such atrocities'.[24] The prominent Bordeaux citizen, Abraham Furtado, a Girondin supporter, was forced into hiding during the Terror, when he was taken in by Nanci's father, but at least there he was to discover fascinating items in the Roblès library, making his time fruitful if worrisome.[25] The Bordeaux Jews were considered fair game by the Jacobins and fined exorbitantly for alleged crimes and misdemeanours.[26] Worse may have eventuated.

The fall of Robespierre in July 1794 made life even more difficult for Lopès Fonseca, however, and fleeing Bayonne, he returned to Bordeaux with his family to lead as circumspect a life as he could manage. He entered a marine insurance business with Isaac Rodrigues Pereire, a young man prominent in the Sephardic community of Bordeaux but with whom he had formed an association while in Bayonne.[27] At the Revolution, Rodrigues Pereire had shed the name Rodrigues, becoming simply Isaac Pereire. Another partner in that business was Rodrigues *fils*.

In the wake of Thermidor, 28 July 1794, at the age of eighteen years, Sara Sophie married in October her father's business partner and friend, who was later to receive the letter from Nanci Rodrigues. Indeed, Nanci was a witness to the marriage, which was probably arranged. But arranged or not, there seems no lack of affection on either side, and the marriage was to be long, happy, and productive. Their first child, Benjamin Olinde, was born in 1795. After Rodrigues *fils* had received his discharge from the republican army, an offer of employment from the Bordelais merchant and ship-builder, François-Bertrand Boyer-Fonfrède, saw them move to Paris in 1796.[28] Rodrigues *fils* ultimately took up a position with the bank d'Eichtal and then with the Fould bank. He was later to take a position as chief accountant of the Fonderies de Vaucluse in which the Fould family held a significant interest, a position he held until 1831.[29]

What greeted this young couple in Paris when they arrived there? A small community of mainly Sephardic Jews, some five hundred at the time of the Revolution, was increasing through migration. They included Nanci Rodrigues, her husband Benjamin, and her two sons, Édouard and Henry. Rodrigues *fils*'s employers, the d'Eichtals and the Foulds, also gave entrée to a wider society, one that came to include members of the Mendelssohn family.

Of the nine children who were to follow Olinde, two girls among them did not survive infancy. One of our subjects, Rachel Herminie,

was born on 13 January 1805. Thus, for the next twenty years or so, Sara Sophie's life was necessarily occupied with domesticity, with raising a family and maintaining the home in a new environment. But, together, she and her husband were to explore a different way of living as Jews in acculturation with French society rather than through religious identity with Judaism.

While Sara Sophie experienced a Sephardic religious upbringing, it is likely that the cultural interests of her father were an element in facilitating her path away from Judaism, helping her to establish an intellectual companionship with her new husband. Certainly, the personality and absorptions of Rodrigues *fils* had a profound influence on Sara Sophie, but in some senses she had been well-prepared by her father's literary and philosophic interests, which admired the Enlightenment for the freedom it conveyed to the mind, as well as by the richness of the texts in his library. That the Enlightenment had questioned the social and religious order, both of which the Revolution had so powerfully shaken, was also an element in her development from this time.

Rodrigues *fils* was a true revolutionary and child of the Enlightenment, and the nature of the companionship they shared might be judged by a letter her husband had written to her father at the time of his marriage, where he asserted: 'It is in the progress of philosophy and, by consequence that of public reason, that Despotism has been overthrown, the Republic founded, and man reminded of the exercise of inalienable rights he owes to nature.'[30] Religion had achieved none of these benefits, he concluded. Their son, Olinde, later summed up his father's attitude eloquently when he avowed: 'I was born a Jew, and yet my father wanted to make of me a man for the future and not of the past; I never practiced the rites of Judaism.'[31] Rodrigues *fils* remained a significant figure in the Parisian Jewish community, despite the apparent loss of faith. And this provides some insight into the process of acculturation, at least for the Rodrigues couple: having lost his faith, he did not lose his sense of being Jewish. Appointed secretary to Napoleon's Assemblée des notables in 1806, and then to the Grand Sanhedrin which followed, the task of which was to give greater detail to the decisions made by the Assemblée, he assumed the position of Secretary of the Paris Consistoire in 1809 and held it until 1825.

Rodrigues *fils* may have exerted the more significant influence on the way in which his children addressed their religious lives, but it was Sara Sophie who held the greater sway over their affection. In Félicie Sarchi's letters to her daughter Hélène in the 1860s and 1870s, her most tender thoughts often returned to her mother, remembering the anniversary of Sara Sophie's birthday thus:

> This date, the 11th of January, takes me back to my youth; the 11th of January was mother's birthday. It was [a matter of] who would rise first, to be the first to embrace her and sometimes to offer her a little piece of needlework or some notebook with lines of history or geography. ...When Mélanie and I start on the subject of what we did with Mother, we are inexhaustible. What we did with mother it was our childhood, our first youth which is revealed before our eyes, it was a joyous procession of dances, of blindman's buff, of hide-and-seek, followed by the image, the memory of first emotions, of first joys and also of first sorrows.[32]

In Félicie's description, we gain an appreciation of Sara Sophie's influence on her daughters: clearly authoritative and powerful, having a moral authority within the Rodrigues' home.[33] She raised her daughters to be good and loving, to acquire feminine skills, and to be attentive to the needs of others. But she appears not to have restricted their physical development and interests as seems otherwise to have been the rule at that time. Barbara Corrado Pope wrote of adolescent girls, for instance, that: 'It became less and less seemly for girls to engage in some of their favorite childhood pastimes, like jump rope and hide-and-go-seek which would have offered them some opportunities for vigorous exercise.'[34] From the passage in Félicie's letter, this may not have been the way Sara Sophie brought up her six surviving daughters.

Félicie also recalled that Sara Sophie had been a great reader of the novels of Sir Walter Scott, 'going into ecstasies' over Scott's depictions of elderly people.[35] *Ivanhoe* (1819), with its memorable characterisation of the young Jewish woman, Rebecca, and her struggles with persecution, was a favourite among readers of the time, Jews and non-Jews alike; indeed the historian Maurice Samuels saw it as shaping 'the way the nineteenth century imagined the Jew'.[36] This love of Scott's novels was passed on to Sara Sophie's children, for Félicie also remembered how she, at fourteen years of

age, forgot food or drink, so absorbed was she in the novels of Sir Walter Scott.[37]

Encouraging girls to read novels was not so common in early nineteenth-century France.[38] Indeed, the reading of novels by young girls was explicitly condemned in Catholic manuals as they made 'women's lives appear monotonous or mediocre'.[39] But girls were in turn desperate to lay their hands on such reading matter. Sara Sophie was thus clearly more liberated in her approach to the children's upbringing and especially that of her girls. Nor apparently was she afraid to speak her mind, as Félicie's husband, Charles Sarchi, not one to hold back his own opinions, reported in a letter to his daughter, Hélène, 'Your grandmother Sophie detested me so cordially.'[40]

Félicie's mother was nevertheless aware of the necessary preconditions to a good marriage, the hoped-for destiny of each of her daughters. Foley, for instance, wrote of 'the importance of beauty for girls of the bourgeoisie, whose sole destiny was marriage'.[41] And this was certainly Sara Sophie's view for, as Félicie remembered, she told them: 'beauty is a precious passport'.[42]

She was remembered too with gratitude for arranging classes that enriched her daughter's lives, providing for music and other lessons through the careful management of the family budget.[43] A facility for piano playing was one of the accomplishments expected of young women of Félicie's class, and each of the girls became accomplished musicians and appreciative of music. Piano playing was part of the 'initiation in domestic skills'.[44] It became particularly important also for Jews in the process of assimilation, a means of demonstrating the cultivated tastes so useful in breaching the divide with non-Jews. Indeed, throughout the letters in the Pereire family archive, we find references to musical evenings, sometimes as a means of sociability engaging a wide audience and sometimes purely for family entertainment. We shall come to these again.

Both sons, Olinde and Eugène, as was their right post-emancipation, were educated at *lycées*, a gendered differentiation that reinforced the pre-ordained way in which boys and girls were to live their lives. In the early nineteenth century, if there were a few secondary schools for girls, none of them approached the standard of the *lycée*. After the Revolution, religious orders had started to open boarding schools, but it does not seem that the Rodrigues daughters

attended one of these.[45] And while one of the principal duties of a mother in the nineteenth century was to educate her daughters, whether Sara Sophie did so is uncertain. That she arranged lessons for her daughters suggests, however, that she was directly involved in ensuring they received the best the Rodrigues could then afford. Letters written by each of the daughters displayed a good hand and mode of expression, indicating a level of education superior for the time.

The elder two, Sophronie (b. 1797) and Anaïs (b. 1801), probably attended a school for girls in Paris started by Moses Mendelssohn's daughter, Henrietta, who had settled in Paris at the invitation of her brother Abraham, the banker.[46] In the early years of the century, Henrietta established a well-regarded boarding school located in the large garden of the Foulds' house in the rue Richer. At the time, Rodrigues *fils* was employed by the Fould bank. Henrietta Mendelssohn was described as 'thoughtful, highly cultured', and she was considered by other cultivated women, Germaine de Staël among them, to have 'a quick intelligence, wide knowledge, clear judgment, the most refined courtesy, and the choicest tact'. She was fluent in German, French, and English literature.[47] Henrietta Mendelssohn left the school in the Foulds' garden in 1812, however, to become governess to the daughter of the wealthy General Sebastiani, a post she held until 1823. The four younger Rodrigues daughters, including Herminie, would thus have been educated differently since they were not yet of an age to attend Henrietta's school.

Even though the Rodrigues couple had ceased to be observant, in many ways they remained socially and culturally Jewish. We note this in the Jewish practice they followed in most instances in bestowing as first names on their children the names of forebears or relatives, thus stitching them 'into the family fabric ["tissu familial"]'.[48] Their first child, Olinde, was named Benjamin for his paternal grandfather. Judith Sophronie, their eldest daughter, recalled her paternal grandmother, Judith Mendès. Both choices replicated what was expected in traditional Jewish homes.[49] Furthermore, Anaïs took the name Esther after her maternal grandmother, Esther de Daniel Delvaille. The name Rachel was bestowed on Herminie as a remembrance of her paternal great-grandmother, Rachel Gomes Bourguille. Eugène was David Eugène (b. 1807), for Rodrigues *fils*'s

brother. Mélanie (b. 1809) was given the name Rebecca, possibly for Sara Sophie's sister. While Amélie (b. 1813) also took the Jewish name Noémie, there are no indications of family origin in this. But there are several ancestors with the name Marie, as in Félicie Marie (b. 1811).[50] Altogether, this continuation of a long-established Jewish custom in naming their children reflected a strong inclination to retain some cultural link with their Jewish origins, particularly with the Rodrigues and Lopès Fonseca families.

Aside from observing the Jewish custom in naming their children, what is equally remarkable about the second names that Sara Sophie and Rodrigues *fils* gave them was the clear familiarity with secular European culture and, indeed, what may have been an overt intention to demonstrate it.[51] This was evident in the naming of Olinde and his elder sister, Sophronie, whose names appeared in the sixteenth-century Italian poet Torquato Tasso's epic Renaissance poem about the liberation of Jerusalem by the Crusaders, *La Gerusalemme liberato*, in which they appeared as Christians and as lovers. In the same poem, 'Herminie' was a Muslim princess of Antioch, a character immensely popular and copied in literature by Rousseau among others and in paintings by Guercino and Tiepolo.[52] The popularity of Tasso's poem can be gauged by the frequency with which it served as a model for composers: Haydn, Berlioz, Rossini, and Brahms all set the poem to music, and the 20-year-old Fromental Halévy wrote a cantata titled *Herminie*, which won him the Prix de Rome in 1819.[53]

Tasso was not the only secular source for the names of the Rodrigues children. Anaïs was named for a character in the opera by Jean-François de La Harpe, *Anacréon chez Polycrate*, and Mélanie was the principal character in *Mélanie, ou les Voeux forcés*, a drama by André-Ernest Modeste Grétry. The name Félicie appeared in *La Belle et La Bête*, possibly inspired by a particular adaptation of the story by Grétry. Except for Tasso, then, whose work obviously remained immensely popular throughout the eighteenth and nineteenth centuries, these other sources were created by French literary and musical figures allied to the Enlightenment *philosophes*, demonstrating the Rodrigues' familiarity with secular French culture.[54]

The combination of Jewish and non-Jewish names, particularly those associated with literature, drama, and music, evinced in itself a cultural link with modernity uncommon in Jewish circles in the

early years of the nineteenth century.[55] The historian of the Jews of Bayonne, Anne Bénard-Oukhemanou, has commented that this practice of attributing two names to their children, one Jewish and the other of secular European origin, was rare in the Jewish community at that time.[56] It was to be found principally in financially comfortable Jewish circles and those with more frequent contacts among non-Jews, which the Rodrigues certainly enjoyed.[57]

They do not appear to have contemplated the final step in assimilation, however, that of apostasy, even though they had friends and family who were to do so. Connections with Ashkenazi Jews from northeastern France and from Germany were, for instance, particularly significant to the Rodrigues family. The seed in each case was the temporary residence in Paris of Moses Mendelssohn's son Abraham who, like Rodrigues *fils*, came to work with the Bavarian banker, Louis d'Eichthal, late in the eighteenth century and then with maison Fould. The relationship was sustained in the intervening years when Abraham returned to Paris from time to time on business with his family, a city of which he was extremely fond. 'Every entrance into Paris is an important epoch in one's life', he was to write.[58] Having arranged baptism in 1816 for their two youngest children, Felix and Fanny – a measure they saw as a signal of assimilation and in the children's best interests – the Mendelssohns took the dramatic step in 1822 of converting to Christianity themselves in the Frankfurt Reformed Church, paradoxical in view of the position of Abraham's now long-dead father, Moses, the leader of the Haskalah.[59]

The Rodrigues children thus grew up in a household that differed from the one Sara Sophie had experienced in Bayonne and Bordeaux, and not simply in its shedding of religious devotion or adherence. Alfred Pereire, a descendant of Fanny and Isaac, tells us that the home of Sara Sophie and Rodrigues *fils* also became a *salon* for financiers. Two governors of the Banque de France, Jacques Laffitte and Vital Roux, were among them, and so was Benoît Fould of the Fould bank. Abraham Mendelssohn, his wife Léa, their daughter Fanny, and Abraham's sister Henrietta also visited regularly when they were in Paris.[60] Yet another visitor was Moses Ensheim, a scholar from Metz, who had been tutor to Moses Mendelssohn's children and whose name appears from time to time in Pereire family correspondence.[61] Thus, while Rodrigues *fils*'s

position with the Paris Consistory tied the family to a Jewish social circle, through his employment with the Fould bank they had established themselves also within a social and cultural environment in Paris, a cultural mix of Jewish and non-Jewish individuals carrying substantial weight in financial circles.

When Sara Sophie's children came to marry, there was some variety in the circumstances: some marriages were arranged, others were not, others are indeterminate to us. It is not clear, for instance, whether Olinde's marriage with Euphrasie was arranged, for they were not of the same religion, nor were they from the same city. But we do know that his sister Sophronie's marriage with David Andrade came about through her parents' intervention, for Herminie told us so. Writing to Sophronie on 15 December 1815, the day of the wedding, Herminie said:

> Here the day so much desired has arrived that we hope will make you happy in uniting you with the spouse that our parents have chosen for you; all the more that he combines the qualities of heart to those of the spirit. I do not doubt that you will fulfil the duties of a good spouse with those of a good mother to your children if you have the happiness to have them.[62]

On the other hand, in view of Charles Sarchi's comment about Sara Sophie 'detesting' him, it is possible that the Sarchi marriage was a matter of personal inclination and not favoured by Sara Sophie.[63]

The marriage patterns they established were as markedly different from the norms of France's southwest as their upbringing had been. Some of Sara Sophie's children married Jews, others married Catholics. Olinde married a Catholic, Victoire Denise Martin, known as Euphrasie. Anaïs, at the comparatively late age of twenty-six, was to marry the Catholic Romain Regnauld. The Saint-Simonian lawyer Henri Baud, whom Mélanie married at twenty-three years of age, was also a Catholic.

Sophronie, Herminie, Félicie, and Amélie all married Jews, but while these marriages were endogamous, there the similarities with Jewish tradition ended. In December 1828, Félicie married Charles Sarchi, a Jew who had converted to Catholicism and whose animosity towards Judaism remained potent to the end. Amélie, the youngest of the surviving children and the last to marry, at the age of twenty-five, married a Jewish widower, Abeillard Armand Servedieu

Lévy, a mathematician and mineralogist who was to die relatively early in the marriage, in 1841.

The only child of Sara Sophie and Rodrigues *fils* whose marriage and life thereafter in any way conformed to Sephardic practice was Herminie, who married her cousin, Emile Pereire, in 1824. We will come to her and to this marriage in the next chapter.

There was one union which needs further elaboration for its unfortunate effect on the Sephardic community of Bordeaux, that of Sophronie with David Andrade. During the French Revolution, David's father, Abraham Andrade, had been a close friend of Sophronie's maternal grandfather, Mardochée Lopès Fonseca, and like him had rallied to the Jacobin cause. Andrade became Rabbi in Bayonne in 1789 before his appointment as Chief Rabbi in Bordeaux. As a member of both Napoleon's Assemblée des notables followed by the Grand Sanhédrin in Paris, he would certainly have encountered Rodrigues *fils* then, if not before. Thus, it was most likely family relations that brought Sophronie and David together. But there the conformity ended, for the marriage which took place in 1815 when the bride was eighteen years of age was to lead to apostasy. Her parents in 1826 gave their blessing to baptism of the Andrades' children in the Catholic Church.

This action was to cause a schism between the Rodrigues family and their relatives in Bordeaux, the Rodrigues having left behind family and friends who remained more steadfastly committed to Judaism and who came to regard David Andrade's actions as treacherous, completely disloyal to his father. 'Everybody here pities a great deal the cruel situation of the poor father [Chief Rabbi Andrade] and of the mother. I think this will bring him to the grave with dishonour for all the community ["Le Kâl", possibly "Kahal" (Heb.) meaning organised community]', wrote an uncle of Emile Pereire from Bordeaux, further describing David Andrade as 'a Brigand'.[64] Despite the criticism some historians have levelled against the Sephardim, describing their religious devotion as superficial and most likely to result in apostasy, when apostasy did occur, the pain caused by this family division was as traumatic for Sephardim as it was for Ashkenazim.[65]

The Fould bank regarded their employee highly. A skilled accountant when the modern profession was in its infancy, Rodrigues *fils* had written treatises on the subject. But he was not as wealthy as

several others in his extended family; he was not a business owner and needed to provide dowries for six daughters, all of whom in due course did indeed marry and marry well. These dowries were by no means extravagant, but they indicate nevertheless the relatively comfortable middle-class position Sara Sophie and Rodrigues *fils* had reached progressively over the twenty-five years in which their children were marrying. The greatest sum was ten thousand francs for each of Anaïs and Amélie (m. 1838). David Andrade's account was paid four thousand francs on his marriage with Sophronie (m. 1815) after Rodrigues *fils* had reduced the sum from six thousand francs; four thousand francs was also paid into the account of Emile Pereire when he married Herminie (m. 1824) and the same for Charles Sarchi on his marriage with Félicie (m. 1828); and just under three thousand for Mélanie (m. 1832) when she married Henri Baud, the son of a wealthy business person. Fifteen hundred francs was paid into the account of Olinde on his marriage to Euphrasie (m. 1817).[66] In addition, in 1843 Rodrigues *fils* noted in giving an account of the inheritance of each of his children that 'Each one of my daughters has cost me 2000 to 2200 for a Trousseau.'[67]

Olinde was the first to explore the persuasive doctrines of Claude Henri de Rouvroy, comte de Saint-Simon (1760–1825), becoming, through his acquaintance with Auguste Comte, Saint-Simon's secretary. His brother Eugène rapidly followed this interest, as did his cousins, Emile and Isaac Pereire. The message of industrial development, a quasi-socialist ethos, and a new religion which gave some primacy to Judaism as the forerunner of Christianity spoke to those Jews who were searching for an affirmation of their religious and social identity, one which recognised and valued Judaism.[68] The coincidence of a movement towards regeneration of the Jewish religion, which had originated before the Revolution and was to be a continuing theme post-emancipation, provided a compelling reason for Jewish Saint-Simonians to concentrate their attentions on this turn in the doctrine.

Following the death of Saint-Simon, a decision had been made by the developing Saint-Simonian hierarchy to promote to a wider audience the theories outlined by a small group which included the Rodrigues sisters' younger brother Eugène, Isaac Pereire, and Charles Sarchi.[69] Herminie, Félicie, and Mélanie Rodrigues were also to join the Saint-Simonian movement at a particularly important

moment in its life, just before the first major exposition of the Saint-Simonian doctrine in a public meeting in December 1828.

While there has been some dispute over the significance of Jews in Saint-Simonianism, the majority of those who were shaping the Saint-Simonian doctrine were incontrovertibly Jewish men, including the brothers Olinde and Eugène Rodrigues and Emile and Isaac Pereire.[70] Olinde Rodrigues had encouraged his brother Eugène to examine the development of a religious base for the movement, conscious that the master's final work, *Le nouveau christianisme*, had been an attempt in this direction to reconstruct Christianity as the moral basis for his philosophy. Eugène subsequently authored *Lettres sur la religion et la politique*, aiming to forge links between Judaism and Christianity as well as to create this religious foundation for Saint-Simonianism. In doing so he called for tolerance: 'Christians, hold out your hand to the Jews, God commands you to cease your hatred of them', he wrote.[71]

The most significant influence on the intellectual life of the Rodrigues to that point, their father, was, however, at best lukewarm about the movement. Felix Mendelssohn was to write of him to his own father Abraham that 'Rodrigues, the father ... is in no way a Saint-Simonian, and the apostlehood of his son and of his daughter [*sic*] seems to give him little joy.'[72] Rodrigues *fils* himself, in an exchange with the leader Prosper Enfantin concerning what the latter saw as the hoped-for pre-eminent role of bankers in French society, spoke of the impossibility of 'replacing the paternal solicitude by the solicitude of bankers'. But in view of the beliefs of his children and of his nephews Emile and Isaac Pereire, he commented sardonically: 'It is so painful to find myself divided in opinion from what I hold most dear in the world, that you would render me a real service if you could assure me to think like you.'[73] This Enfantin did not manage to do.

One of the leaders, Saint-Amand Bazard, delivered the first public *Exposition* of Saint-Simonianism in December 1828, but the question of female equality emerged most cogently in the sixth *Exposition* in 1829. It was in the context of exploitation: of men by men and of workers by proprietors. Bazard then turned to the 'relations ... between the sexes' and the causes of women's 'subalternity'. He foresaw a new social order of peaceful harmony between all, in which women's situation as a 'perpetual minority' would at last give way to real equality.[74]

The Saint-Simonians had begun to reflect on the subject of women, female equality, marriage, and divorce, and this may have played a part in the decision of women to begin to discuss the issues separately from their male colleagues. Prosper Enfantin, writing to a female friend, reported with pleasure the involvement of women in the Saint-Simonian movement:

> The ladies of the doctrine have been seeing each other regularly for two months in meetings which have a semi-social ['semi-mondain'] character, although the doctrine may not be discussed. We are attending them, but soon they will be having more private meetings. In the one today they read from their correspondence and from their own works. Mme Bazard, Mme Fournel, Mme [Félicie] Sarchi, a daughter and a mother of Mme Bazard, a sister of Rodrigues [Herminie] married to the brother of [Isaac] Pereire, these are our ladies. Mme Olinde has begun recently to read, study, and copy some of our works. She came once to our meetings, but she has a lot to do to feel at home there.[75]

Historians have been drawn to the view that these young women were influenced in their attraction to Saint-Simonianism primarily by men: their brothers, Olinde (1795–1851) and Eugène (1803–31), both of whom were leaders, although in different ways; their cousins, Emile and Isaac Pereire, who were deeply involved; and their father, Isaac Rodrigues, who, while not a Saint-Simonian, was devoted to Enlightenment philosophy, arguably a pre-condition to Saint-Simonianism. Olinde, one of the triumvirate of leaders, and Eugène forged ideas combining elements of Judaism and Christianity to give the movement a religious character. Emile Pereire and his brother, Isaac, both of whom had married into this family, contributed to shaping Saint-Simonian economic and social theories. Undoubtedly the engagement of male family members with the life of ideas and their importance to the Saint-Simonian movement had an effect on the Rodrigues women. One can neither ignore nor deny the significance of these men in the lives of Herminie and her younger sisters Mélanie and Félicie.[76]

Yet several women had developed a powerful presence, including Claire Bazard, wife of Saint-Amand Bazard, one of the leaders; Cécile Fournel, wife of another important figure, the engineer Henri Fournel; and Olinde's own wife, Euphrasie. All three were

important to the development of a feminist perspective in Saint-Simonianism. And while the influence of these women on others has not been well-developed in the literature and was probably of fairly short duration, it might have been considerable in the case of the Rodrigues sisters. Certainly, Cécile Fournel and Euphrasie Rodrigues were to remain throughout a constant source of friendship, support, and sociability to Herminie Pereire and figured in the life of Fanny as well.

A different perspective on the attraction of Herminie, Félicie, and Mélanie Rodrigues to Saint-Simonianism proposed that the doctrine provided these young Sephardic women with an alternative to assimilation, 'instigat[ing] strategies of resistance and dissimulation'. It afforded them opportunities to explore and engage in a movement that underscored integration and equality in French political and intellectual society, one that valued and, at least for a time, aimed to advance their role as women.[77] If, however, Mélanie and Félicie were attracted to Saint-Simonianism for the primacy accorded Judaism, this circumstance was to lose its vibrancy rapidly. Both became Catholics after their respective marriages to Saint-Simonians, Mélanie to the Catholic Henri Baud and Félicie to the Catholic convert from Judaism Charles Sarchi. Not only did Mélanie and Félicie convert to Catholicism themselves, they appear to have become devout. Herminie's situation was different again, and we shall come to that shortly.

By 1830, about one hundred women had begun to attend meetings and even more arrived after the July Revolution in that year when the movement launched a concerted effort to attract the working class.[78] They partnered men in managing Saint-Simonianism in the *arrondissements* and in providing health services. As Claire Goldberg Moses has described them, however, the early feminists in the movement were 'bourgeois'; the real impetus towards female equality was to come later from working-class women attracted vitally to Saint-Simonianism by the debates about equality, marriage, and divorce.[79]

Nevertheless, for more than three years from late 1828 until early 1832, the young Rodrigues sisters were not passive onlookers. They did not simply attend meetings; they were activists. Mélanie wrote propaganda letters, as did Félicie. According to Cécile Fournel, in contrast with the timidity of other female Saint-Simonians, Félicie

was also 'an able orator' in addition to her letter writing, the purpose of which was the conversion of young women.[80] This was a task similar to that undertaken by her brother Eugène and her cousin, Isaac Pereire, both of whom were in contact with a convert from Castelnaudary, Jacques Rességuier, and whose sisters were now the target of Félicie's propaganda.

The tone of Mélanie's writing may be gauged from an example which remains to us, a letter published in January 1832 in the Saint-Simonian journal *Le Globe*, addressed 'to young girls'. It is vigorous and passionate, aimed to stir young women from the lethargy into which society had lulled them. 'You above all young girls, raised in luxury and neglect to enjoy all that the world offers, so seductive, so flattering, are you not forced to close your hearts to the voice of pity, to reject the spectacle of misery, – the world showers you with praise, you breathe from all sides an intoxicating incense.' Only the word of God through Saint-Simon could save these young women from lack of belief and open their hearts to the misery around them. In doing so, they would find their 'pleasures will be a thousand times more real, livelier than those [they] enjoy today'.[81]

Mélanie then painted a picture of the ideal Saint-Simonian family.

> Do not fear to be taken away from your well-loved sisters; the moment when you enter the paternal house will not be an occasion of pain for you ... Your mother will be of all women the one who will love you the most and who will be the most capable of directing you towards an eternal progress. You will have a father, brothers with whom you will be happy to belong and whose delightful support will teach you to know that other half of humanity that you have only just met and with whom one day you must be united and associated. Nothing will equal the admirable harmony which will reign inside your families, you will draw from it each day a new subject of actions and grace.[82]

This picture of the ideal family magnified both the significance of the mother as the fountain of maternal affection and moral guidance, and the maternal role as a necessary fulfilment in marriage for young women.[83] What it says about Mélanie's own family is more difficult to determine, though she could scarcely have avoided drawing on aspects of her own family life in her vivid description; her readers could have been forgiven for believing this to be the case.

Enfantin began to place more emphasis on religion which depended on this reconciliation between Judaism and Christianity, seeing in Mélanie and Félicie what one historian described as 'an ideal premise to join in Saint-Simonism'.[84] The tone of his conversations with women is caught in a letter he wrote to Félicie in about 1830, when he said,

> You have in you the Christian love and the love of the children of Moses, but you do not live yet the Saint-Simonian life. And yet you have received the seed through Eugène, through Olinde, through Sarchi [her husband], through me, through us all. Let us learn together to live, to love. No woman, no man has yet felt Life, Love, God like us.[85]

Thus, according to Enfantin, the influence of her brothers and her husband, all Jewish, and Enfantin, a Gentile, should endow Félicie with the perfect entrée to the Saint-Simonian life.

The Saint-Simonian discourse on women began to move beyond the subject of female equality to one of free love and divorce. But as Pamela Pilbeam has remarked, 'women who had been associated with the sect ... considered Enfantin's ideas smacked not of liberty but of sexual licence: freedom for men, the opposite for women'.[86] Certainly, in the course of this attempt towards sexual liberation, their brother Olinde (their other brother Eugène having died suddenly in 1830) was humiliated by Enfantin's public revelation of marital problems confided in him by Olinde's wife, Euphrasie. It must also at the least have embarrassed, if not angered, Olinde's sisters. This unwanted airing of dirty linen, added to Enfantin's about-turn on the position of women in the hierarchy, contributed to their desertion of Saint-Simonianism.

In 1832, Enfantin effectively cut women out of the positions of leadership they had begun to enjoy. And beyond the demise of Saint-Simonianism, the women who did most to advance the cause of equality were from the working class. They were not bourgeois, as the Rodrigues sisters clearly were. None of the Rodrigues sisters was among those who later contributed to feminist journals, such as *La Femme libre*, *La Femme de l'avenir*, *La Femme nouvelle*, or *l'Apostolat des femmes*, almost all of which emerged through the efforts of working-class women who had engaged with the movement, Pauline Roland, Jeanne Deroin, and Suzanne Voilquin among them.[87]

Not that the sisters received any real encouragement to continue their efforts, if Charles Sarchi's attitude can be taken as an example. In later letters, he was to write scornfully of 'the bluestockings' that Félicie and Mélanie happily left behind once they had 'grown up'![88] He boasted to his daughter Hélène of his pride in a letter Félicie had written to Fanny Pereire, the other of my subjects here, a letter that was: 'entirely worthy of the brilliant education that I have given her for nearly forty years. I am very pleased with it.'[89] Félicie herself, on her sixtieth birthday, reflected on the intellectual development that she owed to her husband, of all the things he had done to develop in her 'the faculties which doubtless would have been stifled if I had been married to [someone else]'.[90]

The very happy marriage of the Rodrigues couple who had given life to these interesting individuals lasted over fifty years. Sara Sophie died in February 1845, at the age of sixty-eight. Rodrigues *fils* survived only a further seven months before he too died at seventy-four years of age in September of the same year. He did not die in Paris but in Saint-Cloud, at the home outside the capital where Herminie had moved with her husband Emile Pereire. We do not know whether he had left Paris permanently or whether illness drew him to seek the care of his middle daughter and the comfort of her home at the time of his death. Certainly, he owned parcels of land that were associated with the Paris–St Germain rail line, which Emile Pereire had brought into being. It is indicative of the close relations entertained by the Rodrigues family, however, that the pattern of family co-habitation that had been forged over a long period should be maintained to the end. The mortal remains of Sara Sophie and Rodrigues *fils* lie side by side in the Père Lachaise cemetery in Paris, not far from an enclave of Saint-Simonian graves including those of their sons, Olinde and Eugène.

The Rodrigues family remained central to the lives of its members, forever part of an intimate circle. But the legacy Sara Sophie and Rodrigues *fils* bequeathed to their children was diverse. While they had left Judaism behind and embraced a secular Jewish identity, they did not countenance apostasy for themselves. They consorted with other Jews, both those who remained practising and Jews who had converted. While their girls were expected to marry and raise families, they experienced a degree of freedom unusual for the time. This freedom was also intellectual, opening the way

to explore new ideas about religion and society which some of their children, including several of their daughters, exercised most notably in the attachment they developed to Saint-Simonianism. The Rodrigues family legacy provided a pathway towards which, as Jews, they would see themselves increasingly also as citizens of France.

In the next chapter we shall make the acquaintance of the subjects of this book in greater depth, both members of and linked irrevocably to the Rodrigues family: Herminie and her daughter, Fanny. The chapter will draw out some of the residual influences and social connections of this family that gave these women their individual characters and personalities.

Notes

1 I am indebted here to two genealogical sources. The first, www.nebuleuse-rh.org, accessed 15 July 2017, has been prepared by members of the Rodrigues Henriques family and is updated from time to time; the second is Paul M. Simeon, 'Tableau Synoptique des Origines, Ascendances & Alliances de la Famille Rodrigues Henriques au cours des 17, 18, et 19èmes Siècles' (Paris, November 1998).
2 Burr Margadant, *The New Biography*, 10.
3 AFP, Nanci Rodrigues, Paris, 'A Monsieur Rodrigues fils rue de l'Echiquier à Paris', 26 June 1806.
4 Ibid.
5 That she had done so was recorded by Michel Berr in his *Éloge de M. Abraham Furtado, l'un des adjoints de la mairie de Bordeaux* (Paris, 1817), 18, fn. 1.
6 Jennifer Sartori, 'Reading, Writing and Religion: The Education of Working-Class Jewish Girls in Paris, 1822–1914', in Zvi Jonathan Kaplan and Nadia Malinovich (eds), *The Jews of Modern France: Images and Identities* (Brill Online, 2016), 62. I am also indebted to Jennifer Sartori's dissertation '"Our Religious Future": Girls' Education and Jewish Identity in Nineteenth-Century France' (PhD diss., Emory University, 2004).
7 Léon Kahn, *Histoire des écoles communales et consistoriales israélites de Paris (1809–1884)* (Paris, 1884), 34.
8 Nancy Green, 'La Femme Juive: Formation et transformations', in Geneviève Fraisse and Michelle Perrot (eds), *Histoire des femmes en Occident IV: Le XIXe siècle* (Millau, 2001), 262.

9. Kahn, *Écoles communales*, 26.
10. Ibid., p. 48. See also Archives Nationales (hereafter AN), F/17/12514.
11. For references to Sophie Roblès, see Nahon, *Juifs et Judaïsme à Bordeaux*, 196, 210, 212, 226. Relations between Bordeaux and Paris in the development of the girls' school in Paris can be found at Zosa Szajkowski, *Jewish Education in France, 1789–1939*, Tobey B. Gitelle (ed.) (New York, 1980), 4, 48–9.
12. Philippe Gardey, *Négociants et marchands de Bordeaux: De la guerre d'Amérique à la Restauration (1780–1830)* (Paris, 2009), 72–4.
13. Maurice Samuels, *Inventing the Israelite: Jewish Fiction in Nineteenth-Century France* (Stanford, CA, 2014), 33.
14. Geneviève Halévy married first the composer Georges Bizet, who died at the age of thirty-six, and sometime after married again, to the banker Emile Straus. She will reappear in Chapter 8 below, 'Being Jewish'.
15. 'Imposition des Juifs de Saint-Esprit pour 1783', in Gérard Nahon (ed.), *Les "Nations" Juives Portugaises du Sud-Ouest de la France (1684–1791): Documents* (Paris, 1981), 90–3.
16. Archives communales de Bayonne (hereafter ACB), 'Enregistrement d'environ 221 mariages (par le 'sieur rabbin de la nation juive du bourg de Saint Esprit près Bayonne): 1751 à 1787', folios 79, 83, 87, 89.
17. See for instance, Gardey, *Négociants et marchands*, 443, where he refers to an account paid by Joseph Azevedo for his daughter's boarding school ['pension'] fee. Gardey's reference is to Archives départementales de la Gironde (hereafter ADG), Mathieu notaire, 3E 24136, 9 September 1809.
18. Cavignac, *Les Israélites Bordelais*, 339 and 363.
19. Peter McPhee, *Liberty or Death: The French Revolution* (New Haven, CT, 2016), chap. 9.
20. Ernest Ginsburger, Grand Rabbin, *Le Comité de Surveillance de Jean-Jacques Rousseau Saint-Esprit-Lès-Bayonne: procès-verbaux et correspondance II octobre 1793 fructidor an II* (Paris, 1934), 90, procès-verbal, 'Séance du second mois du seconde année de le Révolution française'.
21. Ibid., 26–32. Notes on these pages are derived from notes taken at the meetings of Lopès Fonseca's Société montagnarde and show the equivocation with which the Société dealt with demands from the Jacobins.
22. Henri Léon, *Histoire des Juifs de Bayonne* (Marseille, 1893, reprint, 1976), 164.
23. Ibid.
24. Bibliothèque nationale de France-Arsenal (hereafter BNF-A), Fonds d'Eichthal, Nanci Rodrigues, Paris, to Cécile d'Eichthal, unknown address, 28 May 1842, ms.13750–109.

25 Abraham Furtado, 'Mémoires d'un Patriote proscrit', Bibliothèque de Bordeaux, Ms. 1946, MIC. 1370.
26 The Sephardim at the time numbered about 4 per cent of the Bordeaux population but were subjected to nearly 10 per cent of the fines extracted. See M. Aurélien Vivie, *Histoire de la Terreur à Bordeaux* (Bordeaux, 1877), vol. 2, 403–5. See also Nahon, *Juifs et Judaïsme*, 171–2.
27 Isaac Rodrigues Pereire had been secretary to Lopès Fonseca's Société *montagnarde* in St Esprit. Léon, *Histoire des Juifs de Bayonne*, 164.
28 AFP, Rodrigues fils, Bordeaux, to Isaac Pereire, Toulouse, 21 April 1796.
29 Barrie M. Ratcliffe, 'Towards a Better Understanding of Olinde Rodrigues and His Circle: Family and Faith in His Life and Career', in Altmann and Ortiz (eds), *Mathematics and Social Utopias in France: Olinde Rodrigues and His Times*, 52.
30 AFP, Rodrigues, Bordeaux, to 'I. de J. Pereyre chez l'héritier d'Ic. Levy à J. J. Rousseau Lez-Bayonne, 23 Prairial *an* II [11 June 1794] de l'ère française'.
31 *Oeuvres de Saint-Simon & d'Enfantin* (2nd ed. Paris, 1865), vol. 4, 209, séance 27 November 1831.
32 Sarchi, *Lettres*, Félicie Sarchi, Florence, to Hélène Van Tieghem, Paris, 11 January 1867, vol. I, letter 200, 302.
33 Barbara Corrado Pope, 'Mothers and Daughters in Nineteenth-Century Paris' (PhD diss., Columbia University, 1981). Corrado Pope describes this sort of relationship exactly.
34 Ibid., 223–4.
35 Sarchi, *Lettres*, Félicie Sarchi, Néris, to Hélène Van Tieghem, Paris, 5 June 1864, vol. I, letter 31, 58–9.
36 Samuels, *Inventing the Israelite*, 36.
37 Sarchi, *Lettres*, Félicie Sarchi, Néris, to Hélène Van Tieghem, Paris, 5 June 1864, vol. I, letter 31, 58–9.
38 Foley, *Women in France*, 35. Foley noted that for many, 'The imaginary world of the novel was likely to appear too enchanting, contrasting dangerously with the real lives for which they were destined.'
39 Ibid., 35–7.
40 Sarchi, *Lettres*, Charles Sarchi, Florence, to Hélène Van Tieghem, Paris, 3–4 January 1866, vol. I, letter 45, 88–9.
41 Foley, *Women in France*, 37.
42 Sarchi, *Lettres*, Félicie Sarchi, Milan, to Hélène Van Tieghem, Paris, 12 May, 1868, vol. I, letter 295, 450–1.
43 Ibid., Félicie Sarchi, Le Havre, to Hélène Van Tieghem, Paris, 21 September 1862 vol. I, letter 21, 42–3.
44 Smith, *Ladies of the Leisure Class*, 169.

45 Françoise Mayeur, *L'Éducation des filles en France au XIXe siècle* (Paris, 1979).
46 Ratcliffe, 'Towards a Better Understanding of Olinde Rodrigues', 59.
47 Sebastian Hensel, *The Mendelssohn Family, 1729–1847: From Letters and Journals* (New York, 1969, first published 1882), 43.
48 Anne Bénard-Oukhemanou. *La Communauté juive de Bayonne au XIXe Siècle* (Anglet, 2001), 92.
49 Ibid., 91.
50 This information has been compiled from the genealogical data gathered in www.nebuleuse-rh.org, and from very useful family trees contained in Altmann and Ortiz, *Olinde Rodrigues*, 7–8.
51 Bénard-Oukhemanou, *Communauté juive de Bayonne*, 92. Ratcliffe in 'Towards a Better Understanding' and Paola Ferruta in 'Nineteenth-Century "New Marranism"' also draw attention to the source of this naming of some of the Rodrigues children.
52 ACB, 'Enregistrement des Naissances, Mariages et Décès de la Communauté Juive de Saint-Esprit', undated, f. 83. Rachel had been the name given to her mother's youngest sister also.
53 https://www.jewishchoralmusic.com/composers-bios/2019/6/21/jacques-halévy, downloaded 27 June 2022.
54 Again, I am indebted to the web site established by the Rodrigues Henriques family and noted above in note 1.
55 Bénard-Oukhemanou, *Communauté juive de Bayonne*, 92.
56 Ibid., 89–92.
57 Ibid.
58 Hensel, *The Mendelssohn Family*, 253, 13 July 1830, letter from Paris.
59 Ibid.
60 Alfred Pereire, *Autour de Saint-Simon: documents originaux* (Paris, 1912), 101.
61 For example in AFP, Nanci Rodrigues, Bordeaux, to Isaac Rodrigues *fils*, Paris, 26 June 1806.
62 Ibid., Herminie Rodrigues [Paris], to 'Minette' [Sophronie] Rodrigues, Paris, 15 December 1815.
63 Sarchi, *Lettres*, Charles Sarchi, Florence, to Hélène Van Tieghem, Paris, 3–4 January 1866, vol. I, letter 45, 88–9.
64 AFP, letter Uncle Seba, Bordeaux, to Emile Pereire, Paris, 30 July 1826.
65 Todd Endelman is one who perceives this to be the case in *Leaving the Jewish Fold*, 56.
66 AFP, 'Établissement de mes enfants: Avancement d'hoirie à mes enfants', document in the hand of Rodrigues *fils*.
67 Ibid.
68 Davies, *Emile and Isaac Pereire*, 48–9, 50–1.

69 Robert B. Carlisle, *The Proffered Crown: Saint-Simonianism and the Doctrine of Hope* (Baltimore, MD, 1987), 87–8.
70 Ibid., 89–90.
71 Eugène Rodrigues, *Lettres sur la religion et la politique, 1829; suivies de l'éducation du genre humain de Lessing traduit de l'allemand* (Paris, 1831). Quote from 131–2.
72 Quoted in Ralphe P. Locke, *Music, Musicians and the Saint-Simonians* (Chicago, IL, 1986), 111.
73 Bibliothèque Thiers-Dosne (hereafter BT/D), Fonds d'Eichthal, letter Rodrigues *fils*, Paris, to Enfantin, Paris, 5 November 1828.
74 *Doctrine de Saint-Simon: première année, exposition 1829* (Paris, 1830), Sixième séance, 107.
75 BNF-A, FE 7676/13, letter Prosper Enfantin to Aglaë St Hilaire, 17 December 1828. Enfantin omitted to mention Mélanie Rodrigues.
76 Ferruta, 'Nineteenth-Century "New Marranism"', 97–8; Goldberg Moses, *French Feminism*, 51.
77 Ferruta, 'Nineteenth-Century "New Marranism"', 97–8.
78 Goldberg Moses, *French Feminism*, chap. 4.
79 Ibid., 63–7.
80 Ferruta, 'Nineteenth-Century "New Marranism"', 116.
81 Mélanie [Rodrigues], 'Aux jeunes filles', in Michèle Riot-Sarcey (ed.), *De la liberté des femmes: "Lettres de Dames" au Globe (1831–1832)* (Paris, 1992), 99–104.
82 Ibid., 103.
83 Corrado Pope, 'Mothers and Daughters', passim.
84 Ferruta, 'Nineteenth-Century "New Marranism"', 117.
85 BT/D, Carton V-A, 141, letter about 1830, Enfantin to Félicie. There is some suggestion that this letter was written at the time Félicie suffered a miscarriage.
86 Pamela Pilbeam, *Saint-Simonians in Nineteenth-Century France: From Free Love to Algeria* (London, 2014), 50.
87 Goldberg Moses, *French Feminism*, 63–7.
88 Sarchi, *Lettres*, Charles Sarchi, Le Havre, to Hélène Van Tieghem, Paris, 2 September 1862, vol. I, letter 20, 42.
89 Ibid., Charles Sarchi, Florence, to Hélène Van Tieghem, Paris, 12 January 1867, vol. I, letter 204, 305–6.
90 Ibid., Félicie Sarchi, Torno, to Hélène Van Tieghem, Paris, 3 July 1871, vol. II, letter 407, 158.

2

Herminie and Fanny: mother and daughter

The Rodrigues family were talented, cultivated, and acculturated Jews. The remarkable milieu they created was the world into which Herminie and her daughter Fanny were born. This chapter will address the biographies of Herminie and Fanny up until the early years of the Second Empire: the circumstances of their lives, the influences upon them, and the relationship between them – mother and daughter. This will provide the foundation in subsequent chapters for a broader analysis of their roles as Jewish *grandes bourgeoises* in nineteenth-century France.

In 1805, the year Herminie Rodrigues was born, there were close to two thousand Jews in a total Parisian population of about six hundred thousand, a dramatic increase from a mere five hundred living there at the time of the French Revolution. It was not childbirth that accounted for this significant demographic, however, but an influx from the provinces and in particular of Ashkenazi Jews from Alsace-Lorraine.[1] With the centralising of government, judiciary, finance, and the economy in Paris during the Revolution and the multiplicity of opportunities this afforded, together with the new citizenship resulting from emancipation that encouraged mobility, the capital became a magnet for increasing numbers both from within France and without. In the latter part, Jews from Central and Eastern Europe also left the *shtetls* for the promise of a better life in the Land of Liberty. They were not necessarily to be welcomed. In moving from Bordeaux to Paris in 1796, Herminie's parents had thus been at the forefront of significant social and demographic change.

Rachel Herminie Rodrigues entered a world that was to present her with as many challenges as advantages compared with previous

generations. Her childhood passed during the reign of Napoleon I, a sovereign who, despite extending emancipation to every place he conquered, scarcely wavered in his negative opinion of Jews. After the defeat of Napoleon at Waterloo and the Bourbon Restoration, matters did not improve with the Bourbons' attempt to reintroduce Catholic supremacy. The years from 1815 to 1830 with the reigns of Louis XVIII and Charles X also saw a resurgence of attention to 'the Jewish Question' and an added push to 'regenerate' Jewish religious practices, to make them more acceptable to Gentiles. In 1824, an essay competition took place in Strasbourg with the objective to test ideas about how best to achieve this in the context of emancipation and the granting of French citizenship.[2] While the locus of anti-Jewish sentiment was notably Alsace, where the greater number lived, the Jews in Paris were scarcely exempt from the questioning that took place.

Of the ten children born to Sara Sophie and Rodrigues *fils*, Herminie was a middle child in an increasingly large family, attuned to and valuing of family life. The birth order may have its significance. For psychiatrist Alfred Adler, the first to describe the personality of children in relation to their place in the family, the middle child was often both a helper of her younger siblings and mindful of parental authority, the seeker of consensus, the peace-keeper, the one who maintained family solidarity.[3] Adlerian psychology has been challenged many times, but his theory is not without merit in describing the development of Herminie's personality as she matured.

This position in the birth order also provided many opportunities to become adept at caring for young children and for the sick, an interest in which Herminie in later life was to show much skill and aptitude, not to mention compassion. With the experience of her youth in a large family, she had much practice in its care.

Herminie was Sara Sophie's daughter. In a fine analysis of mother–daughter relationships at this time, Barbara Corrado Pope described Herminie's future in this way:

> Daughters were loved and valued for the happiness that they would foster inside the home. As they grew up they were supposed to become ornaments of the family, gentle understanding creatures who would lovingly perform small kindnesses for fathers, mothers, brothers, and

young children. Most of all, for the bourgeois women who led relatively secluded lives, daughters represented future companionship.[4]

The commentaries we have on Herminie's relationship with her family confirm this description.

The Rodrigues family members we met in the previous chapter remained close to each other throughout, for Herminie's sisters, their husbands and children, were to form the inner circle of her later social and domestic life. And not only of her own: the aunts Andrade, Baud, Lévy, Regnauld, and Sarchi, as well as Olinde's wife, Euphrasie, were favourite and important figures in the lives of Herminie's children, influential in a myriad of ways. Nanci Rodrigues and her sons Édouard and Henri were also part of the relational fabric; so, too, were Léonie Rodrigues Henriques and her husband, Fromental Halévy.

Herminie's personality, conditioning, and predilections were altogether consistent with aspects of the part she would be expected eventually to play as the wife of a Jewish businessperson, one for whom home and the family would be central. At the same time, she would be called upon increasingly to perform a more public role, as hostess, accompaniment, adornment, consumer, and contributor to charitable causes. In some respects, this role was more difficult for Herminie. She had to learn it, and it did not come easily.

Contemporary prescriptions prepared bourgeois women for the roles they were destined to play. Manuals existed. François Cattois in 1844 revived a particular treatise concerning the education of women for a life of domesticity: *Essai sur l'instruction des femmes* written by Thérèse LeGroing.[5] Cattois had his own views on the subject, which generally agreed with LeGroing, and in an introduction to the *Essai* he wrote:

> Today, two interests dominate the lives of men who are called to exercise influence: the conservation and advancement of private fortune and the difficult conquest of the various degrees of social position. The result is a general movement, an impulsion which pulls each man outside and away from that intimate sphere where once his paternal duties centred. In these circumstances, which come upon us as a result of events, the obligations of the mother are enlarged and multiplied.[6]

These 'obligations', brought on and demanded by the entrepreneurial gifts of Emile Pereire and his brother Isaac and their success in employing them, were to become eventually the driving force of Herminie's life.

The intellectually stimulating but non-practising Jewish family environment in which Herminie grew up meant that she was relatively free of any significant religious upbringing. At the same time, while the Rodrigues had all but abandoned the rituals of Jewish daily life and the religion from which these rituals derived, the primary social attachment of the family remained embedded in the Jewish community; they identified as Jews, the father's employment was within the Jewish community, and they mixed largely, although not solely, with other Jews.

The intellectual and cultural interests of Herminie's parents added to the view that they maintained an enlightened attitude towards their daughters' upbringing, suggest that their daughters' education was a significant matter for them, that it had some priority. Herminie would have been too young to attend the school of Henrietta Mendelssohn, unlike Sophronie and Anaïs. Education of girls in the first half of the nineteenth century was monopolised by the Catholic teaching orders; while secular education for girls existed, teaching standards were poor.[7] Indeed, the recollection of Félicie Sarchi that their mother Sara Sophie had made sacrifices to pay for music and other lessons could mean either that a governess educated Herminie and her younger sisters or that they attended one of the secular schools.

Throughout the first fifty years of the century, however, there was a growing interest in the idea of mother as teacher to her daughters. 'Taking up the role of mother-teacher gave women the right to be, and to be seen as, educated, useful, serious and reasonable', in the summing up of Corrado Pope.[8] This reflected contemporary views about the nature of the maternal role and was to lead in mid-century to a more precise formulation and definition.

Given Sara Sophie's interest in literature, she almost certainly had a hand in educating her daughters as 'La Jeune Mère Institutrice'.[9] Whatever the circumstances of her own education, though, Herminie displayed from an early stage in her life an assured hand in her letters and a comparatively sophisticated form of expression which

only a standard of education relatively high for the time could have provided.

The principal expectation for Jewish girls of Herminie's age and social class, that is, marriage and family, was little different from that of young Gentile women. Education served to render the young girl more attractive to potential suitors and prepare her for her role in bourgeois society. But how would the expectation of marriage and family have been shaped in the circumstances of the Rodrigues household, one in which the place of religion was no longer pre-eminent, where the family had adopted a secular set of values, and where there seems to have existed a certain freedom in the choice of a partner?

Following emancipation, Jewish leaders frequently used the central place of marriage in Jewish social and cultural considerations as a demonstration of the community's capacity for responsible citizenship, drawing 'separate spheres' to the fore in the process. Napoleon's Code Civil of 1804 performed much the same service, propelling women even further towards domesticity. Yet Bonnie G. Smith's Catholic women of the Nord department assumed significant roles in the businesses run by their husbands at an early time. And while Smith also contended that these same women later turned away from business activities, their situations re-defined towards domesticity, other historians have taken issue with this interpretation. We have noted Béatrice Craig's argument that women of the Nord remained in business longer than contemporary social constraints may have preferred, and that 'late nineteenth century sources were generally reluctant to admit that women of the better sort may have stooped to doing something as crass as making money'.[10]

Even if there is no clear indication that women in the Rodrigues family were to engage directly in business as did the *bourgeoises* of the Nord, this challenge to Smith's hypothesis is relevant here for both the Rodrigues and Pereire households nevertheless. For there were clear signs of a growing sense of agency and independence among several female members.

The rather less constrained life led by Nanci Rodrigues and others of the extended family that we observed in the previous chapter, and who were an intimate part of the life of Sara Sophie and Rodrigues *fils*'s family, illustrates a degree of freedom in the way in

which women realised the marital role that conferred some influence on Herminie and her sisters. The comparative independence of these women certainly goes against the tide of 'separate spheres' historiography. After all, a freedom to explore, support, and advocate new ideas became apparent in the Saint-Simonianism of several of Sara Sophie's daughters, including Herminie. And while undoubtedly there were pressures to marry, the influences which were at play were subtle, based upon opportunity, suitability, and mutual attraction as well as parental persuasion.

What can we say then about Herminie on the eve of her fateful meeting with her cousin, Jacob Emile Pereire? A letter written in May 1821 to her sister Sophronie, who was in Créteil, gives us a small glimpse. First there was a small complaint. 'Ma chère Minette [the pet name for Sophronie], it is really bad of you to write thus to Anaïs', she said, 'without a single word to me'. As the middle daughter, Herminie evidently felt some hurt and exclusion from the special relationship existing between her two older sisters, Sophronie being eight years and Anaïs four years elder. But the letter then turns to family gossip, the young girl of sixteen years writing excitedly about a household drama. 'There is a change in the house', she wrote breathlessly. A servant had just been given notice unexpectedly by her brother Olinde and was most unhappy about it. They already had a replacement, a nice country woman, 'one who will suit mother a lot'.[11] She ended with an effusion of affectionate words for Sophronie, 'embracing her with all my heart' and her daughters. Family, siblings, the home, domesticity, these are at the heart of this letter, infused with a young woman's excitement about ordinary events and love of her family.

The engagement of Herminie with her cousin, Emile Pereire, was not quite of a piece. She was seventeen years old when Emile came from Bordeaux late in 1822 to live with the Rodrigues. Her elder brother Olinde had married several years earlier in 1817 and Sophronie in 1815. As for Emile Pereire, prospects for advancement in Bordeaux had become increasingly limited with the collapse of the Atlantic trade and the wars of 1814–15. Rodrigues *fils* finally persuaded Henriette, Sara Sophie's sister and the widow of his closest friend, Isaac Pereire the elder, to allow her son to join them in Paris. Emile thus left behind many friends and family in Bordeaux whom he missed and that he regretted, but he welcomed the comparative

freedom and novelty of the Rodrigues establishment. Not only did the large metropolis of Paris present a shock, however; the household was very different in its attitude towards Judaism from his home in Bordeaux where he had been raised within the fold.[12]

Emile fell in love with Herminie very soon after his arrival in Paris, a *coup de foudre*. Letters home to his family in Bordeaux at the time concerning this sudden attraction give no sense that marriage was in any way arranged, that his mother had reached an understanding with the Rodrigues parents about a union between her son and one of their daughters. If indeed this was the case, Emile was certainly unaware of it. He believed, on the contrary, that one or other of the young Rodrigues women may have been 'promised' to a member of the Sephardic Vaz family in Bordeaux. He feared it may have been Herminie. He explained in a letter to Herminie's aunt Rosalie Rodrigues in Bordeaux that from the first moment of their acquaintance Herminie had pleased him; when an opportunity arose fortuitously soon after his arrival in Paris, in about December 1822, he broached the subject of a possible betrothal with her mother, Sara Sophie.[13]

Emile's overt expressions of love for Herminie were unusual at a time when bourgeois marriages more often than not were arranged. Love and affection may not have been the usual grounds for them, but there seems to have been a gradual movement in that direction. While family connections and financial stability remained significant objectives, the protection and augmentation of the family wealth and status, compatibility and mutual affection came also to be regarded as desirable.[14] These thoughts were to come into play increasingly in several Pereire marriages, but it does not really explain the marriage of Herminie and Emile, for it was Emile's passion that drove this union. The cultural background that they shared, the family relationships, and Emile's fine prospects played a part, but they appear to have been peripheral.

There is no mention in the documents that Herminie was involved in the negotiations which followed, nor any indication of a passion reciprocated. While the marriage was not an arranged one, it is not clear either how far Herminie was aware of Emile Pereire's offer of his hand in marriage before her parents gave their formal consent to it.[15] That much of civic requirement and Jewish cultural practice in approving the marriage was necessary, which

included the approval of Emile's mother. We can only assume that the Rodrigues, who were after all, loving parents, had sought their daughter's feelings on the possibility. But while Emile continued to write to friends in Bordeaux of his happiness once the news was out, we do not know whether his happiness was shared by his future wife. Notwithstanding, both Herminie's parents seem to have been delighted with this turn of events, the impending union between their daughter and Sara Sophie's nephew, who was also the son of Rodrigues *fils*'s now deceased best friend.

A letter survives from a Mlle. M. E. Copin, however, an older woman and family friend writing from Orléans in July 1823, which may provide some insight. Herminie had evidently confided in her, as Mlle. Copin thanked her profusely for doing so:

> I am grateful for all the details which you dare to share with me [she wrote]. Do not deprive me of the happiness of helping you whether through my advice or my actions. ... If you conceive of any disquiet my dear child, let me know immediately. ... I am worthy through my fondness for you all of the attachment and the confidence that you witness in me.

She then immediately went on to say: 'I hope that M. Emile will be happy with the details that I give [whatever they were]. What happiness to be able to be so proud of his ancestors. Tell him that I attach a high price to his memory and that I thank him for his compliments of friendship.'[16]

The tone is non-committal about Herminie's marriage, and Mlle. Copin does not tell us whether Herminie had conveyed indications of her own happiness. But the writer was evidently well-entrenched with the Rodrigues family, for there is another letter in the family archive from her to Herminie's sister, Anaïs. She has also been suggested as having played a role in the conversion of Sophronie Andrade and her family and possibly to have influenced another of Herminie's sisters, Félicie, in the direction of Catholicism.[17] If this is so, it is unusual to find the Pereires' uncle, Moïse Seba, a devout Jew and one whom the conversion of the Andrades had offended deeply, commending in letters from Bordeaux: 'the incomparable Mlle. Copin for whom our gratitude will be eternal'.[18] Whatever the case, it is clear enough from Mlle. Copin's letter that she was a *confidante* with whom Herminie had certainly shared her thoughts

about the impending nuptials. Further, the letter-writer's invitation to disclose 'any disquiet' to her may also have implied that Herminie did indeed entertain concerns.

That Emile had spoken to Mlle. Copin of his 'pride in his ancestors' is revealing of a heightened sense of the Pereire family's significance to the Jews of France. He had evidently referred to his grandfather, Jacob Rodrigues Pereire (1715–80), a remarkable individual and something of a polymath. The official representative of the Sephardic Jews of the southwest at the courts of Louis XV and Louis XVI, Jacob had been appointed secretary and interpreter in Spanish and Portuguese by Louis XV, had been elected a member of the Royal Society of London following a recommendation from the French Académie des sciences, and had developed a method of teaching deaf-mutes how to speak, for which he received many accolades, including from Rousseau.[19] This family background of significance in a number of different fields, but particularly as official representative of the Sephardim, a significance frequently reinforced by his mother in reverential terms, was to exercise a powerful influence over any decision Emile made about his own relationship to Judaism.

The marriage of Herminie with Emile Pereire did not take place until April 1824, and one may also question the elapse of time following the engagement. This was not caused by reluctance on Herminie's part, however, for she had come to accept Emile's hand well before. It was the actions of Emile's mother on her arrival in Paris in November 1823 with her younger son Isaac that caused a problem. What Henriette discovered of the Rodrigues household distressed her profoundly, interpreted as a profligate disregard for Jewish traditions and practices. Nowhere was this more evident than in the behaviour of the Rodrigues women, including Herminie, who did not observe the Sabbath nor many other religious conventions. Henriette stormed back to Bordeaux forthwith, taking Isaac with her, creating waves of discontent and much local gossip in the process.[20]

It was not only his mother who presented Emile with problems: in turn, his uncle, Rodrigues *fils*, believed that Henriette had unnecessarily disturbed the whole household, and tension arose between Emile and his prospective father-in-law as a result. To make matters worse, Emile had been inclined to persuade his betrothed to observe

Jewish customs overtly in the presence of his mother, dissimulation that met with opposition from Rodrigues *fils*.[21] Altogether there had been a painful clash of loyalties and opposing religious sentiment between Henriette and her sister's family. Herminie and Emile were not off to a good start.

Nor was it only Emile who was susceptible to a sudden, all-consuming passion. A further cause of distress for Henriette and the elder Rodrigues as well was the obsession Emile Pereire's younger brother Isaac developed for the fourteen-year-old Mélanie Rodrigues when he arrived in Paris in 1823: he fell madly and publicly in love with her.[22] His mother effectively killed off the infatuation, however, by placing rigid conditions around it, but not before her own behaviour caused difficulties with her sister and brother-in-law, who believed her to be hysterical. She had, among other demands, insisted that Rodrigues *fils* renounce any further marriages with Christians.[23]

While there is no evidence that Mélanie's parents supported the relationship of their daughter with Isaac, neither did they take seriously this bizarre condition on any possible marriage. Their *salon* was open to Jews and non-Jews alike, and in a period when the Bourbon Restoration had led to a revival of Catholic triumphalism under Charles X, it was scarcely feasible to erect barriers against the majority. Besides, they had raised no objections to the marriage of Olinde with a Catholic and were unlikely to do so as a result of threats from Henriette. As Emile Pereire wrote to a family friend in Bordeaux, 'My uncle, for his part, does not wish to hear talk of any conditions ... he does not wish to sacrifice his other children for the [marriage] settlement of one.'[24]

Nevertheless, Henriette was clearly suffering from one of several ambiguous complications resulting from emancipation. The French Revolution had provided Jewish men of France with equal citizenship, with access to employment from which they had previously been excluded, and with freedom to live where they chose. But it had also thrown out challenges of a different sort. With the introduction of civil marriage there was now a possibility that intra-confessional unions need not be the norm, that marriage might be contracted between women and men of different faiths. Napoleon certainly believed that any problems presented by the Jews would be settled by intermarriage, that Jews would simply merge with

French society and lose their specificity and thus their capacity to irritate. These considerations and fears may well have preyed on the mind of Emile's mother, Henriette, confirmed perhaps by her nephew Olinde's marriage with the Catholic Euphrasie Martin some years earlier.

The marriage of Herminie and Emile finally took place, however, and several days after the civil ceremony in the *mairie* there was a religious service in a new synagogue in the rue Notre-Dame de Nazareth. Emile's mother thus had a small victory. Having been raised in a non-observant household, Herminie went through a full religious ceremony.[25] This episode might suggest some hesitancy in the mind of the bride about what should have been a happy occasion, but it was also symptomatic of the sort of quandary facing Jews in their drive to integrate as citizens into a new French nationality: needing to compromise, to make many concessions to many parties.

Emile was now twenty-three years of age and Herminie nineteen. What can we say about this marriage? Was it a happy one? Divorce, although permissible within Judaism and having been legislated by the French Revolution in 1792, was made more restrictive under Napoleon's Code Civil and abolished altogether with the Bourbon Restoration. Thus, marriage being indissoluble, the development of a couple's relationship over time would ripen or wither. The early documentation in this case is also one-sided, providing a window into Emile's feelings but not directly into Herminie's. The marriage lasted for the remainder of their lives but it was not until 1884 with the re-introduction of divorce by the Third French Republic that there was any alternative.

If Emile's letters are a fair reflection, however, the state of the marriage through the first few years was rocky. In an emotional letter to his brother Isaac in October 1825, eighteen months after it had taken place, the realities of married life had begun to hit home, complicated by the continued tensions between his mother, who had finally agreed to remain in Paris after his wedding, and the Rodrigues parents. He was then working with his uncle as a stockbroker on the Paris Bourse. The economy lost momentum when a series of poor grain harvests from 1826 brought rising food prices and an inept response from the Restoration government of Charles X. Emile's livelihood was in turn further affected, and he owed his father-in-law money.

He admitted to his brother Isaac, in words that indicated a troubled frame of mind, that his marriage may have been precipitate: 'I married at 23 years. I believe that was too early for me ... Moyse said leave your father and your mother for your wife ... In my case [this principle] appears untenable ... I ask myself often in good faith whether it is my mother or my wife that I prefer.' He went on to counsel Isaac, still smitten with Mélanie Rodrigues, that it was better to pass for one who was 'little susceptible to a grand passion than to be an ungrateful son'.[26]

There were in fact attempts during the early years of the July Monarchy to revive divorce. Odilon Barrot introduced legislation to the Chambre des députés in 1831, and Emile Pereire, then writing for the journal *Le National*, contributed a column in support. Barrot was, according to Pereire, one of the great legislators, and Emile went on to express complete agreement with the idea of divorce by mutual consent.[27] Whether his argument originated in traditional Jewish teaching, which admits the possibility of divorce, or philosophic ideals of personal freedom, or even whether it was a simple case of wishful thinking at the time, we do not know.

Whatever the situation between the newlyweds, Herminie was placed in a painful situation which must have caused some hurt, caught between Emile's loyalties divided between his wife and his mother.

Part of Emile's problems were financial. Herminie had given birth to their first child in February 1825 and Emile thus seems to have been maintaining a ménage of five, including a nurse, which was proving difficult on his remuneration, for on Sunday 6 February 1825, exactly ten months after the ceremony in the Notre-Dame de Nazareth synagogue, Fanny Rebecca Rodrigue Pereire was born in Paris at the same address in the rue de l'Échiquier where her mother was born.[28] The time of her birth, within a year of marriage, conformed to the norm for first-born children in the Parisian Jewish community.[29] Herminie, nearly twenty years old, and her husband now aged twenty-four, were living with Herminie's parents as they were to do at various addresses for a further ten years. Félicie Sarchi, writing much later to Hélène Van Tieghem, recalled the day of Fanny's birth: 'to the joy of all when at 5 o'clock in the evening, a little girl was announced and took her place in the family'.[30]

We do not know how she came to be named Fanny. One might hazard that the infant was named after Fanny Mendelssohn, daughter of the banker Abraham and sister of Felix, who visited Paris on a number of occasions and was known to both Herminie and Emile. But this can only be conjecture.

At this early stage of the marriage, Emile still saw his identity as inextricably Jewish. He expressed these thoughts in a forthright letter to his uncle Jacob Lopès Fonseca in 1826: 'I am not religious, you know, I was born in the Jewish faith and there I stay. Not that I believe it perfect but because I do not know a better and I have the personal conviction that to change one must be either a sincere believer or a hypocrite.' He saw no reason to change his religion, to give way to the opinions of others. Even though religion in that day and age was 'obligatory' and Judaism subject to 'unjust prejudices', he saw no reason to raise his children in any religion other than his own. Were he to do this, he would be deviating from his principles. 'My children will be Jews ["israélites"]', he wrote.[31] At the time of this unequivocal declaration, his mother Henriette was still living. Its principal message was to lose some of its assurance on her death.

Henriette died in 1827 at Auteuil, then a town west of Paris and now part of Paris's sixteenth *arrondissement*, where she was staying temporarily, being known at that time for its health resorts in which she may have sought respite.[32] She had experienced debilitating chest pain, leading to a probable heart attack. Emile was stricken, writing sorrowfully to his uncle Jacob Fonseca that he and Isaac were present at her death and, holding her hand, recited the *Shema Israel* with her.[33]

Herminie and their small daughter, now two years old, were also there, and towards the end Henriette blessed Herminie and embraced her, speaking painfully of her regrets in leaving her so early (Henriette was forty-nine years old).[34] This final blessing was a sign of reconciliation for evidently there had been a turning point of some sort for both Herminie and Emile. The birth in 1825 of Henriette's first grandchild and her naming as Fanny Rebecca would have helped. This gesture of recognition towards Henriette, whose first name was passed down to the infant, provided the circumstance, albeit it was the second name. But we might also recognise in this Herminie's deep love of family and her sense of duty towards family members which by this time enveloped her mother-in-law.

This surmise seems to be confirmed by a letter written to her by Emile's uncle Seba from Bordeaux:

> The sole consolation which remains is your diligence and the complicity to become all that she could desire, in all the kindnesses that you had for her to her last moment. May God return them to you and send you a thousand happinesses dear Herminie in recompense for all that you had done for your venerable mother-in-law.[35]

Henriette's death allowed Emile and his brother to plunge unfettered into Saint-Simonianism, further loosening the hold that the religious practices of their youth had once exerted and that had been assailed by the domestic environment in which they found themselves in Paris. But it also released Herminie from a troubling presence in her life. The arrival of Fanny and the death of Henriette may thus have been the catalyst for Herminie's growing confidence in her role in Emile's life. From this time, the letters she was to write evinced an increasing dedication to his career and well-being and a sense of control over the household she was constructing for him.

A further bond with Emile was also forged through their shared adherence to Saint-Simonianism. As we have learned, Herminie, together with her sisters, was among the group of women who began to meet within the Saint-Simonian circle from about October 1828.[36] It is not certain what these meetings involved and Claire Goldberg Moses described Saint-Simonian feminism at that time, probably accurately, as 'an ideology of masculine invention'.[37] But over a comparatively short space of time, women in the movement became a powerful force for equality, taking the discourse to a new level and exerting influence on its direction.

The Rodrigues family's interest in Saint-Simonianism was ensured by the respect the movement accorded Judaism as the wellspring of Christianity, a point of view that received its most cogent expression from Herminie's brother Eugène in his *Lettres sur la religion et la politique* (1831). But as it had been for her sisters Félicie and Mélanie, Herminie's interest was nurtured further by the emerging emphasis on female equality. As a young woman whose Jewish background placed her at the periphery of French society, the religious turn in the doctrine theoretically opened a place in civil society for her. As questions about the position of women came to dominate Saint-Simonianism, she became even more involved.

How much she was able to contribute is uncertain, although an account book kept by Isaac Pereire who, with his uncle's tuition, had become a skilled accountant and who managed the Saint-Simonian finances, shows that she contributed financially nine and then ten francs to the movement in 1831.[38] She attended meetings regularly since her presence was recorded by other Saint-Simonians. Charles Henry, for one, mentioned her as being 'even lovelier because of her Saint-Simonian tenderness'.[39] Prosper Enfantin also recognised her presence at meetings over a two-month period from October 1828.[40] But she did not play the same active role as her sisters, for while she was thus engaged by this revolutionary new movement, Herminie was pregnant again, giving birth in 1829 to a second daughter, Noémie Léah, known as Cécile. Another, born in 1834, was named Claire.

The names conferred on these two infants may have been tributes to the cousins Cécile Fournel and Claire Bazard, important figures in the Saint-Simonian women's group. Cécile Fournel, wife of the Saint-Simonian engineer Henri Fournel, remained committed to the movement beyond its demise and even went to Egypt in 1834 with a group of former Saint-Simonians, including Enfantin, in search of a female pope. Cécile, together with her husband, Henri, remained a close friend of Herminie for the remainder of her life. Claire Bazard, wife of one of the triumvirate of leaders, Saint-Amand Bazard, for a time became a senior leader of the movement herself, accorded the title 'Mother', and charged with teaching the women who joined the group. She and her husband left the Saint-Simonians in disagreement with the turn towards free love, and Saint-Amand Bazard died not long after. While Claire continued to write and even founded a journal, *La Femme nouvelle*, she lived in relative obscurity to a great age.

Saint-Simonianism as an organised movement came to an end in 1832 with the arrest of Enfantin and Michel Chevalier on charges of immorality and of breaking the law on public gatherings, followed by their incarceration in Paris's Saint-Pélagie prison. Herminie's brother, Olinde, was also charged but acquitted. Despite the loss of leadership, Saint-Simonian influence remained, and Emile and Isaac Pereire carried elements of its practical ideas and ideology into their subsequent careers and ventures, enabling them also to take advantage of what had become an active and highly influential

network of politicians and businesspeople, particularly in the world of banking and finance.

Both Emile and his brother were now working as journalists, Emile for *Le National*, a newspaper founded by Adolphe Thiers and Armand Carrel and funded by the banker Jacques Laffitte, Isaac contributing a column for the *Journal des Débats*. While they always retained a facility for communicating their ideas through the press, Emile had also begun the process of turning Saint-Simonian ideas into practical reality. First, they became railway entrepreneurs, launching in 1837 the first French passenger rail line, from Paris to St Germain-en-Laye, of which Emile was the chief and Isaac his deputy. Nanci Rodrigues's son Édouard, a stockbroker, became a director.

For their part, the Rodrigues women did not remain active in pursuing female emancipation in which some former Saint-Simonian women were to engage subsequently. There is nothing in the family archive nor in any other source to suggest that female equality in political or economic terms was on their agenda. Several journals founded by working-class members gave voice to a comparatively radical platform, however, including *La Femme libre*, created by Désirée Véret, Marie-Reine Guindorf, and Suzanne Voilquin, and *La Voix des femmes*, by Eugénie Niboyet.[41] But these did not speak to the experience of *bourgeoises*. While the Rodrigues remained in touch with several of the more militant feminists, they did not go down the same path.

All the Rodrigues women had married by the time of the trial of Enfantin and Chevalier, and this undoubtedly influenced their views on equality. Herminie's husband had publicly cut himself adrift from Enfantin in solidarity with his cousin and brother-in-law, Olinde, following Enfantin's public humiliation of him. Nor did this endear the sisters to Enfantin nor to what was left of the movement. For their part, both Félicie's husband Charles Sarchi and Henri Baud, Mélanie's husband, tied their fortunes to those of the Pereire brothers. All saw their future at that point as linked to the more limited Saint-Simonian agenda of industrial expansion and employment through technology.

Meanwhile, that there were gaps between the births of Herminie's children – four years between the first two and five years between the second and third – may indicate either that there were further

pregnancies which did not reach full term or that she and Emile exercised birth control. Certain contraceptive precautions were known and practised, but childbirth remained hazardous throughout the nineteenth century, and Herminie was to experience it on at least three further occasions. After three daughters, however, she may have been subjected to pressure to produce a son. Their close Saint-Simonian friend, Michel Chevalier, evidently thought so and had been direct about the matter. 'I hope that you are going to have a beautiful boy', he wrote to Emile at the time that Herminie was about to give birth for the fourth time, 'for you must have one'.[42] In 1837, she gave birth to another daughter, Marie, who died in infancy a year later.

It was to be several more years before their first son Isaac Emile, or Emile II, was born, in February 1840, and given as his first name that of his paternal grandfather and uncle. Another son soon followed in April 1841, named Jacob Henry but known as Henry, names which honoured first his paternal great-grandfather, and then possibly a close family friend, the Saint-Simonian Henri Fournel. While Herminie and Emile continued to acknowledge their Jewish antecedents according to custom, they had also begun to honour their Saint-Simonian friends.

Data on Jewish family size in France during the nineteenth century is patchy, as Paula Hyman found, partially due to the failure of data-gatherers at census time to differentiate religious affiliation.[43] It appears, however, that the number of Herminie's children, six live births in all, was greater than the average family size in France during a century when fecundity in both the Jewish and the French community more generally was falling.[44] Between 1789 and 1829, which included the period when Herminie was bearing her first two children, the average birth rate was just under five children for Jewish women in France. Over the next forty years, from 1830 to 1869, when the remaining four children were born, the birth rate fell to just over three children per family.[45] While throughout the 1830s and 1840s, during the July Monarchy, Herminie was giving birth to and raising children, she was more productive than the average.

Co-habitation with family members and others was common among the Sephardic Jews of Bordeaux. Indeed, the Pereire brothers had been raised in this way, a dozen people sharing the same

address in the Jewish quarter of the port city when they were children.[46] Similarly, for ten years or so, Herminie and Emile lived with her parents either in their rented apartment or in the same building. For a time, Herminie's brother Olinde and his wife, together with her brother-in-law Isaac, also shared this accommodation. First this was in the rue de l'Échiquier, where she was born, then in the rue des Petites-Écuries in what is now the tenth *arrondissement*, and then, by 1831, in the rue Montholon in the ninth. These addresses were in a proximity that demanded only a short walk. They were also areas where Jews had come to live in some numbers.[47]

Number 26 rue Montholon was also the home of Léon and Fromental Halévy, sons of Élie Halévy, the Jewish scholar who had been employed as secretary to the Consistoire Israélite de Paris. Nanci Rodrigues's sons, Édouard and Henri Rodrigues, were other occupants.[48] It was only in 1836 when they moved to 16 rue de Tivoli to live as a family that all the Pereires ceased to live with the Rodrigues couple.

The Pereire brothers' first rail line came to fruition with the support of several bankers, including James de Rothschild. There could have been no more daunting introduction to the role Herminie, now heavily pregnant with Marie, was expected to play than on 24 August 1837, when Queen Marie-Amélie inaugurated the rail line and accompanied six hundred invitees from Paris to its destination at Le Pecq, close to St Germain-en-Laye. 'Thanks to them', wrote one commentator, 'all the beautiful ladies of Paris, and the most timid and the most fearful', must have been reassured by the experience. Among the six hundred were the ducs d'Orléans, d'Aumale, and de Montpensier; the duchesse d'Orléans; princes and princesses; the ministre du Commerce; the prefect of the Seine; the prefect of Police; the directeur général of the Ponts et Chaussées; and various members of the nobility and diplomatic circle. At a vast pavilion halfway to Le Pecq, the guests were treated to an elegant 'collation' with excellent wine, served on old Sèvres plate and with fine silverware, all paid for by James de Rothschild.[49] This extraordinary event received much publicity in the French press reflecting its huge significance to the nation. More rail lines followed.

From the July Monarchy and throughout most of the Second Empire, Herminie thus found herself the wife of an increasingly successful business figure of exceptional power and prestige. A

grandson many years later was to sum up the dynamic changes that took place: 'From 1831 to 1869, everything had changed around Emile Pereire: he himself had changed and the publicist had become one of the most remarkable personalities of the industrial and financial world, in France and in Europe.'[50]

The resulting changes in Herminie's own life were rapid, requiring great emotional adaptability and resilience as well as the acquisition of new skills. As her life changed around her so, too, did the role she was expected to play. It held public and private elements. She was to be not only the hostess but the centre of an ever-expanding family and its busy domestic life – the matriarch. Herminie had been well-prepared for the central caring role within the family that revolved around her. But she was less comfortable outside of it. Indeed, her sister Félicie was to say that

> Her wealth never dazzled her, nor was she charmed by it. She may even have suffered from it more than she enjoyed it. If she had followed the natural bent of her taste and temperament, she would have been much happier with a more ordinary life. This duty to associate with people for whom she had no great esteem was very hard on her. She was made for the intimate ties of family life.[51]

Herminie's role in the Rodrigues family had given her a perspective on family life as the core of her existence, and in turn she instilled in her children a love of family. 'She knew how to inspire in her children the feeling of obedience and respect as well as the love of the family', as Charles Sachi continued: 'Wealth came to her after long years passed in a modest situation and had not altered her tastes and her habits.' He agreed with his wife, Félicie, that Herminie found the demands of a life among the *grande bourgeoisie*, in contrast, uncomfortable.

With these comments in mind, what can we say of Herminie's character? The well-being of her husband was her overriding concern. There is no doubting the love she developed for him and with which she surrounded him. As to her children, they were a source of pride and affection as well as anxiety; their health also required considerable time and effort. Indeed, it seems that Herminie was so embedded in family life that she found the world beyond difficult. She lacked the flexibility needed to adjust to changing circumstances. Others have pointed to her reserve, to her severity indeed,

which may have been the veil behind which she hid her distaste for the social life she was now called upon to manage.[52] Ultimately, Herminie learned to cope with these challenges but, it seems, at personal cost. At the same time, she was soft-hearted and kind, providing help and comfort to friends and family in need, prepared as we shall learn in a later chapter to travel to minister to the sick.

What of her appearance? The *carte de visite* in Figure 2.1 bears out the description on her passport of 22 July 1857, when she was fifty-two years old. She was there described as 155 cm [about 5′2″], with black hair, normal ['ordinaire'] forehead, black eyelashes, black eyes, normal nose, medium mouth, round chin, oval face, and a dark ['brun'] complexion. Further, Herminie had 'no distinguishing features'. The passport described her as 'propriétaire', which suggests that she held property in her own name, possibly from her parents, as well as with her husband.[53]

In the considerable modern literature dealing with family business, trust is an element which features prominently. And the difficulty of maintaining that trust as businesses expand has been given some attention. A contemporary management theorist has succinctly reminded us that trust 'enables cooperation; promotes network relationships; reduces harmful conflict; decreases transaction costs; and facilitates the effective responses to crises'.[54] These benefits were perhaps even more significant and at the same time more difficult to create and sustain in the nineteenth century as commerce and industry began to assume guises more easily recognisable today but which were then still evolving.

Marriage partners became necessary tools in the growth and development of family business. As parents to two small boys in the 1840s, it was to be some years before Herminie and Emile Pereire were in a position to expand the family circle and begin to engage their sons in the business. The 'utility of daughters' as one historian has described it, was to compensate.[55] Yet there was considerable complexity in the circumstances of the marriage of their eldest daughter, Fanny, which returns us to the second subject of this book.

The Jewish population of Paris had by 1825 continued to increase remarkably, from two thousand or so at the time of Herminie's birth in 1805 to nearly eight thousand at Fanny's.[56] Despite that number, with a total population of about 750,000 in Paris, the proportion of Jews was not much more than 1 per cent. When, in 1828,

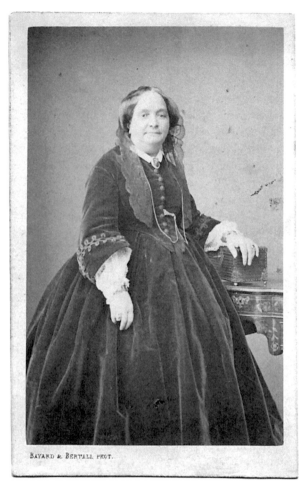

Figure 2.1 Herminie Pereire, c. 1860

Emile Pereire was asked to respond to a request from his uncle in Bordeaux, Jacob Lopès Fonseca, for advice on the likelihood of Fonseca's three daughters finding suitable marriage partners in Paris, Emile was unable to suggest a single eligible individual.[57] The Pereires were still part of a minority, albeit one of high visibility, distinguished as the 'other' of French imagination.

What were the influences on this small girl? The time of her birth coincided with Emile Pereire's avowal that he would raise his

children in the religion into which he was born, but what this meant for her is not at all evident. Possibly, for the first years of her life, she did receive some basic form of Sephardic religious instruction. In later life, however, this would have left only a vague memory as her parents drifted inexorably away from Judaism once her grandmother Henriette was no longer present to hold them to the faith. Nevertheless, there were many elements which continued to reinforce being Jewish. Both her parents became increasingly visible in Paris and, like Sara Sophie and Rodrigues *fils* before them, they were perceived to be Jews within the community and without.

At the same time, the increasing recognition of her family as a result of its business successes brought the Pereires into contact with non-Jewish members of the *grande bourgeoisie* and even with the nobility. The effect of this was to situate Fanny almost from the beginning within a wider social and cultural circle than Herminie had experienced and to engrain in her a different expectation of her role in this circle.

Fanny does not seem to have had many friends of her own age outside the family when she was growing up. Perhaps she was not in need of such companionship, for she had several cousins living nearby, if not in the same dwelling. Her uncle Olinde Rodrigue and his wife Euphrasie frequently lived at the same address with their children, of whom Camille (b. 1821) and Oscar (b. 1827) were of a similar age to Fanny. Likewise, Laure (b. 1823), Caroline (b. 1825), and Edmond (b. 1826) Andrade, children of her aunt Sophronie, also lived in close proximity.[58]

The Sephardic legacy also meant that Fanny, like her mother, grew up with a prescription for female behaviour predicated on home and family as the centre of her existence – a code which also dictated that her father, her maternal grandfather, and her uncle, all the men in her life, engaged vitally with the outside world. One of the ambiguities for Jews in the nineteenth century, however, was that the gendered roles implicit in Judaism were so generally complementary with those of bourgeois France, a similarity which drew many Jews closer to assimilation. In Fanny's case, however, the influence of a Saint-Simonian hope for a better world for all, which assumed and valued the contribution of women and in which her mother and several aunts had played a part, would temper complacency, passivity, and acquiescence. Additionally, a particular influence was the

importance attached within the family to the memory of her great-grandfather, Jacob Rodrigues Pereire, his national significance as a representative of the Jews of the southwest at the courts of Louis XV and Louis XIV, and his contribution to the treatment of deafness. This would create in her, as with others in the family, a sense of obligation and an impulse for action directed towards those who suffered some form of disability or financial distress.

What of Fanny's education? Many years later, a journalist was to write of her that Fanny was 'charming, with a very distinguished education'.[59] That she was well-educated is evident from her letters which, like her mother's, were written in an assured hand and intelligently expressed. Certainly, by the 1830s, there were more options for girls to receive an education than there had been for Herminie in the early years of the century. By the 1840s, twelve thousand girls in Paris from five to eighteen years of age were receiving an education in one of the secular institutions while a further sixteen hundred were in Catholic boarding schools.[60] Napoleon had established schools for daughters of his soldiers who had been awarded the Légion d'honneur.[61] And there remained the possibility that a governess had been employed to educate Fanny and her sisters, Cécile and Claire.

Another element in Fanny's education, however, was the part Herminie played in it. There had been further developments in what Corrado Pope referred to as 'the popularity of the idea of the mother-teacher' during the July Monarchy, when the role had come to be seen as a natural means to further embed the 'separate spheres', to overcome any 'doubts and unsettling experiences for a transitional generation'. Books and manuals proliferated emphasising the utility of such a maternal vocation. Education was interpreted to include religious, moral, and behavioural elements in which the mother modelled good behaviour for her child as well as ensuring her intellectual development. Theories were aired to verify the maternal role as natural to the task of educating children. And while the mother was expected to play a part in teaching her sons, it was recommended that she take full responsibility for teaching her daughters.[62]

The involvement of other Sephardic Jewish women in education we have noted – Nanci Rodrigues, Sophie Roblès – would lead to the view that education was a particularly important issue for

Sephardic women in providing the skills that would lead to financial independence and acculturation. A leading light in what had become a movement promoting the idea of mother-educators was the Sephardic David-Eugène Lévi-Alvares, who taught classes and wrote books on the subject.[63] Whether Herminie carried out all the expected educative roles in relation to her daughters is not known, but in view of the tone of her own letters, as we shall see, she certainly and self-consciously took on their moral and behavioural development.

As to Fanny, her personality at this early stage in her life may be judged by the response of her parents' friend, the Saint-Simonian from Guyana, Ismail Urbain. When he met her as an eleven-year-old in 1836, he recalled to a friend that he fell instantly under her charms.[64] The greatest influence on Fanny's young life was, however, about to be unleashed.

From 1836, her uncle Isaac and his wife, Laurence, lived with their two sons, Eugène (b. 1831) and Georges (b. 1836), in a separate apartment at the same address as Herminie and Emile and their family in the rue de Tivoli. Laurence was the daughter of uncle Jacob Lopès Fonseca whose earlier fishing expedition to find husbands for his three daughters, which had appeared to be doomed, had in fact proven successful in this case. We have a glimpse of Laurence Lopès Fonseca at the age of eleven in a letter written by Emile Pereire's boyhood friend Adolphe Mirès, who, having visited her 'charming little family', found 'Laurence ... above all a wonder, she is a child full of spirit and who is very precocious. She learns her homework with astonishing ease.'[65]

This marriage between cousins which had taken place in 1829 was as typical of the Bordeaux Sephardim, as was Emile and Herminie's. Indeed, Herminie and Laurence were also cousins, as Sara Sophie Rodrigues and Laurence's father Jacob were sister and brother.

Paradoxically, as Christopher H. Johnson found in his study of the *breton* Galles, Jollivet, and Le Ridant families, a notable feature of bourgeois Catholic families of the nineteenth century was 'the new consanguineous kinship system ... [when] cousin marriage became common'.[66] In Johnson's view, this development served to underpin bourgeois power structures and manner of doing things. Different dynamics were at work among the

emerging Jewish bourgeoisie. And as the century progressed, the advantages to Jews in the *grande bourgeoisie* of marriage with members of like, but not necessarily Jewish, families, was to become more appealing.[67]

While, for now, cousin marriage remained relatively common, however, there were to be no more in the Pereire family. The marriage of Isaac Pereire and Laurence Lopès Fonseca was the last, perhaps indicating a further stage in acculturation for the Pereire family. But there was to be one further intra-family marriage, one that created some waves within it.

When Laurence came to Paris where she and Isaac married, Herminie introduced her to the Saint-Simonian circle. One of its members, Charles Henry, described Laurence's appearance at a meeting as Herminie's 'young and charming cousin newly-arrived from Bordeaux'.[68] So, by the few accounts that we have, Laurence Lopès Fonseca was a bright, intelligent, and attractive young woman. But she was shy and nervous of Parisian society, Isaac needing to write sharply to acquaintances who neglected to call on her and make her welcome.[69]

By now, the Pereire brothers were making considerable social as well as financial progress. The inventory of the apartment of Laurence and Isaac published in November 1838, for instance, containing as it did all the trappings of bourgeois ease and show, tells us much about the material distance the Pereire family had travelled. The apartment was on the third floor of number 16 rue de Tivoli in what is now the ninth *arrondissement*. It encompassed a bedroom, a *cabinet*, a salon, a dining room, a kitchen, a linen cupboard, and two wardrobes. Oddly, there does not appear to have been a second bedroom for their two small boys, Eugène and Georges, although the *cabinet* may have done double duty. All the furnishings in the bedroom, the *cabinet* and the dining room were of mahogany, and twelve mahogany dining chairs were covered in silk. The cutlery was of silver, and there were pictures and paintings. Laurence's wardrobe gives a picture of comparative affluence also including as it did three silk dresses, two of white *toile*, and three of cotton; four *peignoirs*, seventeen petticoats, and twenty-four *toile* nightdresses; twelve pairs of white cotton hose, four pairs of gloves, three shawls (including one of cashmere), three silk scarves, and two hats.[70] Isaac's wardrobe is similarly impressive.

The reason we know about this apartment is because the document forms part of an *inventaire après décès* drawn up on the sudden death of Laurence in June 1837.[71] She thus remains a tragic, spectral figure in the history of the Pereire family. Despite her vivacity and intelligence as a child, she is forever remembered rather through her death from causes which are unverifiable to us. And she left a grieving family with none more so than Isaac, now the father of two motherless boys.

Living as they did in close proximity, Herminie and Fanny inevitably gave much attention to these two children. But Herminie had her own young family needing attention, including the doomed infant, Marie, and Fanny gradually assumed at a young age a quasi-maternal role in the lives of Isaac's children. She had after all three small sisters, and as the eldest in the family, she had been Herminie's helper in caring for them. Her conditioning had prepared her well for such an eventuality. But the dramatic turn of events which then ensued would have been far from the expectations of her parents.

While as we know marriage between cousins was common, marriage between closer blood relatives such as niece and uncle was complex in its management. Forbidden in French civil law, article 164 of the Code Civil required assent to such unions from the head of state. But within Judaism, the Levitical strictures which ruled the legality of marriage, while explicitly condemning the union of aunt and nephew, seemed by their silence on the matter to condone marriage between uncle and niece.[72] The example of James de Rothschild's marriage to his niece Betty, daughter of his brother Salomon, in Vienna, was an example well-known to the Pereires, but in that case the marriage took place in Frankfurt and was not subject to the Code Civil.[73] In the year that Isaac Pereire sought permission from King Louis-Philippe to marry his own niece, there were approximately seventy such cases registered in France.[74]

Many obstacles stood in the way when Isaac Pereire sought Fanny's hand in marriage. First, she was much younger than he and may have been ill-disposed to the proposal. From current family hearsay, her parents were completely opposed. The brothers' partnership, the core of their rapidly expanding business interests, was endangered.[75] Even if these hindrances could be overcome, it was essential to mount a plausible case so as to obtain dispensation from the King. Her parents had moved with their daughters from the rue

de Tivoli to a house they purchased out of Paris in the rue Royale at Saint-Cloud, made necessary no doubt by the demands of the Pereires' burgeoning railway interests in the region but also perhaps a sign of their continuing resistance to the union of their daughter with Isaac. They may well have considered this marriage inimical to the relations the brothers were fostering in support of their joint financial future, not to mention the social milieu they were entering. And Herminie, one of whose tasks in life was to see her daughter married well, may have had someone else in mind for Fanny.

The appeal when it was presented did not deal with mutual affection between Fanny and Isaac, although Fanny by then had obviously been persuaded, or had decided, to accept Isaac's hand in marriage. It was argued, first, on the grounds of what was in the best interests of Isaac's two children: namely, that the young woman who had cared for them since the death of their mother Laurence and whom they now regarded as a second mother should assume formal title to the relationship; and, second, that it was of the utmost importance for the two families that the pecuniary interests of the Pereire businesses remain tied. 'The projected marriage is the means to arrive at this end', according to Isaac's appeal. This second argument was ironic if there were indeed tensions between the brothers to which the marriage had given rein.

In his own written statement, however, Isaac admitted that the situation of his children might be 'more serious in the eyes of Your Majesty' than the situation of the Pereire businesses. Moreover, the grounds on which he pleaded his case were sufficiently 'grave' to be taken into consideration, 'in spite of the difference in age which exists between the intended [bride and groom]'. Fanny's mother and father having given their consent, King Louis-Philippe gave his on 24 August 1841.[76]

Fanny married Isaac soon after in September. She was then sixteen years of age; he was nearly thirty-five. Although marriage at age fifteen to nineteen was not unheard-of in France, Fanny was, nevertheless, considerably younger than her own cohort of elite Parisian Jewish women, for whom the average age at marriage was about twenty-two years.[77] This was in turn significantly younger than the mean age at first marriage for all French women, of approximately twenty-five years.[78] And while the average difference in age of about ten years between bride and groom of the elite class

was not considered extreme, the age gap between Fanny and Isaac of almost twenty was unusual.[79] This particular marriage of niece with uncle was thus uncommon on all counts.

They were not married in a synagogue, nor had Isaac's first marriage with Laurence taken place in one: it was simply a civil ceremony in the *mairie* of what was then the first *arrondissement*.[80] Isaac's encounter with Saint-Simonianism had led to almost total renunciation of Judaism, mitigated only by occasional donations to Jewish causes. But the wedding party at her parents' home in Saint-Cloud seems to have been a happy occasion, whatever the prevailing circumstances. Ismail Urbain recalled, 'I attended in the month of September at a villa in Saint-Cloud the marriage of Isaac Pereire with the daughter of his brother Emile, Fanny.' He added, 'it was an event for the Saint-Simonians'.[81]

Fanny thus found herself married to a much older, sexually experienced man. She was mother to two stepsons, now aged ten and five years. She was legally aunt to her own siblings, including her brothers Emile and Henry, eighteen months and five months old respectively at the time of her marriage. Her mother was now also her sister-in-law, thus straining further their relationship, aggravated by the opposition of her father and his anger towards her new husband. Certainly, there were entangled relations which needed to be carefully unpicked.

Fanny did not lack confidence, however. In this she differed from her mother. Apparently outgoing, she seemed to relish the life beyond the hearth. Perhaps the cosmopolitan circle in which she moved from an early stage in her life accustomed her to people and social circumstances beyond the Pereire/Rodrigues family. But for all this she was no less attached to her family, with whom the bonds of affection were tight. And she was beautiful, her lustrous raven hair, dark eyes, and ivory skin captured wonderfully in the portrait by Alexandre Cabanel that we shall come to in Chapter 5.

Two years after the marriage, at the age of eighteen, she herself gave birth to a boy, Jules, who died in infancy. Another son, Lucien, born fifteen months later, died at birth.[82] Gustave, born in 1846, was the first of her children to survive into adulthood.[83] He was followed in 1853 by a daughter, Marie Henriette, known as Henriette, and the only child to be named after another member of the family, her paternal grandmother. Claude Edouard, a son born with

profound intellectual and physical disabilities, followed in 1855. Fanny's last child, another daughter, Jeanne Sophie, was born the following year, when Fanny was aged thirty-one years.[84]

Fanny was thus pregnant three times in the first five years of her marriage, placing great strain on her physical and emotional well-being. Thereafter there was an interval of seven years between the births of Gustave and his sister, Henriette. This may have resulted from birth control, which was usually withdrawal, or it may have been a matter of further pregnancies that did not reach full term or that resulted in infant death. While there is no evidence for this either in the Archives de Paris État Civil or in the family archive, the record of burials in the Pereire family grave at Montmartre included reference to a stillbirth buried on 27 January 1876 after exhumation from the Cimetière de l'Est (now Père Lachaise). This is more likely to have been a child of Fanny than of Herminie (the birth was not dated) given complicated arrangements concerning re-interment at Montmartre. Nor was this a reference to either of Fanny's earlier infant deaths as those infants were also eventually re-interred at Montmartre from Père Lachaise and their names duly recorded.[85]

Infant mortality remained high in France at the time of Fanny's pregnancies; about one in six children died before their first birthday. Even so, this was a considerable change from the situation at the end of the eighteenth century, when one in three infants died within twelve months. The increased use of smallpox vaccine and improvements in methods of delivery in childbirth, together with more sophisticated care of the newborn, are generally advanced as reasons for this improved life expectancy, which was to take a quantum leap forward with the widespread introduction of antiseptics from the 1860s.[86] In Fanny's case, however, the dangers to healthy live births caused by sexual relations between close relatives were scarcely well-appreciated. That there were problems with three of her six children, either dying as infants or, as with Edouard, born disabled, might support such a conclusion.

There was a decline in fertility among Jewish women over the course of the nineteenth century, based on the age of last birth, which was forty years for those born in the mid-eighteenth century to about thirty years for Fanny's cohort.[87] Herminie's age of thirty-six at the time of Henry's birth in 1841 was thus older than the

median. Fanny too was slightly older than the mean age at the time of her last known pregnancy. Her family was larger also if we count those early births, the mean number of births for Jewish women being on average just over three.[88]

While the first years of Fanny's marriage with Isaac were thus physically debilitating, for Herminie too these times were testing, for she was tending four children of her own between the ages of twelve and two years. And while both mother and daughter would have benefited from some form of domestic help the wealth of the Pereires had not reached the amplitude of a later stage and such help may have been limited.

Either because of Fanny's personal tragedies or because of his understandable joy in the safe arrival of Gustave, his first surviving grandchild, letters written by Fanny's father over time began to show an increasing warmth, which would indicate gradual, albeit perhaps grudging, acceptance of the situation. In time, the relationship healed. The business partnership with Isaac, which was so crucial to their long-term future, helped. When Herminie and Emile returned from Saint-Cloud to take up residence in Paris, they continued to co-habit with Fanny and Isaac in separate apartments of the same building, now at number 5 rue d'Amsterdam.

This coincided with a time when the Pereire brothers were deeply and successfully engaged in the business of railways. The Paris–St Germain line launched with so much fanfare in 1837 was followed by the Paris–Versailles (Rive Droite) in 1839. Difficult negotiations to win the government concession for a rail line from Paris to Brussels were progressing and were finally achieved late in 1846. Inauguration of the great Nord rail line took place in June, accompanied by great festivity: seventeen hundred guests travelled to Brussels as guests of James de Rothschild, the principal backer, and returned the following day, dining sumptuously at cities along the route. Hector Berlioz composed a special cantata to mark the occasion.[89] If Herminie entertained any hesitancy in attending such a grand event, this was not evident, the reporter, Alfred Asseline noting the presence of 'the charming family of M. Emile Pereire'.[90]

Bourgeois accoutrements evidenced in the apartment of Laurence and Isaac in 1838 were even more on show. The husbands of Herminie and Fanny were now well-known in the business community with considerable personal recognition, and while they and

their families were not yet part of the fabric of Paris's *grande bourgeoisie*, they were on their way.

To this date the Pereire brothers had received substantial financial support from James de Rothschild, who committed to a significant capital investment in the Pereires' rail businesses. Having been impressed by the acumen of Emile Pereire in particular, he was able to open many doors for the young Bordelais brothers.[91] From the time of the July Revolution in 1830, Rothschild had also provided loans to the new government of Louis-Philippe and carried great political influence with the King, all of which helped the Pereires. Rothschild's support for the successful Paris–St Germain railway had been crucial to its very existence, and that experience also persuaded a somewhat reluctant investor to support even more ambitious projects, such as the construction of the Nord rail line.

With the abdication of Louis-Philippe on the revolution of 1848, however, events saw these powerful connections diverge quickly if not evaporate. The advent of Louis-Napoleon Bonaparte and his election as Prince-President in December, followed by a *coup d'état* in December 1851 and his coronation as Emperor, presented the Pereire brothers with unexpected opportunities. Rothschild had lost his former influence and in any case was not an admirer of the newcomer. The Pereires, having chafed at the bit of Rothschildian financial restraint, thus found in Emperor Napoleon III a willing listener and powerful ally.

Exactly one year after the *coup*, the Pereires founded their bank, the Crédit mobilier, the first significant investment bank in Europe, capitalised at sixty million francs. They branched out in several new directions, establishing in 1854 the Société de l'hôtel et des immeubles de la rue de Rivoli, which was to become the centrepiece of an urban development company and a principal medium for baron Georges-Eugène Haussmann's renovation of Paris. Over the next ten years, the bank financed a rapid growth in the Pereires' business empire, which, aside from urban development, went on to include shipping, insurance, gas services, public transport, and hotels throughout France and ultimately also in other countries in Europe as well as banks in Spain, Italy, and the Netherlands.

Their business successes came at the cost of James de Rothschild's support, however. The birth of the Crédit mobilier led to bitter rivalry between the two families and irreconcilable enmity. The two

had fundamentally different approaches to banking, and Rothschild saw the new bank as financially dangerous as well as a rival to his own interests. He was also outraged, and likely humiliated, that a former protégé should turn the tables on him and present him with political and social challenges as well. These difficult circumstances were to complicate the lives and activities of Herminie and Fanny, who now had to negotiate a continuing and intractable problem.

If family was the backbone of the enormous business success of the Pereire brothers, the next chapter will explore relationships between family and friends, principally through letters written by Herminie and Fanny. These describe the means by which they constructed a solid family life, one which supported their husbands in the challenges which faced them as *patrons* of the Second Empire. This will lead in Chapter 4 to a study of the sociability and patterns of entertainment and leisure to which their new home and other properties owned by the family gave rise, in particular during the heady days of the Second Empire. An account of the servants who worked for the family at their various residences and under the direction of Herminie and Fanny is essential to this narrative. This will be followed by analyses of Herminie and Fanny's conspicuous consumption in support of family recognition and status, their charitable and philanthropic works, the marriages of their children, and the continuing attachment to and identification with Judaism.

Notes

1 Benbassa, *The Jews of France*, 103.
2 Jay R. Berkovitz, *Rites and Passages: The Beginnings of Modern Jewish Culture in France, 1650–1860* (Philadelphia, PA, 2004), chap. 6.
3 Alfred Adler, 'Position in Family Constellation Influences Lifestyle', *International Journal of Individual Differences*, no. 3, 1937, 211–27.
4 Corrado Pope, 'Mothers and Daughters', 199–200.
5 Thérèse LeGroing, *Essai sur l'instruction des femmes*, 3rd edition (Tours, 1844). Contained in Corrado Pope, 'Mothers and Daughters', 111.
6 Ibid., Cattois in the preface to LeGroing, xxxij–xxxiij.
7 Mayeur, *L'Éducation des filles en France au XIXe Siècle*, 67 ff., 86.
8 Corrado Pope, 'Mothers and Daughters', 180.
9 Ibid., chap. 3.
10 Craig, *Female Enterprise*, 2.

11 AFP, Herminie Rodrigues, Paris, to Sophronie Andrade, Créteil, 10 May 1821.
12 Emile Pereire did not use accents in either his first or in his family name for reasons, it is said by present-day family, that he wished to retain an obvious connection with the Spain of his ancestry. Certainly, at no stage in his life did he use accents, although from time to time others bowed to convention and inserted them.
13 AFP, Emile Pereire, Paris, to Rosalie Rodrigues, Bordeaux, [undated] June 1824.
14 Denise Z. Davidson, '"Happy" Marriages in Early Nineteenth-Century France', *Journal of Family History*, vol. 37, no. 1, 2012, 23–35.
15 AFP, Emile Pereire, Paris, to Rosalie Rodrigues, Bordeaux, [undated] June 1824.
16 Ibid., Elisabeth Marie Copin, Orléans, to Herminie Rodrigues, Paris, 27 July 1823.
17 Barrie M. Ratcliffe, 'Some Jewish Problems in the Early Careers of Emile and Isaac Pereire', *Jewish Social Studies*, vol. XXLIV, no. 3, July 1972, 189–206.
18 AFP, Moïse Seba, Bordeaux, to Emile Pereire, Paris, 26 July 1823.
19 Jacob Rodrigues Pereire received considerable attention, the most comprehensive account being Ernest La Rochelle, *Jacob Rodrigues Pereire; premier instituteur des sourds-muets ... sa vie et ses travaux* (Paris, 1882).
20 AFP, Emile Pereire, Paris, to Rosalie Rodrigues, Bordeaux, [undated] June 1824; Adolphe Mirès, Bordeaux, to Emile Pereire, Paris, 25 December 1823.
21 Ibid., Emile Pereire, Paris, to Rosalie Rodrigues, Bordeaux, [undated] June 1824.
22 Ibid., Isaac Pereire, Paris, to Samuel Alexandre, Bordeaux, 24 July 1826; and to Henriette Pereire, Bordeaux, 25 September 1825.
23 Davies, *Emile and Isaac Pereire*, 43–4.
24 AFP, Emile Pereire, Paris, to Samuel Alexandre, Bordeaux, 24 July 1824.
25 Archives du Consistoire Central de Paris, GGI, 'Mariages célébrés dans le temple de la rue Notre-Dame de Nazareth à Paris', 4.
26 AFP, Emile Pereire, Paris, to Isaac Pereire, Bordeaux, 2 October 1825.
27 Emile et Isaac Pereire, *Écrits de* (Paris: 1902), vol. IV, Premier fascicule, Années 1831–1835, 'Du Divorce', 67–70. Article published in *Le National*, 6 December 1831.
28 Archives de Paris (hereafter AP), État Civil, V3E/N 1768.
29 And not just the Jewish community but Catholic women in the Nord department also routinely gave birth within a year. See Smith, *Ladies of the Leisure Class*, 62.

30 Sarchi *Lettres*, Félicie Sarchi, Milan, to Helène Van Tieghem, Paris, 7 February 1870, vol. II, letter 347, 49–50.
31 AFP, Emile Pereire, Paris, to Jacob Lopès Fonseca, Bordeaux, 4 August 1826.
32 Ibid., copy of 'Extrait du Registre des Actes du décès de la Commune d'Auteuil', 22/8/27, extract dated 17/08/41. Rebecca Lopès Fonseca was staying briefly ['passagèrement'] at 16 rue de Molière, now the rue Rémusat.
33 Ibid., Emile Pereire, Paris, to unnamed recipient, probably his uncle, Jacob Lopès Fonseca, Bordeaux, undated.
34 Ibid.
35 Ibid., Moïse Seba, Bordeaux, to Herminie Pereire, Paris, 5 May 1827. This date is puzzling since it precedes the death of Emile's mother. However, the date in the extract (see note 32 above) may have been inaccurate as has frequently been the case.
36 BNF-A, Fonds Enfantin 7676/13, Prosper Enfantin, Paris, to Aglaé St-Hilaire, unknown address, 17 December 1828.
37 Goldberg Moses, *French Feminism*, 51.
38 BNF-A, Fonds Enfantin, 7822/28, 'Livre des Comptes de la Doctrine tenu par Isaac Pereire – Situations'.
39 BNF-R, Fonds Alfred Pereire, 24601/12–15, Charles Henry, Paris, to Charles Duveyrier, unknown address, 11 June 1829.
40 BNF-A, Fonds Enfantin, 7676/13, Prosper Enfantin, Paris, to Aglaé St-Hilaire, unknown address, 17 December 1828.
41 Pilbeam, *Saint-Simoniens*, 64–6, 73–4.
42 AFP, Michel Chevalier, Sorèze, to Emile Pereire, Paris, 28 July 1837.
43 Paula Hyman, 'Jewish Fertility in Nineteenth Century France', in Paul Ritterband (ed.), *Modern Jewish Fertility* (Leiden, 1981), passim.
44 Grange, *Une élite parisienne*, 306.
45 Ibid., p. 305. Figures quoted by Grange are 1790–1829, 4.92 average; 1830–69, 3.26 average.
46 Davies, *Emile and Isaac Pereire*, 21–2.
47 Christine Piette, *Les Juifs de Paris (1808–1840): La marche vers l'assimilation* (Québec, 1983), 61–2 including maps.
48 Léon Halévy, *F. Halévy: Sa vie et ses oeuvres* (Paris, 1863), 16–17.
49 Jules Janin, 'Inauguration du Chemin de Fer de Paris Saint-Germain', *Journal des Débats*, 25 August 1837. https://gallica.bnf.fr/ark:/12148/bpt6k439590n.item, accessed 12 March 2021.
50 Emile et Isaac Pereire, *Écrits de ...*, 4ème fascicule, 1834–1835 (Paris, 1901), xxxiii. Foreword by Gustave Pereire.
51 Sarchi, *Lettres*, Félicie Sarchi, Florence, to Hélène Van Tieghem, Paris, 16 January 1867, vol. I, letter 212, 320–1.

52 Ibid., Félicie Sarchi, Milan, to Hélène Van Tieghem, Paris, 22 May 1868, vol. I, letter 304, 460.
53 AFP, 'Passe-port à l'Étranger', 1857, issued to 'Mme E. Pereire'.
54 Chamu Sundaramurthy, 'Sustaining Trust Within Family Businesses', *Family Business Review*, vol. XXI, no. 1, March 2008, 90.
55 Catherine Nicault, 'Comment "en être"? Les Juifs et la Haute Société dans la seconde moitié du XIXe siècle', *Archives Juives*, 2009, vol. 42, no. 1, 8–32.
56 Benbassa, *Jews of France*, 103–4. Benbassa put the Jewish population 1831 at 8,684 based on Doris Bensimon-Donath's, *Socio-démographie des juifs de France et d'Algérie: 1867–1907* (Paris, 1976), 73.
57 AFP, Emile Pereire, Paris, to uncle Jacob Fonseca, Bordeaux, 7 April 1828.
58 Ibid., 'Avancement d'hoirie à mes enfants', undated ms hand-written by Rodrigues *fils*.
59 Reynaud, 'Portraits Contemporains: Isaac et Émile Pereire [accent sic]', *Le Figaro*, 23 July 1859.
60 Corrado Pope, 'Mothers and Daughters', 230, quoting Octave Gréard, *L'enseignement secondaire des filles* (Paris, 1883), 28–35.
61 Christina de Bellaigue, *Educating Women: Schooling and Identity in England and France, 1800–1867* (Oxford Scholarship Online, September 2007), esp. chap. 1.
62 Corrado Pope, 'Mothers and Daughters", chap. IV.
63 Ibid.
64 BNF-A, 7789/107, Ismayl Urbain to Aglaé Saint-Hilaire, 2 January 1838, cited in Michel Levallois, 'La Génèse de l'Algérie Francap. IV.o-Musulmane d'Ismayl Urbain, 1837–1848' (Thèse de doctorat nouveau régime: Institut National des Langues et des Cultures Orientales, Paris, 1999), 70.
65 AFP, Adolphe Mirès, Bordeaux, to Emile Pereire, Paris, 5 January 1823.
66 Johnson, *Becoming Bourgeois*, 18–22.
67 Grange, *Une élite parisienne*, chap. 9.
68 BNF-R, Fonds Alfred Pereire 24610/12–15, Charles Henry, Paris, to Charles Duveyrier, unknown address, 11 June 1829.
69 BNF-A, Fonds d'Eichthal 14804/13, Isaac Pereire, Paris, to Georges Cazeaux, Bordeaux, 3 December 1832.
70 Archives Nationales de France (hereafter AN), MC/ET/VIII/1595, notaire Fould, 'Inventaire après le décès de madm. Pereire, 9 novembre 1838'.
71 Whitney Walton, *France at the Crystal Palace: Bourgeois Taste and Artisan Manufacture in the Nineteenth Century* (Berkeley, CA, 1992), chap. 3.

72 *Leviticus* chs. 18 and 20 deal with consanguinity and impediments to marriage.
73 Anka Muhlstein, *Baron James: The Rise of the French Rothschilds* (New York, 1984), 76.
74 AN, BB/15/322–333, January-December 1841.
75 Conversations with current members of the Pereire family, from 2001–14.
76 AN, BB/15/29---No. 4682–49, registered 24 August 1841.
77 Grange, *Une élite parisienne*, 176.
78 Hyman, 'Jewish Fertility', 91. In the absence of coherent official figures for the period, Hyman used a variety of data series to establish probable ages for Jewish and non-Jewish women, which led to an estimate of non-Jewish women having a median age at first marriage in 1851 of 25.5 years.
79 Grange, *Une élite parisienne*, 176, 305.
80 AP, État Civil de Paris, V3E/M 793
81 Anne Levallois, *Les écrits autobiographiques d'Ismayl Urbain: Homme de couleur, saint-simonien et musulman (1812–1884)* (Paris, 2005), 109, fn. 19.
82 AFP, 'Établissements de mes enfans' of Isaac Rodrigues.
83 Ibid.
84 AP, État Civil de Paris, V3E/N 1768, 'Acte de Naissance' of Henriette and of Jeanne.
85 My understanding of the history of the Pereire tomb is based on a document in the AFP, hand-written at various times, 'Emplacement de la Sépulture'. This is significant to Chapter 8 below, 'Being Jewish'.
86 Institut national d'études démographiques, 'Infant mortality in France', [INED Fact Sheet] downloaded 19 February 2018.
87 Hyman, 'Jewish fertility', 82–3. Cyril Grange in *Une élite parisienne*, 302–7, also deals with the declining fecundity among Jewish women and French women more generally.
88 Grange, *Une élite parisienne*, Tableau 12.2, 303.
89 Niall Ferguson, *The World's Banker: The History of the House of Rothschild* (London, 1998), 455–6.
90 Emile and Isaac Pereire, *Oeuvres de …*, ed. Pierre-Charles Laurent de Villedeuil (Paris, 1912–20), series G, t. 2, 1713.
91 The relationship between the Pereires and James de Rothschild is covered in full in Davies, *Emile and Isaac Pereire*.

3

Relations and relationships

In July 1864, Emile Pereire II wrote a letter to his brother Henry in Egypt in which he expressed some slight annoyance with their sister, Fanny. He recounted in a jocular fashion, 'I must not speak ill of her, for I love her a lot; but I told her that since I was her nephew, I would not fear to torment her a little.'[1] In view of the gap between her age and theirs, Fanny was in fact more like an aunt than an older sister: fifteen years older than Emile II and sixteen years older than Henry. This paradox concerning age in family relationships was not unknown in nineteenth-century Europe although the situation of the Pereire family was unusual. Indeed, and as Emile II was playfully acknowledging, with the marriage to their uncle Isaac, Fanny was legally their aunt as well as their sister. Such complications that we noted briefly in the previous chapter carried many challenges for her, especially in her relationships with the immediate family.

While later chapters will consider the various ways in which Herminie and Fanny engaged with the world outside the family, this chapter will explore the inner world of the Pereires as they maintained and experienced it: the relationships between wife and husband, mother and children, siblings, and extended family, for family was crucial to the contentedness, the well-being, and, ultimately, the success of the Pereire brothers. And it was to Herminie and Fanny that the construction of a close, intimate circle of family and friends was entrusted. A notable feature of this inner circle was the importance of continuing and close personal friendships with former Saint-Simonians.

Much of the underpinning here derives from letters in the family archive, either reinforced or reinterpreted by those of the Sarchi couple. These letters tell us much about how the family lived, what

they did, where they went, whom they married, and how they spent their money – all of which we shall in turn explore. But the letters of Herminie in particular also tell us about the relationships between its members, what sort of family it was, how it retained its unique identity, and how family members dealt with love, affection, pain, and grief. Herminie's letters were also a potent tool in establishing family cohesion, if not control, and this also speaks to her crucial role in creating the family image. Indeed, through these letters we see Herminie as the central domestic figure in the family, the matriarch, maintaining its connectedness, instilling pride in its members' achievements, disseminating news of family members, demanding and achieving solidarity in the face of disaster.

Letter-writing was largely confined to those *bourgeoises* who, until well into the nineteenth century when educating girls began to receive some priority, had received a good level of education. In writing their letters, Herminie and Fanny followed certain generally accepted conventions established for women of the upper bourgeoisie. They wrote on heavy paper embossed with their initials, 'HP' and 'FP'. They wrote the name of the place from which they were writing but did not include the full address. As the letters are missing the envelopes in which they were contained, it is only from other sources that we may be able to identify the location of the recipient. The opening salutation employed by each of Herminie and Fanny with their children invariably followed the same pattern: as instances, 'My dear Fanny' (from Herminie) and 'My dear Gustave' (from Fanny). The closing salutations varied. Herminie concluded: 'Your mother and good friend, H. Pereire.' Fanny signed off: 'Your mother who loves you dearly, Fanny P.'

Before reaching this end point, both Herminie and Fanny extended at some length their best wishes and affection to other family members, friends, or associates of the Pereire businesses, again in conformity with custom. 'Tell Polack [the head of the Chemin de fer du nord de l'Espagne in Madrid and a family friend] and his wife a thousand affectionate things and embrace his children', wrote Fanny to Gustave when he was travelling in Spain.[2] 'Farewell dear daughter', wrote Herminie to her daughter Cécile, 'I embrace you with all my heart as well as my good Charles [Cécile's husband] and our dear little girls [Cécile's three daughters].'[3]

Writing letters, typically, was a major part of Herminie's role as a mother and matriarch of her class. Even so, there is something a little obsessional about her engagement in the task. Michelle Perrot talks of letter-writers among bourgeois women as 'frustrated authors who found in correspondence an acceptable outlet for their energies'.[4] This could certainly be said of Herminie, who devoted hours each day to the job. It was an activity normally undertaken in the morning after *le petit déjeuner* and the daily ordering of the servants. Family came first, but friends also received dispatches from her. To Henry in January 1859, she cut short the missive because she had already written four that day and still had one more to do.[5] She was indefatigable in the exercise of her craft. While there was an expectation in many cases that the recipient would convey the contents of a letter to others, either within the family, to close friends or, in some cases, to business associates, this did not necessarily lead to any economies in effort, since Herminie was busily writing to many friends and relatives.

Historians note that the circulation of letters among family members or others was commonplace during the eighteenth century but that over the nineteenth century for the first time 'one sees letters written entirely and only for the recipient'.[6] Certainly, some of the letters under review here were intended as private communications between two individuals. There are also times during the reading of the correspondence that the writer cautions the recipient not to reveal the contents to anyone else or not to reveal sections of a letter to certain individuals. The inference is that the recipient may usually have been given permission, or have been expected, to do so. The letters here are for the most part transitional in terms of privacy: where privacy or confidentiality was required, the recipient was duly advised, but otherwise the contents were accessible to all. Nevertheless, and as we shall see, one cannot imagine that all the letters between Herminie and her husband or Fanny and hers were intended for a wider audience.

The extant letters from Fanny are comparatively few, and therefore precious, because of the circumstances in which the family archive came into being: that it was Fanny's brother Henry who collected and maintained it, with the inevitable bias towards his parents, Herminie and Emile, and other siblings. But we learn about Fanny from the letters of others for she was a constant and

important figure of great affection in the lives of her immediate and extended families. Letters in the family archive contain numerous references to her as do the letters from Herminie's sister Félicie Sarchi and Félicie's husband, Charles, to their daughter Hélène Van Tieghem, all confirming Fanny's central place in their lives.

In what Jean Lhomme has described as the rise to power and supremacy of France's *grande bourgeoisie*, the family was a most significant instrument in achieving and maintaining ascendancy.[7] Overall, the Pereire family was close, proud of its history and its achievements, and wishing to instil in all its members a reverence for and acceptance of the bond which had made it increasingly successful. As we shall see, however, this welcome was not as universal as Herminie believed.

Other Jewish families of this status probably exhibited the same ambition and the same characteristics of pride in recognition. The most significant banking family, the Rothschilds, for instance, valued similar family ties and affection, which they reinforced in many ways and pre-eminently through their continued and united observance of Judaism.[8] When a member of the family in London announced her intention to marry a non-Jew, the head of the Paris house, baron James de Rothschild, fulminated: 'nothing could be more disastrous for our family, for our continued well-being, for our good name and for our honour … [than to renounce] the religion which, thank God, made us great'.[9] From their biographer, Hervé Le Bret, we learn that the d'Eichthal banking family in France was also ambitious to make their way in this new country, although they followed a different path. In leaving Bavaria (the family name was originally Seligmann), unlike the Rothschilds, they not only changed their name but also early on converted to Catholicism as a means of establishing themselves in the capital.[10]

The Pereires on the other hand, while not observant Jews, did not convert. The bonds of Jewishness were not severed for the Pereire family continued for the most part to identify as Jews and to forge a secular path while doing so. They thus differed from the Rothschilds and the d'Eichthals in this significant way. Status among Jewish families of France's *grande bourgeoisie* was achieved and maintained through many different paths.

Leonore Davidoff's extensive analysis of families in England during the period 1780–1920 shows that the number of children

born there was greater than the average of French families, Jewish or non-Jewish, over the same period. Demographic analyses suggest that the fertility rate in England in the early 1800s was about 5.5 children, declining to just under 5 children from 1830 to 1880, although some families, according to Davidoff, could count up to ten children.[11] In the case of Jewish women in France, the average family size – from just over three children in the early years of the century to just over two births by 1851 – was considerably smaller.[12] Nevertheless, some of the resulting characteristics of family relationships teased out in Davidoff's study were remarkably similar to those encountered in the Pereire family.

In Herminie's case, the Rodrigues family of ten children was large in comparison with other French Jewish families. She was younger than her brother Olinde by nine years and older than her youngest surviving sister Amélie by eight. The seventeen years of her own mother's child-bearing were thus punctuated regularly by newborn siblings. The kinship patterns in England described by Davidoff suggest that a high birth rate and large family size could produce similar relational complications to those confronted by Herminie. That is, older sisters could seem like aunts to their younger brothers or sisters when there were up to ten or more in the family. And while Davidoff wrote of 'ragged age gaps between the living' based on the larger family size of middle-class England and the effects of illness, death, or miscarriage, among other tragedies, the age gaps in the Pereire family were not dissimilar, albeit for different reasons.[13] Herminie, as a middle child in the family, was thus the little sister to some and the aunt to others.

There was a further kinship complication for Fanny: that was her relationship with Eugène and Georges, the sons of Isaac's first wife, Laurence Lopès Fonseca. On their mother's death in 1837, their cousin, the twelve-year-old Fanny, as the eldest of the second generation and having been a significant helper to her own mother, took on an important role in caring for them. This experience as we know was to lead four years later to her marriage with Isaac and thus also to the maternal role in the lives of two small boys. By the time their father remarried, Eugène was ten years old and Georges five. Georges was to reach adulthood but died at the age of twenty from causes unknown to us. There was only six years' difference in the ages of Fanny and Eugène, however, and Fanny was more like the older sister to Eugène that she never was to her own brothers.

We can only judge the emotional quality of these relationships through the lens of their later shared lives, but on the evidence it seems that her stepson Eugène regarded Fanny with some affection. That he was the eldest of the second generation of men (nine years older than Emile II, for instance) meant that he had become a contributor to the family businesses for a considerable time before either of his cousins was in a position to do so. By the time they had finished their education, he was already occupying significant posts in Pereire companies. He was also talented in ways that his cousins were not, and thus rapidly assumed the pre-eminent position among his generation of young Pereire men: Emile II, Henry, and his half-brother, Gustave. Fanny came to rely on him and, as we shall see, from time to time she was to enlist Eugène's help in delicate family situations.

Just as Fanny had grown up with her cousins as her best friends, her own children were of an age with their cousins, the children of Cécile and Claire, and thus had many readily accessible playmates. Whereas it was the size of families among Bonnie G. Smith's *bourgeoisie* of the Nord that rendered the need for playmates outside the family unnecessary, in the case of the Pereires it was the unusual family structure, with children from three marriages and at various ages, as well as the circumstances of their co-habitation, that encouraged close friendships.[14] These circumstances could also give rise to competitiveness and jealousy, however.

Naturally, all these intra-family relationships varied in significance. The central relationship in the lives of Herminie and Fanny Pereire was with their husbands, Emile and Isaac respectively. In Herminie's case, this relationship did not commence with great wealth; in fact money was tight, with Emile supporting his wife, his daughter, his mother, and a nurse for Fanny from the mid-1820s.[15] Having received four thousand francs from Rodrigues *fils* on his marriage with Herminie, he brought little to it himself by way of ready cash. They lived for some time with the help of loans from Herminie's father. It was only with the launch of the Paris–St Germain rail line twelve years later in 1837 that real wealth began to materialise. Even here, it was with the assistance of two supporters, the bankers Adolphe d'Eichthal and Auguste Thurneyssen, who provided the wherewithal for Emile to purchase six hundred shares in his own company. From that point, his natural business acumen ensured that wealth accumulated.

Herminie's married life was thus one of considerable early struggle financially and physically, with three children born within the first ten years. Letters from various sources also tell us that Emile was not an easy person to live with: mercurial, given to sudden rash decisions, intransigent, believing in his own infallibility, and with a ready temper. As we have learned, at an early stage he also entertained serious reservations about the wisdom of his marriage. This marriage was further complicated for Herminie by her husband's asthma, a chronic illness from which he suffered from childhood and that was apparent from the very beginning of their acquaintance. While the means of treating this affliction became better known over the years that were to come, and Emile Pereire throughout had the benefit of treatment by an eminent physician, Armand Trousseau, asthma remained a distressing ailment, one for which Herminie's personal ministrations were necessary and that she needed to negotiate with the outside world.[16]

Emile Pereire's introduction in 1850 to the seashores of Arcachon on the Atlantic coast, sixty kilometres from his birthplace, Bordeaux, brought him some relief. But this welcome turn in the life of her husband meant for Herminie continuing lengthy and not altogether satisfying sojourns there. Arcachon was far from Paris, and she was often separated from her children and their families as well as from her habitual activities and sources of entertainment. She frequently languished.

This was so much so that from time to time in the 1860s, friends and family mentioned Herminie as unhappy, given to fits of tears. After the opening night of Emile Augier's *Fils du Giboyer* attended by the Pereire family in December 1862, Édouard Charton wrote to his wife that 'Mme Pereire seems to us to be very sad and for some time.'[17] Fanny also reported in a letter to Henry that while 'It has been a long time since I saw Mother so calm; she no longer cries like she used to last year.'[18] That letter was dated 17 January 1865, but the very next day, Fanny's brother-in-law Georges Thurneyssen reported to Henry, who was in Egypt, that Herminie had been forced to retire to another salon to 'shed one of several tears'.[19] Some of these tears may have resulted from Henry's absence, which affected Herminie greatly, but gradual deterioration in her health did not help her state of mind. Nor can we exclude the possibility that her unhappiness resulted as much from difficulties in her marriage as through any other cause.

Did Emile Pereire keep a mistress? It was not unusual for bourgeois men in nineteenth-century France to do so. A report appeared in *Le Figaro* in December 1857 contending that he was in the habit of paying daily visits to an address in the rue Saint-Georges, a quarter that was known to accommodate a large number of kept women. The report seemed to lend credence to the possibility that Emile did indeed have a mistress. Mme. Jules Baroche, wife of the President of the Conseil d'État, noted this report in her journal along with the response of the accused man, who seemed scarcely to deny the veracity of the inference: 'My morality and the respect of the family are the most precious heritage I can leave to my children [Emile wrote in a letter of reply which he demanded the journal publish] and I do not allow anyone the right to undermine it.'[20] Emile himself received a letter from Charles Grobois in Auch informing him of rumours circulating that he kept a mistress in Bayonne, a Mme. Léon, the wife of the ship-builder, Émile Léon.[21] This possibility is drawn out further when, after Emile's death, the Paris correspondent of the *Boston Daily Advertiser* wrote of a reception given by the Prince Napoleon at which Emile 'had something of the Mephistopheles about him', peering lecherously through an eyeglass at the bare shoulders of the pretty women there, much as Emile Zola had described the behaviour of the lascivious Napoleon III in the novel *La Curée*.[22]

One biographer hazarded that the brothers were far too busy with their various enterprises and 'too attached to their family life' to entertain any ideas of extra-marital dalliance, and that in any case there was no evidence to point in this direction.[23] Admittedly, the anecdotal evidence presented above is fairly slim and inconclusive, but it does exist. And one might also point out that Isaac was never subjected to such innuendo.

Towards the end of their lives, Herminie and Emile seemed nevertheless to have reached an affectionate resolution to whatever difficulties they had traversed together. Herminie had become increasingly ill: she suffered a stroke and was clinically blind. Emile was dying. Writing to her from Arcachon the day before his seventy-third birthday, he regretted that for the first time in forty-eight years they were not together to celebrate. He reported on some of the projects they had commenced around their villa and recorded with pleasure the progress made.[24] He wrote this letter less than

two months before her death in Paris, when he received the thousand or more people who attended the hôtel Pereire to tender their condolences.

Fanny and Isaac Pereire did not have the kind of difficulty in their marriage that Herminie and Emile seem to have experienced. Isaac was a different personality from his brother, expansive, outgoing, and by nature a passionate man, evidenced not only in his early attachment to his cousin Mélanie but in other ways as well. While from time to time his health brought on its share of concern, this ill health was not the constant preoccupation for Fanny that Emile's was for her mother. From the outset of her marriage also the bonds of affection were pronounced. Possibly because of the manner in which the union came about, the hurdles needing to be cleared, both partners had become confident in the desirability of it. The erotic quality in the married life of uncle and niece was evident, and their mutual affection seems to have been unqualified, never tested.

During the Saint-Simonian days, Isaac had spoken out forcefully in support of women, declaiming the horrors of 'the inferior position' in which they existed. While the heady experience of those days had long receded by the time of his marriage with Fanny, it is worth recalling the conviction of the man who was to say in 1831 during one of the Saint-Simonian 'Enseignements', or 'Teachings': 'beyond we *men*, there is a whole world compromised, a world tortured by horrible suffering that we must overthrow'.[25] Isaac may not have retained such a powerful sentiment as time slowly eroded that passion, but something of this empathy towards women flowed through in his relations with his wife. Fanny in turn responded warmly.

The young girl had grown up in the light of the development of the Pereire businesses. She was twelve years old when the Paris–St Germain rail line was inaugurated with great style and royal pomp and would have been aware of plans for further rail projects thereafter. While the reasons advanced for marriage with Isaac in 1841 were primarily to do with the care of his two young sons, her compatibility with the family's business interests was also acknowledged. There is no doubt that she was fully conversant with her father and husband's plans and ambitions, and this gave her a significant bond with her husband from the outset.

Relations and relationships

The letters between Fanny and Isaac Pereire may be read as love letters as well as indicators of a marital and business partnership. In sharing business information, as well as concerns about their loved ones, there was also a subtext of close affection. Isaac usually addressed her as 'My dear friend' or, less frequently, as 'My dear Fanny'. He usually concluded, 'Your friend who loves you dearly' and, sometimes, 'So I leave you and embrace you a thousand times' or 'I kiss you as I love you.'[26] While these are not necessarily original expressions, in that we come across them in other volumes of letters, nevertheless they indicate a depth of affection which was far from perfunctory.

Fanny's responses were no less affectionate, addressing Isaac as 'My dear friend', and concluding with 'Farewell, my dear friend, I kiss you most tenderly.' The close relationship between the two was most clearly displayed during their separation by the Franco-Prussian War and the Commune when business forced Isaac to remain in Paris. Fanny wrote 'On all sides they tell me that you have never been so good, so courageous, and that gives me great pleasure since inevitably I am obliged to stay far away from you and that for the first time in my life I am not at your side to share your worries and your work.'[27]

Letters extant between Emile and Herminie were written over a much longer period, between 1850, when they had been married for twenty-six years, and 1873. By the time the earliest of these was written, their relationship was settled. The great passion that had seized Emile at the outset of their betrothal had transformed into a cooler temperature. Emile invariably addressed Herminie as 'My dear Herminie', and concluded with 'All yours ["tout à toi"] Emile Pereire.' Whatever reservations Herminie may have harboured at the beginning of their marriage, she was now more effusive in her affection, commencing with 'My dear friend', or 'My dear Emile', but concluding in a more emotive tone; 'I embrace you with all my heart and am always all yours', she wrote in October 1859. Sometime later, in November 1872, when she was ill and her daughter, Cécile, was writing most of the letters on her behalf, she took up her pen nevertheless: 'I want to say to you once more myself that I am and will be as always all yours from the bottom of my heart.'[28]

There were times when they appeared to quarrel. Herminie complained about the lack of communication more than once when

Emile was away on business. His replies could be terse. 'I cannot always be on the road and on the railway and write to everybody', he hit back in irritation on one occasion.[29] There was also at times a certain coolness in Emile's letters to his wife. From Arcachon to Herminie in Paris in October 1873, he wrote, somewhat thoughtlessly, that he was not writing so much to her because he was writing every day to Henry who thus had all his news. But since Henry was that day absent in Valenciennes, Herminie could receive his letter instead.[30]

Gendered roles nevertheless dictated the functioning of the Pereire household and, as with many other elite families engaged in economic life in nineteenth-century France, women were thus excluded from playing any overtly active role in family firms. Mayer Amschel Rothschild, the Rothschild family patriarch in Frankfurt, inserted a paragraph in his will to the effect that 'My daughters and sons-in-law and their heirs have no share in the capital existing under the firm "Mayer Amschel Rothschild and Sons" ... and [that it] exclusively belong to and be owned by my sons.'[31]

But in the case of Herminie and Fanny, there were instances where these boundaries were porous. A striking feature of the letters they received was the degree to which they were taken into the confidence of their husbands and entrusted with significant business information. They were *confidantes*. Some of this information, although by no means all, was intended to be passed on to other, mainly male, members of the extended Pereire family; sometimes it was to be forwarded on to government officials or senior business figures.[32]

Whatever the eventual path of circulation, what is significant in this correspondence is that the letters received by Herminie and Fanny from their respective husbands, including business correspondence, were invariably written in a way that implied the recipient understood perfectly the information that was being conveyed. When Bonnie G. Smith described the *bourgeoises* of the Nord department in the early part of the nineteenth century as 'businesswomen', women who achieved a certain unity between home and business, there are similarities with the Pereire wives who, albeit later than Smith's subjects and while not performing a direct function in the family businesses, nevertheless had a significant part to play.[33] This had its social element – mounting the extravagant

events and being seen at similar ones, theatre- and opera-going – which we shall explore. But they also kept an ear to the ground and provided business information and information on competitors. The proximity of the hôtel Pereire, the mansion acquired by the Pereire family, to the place Vendôme where their business empire had its headquarters meant that in any case business and family life for Herminie and Fanny were tied in a way not dissimilar to the 'symbiosis between home and factory' which Smith described.[34] And while Michelle Perrot has suggested that money was a subject not discussed in the correspondence of some bourgeois families, this was nowhere near the case with the Pereires.[35]

Isaac frequently travelled away on business and filled his letters to Fanny with details of the commercial negotiations he undertook elsewhere in France, in Genoa, Madrid, Vienna, and St Petersburg. These involved dealings with senior government figures and business leaders, of which he provided Fanny with blow-by-blow accounts.[36] Again, when he and Fanny were separated over 1870–71 throughout the Franco-Prussian War and the Commune, Isaac having stayed behind in Paris to protect their affairs and Fanny taking refuge in the southwest with their daughters, there were many occasions when he wrote to her about business or the state of the economy. In July 1870, the Bourse had risen a little, he reported, and went on to give current share prices for a range of railway companies, including their own. The prices of the Lombard and Austrian railways had fallen, however, and in this case a stockbroker in Lyon had let him down, leaving him out of pocket. He was owed thirty thousand francs on account as a result. He went on to detail the situation remaining in the shares still held in their own companies.

> It is certain that the situation is very tense in the current circumstances [he concluded], and that I am not exactly on a bed of roses. But until now I've succeeded in staying ahead of the storm. I must hope that I shall be able to manage until the end. I am doing my best in the middle of events of force majeure which are happening to us.[37]

Whether Fanny had a direct influence on the commercial decisions or negotiations of her husband or father is difficult to say. But if we examine the letters Isaac sent from Vienna and St Petersburg, Fanny was nothing if not completely cognisant of the intricacies

of international diplomacy and the implications this had for the Pereire businesses. Taking one example, that of the Crédit mobilier's interest in the Russian railways, Isaac wrote to Fanny at least every second day in July 1861 after an impasse had developed in negotiations and he had departed for Russia to sort it out. The Russian economy was in trouble and the whole rail project on the backburner following the emancipation of the serfs earlier that year. While construction of the line from St Petersburg to Warsaw was in train, the French-led Grande Compagnie des chemins de fer russes was seriously under-financed, and Isaac was supplicating Russia for more funds to advance the work.[38] French involvement with the development of railways in Russia was crucial to the ambitions of Napoleon III, which thus provided an additional motive to achieve a successful outcome.

In this case, what the letters from St Petersburg reveal and with which Fanny was completely *au fait*, and was expected to be, was an international network of influence: of Russian royalty and nobility; ministers of and high-level advisers to the Emperor and the Imperial Government; Russian bankers; Russian, French, and British diplomats. The network Isaac discussed with Fanny extended from the brother of the Emperor Alexander II, the Grand Duke Constantine, to Prince Gorchakov, the Emperor's most trusted counsellor; the former Minister for Foreign Affairs, Comte Nesselrode; and General Tcheffkine, the Minister for Transport.[39] The facilitation of the French Ambassador to Russia, the duc de Montebello, had assisted considerably in easing the path, but the bankers in Russia – Stieglitz and Mendelssohn – who were lending support to Isaac's bid were also prominent. What was on the table was a demand for a considerable increase in the level of Imperial government support.[40]

In one letter, Isaac noted the number of meetings to this end held at Peterhof with Tcheffkine and Gorchakov. Isaac detailed the demands that he was to put to a council of ministers led by Tcheffkine and in the presence of the Emperor. First, the Russian Government would be liable for completion of the lines. Second, it would guarantee interest on the company shares at 5 per cent and in cash in those places where shares were purchased. Third, the Russian government would reimburse the company to the extent of half the outlay to that date. These changes were to be inserted in the company statutes.[41] Given the way in which this information was

laid out in the letter, it is undeniable that Fanny was very familiar with the fine detail involved in Isaac's mission to Russia.

Whatever the occasional difficulties in their marriage, Emile also treated Herminie as a reliable partner in the sharing of business confidences. Many of the more than one hundred of those letters extant concern the negotiations which contributed to the success or otherwise of family businesses; many are in confidence. In 1860, Emile purchased from the Orléans family almost the entire plaine de Monceau and the neighbouring *quartier*, which proved immensely profitable to the Pereire brothers in real-estate development, providing fashionable housing for Paris's bourgeoisie (Emile Zola's Aristide Saccard of *La Curée* and Charles Ephrussi, the cousin of Edmund de Waal's grandfather, among them).[42] 'We have paid a high price, but that allows us to get a good deal for the whole and we are receiving interesting offers', he told Herminie.[43]

When, in 1864, following the annexation by France of Nice and Savoy, Emile Pereire attempted to take over the Bank of Savoy, which would thus have competed directly with the Banque de France, his letters to Herminie were replete with details of the lengthy discussions and complex negotiations with Napoleon III and his ministers which transpired. In this case he swore Herminie to secrecy, even from their adult children.[44] This audacious move, which would have countered the influence of the Banque de France, was thwarted by the finance minister of the day, Achille Fould, and came to nothing.

One month after Isaac had written his letter to Fanny just before the outbreak of the Franco-Prussian War in July 1870, Emile wrote similarly to Herminie from Arcachon:

> In this grave crisis our situation is not too bad. The fall in all the share prices represents for us losses which are considerable enough. But as we are not about to realise them we can hope that these [losses] will disappear. ... The Crédit Mobilier Espagnol is in a magnificent situation. It owes nothing to anyone, its capital is intact. It has as well three million, five hundred thousand francs in reserve and 2,500,000 fr in actual profits.[45]

Sharing business intelligence and detailing challenges and problems in this way instilled in the wives of Emile and Isaac Pereire a powerful sense of family identity and pride, quite apart from the usefulness to which they could put the information. Their understanding

of the situation of each of the Pereire companies also enabled them to identify the competition, which was fierce, and, with this knowledge, contribute to steering a steady course in the interests both of family unity and business success. The intimate knowledge of the business conveyed in the letters of Emile and Isaac and enjoyed by Herminie and Fanny underscored their partnership in the family enterprise.

These relationships could be perceived in a more negative light, however. Sometime after the collapse of the Crédit mobilier, Michel Chevalier, a director of the failed bank and one-time close friend who had lost money and reputation and as a result became bitterly estranged from Emile and Isaac, wrote to his lawyer about a court case he had brought against Isaac Pereire. His tone was caustic. In his letter he was to say of Fanny that it was she who had pushed Isaac to contest the suit: 'for in this family the women share the sceptre with the men', that they leapt aggressively to the defence of their husbands against any and all attacks. He went on to contend that bringing his legal action had so infuriated the Pereire women that they would treat him 'like the squaws of North America'.[46] In other words, they would skin him alive if given the chance!

The awareness of business conditions exhibited by Herminie and Fanny was the subject of more friendly comment by other members of the extended family, however. When the Credit mobilier failed, it was Fanny who, because of Isaac's resulting indisposition (he became very ill), dealt with many of the repercussions which followed. Her aunt, Félicie Sarchi, writing to her daughter about Fanny's behaviour, noted that

> Fanny shows an imperturbable calm. She surrounds her husband with all the attentions, with all the care imaginable. She receives businessmen, consults with them but never says a pointless word, [nor] a kneejerk reaction, never an *if one had done this or that*; she only speaks in order to be useful or agreeable and never moans.[47]

Despite Félicie's attribution of complete femininity to Fanny's behaviour, of modesty and female composure, of knowing her place, Félicie's letter also attests to Fanny's understanding of the serious business situation that the family now faced and that Fanny dealt with so competently.

In contrast, Herminie's role during the crisis that enveloped the Crédit mobilier concerned the domestic; it was she who rounded up the family. In this she played the matriarchal role to perfection. Writing to her daughter, Cécile, she noted with approval a letter received from her youngest daughter, Claire, who was returning to be with the family at this difficult time. She asked Cécile to return also, for 'We have major courses of action to take and for that we need to reunite as a family and consult one another.'[48] To Henry on the same day she sent much the same message, concluding with 'Finally, we all have need of you.'[49]

One of the complications that both Herminie and Fanny needed to negotiate was the relationship between the brothers, so critical to the success of the businesses and to the peace of the household. This relationship was not always easy. Emile was six years old when his father died. Isaac was born only five days after this family calamity and never knew his father. There was a middle child, Télèphe, three years old at the time of Isaac's birth, who died at the age of seventeen but who, until his untimely end, played a role in the lives of his brothers. Emile thus grew up practically *in loco parentis* to Télèphe and Isaac and was effectively the head of the household at a relatively young age. This had its effects on any future relationship, and while Emile was to assert more than once that Isaac was always destined to be his (business) partner, it remained clear which one of them was destined to be the chief.

The very different personalities of Emile and Isaac played their part. On Isaac's entry to Paris and his passionate advances towards Herminie's sister, Mélanie, there had been an acrimonious falling out between the brothers. Later, when Isaac had been captured by the spell of the Saint-Simonian leader, Prosper Enfantin, and Emile had resigned in protest about Enfantin's turn towards free love, a fraternal schism led to Isaac's retreat back to Bordeaux.[50] There were further difficulties, marriage to Fanny being one. It is inconceivable that there were not others, perhaps involving quarrels over business decisions arising from their extremely close working arrangements.

The collapse of the Crédit mobilier which had caused Herminie to summon all the children to return to Paris in 1867 was in time to lead to intra-family quarrels. The most serious of these family disturbances was between Emile and Isaac, the latter of whom presided over the failed bank and the former of whom presided over

the development company, the Compagnie immobilière, which precipitated the failure. In the aftermath, Félicie Sarchi wrote to Hélène that the Pereire women were not lacking in courage:

> The only one who is often crushed is Fanny and it is not the attacks and the external struggle, nor through any pain of a probable change in fortune, which makes life so painful; it is the internal struggles and the very difficult position in which she finds herself between the two parties. Herminie has regained the energy of her youth. Cécile and Claire are perfectly calm, resolved as they are to follow their father in everything. Henri [sic] and Emile [the younger] form with them a serried phalanx and all this side of the family is marching in concert. As for the other [Isaac], he deceives himself, he believes too much in himself, he would always walk with his head lowered against the canons; you know him, it's his nature.[51]

While Fanny was able to deal with the complexities of the external situation, including what was most likely a gathering antisemitic sentiment caused by the bank's failure, conflicting loyalties between her father and her husband were proving more intractable and difficult for her to manage.

A letter from Isaac to Emile, which is unfortunately undated but from other sources is probably about this time, did corroborate this version of events.[52] It was written against the background of Emile's unceasing attempts to find a solution to the bankruptcy of the Crédit mobilier and the Compagnie immobilière.

> Alone you [Emile] can do nothing [Isaac wrote]. Your age and your health will not permit it. You have no choice but to rely on me and I absolutely refuse to step in, to re-engage anew in a business world which has rejected us, where we can hold only an infinitesimal role, to plunge into this abyss again. ... I want my revenge on the abuse of the egotists who surround us.[53]

Herminie, once more the peacemaker, predicted confidently that a rapprochement was inevitable, as it was and as it happened. And in fact, Isaac did subsequently plunge once more into the world of business, saving several of their companies including a number outside of France and re-establishing himself as a significant figure in France's industrial and commercial world.[54]

Having looked at the relations with their husbands, we turn to the matter of relations between Herminie and Fanny and their

respective children. In doing so, we have noted previously the expectation that mothers would play an important role in the education of their daughters in nineteenth-century France. Less is said about the maternal role in educating sons, particularly as they grew older, when they usually went to a *lycée*. Michelle Perrot wrote that it was the father who made the decision on the education of his sons, and that was true of the Pereire boys.[55] Eugène Pereire, Isaac's son with Laurence, was the eldest of the sons for whom education was planned, Isaac deciding that he should attend the Collège Royale de Bourbon (now the Lycée Condorcet) and then the École centrale des arts et métiers (est. 1829), which provided high-level engineering training for the new industrial enterprises in France. The École centrale was an alternative to the well-established École nationale des ponts et chaussées (est. 1747), which educated engineers for large public works projects. Isaac's decision was replicated for all the sons who followed: his own son, Gustave, and Herminie and Emile's.

Yet Herminie also played an important role in her sons' education with her intuitive understanding that direct experience in industry was equal in importance to formal education. Knowing that Emile II and Henry would enter the family businesses, she was particularly concerned about giving them a practical introduction to those industries in which the family was so significant. We see this first when in 1857 she took the seventeen- and sixteen-year-old boys on a tour through Europe: from Belgium to Baden and Frankfurt, on to Prussia and Switzerland, to Austria and Rumania, and back to Tuscany and Naples. While such a trip was part of the socialising of young men at that stage of their lives, these were all places where the Pereires held or were to develop interests in mining, railways, and banking.[56] She was also able to introduce them to important figures in those countries.

In 1861, when they were young adults, she mapped out a plan for them to visit France's industrial north and some of Belgium's industrial towns and cities. The mines, forges, blast furnaces, and factories Emile II and Henry were to visit were all within a circumscribed radius. She proposed eleven excursions in detail. In Valenciennes, she included the coal mines and forges of Denain and Anzin. For reasons unknown, whether because of safety concerns or of time, while permitting them to explore the mines in the former,

she directed them to not go down the mines of the latter but only to observe the working of the coal extraction machines. The establishment of the Englishman John Cockerill in Liège, which manufactured locomotives and machinery for heavy industry, was on the list; so too the canon foundry at Douai; the blast furnace of the deputy, René Hamoir at Maubeuge; the forges and blast furnaces of Hautmont; the zinc mine of the Société de la vieille montagne near Liège; and the 'Atélier Central du Chemin de fer' at Malines. Linen and cotton spinning in Lille and sugar refining at Saultain presented other learning experiences.[57]

What is arresting about this by no means modest itinerary was not only the nature and significance of the industrial sites to be visited but the references to individuals who would guide her young sons in their excursions. Herminie had obviously done her homework and identified people who could assist. Several years earlier, when Emile II was planning a visit to Lyon, she urged him to take advantage of the friendship of the former Saint-Simonian, François Arlès-Dufour, and visit his silk manufacturing establishment.[58] Herminie also understood the valuable role her husband should be playing in their training and encouraged paternal involvement. When Emile II went on a business journey with his father in 1863, Herminie wrote with approval: 'I am very happy about the trip with Emile and yourself. Every moment he spends with you will be of great usefulness.'[59]

She was not blind to the differences in potential of each of her sons, however, writing to Fanny in August 1859 when both had finished their school years and waiting on the oral examination. 'I wish very much that they had finished and knew the result which is more certain for Henry than for Emile who has taken just as much trouble but with less aptitude.'[60]

We know less about Fanny's role in educating her son, Gustave. What Fanny bequeathed to him, however, was the intense pride in family which he displayed in many of his later activities. If Henry was the Pereire family's archivist, Gustave was its memoirist. While he was to play senior roles in several of the family's Spanish companies, including the Chemin de fer du nord de l'Espagne, he more than any other of the third generation set himself the task of memorialising the family's intellectual legacy. After the death of his father, he played a role in the continued existence of the newspaper *La*

Liberté. He was the chief executive of the organisation set up to manage the hospitals founded by his mother (see below Chapter 6). And he produced a considerable series of volumes drawing together the writings and business activities of the Pereire brothers: the *Écrits de Emile et Isaac Pereire* (Paris, 1900–9) and the *Oeuvres de Emile et Isaac Pereire* (Paris, 1913–23) for which he employed a former journalist with *La Liberté*, Pierre-Charles Laurent de Villedeuil, as editor.[61] He also became a financial supporter of the photography studio of Nadar and of the Falize jewellery business. Gustave was a key beneficiary of the Pereire legacy, its significance instilled in him by Fanny as Herminie had done with her sons.

From what we know about James de Rothschild's household, Betty de Rothschild also played a role in the education of her sons, Alphonse, Gustave, and Salomon, although somewhat differently. While practical experience in finance and banking was readily accessible and frequently availed of through the uncles of these young men, uncles located in Frankfurt, London, Naples, and Vienna aside from their father's house in Paris, their mother had also participated in some of their lessons when they were growing up and, in a sense, educated herself along with them.[62]

The baronne was also a devout Jew who saw to the religious education of her children which she thought vital to the family's continuing success. Thus did she choose the teachers who took on this task.[63] In this respect, she was little different from those aristocratic mothers for whom the inculcation of religious (usually Catholic) education to their children was a priority: boys were educated at Jesuit schools, girls at convents.[64] Religious education of her children, boys and girls, was not a priority for Herminie, however, which makes her involvement in the practical side of education the more remarkable.

Gustave was the only one of Fanny's children who did not suffer problems with his health. Indeed, Fanny was to be preoccupied pre-eminently in dealing with serious medical problems of her two daughters and younger son, Edouard. There are many references to her daughter Henriette's lack of mobility through muscular rheumatism that necessitated Fanny's frequent and careful ministrations, including trips to spas in the Pyrenees. And while this was to ease with time, it left a permanent mark on Henriette. Jeanne, too, suffered from an illness which is difficult to identify and Herminie

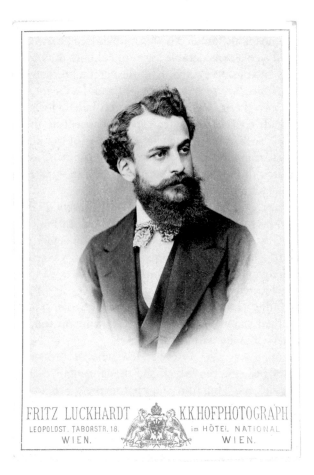

Figure 3.1 Gustave Pereire, c. 1880

was to lament the extent of it. As she did with Henriette, Fanny conducted Jeanne to health-giving spas and similar places in an endeavour to effect a cure.

We know rather more about Fanny's relations with her profoundly disabled son, Edouard (b. 1857), principally because he was the subject of the Sarchis' interest and pity and because from adolescence he did not live at home. Otherwise, family correspondence scarcely mentions him. Only seven letters exist between members of the immediate Pereire family that refer to Edouard at all: between the boy's parents in letters to each other; in one from his

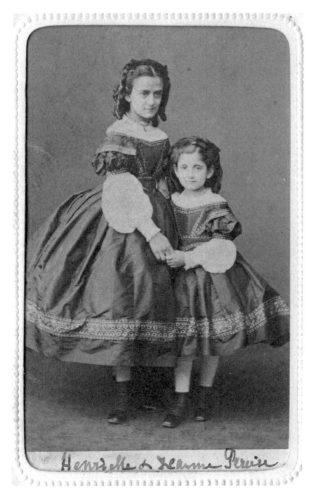

Figure 3.2 Henriette and Jeanne Pereire, c. 1860

grandmother, Herminie; and in another from an uncle. When taken in the context of the family's obvious concerns for the health of its members, including a very lengthy exchange on the health of Fanny's daughter, Henriette, this ignoring of Edouard is the more revealing.

The few letters that exist never specified the nature of Edouard's disability although they recorded its manifestations. A letter from Edouard's father, Isaac, to Fanny when the child was five years old,

commented on her calmness in the face of these daily issues: 'As to Edouard, I am not worried, I know your tenderness for the poor child.'[65] Isaac seems to have been an absent father when it came to this son, and these few letters existing within the extended family convey powerfully the heavy burden Fanny carried in dealing with Edouard's affliction.

From Arcachon, Fanny reported that seven-year-old Edouard was doing well from the pine-scented atmosphere, but she would not allow him to go swimming in the sea there as her daughters were doing enthusiastically because she 'feared his anger'.[66] This reflected an attempt to introduce her son to physical exercise, but from her comment it seems Edouard may also have been given to fits of uncontrollable rage. Herminie, writing to Henry the following year, noted that Edouard had just had a 'horrible crisis'.[67]

Herminie's sister Félicie and her brother-in-law Charles Sarchi also wrote of Edouard, however, and were more forthcoming. To her daughter in 1866, Félicie commented, 'I hear that poor Fanny is still miserable with Edouard [now eleven years old]; he scarcely merits the trouble she takes. May God have pity on her and on that so imperfect creature.'[68]

While Edouard appears to have been living with his parents during his childhood, when he was thirteen years of age in 1868, he was in the care of the Carlier family in Mortefontaine, department of Oise. The Carliers were clearly paid to look after him.[69] In that year, Félicie Sarchi wrote of Fanny having taken advantage of Isaac's better health after illness to make a sudden trip to Mortefontaine.[70] We must assume therefore that Edouard was unable to be cared for adequately at home, that his presence as a maturing adolescent was difficult to manage. In addition, the Pereire family at that time was endeavouring to come to terms with the huge financial losses of several of their companies and the resulting circumstances, which were having an immensely traumatic effect on the family. A profoundly disabled teenaged boy in the family home may have been considered an extra complication.

During the Franco-Prussian War and Commune, in a journal kept by Fanny's chambermaid Camille Desrochers, Camille drew attention to Edouard's stay in Paris.[71] Mortefontaine in the north was within striking distance of the advancing Prussian troops, and from September 1870 to February 1871, Mme. Carlier moved into

an apartment in the Hotel Scribe adjacent to the Opéra Garnier, the construction of which had been halted due to the War. No doubt Fanny, who was in the southwest with her daughters, arranged and paid for this accommodation. In a note to Henry, Fanny demanded of him to 'tell your uncle [Isaac] to go and see Edouard', but there is no evidence that this visit came about.[72] On the other hand, Camille Desrochers visited them several times, finding Edouard to be 'in very good health, even very bright'.[73]

The 1872 Census, however, recorded Edouard's presence at Mortefontaine with the brutal observation, 'idiot'. And a death certificate of 29 November 1876 recorded his death there at number 6 rue de Louvres at twenty-one years; Louis Denis Carlier, 'rentier' and 'chef de ménage', and Louis Adolphe Févé, locksmith, witnessed the certificate.[74] Several days later, Charles Sarchi wrote of this to his daughter: 'As you say rightly, the death of this poor Edouard is a real deliverance, for him and for his parents.'[75]

Whatever thoughts Fanny held about her disabled son, from the evidence we have in her letters, she kept them largely to herself. Those that exist between members of the immediate Pereire family scarcely distinguish Edouard's condition from illnesses among the other children. 'Fanny ... only has here little Edouard who she has brought back [to Paris] with a small fever but who is going well today', wrote Herminie to Henry when Edouard was three years old.[76] Herminie's son-in-law, Charles Rhoné, in a letter to Henry, noted that the eight-year-old Edouard 'has been well'.[77]

Intellectual disability or any other kind of birth defect in nineteenth-century France was hidden from view to the extent possible, regarded as shameful and, in the words of Michelle Perrot, seen to be resulting from 'tainted blood'.[78] For members of the *grande bourgeoisie*, there was even more reason to conceal a problem of this sort, since it raised questions about the health and stability of the family itself. In contrast, Fanny showed considerable compassion and love for this child, and one may speculate that she had visions of keeping him at home. It is only with knowledge from other sources, however, principally the Sarchis' letters and the 1872 Census, that the full picture of Edouard's situation becomes apparent.

If the Pereire family was close-knit, proud of its achievements, and with an intra-family loyalty, the same affection and loyalty was

afforded the extended family and friends. The Saint-Simonian circle in which Herminie had been active became an integral part of her family life, strengthening even further the bonds with her sisters, Félicie and Mélanie. The Pereire family correspondence confirms the closeness of these sisterly relations. Charles Sarchi was to tell his daughter that he and his wife Félicie at one time lived 'in the closest intimacy with the Pereire family, with Olinde [Rodrigues] and with the Bauds living in the same quarter, & often the same street, and seeing each other at all hours'.[79] The mutual affection between members of the Rodrigues family, which retained its intensity over their lifetimes, was facilitated by this close proximity. Likewise, when Fanny was growing up and throughout her life, the Rodrigues aunts and uncles extended their affection to her and to her family.

Herminie thus was the centre of the Pereire family while she was physically able. Through her meticulous attention to its needs, the careful coaching of its younger generation, its members owed the closeness and pride in achievement, their family devotion and loyalty, characteristics recognised also as somewhat exceptional by observers. When, eventually, her powers began to wane, Fanny did not take her place. Relationships with her siblings, and especially her brothers, put Fanny at a disadvantage. She was indisputably the matriarch of her own family with Isaac, but her sisters and brothers, on leaving the hôtel Pereire for homes of their own, went on to establish their own nuclear families.

Having considered aspects of the structure of this extraordinary family and in particular the working of intra-family relationships, let us now consider how they put these characteristics to work through their sociability, their *domaines*.

Their peers were busily establishing themselves in mansions commensurate with superior socio-economic status, an appropriate dwelling of which the Pereires were in need. With the establishment of the bank and its immediate success, they required an address that proclaimed just as emphatically the position they had reached, the wealth they had acquired and that they expected to increase. James de Rothschild's family was well-ensconced in luxury in the rue Laffitte where they and their banking house occupied numbers 17, 19, 21, and 23.[80] A close friend of the Pereires, Adolphe d'Eichthal, lived in the rapidly advancing financial district of the rue de la Chaussée d'Antin. Nanci Rodrigues's son, the stock broker

Édouard Rodrigues, was at number 32 rue Neuve des Mathurins and his brother Henri at number 34.

An opportunity arose in 1855 to purchase an eighteenth-century mansion at numbers 35–37 rue du Faubourg Saint-Honoré in the highly desirable eighth *arrondissement.* Its provenance was impressive. For added prestige, next door to it was the hôtel de Charost, formerly the residence of Napoleon I's sister, Pauline de Borghese, and from 1814, the British Embassy. All of these attributes fulfilled the Pereires' needs – position, magnitude, potential, and provenance.

The acquisition of this magnificent *hôtel particulier* brought major changes to the lives of Herminie and Fanny, enabling if not demanding them to play a more public role than circumstances had demanded hitherto. What were the influences on these two women that prepared them for the life of a *grande bourgeoise*? What did they need to learn? From whom did they learn it? What difference did the twenty years' difference in their ages make to this learning?

There were copybooks, books of etiquette in refined behaviour. The aristocracy was a source of modelling. Yet another source was on hand.

It is interesting to consider what role the baronne Betty de Rothschild played as a model for Herminie. They had several things in common. They were born in the same year and married in 1824, albeit there was considerable disparity in the wealth of their respective households at that time. The baronne was a woman in whose orbit Herminie moved from the mid-1830s, when the Paris–St Germain railway line was under negotiation, constructed, and then inaugurated. As much as anything this brought the two women together as their husbands worked on what was an unprecedented, costly, and complex project. At the same time, from her arrival in Paris in 1824, Betty de Rothschild had steadily entrenched herself in *le tout Paris*, becoming a friend of Queen Marie-Amélie and leading with her husband James a social life hinged on the calendar of the court of Louis-Philippe.[81] Herminie may have been on the fringes of this society, but she was no stranger to the ways in which the Jewish baronne had achieved this visibility, the activities she planned and organised, the behaviour she exhibited, and the benefits afforded the Rothschild family through her efforts.

Fanny's experience was different. She grew up in concert with the Pereire businesses. From the beginning she was aware of business

circumstances and the figures who mattered in the business world. The Paris–St Germain railway launch occurred when she was twelve, old enough to begin to take in the progress of her family's businesses. The headquarters of this business were located for a time at 16 rue de Tivoli, where Fanny was living with her parents. From there Pereire enterprises took off. Fanny was launched as a young *bourgeoise*.

By the time of the Second Empire, then, the family of the Pereire brothers provided a formidable weapon in its assault on the *grande bourgeoisie*. While Fanny's situation in relation to her siblings was a cause of some tension from time to time, overall both families exhibited unity and strength when confronting the outside world. Herminie's assiduous management of family relations had much to do with this. In the next chapter, we shall see how the two women approached the new circumstances brought about through their husbands' increasing wealth and prominence, the challenges confronting them, and the range and diversity of events they were called upon to manage.

Notes

1 AFP, Emile Pereire II, Paris, to Henry Pereire, Egypt, 26 July 1864.
2 Ibid., Fanny Pereire, Pau, to Gustave Pereire, Madrid, 11 December 1870.
3 Ibid., Herminie Pereire, Paris, to Cécile Rhoné, unknown address, 8 August 1859.
4 Michelle Perrot, 'The Family Triumphant', in Michelle Perrot (ed.), trans. Arthur Goldhammer, *A History of Private Life IV. From the Fires of Revolution to the Great War* (Cambridge, MA, 1990), 132.
5 AFP, Herminie Pereire, Paris, to Henry Pereire, unknown address, 16 January, 1859.
6 Barbara Caine, 'Letters between Mothers and Daughters', *Women's History Review*, vol. 24, no. 4, 2015, 489. The epistolary historian Marina Dossena commented that: 'We may never be sure how many readers had access to the text [of a letter]: … friends and family could gather to read letters from afar collectively, and even in business contexts the message could circulate from secretaries to managers to assistants or business partners.' See Marina Dossena and Gabriella del Lungo Camiciotti, *Letter Writing in Late Modern Europe* (Amsterdam, 2012), 18.

7 Jean Lhomme, *La Grande Bourgeoisie au Pouvoir (1830–1880)* (Paris, 1960).
8 See for instance Ferguson, *The World's Banker*.
9 Stanley Weintraub, *Charlotte and Lionel, A Rothschild Love Story* (London, 2003), 70.
10 Hervé Le Bret, *Les frères d'Eichthal: Le saint simonien et le financier au XIXe siècle* (Paris, 2012).
11 Leonore Davidoff, *Thicker Than Water: Siblings and Their Relations, 1780–1920* (Oxford Scholarship Online, January 2012, DOI: 10.1093/acprof:oso/9780199546480.003.0005), 79.
12 Grange, *Une élite parisienne*, 305.
13 Davidoff, *Thicker Than Water*, 79.
14 Smith, *Ladies of the Leisure Class*, 127.
15 We know there was a nurse attending to the infant Fanny through a letter Emile Pereire, Paris, wrote to an unknown recipient, 6 July 1828, in which Emile seemed to be asking the male recipient to marry the nurse who was now herself pregnant.
16 Helen M. Davies, 'Living with Asthma in Nineteenth-Century France: The Doctor, Armand Trousseau, and the Patient, Emile Pereire', *Journal of Medical Biography*, vol. 28, no. 1, 2020.
17 Édouard Charton, Paris, to Hortense Charton, Versailles, 2 December 1862 in Édouard Charton, *Correspondance générale (1824–1890)* Marie-Laure Aurenche (ed.) (Paris, 2008), vol. II, Letter 62/71, 1230.
18 AFP, Fanny Pereire, Paris, to Henry Pereire, Egypt, 17 January 1865.
19 Ibid. Georges Thurneyssen, Paris, to Henry Pereire, Egypt, 18 January 1865.
20 Mme. Jules Baroche, *Second Empire: notes et souvenirs* (Paris, 1921), 49–50.
21 AFP, Charles Grobois, Auch, to Emile Pereire, Paris, 27 March 1867. From other letters in the family archive, we know that Emile Pereire stayed with the Léons frequently when in Bayonne, and that Mme. Léon visited Arcachon when Emile was in residence there.
22 *Boston Daily Advertiser*, 17 February 1875.
23 Guy Fargette, *Émile et Isaac Pereire: L'esprit d'entreprise au XIXe siècle* (Paris, 2001), 203.
24 AFP, Emile Pereire, Arcachon, to Herminie Pereire, Paris, 19 October 1873.
25 BNF-A, Fonds Enfantin, 7822/81-2, 14 October 1831. The italicised word is underlined in the original.
26 AFP, letters Isaac Pereire, St Petersburg, to Fanny Pereire, Paris, most in July 1861.
27 Ibid., Fanny Pereire, Biarritz, to Isaac Pereire, Paris, 26 July 1870.

28 Ibid., Herminie Pereire, Paris, to Emile Pereire, Bordeaux, 8 October 1859; Herminie Pereire, Paris, to Emile Pereire, Arcachon, 17 November 1872.
29 Ibid., Emile Pereire, Marseille, to Herminie Pereire, Paris, 14 October 1863.
30 Ibid.
31 Ferguson, *The World's Banker*, 79, quoting C. W. Berghoeffer, *Meyer Amschel Rothschild: Der Gründer des Rothschildscher Bankhauses* (Frankfurt am Main, 1924), 201ff.
32 See note 6, where Barbara Caine comments on this practice.
33 Smith, *Ladies of the Leisure Class*, chap. 3.
34 Ibid., 42.
35 Perrot, 'The Family Triumphant', 132.
36 AFP, Isaac Pereire from Genoa, Madrid, Vienna, and St Petersburg, to Fanny Pereire, Paris, 1860, 1861, 1866, and 1870–71.
37 Ibid., Isaac Pereire, Paris, to Fanny Pereire, Biarritz, 7 July 1870.
38 The vicissitudes of the Russian rail project are covered in details in company reports at the Archives nationales du monde du travail (hereafter ANMT), Crédit mobilier, 25 AQ 1, meetings 30 April 1860, 1861, 1862.
39 W. Bruce Lincoln, 'The Ministers of Alexander II: A Survey of Their Backgrounds and Service Careers', *Cahiers du Monde russe et soviétique*, vol. 17, no. 4, October–December 1976, 476–83.
40 AFP, Isaac Pereire, St Petersburg, to Fanny Pereire, Paris, especially letters of 15 July, 22 July, and 24 July 1861.
41 Ibid., Isaac Pereire, St Petersburg, to Fanny Pereire, Paris, 22 July 1861.
42 Edmund de Waal, *The Hare with Amber Eyes: A Hidden Inheritance* (London, 2010).
43 AFP, Emile Pereire, Paris, to Herminie Pereire, address unknown, 11 September 1860.
44 Ibid. Emile Pereire, Vichy, to Herminie Pereire, Paris, 22 July 1864.
45 Ibid., Emile Pereire, Paris, to Herminie Pereire, address unknown, 16 August 1870.
46 Michel Chevalier, Lodève, to his lawyer, Michel Pilastre, Paris, 12 November 1877. Letter sold by auction through Vente Piasa, Paris, 13 February 2009.
47 Sarchi, *Lettres*, Félicie Sarchi, Paris, to Hélène Van Tieghem, Douai, 4 September 1867, vol. 1, letter 258, 390. The italicised phrase is underlined in the original.
48 AFP, Herminie Pereire, Paris, to Cécile Rhoné, Arcachon, 18 September 1867.
49 Ibid., Herminie Pereire, Paris, to Henry Pereire, unknown address, 18 September 1867.

50 These problems in the brothers' relationship are covered in Davies, *Emile and Isaac Pereire*, chap. 2.
51 Sarchi, *Lettres*, Félicie Sarchi, Paris, to Hélène Van Tieghem, address unknown, 18 August 1868, vol. I, letter 309, 469.
52 The letter was located among a group dated 1868 in the AFP.
53 AFP, Isaac Pereire, unknown address, to Emile Pereire, unknown address and undated.
54 I have outlined some of this in *Emile and Isaac Pereire*, 226–7, which is based on relevant archival material in the ANMT.
55 Perrot, 'Roles and Characters', in *From the Fires of Revolution*, 71.
56 AFP, 'Passe-port à l'Étranger', 1857 [22/7], Mme. E. Pereire née Rodrigues, Herminie, native of Paris.
57 Ibid., 'Voyages dans le Nord de mes fils 1861', itinerary in handwriting of Herminie Pereire.
58 Ibid., Herminie Pereire, Paris, to Emile Pereire II, Lyon, 18 May 1859.
59 Ibid., Herminie Pereire, Armainvilliers, to Emile Pereire, unknown address, 18 October 1863.
60 Ibid., Herminie Pereire, Paris, to Fanny Pereire, Crécy, 12 August 1859.
61 *Écrits de Emile et Isaac Pereire* (Paris, 1900–9); *Oeuvres de Emile et Isaac Pereire* (Paris, 1913–23).
62 Schor, *Baroness Betty de Rothschild*, chap. 3.
63 Ibid., 59.
64 Elizabeth C. Macknight, *Aristocratic Families in Republican France, 1870–1940* (Manchester, 2012), chap. 6, 'Aristocratic Motherhood'.
65 AFP, Isaac Pereire, Paris, to Fanny Pereire, address unknown, 12 May 1860.
66 Ibid., Fanny Pereire, Arcachon, to Isaac Pereire [Paris], 22 August 1864.
67 Ibid., Herminie Pereire, Paris, to Henry Pereire, Egypt, 10 March 1865. It is probable that Fanny was drawn to the work of Édouard Séguin, a doctor associated with Saint-Simonianism and who wrote a biography of *Jacob Rodrigues Pereire ... Notice sur sa vie et ses travaux et analyse raisonnée de sa méthode* (Paris, 1847). Séguin became expert in the treatment of intellectual disability in children, writing on the need for physical activity to promote independence.
68 Sarchi, *Lettres*, Félicie Sarchi, Florence, to Hélène Van Tieghem, Paris, 22 January 1866, vol. I, letter 74, 129–31.
69 This family seems to have been known to Fanny and Isaac since a notarial document of March 1857 shows they were all living at the same address, at number 5, rue d'Amsterdam. 1857 was the year Edouard was born. See Fould notaire, AN/MC/ET/VIII/249.
70 Sarchi, *Lettres*, Félicie Sarchi, Paris, to Hélène Van Tieghem, address unknown, 18 August 1868, vol. 1, letter 309, 469–70.

71 AFP, Camille Desrochers, 'Journal d'une Femme de Chambre pendant le siège de Paris: 24 septembre 1870–18 avril 1871'.
72 Ibid., Fanny Pereire, Arcachon, to Henry Pereire, Paris, 8 September 1870.
73 Ibid., 'Journal d'une Femme de Chambre', entry 2 January 1871.
74 Archives départementales de l'Oise (hereafter ADO) 'Recensement 1872'; 'Acte du décès', 29 November 1876.
75 Sarchi, *Lettres*, Charles Sarchi, Venice, to Hélène Van Tieghem, Paris, 3 December 1876, vol. III, letter 722, 43–3.
76 AFP, Herminie Pereire, Paris, to Henry Pereire, address unknown, 11 July 1859.
77 Ibid., Charles Rhoné, Paris, to Henry Pereire, Egypt, 5 October 1864.
78 Perrot, 'The Family Triumphant', 147.
79 Sarchi, *Lettres*, Charles Sarchi, Milan, to Hélène Van Tieghem, Paris, 3 May 1875, vol. II, letter 625, 405–6.
80 The Rothschild Archive, 'Rothschild Family Estates by Country', downloaded 20 December 2018.
81 Schor, *Baroness Betty de Rothschild*, chap. 1.

4

Sociability, entertainment, real estate, and servants: 'Fêtes, because fortune obliges it'

In *Le Figaro* of 23 July 1859, the journalist Gabrielle de Saint Mars, writing under the pen name 'Jacques Reynaud', reported on the eighteenth-century mansion acquired and revamped at great expense, time, and effort by the Pereire family. 'L'hôtel Pereire, rue du Faubourg-Saint-Honoré, is one of the most beautiful, the most elegant of our great Paris. They have brought together here artistic and industrial marvels. The two households do the honours with perfect grace, but with so much simplicity, that they seem the hosts rather than the masters.' Reynaud went on to say of the sociability to which the mansion gave rise and the demeanour of its owners:

> These are not the receptions of a great lord, like those at the home of M. de Rothschild; it is still the aristocracy of finance without doubt, nevertheless it is a softened ['modifiée'] aristocracy, an aristocracy that does not aspire to the nobility and to the display of the court, it is an aristocracy of this time and of this country … an egalitarian aristocracy.[1]

These sentiments, at once admiring of the Pereires' sumptuous living arrangements while eulogising the comparatively modest demeanour of the inhabitants, especially compared with the Rothschilds, would have struck exactly the right note for Emile and Isaac Pereire. The article was for them a masterstroke in public relations, for the Pereire brothers and their family clung to somewhat conflicting ideals of behaviour in family life: on the one hand they stressed the value of privacy, simplicity, and self-effacement in day-to-day living while, on the other, they fulfilled the expectations of *le tout Paris*, the wealthy and fashionable elite of Parisian society.

Acquiring the Paris mansion enabled the Pereire family to take their place in France's *grande bourgeoisie*, literally and figuratively. A short space of time later, they consolidated their position through the building of a grand chateau. Yet other prestigious dwellings were to follow. By 1864, the Pereires owned several magnificent properties, providing spaces for living, socialising, entertaining, and for leisure and recreation. Each one of these properties – the mansion in Paris, the chateau in the countryside, a great villa on the Atlantic coast, a *vignoble* in the Médoc – demonstrated the family's wealth and position and had its purpose. They did not by any means represent the full extent of the Pereires' real-estate holdings which were even more considerable; they were simply the places where they spent an appreciable amount of time. In the range of these residences there were also similarities with the style of life of noble families who, as Elizabeth C. Macknight has described, decamped with their servants from the city to the provinces in the summer months.[2]

This chapter will consider the manner in which Herminie and Fanny Pereire used these residences, the activities planned and organised, their meaning and significance, and the effects they were intended to have in the interests of family life, entertainment for themselves, and for *le tout Paris*. We will later consider the indispensable role servants played in them; the role played by Herminie in particular in managing them; and how the servants employed in these establishments of the *grande bourgeoisie* compared with those employed by the nobility, in duties and in salaries.

A reassessment of the situation facing Jews during the July Monarchy and beyond led the historian Julie Kalman to the conclusion that for many French, 'Jewishness ... was representative of all that went against the nation.'[3] For wealthy Jews in nineteenth-century France, overcoming impediments of suspicion and barriers to advancement and gaining acceptance by *le tout Paris* thus became the goal, meaning, as Catherine Nicault wrote, 'receiving the "gens du monde" at home and being received by them' in turn.[4]

Women were crucial to the project of acceptance in the *grande bourgeoisie*. They planned, organised, and presided over social events in the capital and elsewhere, events designed to show off high culture and polished, civilised manners just as much as wealth and opulence. They displayed and contributed a more approachable and

appealing side than did the men. 'The worldly success of the finance tycoons rests largely on the shoulders of their wives [as Nicault commented], but particularly perhaps in the case of Jews who have even more for which to forgive themselves.' Nicault differentiated the roles thus: 'to the man the jungle of business, to the woman the conquest of worldly position'.[5]

While nobles were a model to emulate and almost certainly had an influence on the way the Pereires engaged in entertainment and sociability, as well as on the kinds of establishments they built, most of the Pereire residences were acquired in one way or another as a riposte to the Rothschilds with whom the Pereires had become bitter rivals, Jewish families locked together in a competition of display as many commentators have noted.[6]

The principal residence, the hôtel Pereire, at numbers 35–37, rue du Faubourg Saint-Honoré in Paris's eighth *arrondissement*, was an existing mansion substantially renovated to plans by the Pereire company architect, Alfred Armand.[7] The nephew and son-in-law of James de Rothschild, Nathaniel, in 1856 had purchased number 33 in the same street, built in 1714 by Pierre Grandhomme. He was thus an immediate neighbour to the Pereires, although enhancements to his mansion were not completed until 1867.[8] The Château Pereire at Armainvilliers just outside of Paris was a stone's throw from the Rothschilds' Château Ferrières. Again, in 1853, the same year that Nathaniel Rothschild purchased the Pauillac vineyard in the Médoc, which was to become known as Château Mouton Rothschild, the Pereires purchased their own, Château Palmer, in the Margaux commune.

Thus, as much as anything else, did the Pereires compete through their properties for primacy among the Jewish elite of the Second Empire. The only major acquisition that did not have a competitive equivalent with Rothschild was the Pereires' investment in the *station balnéaire*, Arcachon, on the Atlantic coast, sixty kilometres from Bordeaux. The Villa Pereire on forty-one hectares was completed there in 1864, and by 1878, ninety additional villas had been constructed.[9] It was not until the twentieth century that the Rothschilds invested in anything of a similar nature or scale to Arcachon, and that was the ski resort, Megève. Here, ironically, it was a Pereire descendant, Noémie Halphen, great-granddaughter of Isaac Pereire and wife of baron Maurice de Rothschild, who

kick-started the project through a hotel she had caused to be constructed there, l'Hôtel du Mont d'Arbois.[10]

If the domesticity of women was differentiated from the public, active role, of men, it is in the home that this separation was most evident. Managing the task of entertainment devolved to them. This was so for Herminie and Fanny Pereire, although the sheer number of places they could call home rendered the management of this family life challenging. At the same time, the spheres were not always hermetically sealed, for we find Herminie and Fanny dealing with the outside world in different circumstances that we shall come to over the course.

Herminie was the principal household manager of the various establishments in the early stages and during the Second Empire. Account books dating from July 1869 to August 1870 exhibit something of the way she managed this oversight. They show minor expenses incurred on a monthly basis for each of Herminie, her daughters Cécile and Claire, and Eugène Pereire's wife, Juliette, for a variety of items mainly associated with Armainvilliers. These accounts did not include clothing but they did include expenses for haberdashery, postage, tobacco, travel (bus fares and horses), as well as purchases of soft furnishings such as mattresses and *passementerie*. The accounts also covered wages for the local workers who cleaned the chateau, forty-six francs, presumably in readiness for the summer onslaught of visitors, and for the travel of servants to and fro. There was also a certain amount of reimbursement between the women in cases where slight errors may have been made. Herminie's accounts covered all but October and December 1869, when she would have been in Paris. She thus kept a tight rein on expenditure. The source of payment for these accounts was not Herminie, however, but her husband, who is noted elsewhere in letters as providing her with more money at her request to cover costs. There seems not to have been a regular arrangement, which might suggest that while Herminie maintained a budget more money was provided as it was required.

The social engagements of the Pereire family differed according to the venue. From letters in the family archive as well as from published sources, it is apparent that the range of activities offered, the guests invited, the frequency and duration of their visits, all were clearly differentiated according to properties.[11] To Herminie

and Fanny, the properties represented different opportunities for sociability, entertainment, and leisure, and at different times of the year. They were also residences where they felt either more or less at ease. Both, it seems, were at home at Armainvilliers but less so at Arcachon, for instance.

What the Pereire women did in Paris at the hôtel Pereire, and which was expected of them, supported the ambitions and businesses of Emile and Isaac. Both men had offices in the mansion where there was much toing and froing with their companies' combined headquarters nearby at 16 place Vendôme, now the Hotel Ritz. Thus, Herminie and Fanny arranged dinners, 'at-homes', concerts, and balls, and Herminie and Emile's daughter Cécile, married to Charles Rhoné, a senior figure in the Pereire companies, was also 'at home' each week during the social season at the hôtel Pereire, where the Rhonés also lived.

In 1863, the roles played by Herminie and Fanny became even more important with the election to the Corps législatif of both Emile and Isaac Pereire as deputies, Emile for the Gironde department and Isaac for the Pyrénées-Orientales. The guests Herminie and Fanny invited were now frequently politicians in positions of influence as well as business associates, or men the brothers wished to cultivate in the interests of their businesses. They often included people the women did not know, and not all of these social occasions included other women.

In Armainvilliers, on the other hand, where Emile and Isaac also kept bureaux, Herminie and Fanny Pereire had more time and scope to relax informally with family and friends. While larger gatherings and hunting took place there to promote in one way or another Pereire business interests, the women controlled the uses to which the chateau was put to a greater degree than they did in Paris. For this reason, Herminie especially felt most at home here. It was close enough to Paris for Emile and Isaac to transact business – the Est rail line included a branch to Gretz, close to the Château Pereire, and there was a telegraph installed at the chateau – but its proximity to Paris also encouraged friends and family to visit and stay.

Arcachon was a different proposition again, a place for summer holidays *en famille* although much associated with the health of the patriarch Emile and his chronic asthma. Too far from Paris for day visits, and not as expansive as Armainvilliers, guests arrived in

response to a clear invitation sent well in advance and needed to set aside time. Herminie also arranged accommodation for their friends at nearby chalets when the Villa Pereire was overflowing. In turn, Château Palmer was a working vineyard but one which provided opportunity for recreation for the whole family.

One important difference, however, was that friends and family from Bordeaux and Bayonne were, for practical reasons, more likely to visit the Pereires in Arcachon or at the Château Palmer than in Paris or at Armainvilliers. More than likely, the purchase of these properties enabled the Pereire brothers to maintain their roots there, Emile's especially, for he was more sentimentally attached to the region of his birth than his brother.

We will study the Pereire mansion in Paris to begin with. Of the Paris *arrondissements*, the eighth was the one which appeared to be favoured almost exclusively by Jews of the *grande bourgeoisie*.[12] In the rue du Faubourg Saint-Honoré we note the presence of well-to-do bankers, including the Rothschilds and the Pereires. In this street as elsewhere, the attraction for Jews of *hôtels particuliers*, private mansions, especially those with an *ancien régime* provenance and a demonstrable connection with its nobility, was apparent.[13] The Pereires were no different. The hôtel Pereire had started life in the eighteenth century as the hôtel Chevalier, then became in turn the hôtel d'Esclignac, residence of the comte d'Esclignac. Sold in 1813 to the lawyer Anne-Elie Pierre Jean Commaille, it came on to the market again in 1855 and was purchased almost immediately by the Pereires at a price of 1,600,000 francs. It underwent substantial reconstruction inside and out to a design by Alfred Armand, the architect of the Pereires' Grand Hôtel du Louvre and the Grand Hôtel as well as of the stations associated with their railways. When finally ready for habitation the inauguration took place in February 1859.

The hôtel Pereire thus combined tradition with innovation, elements noted by the architectural historian François Loyer as typical of mid- to late-nineteenth-century urban Parisian architecture for the wealthy.[14] Armand was careful to retain elements of the building's historical past, including an impressive entrance foyer, a grand staircase, and a number of rooms for receptions. But in the use of new materials, iron and glass; the provision of new spaces, a *serre* and *jardin d'hiver*, grand salons and small; and in introducing new

Sociability, entertainment, real estate, and servants 125

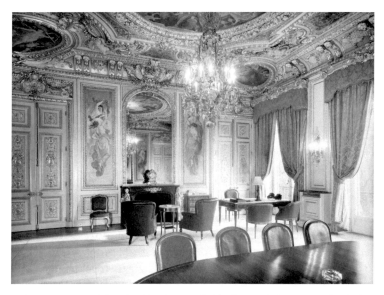

Figure 4.1 Hôtel Pereire, 35–37 rue du Faubourg Saint-Honoré, 1952, *Grand salon* now the British Ambassador's Office

technology for heating and hygiene, the Pereire mansion was at the forefront of luxurious modern Parisian architecture and at the pinnacle of domestic aspirations for the *grande bourgeoisie*.[15]

These aspirations were twofold. First, the *hôtel particulier* needed to provide the family with warmth, comfort, security, and convenience based around modern technology and advances in design. Second, it was intended to provide spaces to display the artworks and other precious objects the family had acquired.[16] For the Pereire mansion, there was a further requirement: in tune with Sephardic custom as lived in Bordeaux, it needed to provide a living environment for the entire family. This pattern of family co-habitation was one experienced by the Pereire brothers and their mother in their home city and replicated from the time they arrived in Paris, living in rented accommodation with the Rodrigues. Later they lived side-by-side in apartments in the same dwelling in an area close to the gare Saint-Lazare, in the rue d'Amsterdam, and in the rue de Tivoli. But the hôtel Pereire represented the first opportunity to live together under one roof as a large, extended family. The complications that such co-habitation generated created many problems

for Herminie, and from the outset. As the key figure in organising accommodation for the family, the architect needed to work closely with her in ironing out the practicalities of such an arrangement in his designs for living.

This co-habitation was one of the few indications that the occupants were Jewish. Until the early 1870s, the hôtel Pereire was home to them all, housing in separate apartments Herminie, Emile, and their sons Emile II and Henry Pereire; their daughter Cécile, her husband Charles Rhoné, and their three daughters; and Herminie and Emile's youngest daughter, Claire, with her husband Georges Thurneyssen and their three sons. Isaac, Fanny, their children Gustave, Henriette, Edouard and Jeanne Pereire; and Isaac's son by his first wife, Eugène and Eugène's wife Juliette, were all resident there.

Herminie and Emile Pereire were the first to move in, much earlier than its inauguration, in April 1858, for Herminie needed time to ensure the readiness of the house for its many occupants, family and *domestiques*. Fanny and Isaac took more time, the *Journal de Genève* reporting that they found the apartments 'too beautiful, too big' and missed the more modest circumstances in which they had lived previously.[17] This was somewhat fanciful since with a family of four young children aged from two to twelve years, Fanny clearly needed more space than an apartment in the rue de Tivoli could provide.

The new hôtel Pereire had been reconfigured to provide private and public rooms. There was only so much that could be achieved by Armand's renovation, nevertheless. Despite appearances, residential space at 35–37 rue du Faubourg Saint-Honoré was not ample, constrained by the number of family who lived there. Visitors thus attended social events but could rarely stay overnight. As space became ever more stretched with the birth of children, Isaac's son Eugène by his first wife Laurence Lopès Fonseca, together with his wife Juliette Fould and their daughters, Alice and Marie, in 1873 moved a little further along the same street to their own mansion at number 45 rue du Faubourg Saint-Honoré. This in turn also conformed to the pattern of desirability: the hôtel Brunoy had been an eighteenth-century *hôtel particulier* constructed for the marquise de Brunoy to a design by the visionary architect Étienne-Louis Boullée.

Not unusually, given the social priorities demanded of their mansion, what the hôtel Pereire lacked in accommodation it compensated

for in spaces for entertainment. One might even suggest that this was an equal priority with day-to-day accommodation for the family and, indeed, would confirm the Pereires' insistence on and need for recognition by the fashionable elite. Herminie and Emile lived on the ground floor (*rez-de-chaussée*), Fanny and Isaac immediately above on the first. Each of these apartments provided a *grand salon*, a magnificent *salle à manger*, a music room, and a private gallery for their artworks. Cécile and Claire, together with their families, also had apartments facing onto the rue du Faubourg Saint-Honoré, albeit more confined.[18] A central heating device, a *calorifère*, supplied heating to the whole building through pipes carrying hot water. Several of the reception rooms gave a charming aspect on the garden, created on land which had been purchased subsequently for a further 214,000 francs and which extended to the rue Gabriel, running parallel with the rue du Faubourg Saint-Honoré.[19]

While Herminie and Fanny were by now rather more accustomed to socialising with powerful figures, either Jewish or non-Jewish, circumstances until then had scarcely demanded – and their living arrangements certainly had not permitted – them to organise any very ambitious functions on their own. Now, however, with the imposing family dwelling, they expected, and were expected, to mount grandiose occasions that brought the name Pereire into the social domain and that were reported in the press. Money was no impediment. The hôtel Pereire was to be the family showpiece, allowing the full extent of the family fortune to be placed on display and in direct competition with mansions of others of the *grande bourgeoisie*.

Music was the connecting link between the Jewish family and non-Jewish high society. It was a means of presenting a cultivated front to others of their class.[20] During the July Monarchy, James and Betty de Rothschild had perfected the art of entertaining at their home in the rue Lafitte, providing a musical salon that brought the most renowned performers and composers, including Rossini, Meyerbeer, Chopin, and Liszt, to the attention of Parisian society.[21] By the 1860s, such entertainment had grown beyond the privacy of the musical salon to become a highly orchestrated event in more ways than one. Herminie put to good use her mother's hard-won provision for music lessons, mounting with Fanny musical evenings with well-known performing artists and hundreds of important

guests, figures from across the spectrum of politics, business, and the arts.

The first of the events at the hôtel Pereire was a concert, a 'pretext', according to one journalist, which effectively inaugurated the palatial residence in February 1859, causing a traffic jam among the carriages in the surrounding streets lasting an hour and a half.[22] The presentation of the guests, who were received by Herminie and Fanny, was as lengthy. The invitees were a mix of politicians (the President of Saxony, the Ambassador of the Ottoman Empire, the French ministre de l'Intérieur); business associates of the Pereires, or those whom they were cultivating; journalists and literary figures (Émile Augier, Alexandre Dumas *fils*, Émile de Girardin, Arsène Houssaye); and the comte Émilien de Nieuwerkerke, surintendant des Beaux-Arts and lover of the Princesse Mathilde Bonaparte, the Emperor's cousin. All flocked to this event which was reported in the press and rapidly became legendary. Prominent artists from the Théâtre-Italien – the contralto Marietta Alboni, the coloratura soprano Ermina Frezzolini, and the baritone Francesco Graziani, 'et tutti quanti' – entertained the guests.[23] Of this concert a journalist, reporting what he had been told, noted, 'I'm not sure that anyone listened, but many applauded. Their eyes were more occupied than their ears. The concert was at a disadvantage to the spectacle.'[24]

Five immense salons were 'decorated in the grand style of Versailles. A lot of glass. A lot of gilt, too much gilt, for if they were tempered by the delicious paintings of the ceiling, these, consequently, were a little extinguished by the sparkling of the metal.' Ladies were seated in rows of armchairs in four of these great salons. Men, described as 'grave' of countenance, chatted in groups in the small salon, the dining room, or the *serre*, or strolled through the picture gallery.[25] Thus did Herminie and Fanny ensure an appropriate inauguration for the hôtel Pereire. An impressionable press referred to the mansion frequently thereafter. 'A palace, a domestic fortress', reported *Le Monde illustré*.[26]

The large receptions mounted by Herminie and Fanny invariably included some form of entertainment. Letters from 1864–65, when each was to receive guests within a few days of each other, tell us something of the expense incurred, the organisational complexities involved, and the tastes and preferences of the two women. In all cases, the leading opera theatres in Paris provided the singers: the

Paris Opéra, the Théâtre-Italien, and the Théâtre Lyrique. All the performers were expensive, of which the guests were surely well aware. It is also noticeable from letters that whereas Herminie seemed discomposed by the organisational task and the choices she had to make, flustered indeed, Fanny exuded calm.

Herminie began her receptions fortnightly on a Tuesday. To begin with there was a dinner to plan. For the first of these, on 24 January 1864, she extended invitations to, among others, the diplomat and politician, Adolphe Barrot; Charles de Lagau, the former ambassador to Hamburg and to Tunisia; Vincent Dubochet, the Swiss financier and industrialist; and Auguste Thurneyssen, banker and father-in-law of Claire Pereire, who was the only guest well-known to Herminie. The dinner was clearly mounted in the interests of Pereire business. Adolphe Barrot had recently retired as French ambassador to Spain, where the Pereires had substantial interests, and he was brother of the politician Odilon Barrot. Dubochet was on the board of the Compagnie de l'Ouest des chemins de fer Suisses, a Pereire railway company, as was Thurneyssen.[27]

A concert attended by two hundred followed, at which the pianist Charlotte Tardière de Malleville performed as a soloist and also accompanied Christine Nilsson, the Swedish *bel canto* soprano of the Théâtre Lyrique; and Victor Warot, a Belgian lyric tenor of the Paris Opéra. All three were in the public eye: Malleville as one of the leading pianists of her day and especially for her interpretation of Mozart and earlier composers; Nilsson having recently made her début to wild acclaim as Violetta in *La Traviata*; Warot with leading roles in several premiere performances at the Paris Opéra, including in Victor Massé's *La Mule de Pedro* (1863).[28]

Fanny's receptions were even more ambitious, catering weekly for up to eight hundred, although how these numbers were accommodated is difficult to imagine, even with the large spaces created by Armand for entertaining. She also presented renowned singers, such as Adelina Patti, then of the Théâtre-Italien, who soon after commanded £400 per performance from the St Petersburg Opera.[29] But Fanny was also interested in leading instrumentalists, the violinists Jean-Delphin Alard of the Paris Conservatoire and his star pupil, Pablo de Sarasate.[30] The entire family, with the exception of the very youngest children, was present on these occasions, which finished with dancing until late in the night. The third-generation

Pereires were thus introduced early to the expected sociability of *le tout Paris*.

The effort expended by Herminie and Fanny, much less the ownership of the events they staged, were rarely if ever acknowledged in the press, however. Reports frequently referred to the receptions of the 'MM Pereire' or 'M. Pereire' without identifying them individually. *Le Monde illustré* reported in November 1860: 'It is the season of fêtes. MM Pereire, viceroys of finance are opening their salons.'[31] The journal went further in describing events at the hôtel Pereire as 'Sardanapalesque'.[32] *La Vie parisienne* reported similarly in January 1865 on 'the soirée chez MM. Pereire where we heard Gardoni, Graziani, even the old Tamburini. M. Pereire [who was not otherwise identified] receives with the splendour of M. Fouquet.'[33] *La Vie parisienne* did however report, unusually, in 1864 that 'The concert given Friday at the home of M. and Mme. Pereire was truly princely.'[34] We know that this report referred to Fanny and Isaac because she organised these events on Fridays. It is not clear whether this was deliberate, a pointer perhaps to their being a non-practising Jewish family.

While such sumptuous large gatherings were numerous, social events favoured by Emile Pereire and his brother Isaac could be more intimate. Emile, for instance, regularly entertained a small group of prominent figures, all male, with a private dinner and discussion. Edouard Charton reported in letters to his wife on the attendees: Jacques Bixio, the doctor and politician who entertained his own *dîner Bixio*; Hippolyte Carnot, also a politician and former Saint-Simonian; Armand Trousseau, the eminent physician who was Emile Pereire's doctor; and Charles Daremberg, the medical historian.[35] Isaac also entertained independently, although his guests were more likely to be business associates and/or former Saint-Simonians with whom he conscientiously stayed in touch. While Herminie and Fanny organised these events, including issuing the invitations on behalf of their husbands, they did not attend them.[36]

Not all the events and functions were in the interests of business or to promote the family name. There were, of course, many more relaxed and intimate family occasions in which Herminie or Fanny played some role. Emile II, who celebrated his thirty-second birthday in February 1872, invited his aunts Mélanie Baud and Sophronie Andrade, his brother, Henry, his sister Cécile and her

husband Charles Rhoné, his sister Claire and her husband Georges Thurneyssen and their three children, as well as his wife, two of his young children, and his parents. Interestingly, in this instance neither Fanny nor Isaac nor any of their family appear to have been invited to the party.

Following the calamities of the period 1870–71, and with the death of Herminie in 1874, Charles Sarchi reported that Fanny was to resume the social round of a previous era with entertainments in the hôtel Pereire. This resumption of sociability was not easy. The demise of the Crédit mobilier and the subsequent legal battles in which Emile and Isaac Pereire were forced to engage placed sociability at the perimeter of the family's needs. In his letter to Hélène Van Tieghem, Charles Sarchi wrote with some concerns about this:

> The news that you give me about the impending reopening of Fanny's salons has a certain importance and is an excellent sign. I would wish, however, that one might hold to very moderate limits, and that one does not recommence the splendours of former days, that stirred up so much envy towards them, and so much hatred. Of this population of Paris, so contemptible with some exceptions, the most despicable of all the classes is perhaps that of the financiers and one does not surround oneself with these vile brigands without danger.[37]

With some courage, Fanny began to mount once more the glittering occasions of an earlier day. Aside from anything else, this was her manner of introducing her younger generation, now young adults, to French society. In 1877, the much sought-after Jewish composer, pianist, and conductor Emile Waldteufel, who had once been director of music for Napoleon III, dedicated a piece of music to her: 'Prestissimo galop'. A joyous, rousing piece, it gave rise to a dance that generally drew the evening to a close with some gusto.[38]

One further means of public entertainment should also be mentioned here, and that is the use to which the family put the majestic dining rooms of the Grand Hôtel, constructed for the Exposition universelle of 1867 and now the Intercontinental Paris Grand Hotel. Here again, Herminie and Fanny were caught up in organising even more splendid large-scale events when dinners for several hundred people could be mounted for special occasions.

The Château Pereire at Gretz Armainvilliers served a purpose different again from the hôtel Pereire, although one that carried

similarities to the chateaux of the French nobility. Chateaux and seigneurial residences had been, from the fourteenth century, the mark and the prerogative of the nobility. In the years following the French Revolution, however, 20 per cent of properties belonging to the nobility were sold off, taxes were introduced on existing land, and seigneurial dues, which had been a principal source of income, were abolished. The Code Civil made further inroads into the extent of ownership by the nobility with the abolition of the right to primogeniture and the introduction of partible inheritance, in which children inherited equally.[39] While nobles were losing their estates or struggling to retain them, members of the *grande bourgeoisie* sought to establish themselves outside of Paris, where they could give free rein to their wealth and its display through the purchase of buildings and land. They could also lay claim to the style of life of the previous owners. Thus, they eagerly bought the properties that came onto the market.[40]

For Jews, possession of a country house was a further stage in the process of acculturation, a definitive sign that the family had succeeded. From the July Revolution onwards, they hastened to purchase existing country houses or to construct them. A number of these new owners were friends of the Pereires. Nanci Rodrigues's son, the banker Édouard Rodrigues, acquired the Château Bois-Préau, part of the domaine of Rueil-Malmaison and adjacent to

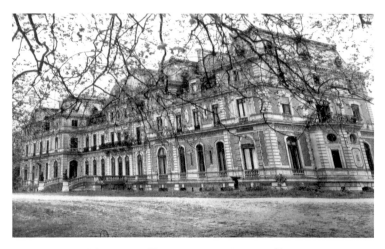

Figure 4.2 Château Pereire, Armainvilliers

the Château de Malmaison. Rodrigues virtually rebuilt the existing early nineteenth-century chateau. Some of the land he later ceded to his daughter, Cécile, who had married a Saint-Simonian and writer, the convert Gustave d'Eichthal, who thus built the neighbouring estate, Vertmont.[41] Édouard's brother Henri was not far away in the Château des Lions at Port Marly in the department of Yvelines.[42] Gustave d'Eichthal's brother, Adolphe, also a banker and politician, developed an extensive property, La Mine, at Dixmont in the Yonne department.[43] Benoît Fould purchased the Château du Val, a sixteenth-century hunting lodge in St Germain-en-Laye, which had belonged to Louis XIV and had been considerably extended and enhanced by the renowned seventeenth-century architect Jules-Hardouin Mansart.[44] And James de Rothschild contracted the British architect Joseph Paxton in 1855 to design the Château Ferrières in the Seine-et-Marne department in a style closely resembling that of Mentmore Towers, his cousin Amschel's stately home in England.[45]

All these country residences not only held their Jewish ownership in common; they were mostly purchased within a comparatively short period in the 1850s. They were testament to the rapidly increasing economic power and social aspirations of the new owners, most of whom were bankers or financiers, and to the encouragement of financial and social success afforded Jews by the Second Empire and its ruler. Crucially important was the coming of rail that rendered all these places within striking distance of Paris.

A large area of land in Crécy-Armainvilliers, also in the Seine-et-Marne, had been purchased in 1853 by the Pereires together with Adolphe d'Eichthal, their business colleague and friend. That it was close to the Château Ferrières and thus caused James de Rothschild much chagrin was almost certainly a factor in the purchase. Indeed, an early letter from an agent to Emile Pereire explicitly stated that the Mulhouse railway line which crossed the forest of Crécy 'approaches the most closely M. Rothschild [but] it does not touch his property!'[46] Rothschild himself was to complain bitterly about the effrontery of his former protégé and of d'Eichthal in purchasing land so close to his own domain.[47]

The Château Pereire, which rose on a portion of the estate at Armainvilliers, was completed in 1862, designed on a large scale again by Alfred Armand, the Pereires' architect, who had restructured

their Paris mansion. Nearly one hundred metres wide, and described by a descendant as in a style 'fairly ugly, that of Napoleon III', it consisted of a central dome flanked by two large wings, each of which housed one or other of the brothers and their respective families. The central cupola carried two decorative motifs in stone: a locomotive and a ship, symbolising fields of endeavour in which the brothers had excelled.[48] What it lacked in taste and elegance, however, the chateau made up for in technology. Serving the business interests of the Pereire brothers, the telegraph was installed there at an early date. Again, the uses of innovation so evident in the hôtel Pereire came to the fore over time as electricity and the telephone were both introduced at the earliest moment. Easily accessible to Paris by rail, the family was frequently in residence, particularly during the summer months.

The chateau was set in a huge area of forested land suitable for hunting, which the male members of the family enjoyed. Their guests included men from across the spectrum of power and prestigious activities: politicians, industrialists, bankers, literary figures. In September 1864, twenty-four men received invitations to the opening of the season, among them the newly entitled duc de Persigny, a stalwart and friend of the Emperor; and Auguste Nélaton, who was to become Napoleon III's personal surgeon. Much anticipated by the male members of the family, it was not an occasion for the women.

Nevertheless, Herminie Pereire felt most at home in Armainvilliers, a fact which Emile Pereire admitted to his son, Emile II: 'Your mother finds it better in Armainvilliers. The tranquility which she can enjoy [is] evidently more favorable than the more agitated life of Paris.'[49] One might hazard that she also found Armainvilliers more congenial than Arcachon, where, late in her life, she was forced to spend long months with an ill and exhausted husband.

Modern interest in the Jewish country house as a subject of historical enquiry has paid attention to the ways in which such a building could be seen as exhibiting something of its owners' Jewish past or present or, indeed, of Judaism per se. Leora Auslander, for instance, posed the question: 'Was there anything particularly "Jewish" about country houses owned by Jews?' She noted that these dwellings, as relatively recent possessions of the Jewish 'super-elites' in nineteenth-century Europe, could be seen to perform

several possible functions, private and public, and went on to outline a number of ways in which the Jewish country house exhibited diverse elements concerning its particular ownership.[50]

Architecturally, the Château Pereire did not accommodate any features that were identifiably Jewish. The small synagogue at the Rothschilds' Ferrières certainly had no equivalent at Armainvilliers. Nor do the decorative features, so far as we know them from inventories and photographs (the latter of which are admittedly principally exterior shots), present any overt indications that this was a Jewish country house, although it is possible that the Pereires' chateau housed certain family memorabilia that was Jewish in nature. And whereas Auslander pointed to the ease with which Jews could obtain access to their country homes through the rail lines in time to prepare for the Sabbath, this was not an issue with the Pereires, who did not observe the Sabbath. Only perhaps, and as with the hôtel Pereire, in its primary use as recreational accommodation for the whole family do we revisit once more the Sephardic family experience in Bordeaux. There was one major difference with the hôtel Pereire: aside from sleeping quarters, all the spaces were shared.

Overall, the chateau at Armainvilliers compensated for what the hôtel Pereire lacked, namely, opportunity to invite extended family and friends to stay. While it accommodated a grand salon and several smaller ones, a library, a gallery, and a very large dining room over four levels, it also housed more than forty bedrooms, some with a private toilet and bidet and some furnished for infants or small children. The chateau's *Inventaire* identified some bedrooms as allocated to specific members of the family and certain servants.[51] There were sixteen separate *cabinets de toilette*, including two *salles de bains* with baths and douches. While the *Inventaire* is dated variously from 1879 to 1889, there is no evidence that there were any major additions to the building beyond 1862 when it was originally built.

On one occasion in October 1863, Fanny entertained twenty guests *à table* for lunch and an expected thirty for dinner the same evening. It is instructive to look at those who were to arrive, who included the Chobrzinski family, one of whom had married a daughter of Olinde and Euphrasie Rodrigues; the former Saint-Simonian Michel Chevalier; the family of the celebrated pianist Rubini; the secretary to the Emperor, Jean-François Mocquard, and his family;

aunt Mélanie Baud and her family; the family of the Saint-Simonian Charles Duveyrier; and several friends of Herminie's son, Henry. This extensive guest list, which welcomed families, close friends of long-standing including from Saint-Simonian days, and a spanning of the generations, was typical of the visitors Herminie and Fanny invited to the Château Pereire.[52] It was not solely business interests that were to be entertained, but an eclectic mix of people of some substance.

Aside from her family, the Saint-Simonian past was Herminie's mainstay. She had a particularly close friendship with the mathematician and physicist, Jean-Marie Constant Duhamel and his wife, Virginie Bertrand; with Charles Duveyrier and his English wife, Ellen Claire, née Denie; and with Henri and Cécile Fournel, all old friends.

Herminie's love of family life and her capacity to draw family together was nowhere more evident than at Armainvilliers. All her children, grandchildren, daughters- and sons-in-law enjoyed her hospitality there. Over the period May to October 1864, when many of her extant letters from Armainvilliers were written, each of her sisters and their families also visited, together with Olinde Rodrigues's widow Euphrasie (Olinde having died suddenly in 1851), who was a frequent and welcome guest. The families into which Herminie's children had married – the Chevaliers, the Rhonés, and the Thurneyssens – were regular visitors. The Sarchis, too, their daughter, Hélène and son-in-law, Philippe Van Tieghem, all came to stay.

Certainly, the Pereires' business associates were frequently there also, although some had become close family friends over the course of years, like Michel Chevalier, who was later to write the damaging letter about Fanny; Casimir Salvador; and the director-general of the Midi rail line, Alexandre Surell. So were people to whom hospitality needed to be repaid by family members. The Sarchi circle greatly facilitated visits to Italy, and thus did signor and signora Juva, on whom Herminie and her two sons had called in Florence in 1860 on a grand tour, stay at Armainvilliers in May 1864, as did another Florentine couple, the d'Anconas, who had extended hospitality to Emile II and his new bride, Suzanne Chevalier, on their honeymoon in Italy of that year.[53]

Herminie's husband was not fond of Armainvilliers, however, believing that it exacerbated his asthma. Armainvilliers is known for

its extensive and unrelentingly humid oak forests, which may have predisposed him to these attacks. His brother Isaac, on the other hand, was there frequently, taking up almost permanent residence towards the end of his life. For this reason Fanny also entertained at Armainvilliers, although she does not seem to have received a different set of family or friends. Perhaps, as the daughter of Herminie, there was some sensitivity about who would invite which guests. It appears that Fanny began to entertain there on a large scale herself only after the death of her mother. And on the death of her father, she and Isaac assumed ownership of the chateau and control of its use, one of the important family events that we shall come to in Chapter 8.

What effect did the Pereires' presence have on the neighbouring town of Gretz? According to one historian of the Rothschilds, for example, their Château Ferrières employed two hundred people from the adjacent village. There was a doctor and a teacher as well as unskilled staff.[54] The Rothschilds were thus important employers in Gretz. The Pereires' establishment was nowhere near so elaborate, and we come to the question of servants later. But there was one incident which perhaps indicates something of how the Pereires were seen by the neighbouring nobility.

The Pereires' chateau, which was built within the forest of Armainvilliers, rapidly came to be known as the Château d'Armainvilliers, to the annoyance of the duc and duchesse de la Rochefoucauld-Doudeauville, who already owned the Domaine d'Armainvilliers, after which their own chateau had been named. The provenance of the existing chateau steeped in nobility may have been the incentive for the Pereires to encourage the name to be associated with their own property. They certainly made no effort to change it.

The year following completion of the Pereires' chateau, the Rochefoucauld-Doudeauvilles requested Emile Pereire to do so, suggesting rather facetiously 'Château de la Souche' ['stump'] as an alternative, perhaps after Molière's unsympathetic character Arnolphe, M. de la Souche in *L'école des femmes*. Emile Pereire refused to accede, and in 1863 the matter went to court. He lost.[55] Whatever this tale suggests it is not one of welcome to Armainvilliers but, rather, of bias that was perhaps either anti-Jewish or anti-nouveaux riches. Ironically, and perhaps this was intentional in view of their

history with the Pereires, when the Rochefoucauld-Doudeauvilles came to sell their property, they sold to the Rothschilds.

We then come to Arcachon, which served a different purpose again, one associated principally with the health of the patriarch, Emile Pereire. The development of the resort at Arcachon, some 60 kilometres from Bordeaux on the Atlantic Coast, showed little resemblance to the pattern of living or of property ownership established by the old nobility. The duc de Morny played a major role in the establishment of Deauville as a centre for horse-racing in the early 1860s. Jewish financiers bankrolled seaside and mountain resorts, largely for profit. But Emile Pereire's rationale was unique and, in its implementation, Arcachon exceeded any comparable developments.

In seeking relief for his chronic asthma, he became an enthusiast for climate therapy, a form of treatment for pulmonary complaints which involved exposure to large doses of sea or mountain air. The theories of Dr Joseph-Émile Pereyra about the efficacy for treating these and other complaints such as tuberculosis, the number one killer in France during the nineteenth century, of bathing, ocean air, and the scent of the resinous pine forests nearby to La Teste at Arcachon came to interest him.[56] That the fishing population

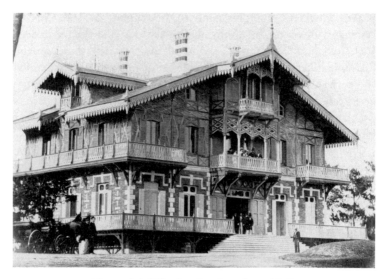

Figure 4.3 Villa Pereire, Arcachon, 1863

along this part of the Atlantic coast appeared to enjoy very good health was known, and the benefits of sea bathing and the open air began to be promoted by the local medical fraternity.[57] The arrival of Emile Pereire in Arcachon was the turning point for the town.[58]

He did expect to make a profit from his investment there. In the planning and development of the 'Ville d'Hiver', the objective was to provide a winter retreat for wealthy TB sufferers and others suffering lung complaints. Villas designed by Herminie's architect nephew, Paul Regnauld, the son of her sister Anaïs, interspersed pine plantations landscaped fashionably 'à l'anglaise', thus keeping out the bitter Atlantic winds. This outdoor sanatorium, one of the first in Europe, incorporated the latest in urban infrastructure and hygiene – gas for energy and lighting, artesian wells for water supply, a steam engine and a laundry for washing and disinfecting linen – and was promoted, including by French, Dutch, and Irish doctors, for its hygienic qualities and climatic effectiveness.[59] After Emile had committed several million francs to the resort in 1861, including an essential extension of the rail line from Bordeaux in 1857, which then connected with the Paris–Orléans line, Paul Regnauld designed and developed a large number of villas there. But the most splendid of the villas constructed was the Villa Pereire, completed in 1864.[60]

Well before this, however, Emile Pereire had also seen profits to be made, politically and financially, in developing the Landes department immediately to the south of Arcachon. A region of marshes generally considered insalubrious and unproductive had rapidly presented a challenge to Napoleon III in overcoming these disadvantages. The Pereires began to purchase parcels of land in the department with the intention of developing pine plantations as a remedial measure. From 1852 they acquired some ten thousand hectares that they employed for a dual purpose: to make way for further expansion of the Compagnie des chemin de fer du Midi rail line from Bordeaux to Bayonne, and to supply timber for railway sleepers. They formed a special company: the Société du mise en valeur des Landes.[61]

The Emperor Napoleon III did not visit Armainvilliers, as he had the Rothschilds' Château Ferrières, a spectacular event which was heavy on symbolism and had major consequences for the Pereires.[62] But he did visit Arcachon on two brief occasions. The first in 1859

followed the extension of the rail line from the neighbouring La Teste and celebrated his decision to create the autonomous commune of Arcachon separate from that town. The second visit was a minor triumph for the Pereire family when in 1864 he called on them at the Villa Pereire. A somewhat blurred photograph taken on the occasion nonetheless shows the Emperor clearly enough standing on the balcony with Emile Pereire immediately to his right and several women in attendance, one of whom was Herminie. As time passed, Emile Pereire spent increasing periods of time at Arcachon and thus, so did his wife.

The principal purpose of the Villa Pereire was domestic, for Emile's recuperation, relaxation, and leisure; it was not a place for entertaining. But there were handsome salons and dining rooms, as Emile Pereire the younger wrote to his father in August 1865 when some final work was being added to it:

> The new rez de chaussée salon is a very convenient room for writing or working. On the second floor ... the dispositions have achieved the goal which had been proposed, to create a greater number of liveable rooms and which are sufficiently habitable for a stay of several weeks like ours.[63]

The family soon came to test the new Villa Pereire and the waters, Fanny reporting to her husband that their daughters, Henriette and Jeanne, had learned to 'swim like fish'.[64]

Perhaps as compensation for the lack of facilities *in situ* for entertaining on any scale, Emile Pereire initiated construction of the Grand Hôtel and a Casino Mauresque in the town, although neither appear to have compensated Herminie for the degree of boredom she experienced at Arcachon.

Her letters do not suggest that Arcachon was a favourite place for Herminie in any case. But she clearly believed that as a wife, and of a sick man at that, her responsibility was to be at his side. That meant increasingly long stays from the time of the Villa Pereire's completion. Through Emile's election to the Corps législatif seat of La Réole in the Gironde in 1863 and his presidency of the Midi railway of the southwest, he had engineered reasons to stay there apart from his health. As Herminie wrote to her son, Henry, in June 1864: 'The climate at Arcachon is beneficial for your father and this will be for us from now on a preferred place to stay.'[65]

Following the collapse of the Pereires' bank, the Crédit mobilier, Emile's enforced retirement from all his companies in 1867, and the advent of the Franco-Prussian War and subsequent Paris Commune from September 1870 to May 1871, these catastrophic events saw them living there almost permanently.

Aside from the physical attractions of the place which captivated her husband but which left her underwhelmed, Herminie lacked the attachment to the southwest which was so important to Emile. She had not experienced Sephardic community life as he had. She had no particular friends among the Bordeaux Sephardim. She was born in Paris and had lived there all her life; that city and its environs were her milieu, and the only consolation in Arcachon was that her family came to stay. Even so, at one time over the fraught period 1870–71, she mourned the long separation from Fanny who had spent some of that time in Pau and then returned to Paris.[66] 'I have such a great desire to embrace Fanny and her girls who I have not seen for six months', she wrote to Henry. 'There has never been such a separation between us.'[67]

The family documents available concerning Arcachon fall largely in the summer months, July to October and in the later years from 1869 to 1873, when those who visited were, in the main, part of the extended Pereire family. Thus did each one of Herminie's children with their spouses stay at Arcachon for varying periods. So too did her grandchildren. This was particularly evident over 1870–71, when Herminie and Emile, together with Fanny, Cécile Rhoné, Claire Thurneyssen, Suzanne Pereire (wife of Emile II), their respective families, and accompanying domestic staff left Paris for shelter in the southwest. Not a time for socialising, this was a period of great anxiety during which the other male members of the family remained in Paris: Fanny's husband, Isaac; Herminie's two sons, Emile II and Henry Pereire; and her sons-in-law, Charles Rhoné and Georges Thurneyssen, together with some domestic staff. The conflict in Paris swirled around the hôtel Pereire, near as it was to the Élysée Palace, which, while only nominally a presidential palace, was nevertheless a target.

While Fanny and her two daughters, Henriette and Jeanne, stayed at Arcachon for part of that time, she also spent some months at Pau, the spa town which had increasingly welcomed British tourists and thus was a charming alternative. Fanny's reasons for staying

in Pau revolved around her daughter, Henriette, however, who had become virtually paralysed and was diagnosed with muscular rheumatism. There are certain inferences that her health was compromised from that time, adding to the burden Fanny carried already with Edouard.

It does not seem that Fanny spent a great deal of time at Arcachon, in any case. Nor did Isaac. Only late in his life and after Emile's death did he acknowledge the value of the place, monetarily and otherwise. On the other hand, Fanny's sister, Cécile Rhoné, had inherited the asthma which afflicted her father and spent increasing amounts of time there, including at times alone with him. She became a semi-permanent resident after the sudden death from stroke of her husband, Charles, in 1873. Indeed, after the death of both her parents, she inherited the usufruct of the Villa Pereire.[68]

The vineyard Château Palmer in the Médoc which dated from 1700 was a serious business proposition for the Pereire brothers, although their purchase of it in 1853 for 413,000 francs from a mortgage company, the Caisse hypothécaire de Paris, appears to have been something of an impulse.[69]

The vineyard was on the market because its then owner was unable, due to lack of capital, to combat the disastrous effects of powdery mildew on the vines. It was one of the first properties the Pereires owned in their own right, even before the purchase of the hôtel Commaille in the rue du Faubourg Saint-Honoré. On selecting the established Bordelais architect, Charles Burguet, they set about rebuilding in a neo-Renaissance style and substantially replanting the vines. While references to visits there are not plentiful, they do indicate a special place in the family's calendar of holidays, when the younger members pitched in to help with the *récolte*.

There is little doubt that the reason for the purchase was as much emotional, stemming from nostalgia for the region in which the brothers were born, as it was commercial. Nevertheless, since Château Palmer was expected to make money, unlike their other properties, its management was frequently under the microscope. On the whole it was profitable, remaining in family ownership until 1938. Its produce supplied the Grand Hôtel in Paris and its restaurants to the extent of 6,745 bottles sold in 1866–67 at a profit of 88 per cent![70] The *Inventaire* of Armainvilliers in 1875 likewise showed a handsome 3,005 bottles in the *cave*. But while for that reason

Isaac was known to have enjoyed his visits to Château Palmer, there is no evidence that Fanny had a similar attachment. Herminie, however, took a keen interest in the vineyard and was frequently known to comment on the superior quality of the wine, the arrival of which she looked forward to in great anticipation.

All the properties owned by the Pereire family thus filled a variety of purposes essential to the *grande bourgeoisie* and the style of life expected of its members. Some were intended as private spaces in which the family could enjoy private family occasions and the company of friends. Some were spaces constructed to display in a more public manner the private style in which the family lived. All had some connection to the Pereire businesses, either as places for socialising, executing deals, consolidating business relationships, or even producing wine or raw materials for the companies, as did the Château Palmer and Armainvilliers respectively.

These properties were enjoyed differently by Herminie and Fanny, neither of whom seems to have been particularly at home in Arcachon, for instance, while both had a particular affection for Armainvilliers, which Fanny came to own after the deaths of her parents and of Isaac. An enduring legacy with the technological advances that had so fascinated the Saint-Simonians was the design and installation of leading-edge household amenities in all of them. Pereire establishments appear to have been the first with the latest, contributing to the family's portrayal as leading members of Paris's elite.

What is also evident is that the properties allowed a style of life that rivalled that of noble families. Passing time at different properties according to the seasons thus became a part of the annual ritual for wealthy families, and none more so than for wealthy Jews.

*

Examining the patterns of entertaining, leisure, and recreation pursued and organised by Herminie and Fanny Pereire at their various dwellings brings us into the presence of domestic servants, for the selection and hiring of servants and the day-to-day management of them was part of the running of the bourgeois household entrusted to women. Obviously, Herminie and Fanny depended on them. The labour of *domestiques* was essential to the maintenance

of the properties in which for varying periods of time the Pereire family resided, mounting the various and frequently extravagant social occasions noted, and caring for the children of whom there were to be over a dozen born to the second generation of Pereires. But historiography points to a further element in the employment of servants in nineteenth-century France: 'servants were the most visible sign of status'.[71]

Whereas we are told most bourgeois households maintained at least one servant, we know less about the establishments of the *grande bourgeoisie*, that is, those whose annual incomes are reckoned, according to one historian, to have exceeded one hundred thousand francs.[72] Households of the French nobility were more comparable, in scale and wealth if not in social status, with the *grande bourgeoisie*, and it will be instructive to examine what we know of these. Such households provide a further reminder, however, of the manner in which the latter appropriated the extravagant lifestyle and past glories of the former.

The task involved in managing the properties that received the family was not insignificant, although as Marion A. Kaplan wrote of elite women in Imperial Germany, 'The actual labor of leisure for upper-middle-class and wealthier women was not physically strenuous, assisted as they were by domestic help.'[73] Certainly, Herminie and Fanny were by now in a position to employ all the help they needed to run them. There were also certain employees paid to carry out management oversight of the Pereire properties, and this was itself a new departure in a household hierarchy.

Several noble households have been subjects of study useful to this one, their wealth somewhat comparable with that of the Pereires. If they did not establish resorts or own vineyards, they did live in a similar style of *hôtel particulier*, they maintained country estates, and they employed at least twenty to thirty *domestiques*.[74] These households include those of Alexandre Berthier, prince de Wagram, and his wife, Berthe de Rothschild; and prince Joachim Murat V and his wife, Cécile Ney d'Elchingen. Both households dressed their staff in distinctive liveries, defined by colour and by insignias, and this as much as anything else marked the significance of the masters and mistresses. It was part of the show. We know little about the distinctive clothing of the Pereire staff other than its colours – a blue and gold livery, colours shared with several other

families, the Rothschilds, the Potocki, and the de Broglie.[75] What would have differentiated them all is difficult to say, whether this was by way of differences in tone, insignia, or design.

The Census of 1860 showed that there were twenty-one domestic servants in the hôtel Pereire, aged between eighteen and fifty-one years.[76] While Herminie and Emile had the greater number, with twelve, there was much sharing of domestic help within the mansion: we know from other documents that Herminie shared certain female servants with Fanny, for instance. This census was also conducted early in the life of the Pereire mansion, and it is highly likely that by 1870 the number of servants had risen considerably.

Considering the generosity in salaries and benefits extended by the Pereire brothers to employees in their businesses, we must assume that servants were similarly rewarded.[77] On Henry's twenty-third birthday in 1864, Herminie presented him with a *landau*, two horses, and an unnamed *cocher*, all as ordered and chosen by Henry, the driver being part of the gift.[78] Perhaps this *cocher* was the same servant who, when Henry sought a *Laissez-Passer* from the Garde Mobile in February 1871 to go to Gretz [Armainvilliers], he was accompanied by 'his servant, his horse, and his carriage'.[79] Similarly, when Herminie sought a passport for travel in Europe with her sons in 1857, they were to be accompanied by an unnamed 'domestique'.[80]

In view of the low status of *domestiques* in France in the nineteenth century, especially of female servants, this lack of identification should not surprise. Only late in the century with what has been described as the 'democratization of private life' were servants recognised by their full name and accorded a certain individuality.[81] The competition for labour between domestic service on the one hand and an exponentially developing industrial sector was by this time fierce. But the comparative lack of attention paid to domestics by Herminie and Fanny in their correspondence sits oddly in contrast with the Sarchis, whose letters carry news and information about servants, their own and others', discussing their strengths and shortcomings, complaining about them, even criticising those who dealt unfairly with them, and all in a manner that brought personalities to light. This does not occur anywhere in the Pereire correspondence. What we have are a few sparse references to one or other, the duties of whom are barely illuminated. This might

simply reflect the idiosyncrasies of the archive, that such letters once existed but are no longer extant. Nonetheless, there are sufficient letters written over a long period in which one might expect servants to rate a mention.

Servants were mobile, they were moved around. Indeed, while Armainvilliers maintained its own mainly outdoor staff, the principal core of servants to the Pereires was in Paris. When the family took holiday in Armainvilliers, Arcachon, or Château Palmer in the summer months, most of them went as well. This was also common in noble families.[82] But it did present a series of logistical challenges for Herminie and Fanny. A letter from Charles Rhoné to Henry Pereire in October 1864 mentions a return to Paris of twenty-six people from Arcachon, including Herminie and Emile, Fanny, Charles' wife Cécile, and himself, with all the children of whom, considering the numbers of family members included, at least ten to twelve would have been servants.[83] A letter from Herminie to Henry in 1872 asked him to have three carriages waiting at the gare de l'Ouest (now the gare Montparnasse) on their return from Arcachon, for an aunt, for Emile, and for herself and himself. 'The servants can take the bus', presumably since, apart from being of lesser importance, they were much more numerous. There is an exchange concerning Fanny's cook, whose name is one of the few we know, Anastasie; she was much criticised for one reason or another by Eugène's wife Juliette and, it seems, Fanny finally had to let her go. Herminie sent her own cook from Arcachon to work for Fanny, who was on holiday with her four children at a rented property in the forest of Crécy and was expecting other visitors.

The *Inventaire* for Armainvilliers adds to our picture of the life of *domestiques* there, even though it was compiled over a time period of 1879–88. Most likely this was a consequence of the division of property following the deaths of Herminie (1874) and Emile (1875) and then of Isaac (1880). The inventory is extremely detailed, as one would expect. Eight of the forty-one bedrooms were designated as 'chambres de domestiques', for servants based in Paris who accompanied members of the family. There were also several rooms that were relatively spartan, containing an iron bed, a commode, a night table, a writing table, chairs, a carpet, and various toiletry aides. These may also have been available to servants when not otherwise in use. But there were four bedrooms of a somewhat more luxurious

standard attached to particular staff, one for the (unnamed) female 'cook', another for the 'femme de chambre' to Fanny, one for 'Adèle and Jean', and a fourth for 'Jules maître de l'hôtel'.[84] We will come shortly to Jules.

Much of the information we have concerning servants emerges in fact from documents written by Fanny Pereire's *femme de chambre*, Camille Desrochers.[85] Camille kept a diary and wrote several letters to her sister Georgine during the harrowing circumstances of the Franco-Prussian War and the Paris Commune, between September 1870 and April 1871. The documents do not provide a picture of below stairs in normal times, therefore, yet they do shed light on relations between master/mistress and servant, albeit under stress. They also provide a glimpse of a hierarchy of domestic help which from the literature appears to have been common both to noble families and to those of the elite *bourgeoisie*.

Once France declared war on Prussia on 16 July 1870 and invaded Prussia two weeks later, Herminie and Fanny needed to make rapid decisions concerning the deployment of staff. The situation was the more critical since Herminie's husband Emile was ill and Fanny's daughter Henriette also. Although the war raged on for six months, France never really recovered after the capture of Emperor Napoleon III at Sedan at the beginning of September. With eastern and northern France seeing the bulk of the fighting, Arcachon to the south was thus for Herminie and Emile the obvious retreat.

When the Pereire women decamped with the patriarch Emile to the southwest to escape the war, Camille Desrochers stayed behind at the family mansion in Paris with her husband Jules, Isaac Pereire's *maître de l'hotel*. A close reading of her journal suggests that this was her choice, a decision occasioned by her husband's necessary presence and attendance on Isaac. Their eighteen-month-old daughter Juliette went with the other women to Arcachon in the care of Georgine, who was *femme de chambre* to Fanny's daughters, Henriette and Jeanne. For Fanny it was somewhat different, and she decided to take her daughters to Pau. Since her *femme de chambre* had stayed behind in Paris and the *domestique* who cared for the two daughters had travelled to Arcachon, it is not clear who accompanied Fanny.

Several other servants stayed behind at the Pereire residence to tend the five male members of the Pereire family there. A letter

from Herminie to Henry revealed that Mme. Leclerc, one of the few *domestiques* whose family name was mentioned, was an important figure in managing the household, 'the housekeeper'. Herminie requested particularly that Mme. Leclerc be informed that Herminie was depending on her for the mansion's 'surveillance' and also to have regard for the poor people who were suffering the effects of the War. So, too, was Brice, a *valet de chambre* to Emile Pereire, told to be vigilant.[86] Indeed, in a manner which also occurred in nobles' households, Brice was to receive a bequest of five hundred francs from his master's will.[87] Another male servant, Hippolyte, who was also at the hôtel Pereire throughout, was to receive an even more handsome bequest of a six-hundred-franc life annuity ('rente viagère') and a gift of one thousand francs.[88] We might thus conclude that Hippolyte was *maître de l'hôtel* to Emile Pereire.[89]

Pierre and Alexandre, *valets de chambre* to Pereire family members who stayed behind, were others serving the Pereire residence at a time of war. Another male servant, Victor, seems to have been a messenger boy, a *valet de pied*, since this fits with Camille's description of his activities. A letter from Fanny to Henry also notes a woman who dealt with the laundry.[90] On this reckoning there were at least nine *domestiques*, six males and three females, who attended the five male members of the Pereire family during the War and Commune. With the exception of Jules Desrochers, the family names of male servants at the hôtel Pereire are unknown.

Camille wrote with much feeling about both her absent mistress and Jules' master, Isaac, who was with them in Paris. There was of course nostalgia for more normal times: 'I go into the bedroom of the young girls [Henriette and Jeanne] sometimes to distract myself [she wrote], I … want to see those little beds occupied, and to see the girls asleep there, and I ask myself also when will I enter Madame's dressing room again to do her hair and dress her! How long the time seems.'[91]

In view of her affection for Fanny, we should not be surprised that she expressed concerns about the health of Isaac. 'It's absolutely necessary that Monsieur doesn't feel the cold so much, a fire is lit in his bedroom morning and evening, we do our best to care for him, for in the absence of Madame we would be much tormented if we saw him indisposed, but thank God, Monsieur is going well.'[92]

Isaac Pereire rose to the occasion and earned much gratitude for his solicitude towards employees. We learn from the journal that he arranged for needy staff from Armainvilliers to be repatriated to the comparative safety of the hôtel Pereire when the chateau was occupied by Prussian troops. Provisions that had been spirited away from it fortuitously kept the household in Paris fed for some time, everyone at the hôtel Pereire sharing in the meat, salmon, pheasant, vegetables, confits, and confitures.[93] When letters arrived from Arcachon or Pau, Isaac read aloud to Camille and Jules those sections which dealt with their family members, bringing forth much emotion and gratitude. 'Those who haven't been stuck and without news for such a long time can scarcely understand that', Camille explained.[94]

In the absence of a number of other servants, she was forced to work at tasks others would normally have carried out, standing in as *valet de chambre* when the male servants were on duty in the Garde Nationale. She prepared dinners under difficult circumstances for large numbers of guests (eighteen on one occasion), but despite the providential supplies from Armainvilliers, food was increasingly scarce. The Paris household of necessity ate its way through all the horses in the Pereire stables!

Camille's journal and letters convey not only a vivid description of the horrors of war and civil unrest, they also describe a harmonious, devoted household. While Macknight cautions against taking this kind of description too seriously, most such claims Macknight described derive from the writings of employers and not from the *domestiques* themselves. Authorship of the documents we have noted here is certainly with Camille Desrochers and not with anyone else. We cannot deny Camille's account of her emotions, nor could the events she described and the servants who inhabit her narrative have been the subject of invention.

Aside from the extensive journal and letters of Camille Desrochers, an account book for Armainvilliers in the month of July 1871, by which time the Franco-Prussian War was at an end, provides more prosaic information of staff numbers and tasks, this time in the chateau, the parks (listed as 'grand' and 'petit'), the orchard, and the hothouses. As Herminie's health was deteriorating, Fanny Pereire's management of these staff is clear from a sort of employment contract for M. Monthilé of 1871, which showed him

specifically to be responsible for 'the maintenance of the Park and its outbuildings'. It was signed by the Garde Général and countersigned – 'seen and approved' – by Fanny Pereire.[95] There appear to have been seventeen staff in all working in the chateau and the forest, and another fourteen in the parks and hothouses. Some of these worked on several different jobs around the chateau, jobs which were largely unspecified, with the exceptions of a young woman who worked at tasks such as washing and ironing and another who worked in the cowshed. These servants were tied to Armainvilliers and not to Paris and, it seems, lived at the chateau or in the vicinity of the commune of Gretz. Over and above them was the supervisor, who in turn reported to the Garde Général, name unknown, a sort of general manager of the establishment.

There is also evidence to suggest that labour was brought in from Gretz for particular jobs when needed. We are reminded of the accounts in Herminie's name for July and August 1869, for instance, showing forty-six francs for seven workers to clean the chateau.[96] We do not know the wages of the staff in Paris but we do know something of the salaries of these outdoor staff at Armainvilliers. This may be sketchy, but from the information we have, salaries seem comparable with those in the aristocratic households cited already. The information is tabulated here in an appendix and one should note that the expenses are described in the documents as 'approximate'.

Expenses for Armainvilliers for the month of July 1871 show that the senior gardener in the kitchen garden there earned 200 francs, or 2,400 per annum, and a more junior gardener earned half that sum, or 1,200 francs per annum. Drawing on the Wagram and Murat data, this compares with 1,300 francs per annum for gardeners in the Wagram establishment between the years 1830 and 1886, a period when wages have been described as 'static', and 2,400 francs for gardeners in the Murat establishment in 1904. Again, a house maid at Armainvilliers earned 25 francs per month, or 300 francs annually, and the young girl working in the cowshed, 18 francs, or 216 francs over the year. These figures are somewhat lower than those of the Wagram or Murat establishments, of 420 to 480 francs per annum. But bearing in mind that what is being compared here are wages paid at the Paris establishments of the Wagram and Murat families with those of the Château Pereire

at Armainvilliers in the provinces, there may be discrepancies.[97] Nevertheless, staff expenses of the Pereire establishment which situates itself in time between the Wagram and Murat figures would thus seem to be comparable overall.

Michelle Perrot has noted that 'maids were normally unmarried' and without husbands, lovers, or children. Perhaps this was the case in middle-class households of the time, but it was not so in the case of the Pereires' employees.[98] Nor was it the case with the noble families described in Mark Girouard's *Life in the French Country House*, where 'all the servants were more or less related to each other ... Such interrelationships [Girouard observed] were typical; so was long service and corresponding devotion to the family.'[99] Anne Martin-Fugier likewise commented on the relative stability of employment in the 'grandes maisons' as a result of the number of servants 'en couple'.[100]

Reminiscent of a number of Girouard's aristocratic families, we note the presence of many family members among the *domestiques* working for the Pereires, including married couples. Aside from Camille and Jules Desrochers, Camille's parents, M. and Mme. Aubert, were gardeners at Armainvilliers, maintaining the *potager*. Thus, with their other daughter, Georgine, it appears the whole Aubert family was in the employ of the Pereire family. Another female servant, Isabelle, who was at Arcachon at the time of Camille's writing, was wife to one of the *valets de chambre* who had remained in Paris, either Pierre or Alexandre.[101] Again, the statement of expenses for Armainvilliers established that Juteau *père et fils* worked in the kitchen garden. The park supervisor, M. Monthilé, also was married, to the servant who kept chickens for the household.[102] Comments by Girouard and Martin-Fugier that family employment created stability and devotion towards the employer seem to be confirmed by what we read in Camille Desrochers' journal. Herminie's admiration and respect for family life may also have accounted for the strong family representation among her *domestiques*.

While 'land ownership remained the core of aristocratic identity and the primary source of income for the French nobility', this was not the case with the *grande bourgeoisie*, most of whose members derived their wealth from commerce and industry.[103] This did not stop them from mimicking the nobility in the uses to which they

put their country estates, and not just in France. Baron Ferdinand de Rothschild and his sister Alice in England continued to maintain a large garden at their Waddesden Estate, purchased from the Duke of Marlborough in 1874, and 'were proud to be self-sufficient' in fruit, vegetables and flowers, for 'becoming a landowner has always been the route to social advancement in England'.[104]

Herminie too took great pride in the quality of the fruit, vegetables, and flowers from the kitchen garden, the orchard, and hothouses and the produce from the cowshed and chicken coops, all emanating from Armainvilliers. These served the other Pereire properties well. She noted with pride in a letter to Henry that Mme. Monthilé, the wife of the park superintendent, had won four silver medals at a show for the poultry and several other prizes.[105] There was a commercial element to the ownership of Gretz-Armainvilliers, however, for, in addition, timber from the forest of Armainvilliers was put to good use in the manufacture of sleepers for the Pereires' railways.

While several local residents were employed to maintain the Villa Pereire at Arcachon, the servants from Paris served there too. Herminie thus sent some of them ahead to make preparations in advance of a more general arrival. As with Armainvilliers, where there was a general manager, a resident caretaker lived there permanently with his own abode, a *conciergerie* (caretaker's lodge).[106] Château Palmer was a different matter again since most of those employed there worked in the vineyard but, here too, a general manager maintained the property. It was a commercial proposition, and these employees served the business as much as the family.[107]

It has been said that the work of managing servants was not physically demanding, but for elite women it could be a logistical nightmare just the same – challenging, to say the least. Moving servants from one location to another according to need, anticipating requirements for stays of varying lengths of time, ensuring all the Pereire properties were adequately staffed, hiring and occasionally firing – all these actions and more demanded time and patience. This was a task in which Herminie became proficient and Fanny exhibited considerable skill.

Altogether, managing the Pereire households and the events that took place in them was thus a significant management undertaking entrusted to Herminie until her later years and, to a slightly

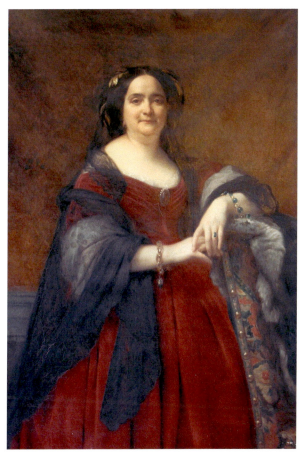

Plate 1 Rachel Herminie Pereire, copy undated C. Brun of portrait by Alexandre Cabanel, 1859. Private collection, photo Christophe Fouin.

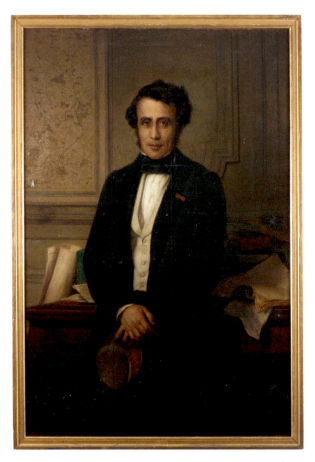

Plate 2 Emile Pereire, copy 1894 Charles François Jalabert of portrait by Paul Delaroche, 1853. Collection famille Pereire, photo Christophe Fouin.

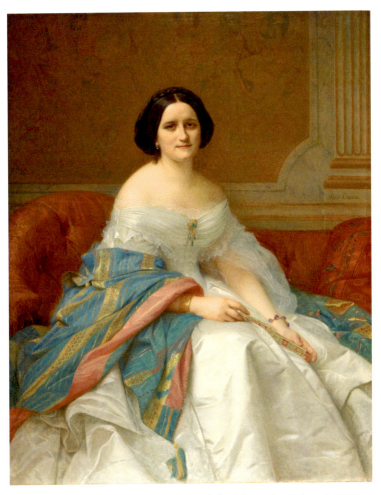

Plate 3 Fanny Rebecca Pereire, portrait by Alexandre Cabanel, 1859. Photo © RMN – Grand Palais (domaine de Compiègne) / Stéphane Maréchalle.

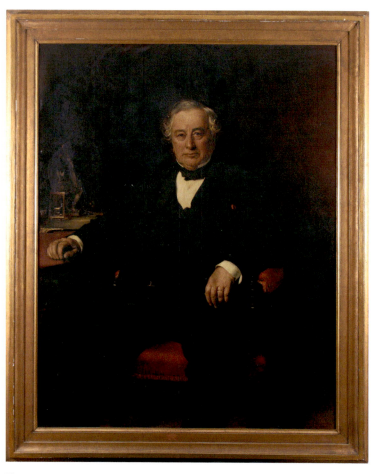

Plate 4 Isaac Pereire, Léon Bonnat, 1878. Courtesy Château de Versailles, photo Christophe Fouin.

lesser extent, to Fanny Pereire. They presided over a large number of establishments in the ownership of the Pereire family. They each presented fabulous entertainments and sumptuous occasions in Paris, ensuring that the musical evenings measured up to, if not exceeded, the expectations of their guests as well as the wider public who read about them in the press, and that the repasts offered were little short of magnificent. Even the more modest yet nevertheless time-consuming get-togethers organised in the family chateau, at the *station balnéaire*, and at the Médoc vineyard were far from simple in the time needed to be invested in them. Indeed, one might suggest that this investment of time, money, and energy in the service of preserving and magnifying the Pereire family name was akin to running a sizeable small business.

Appendix

'Forêts d'Armainvilliers: Etat approximative des dépenses pour le mois de juillet 1871'

Forêts:
Henry 2/3
Télot
Brochot
Dégoullion
} 317.33 francs

Château:
Morel, potager
Morel 1/3

Verger:
Honoré 100 francs
Gerbier 100 francs
Henry 1/3

Ménage:
Gage de la fille 25 francs ['+ pain 70, viande 65, épicerie 70, lavage et repassage 12 = 242']

Étable:
Gage de la fille 18 francs

'*Dépenses approximatifs du Parc, Potager, etc pour 1871*'

Château:
Pavillot, entretien du château 1200 francs

Potager:
Aubert	200 francs par mois
Rocher	100 idem
Huré	260 jours à 3 francs par jour
Juteau père	idem
Juteau fils	240 jours à 1.25 francs par jour
Femme Trébuchet	267 jours à 1.75 francs

Total = 6,287 francs

Notes

1. 'Jacques Reynaud' [Gabrielle de Saint Mars, aka 'Countess Dash']. 'Portraits Contemporains: Isaac et Emile Pereire', *Le Figaro*, 23 July 1859.
2. Macknight, *Aristocratic Families*, 95.
3. Julie Kalman, *Rethinking Antisemitism in Nineteenth-Century France* (Cambridge, MA, 2010), 191.
4. Nicault, 'Comment "en être"', 8.
5. Ibid., 18.
6. Including by this author.
7. From 1947, the Chancery of the British Embassy. For the circumstances of the sale to the British Embassy, see the Conclusion.
8. See *Le Figaro*, 15 March 1867. In 1920, the Rothschild property became home to the Cercle de l'Union Interalliée, a private dining club.
9. Christophe Bouneau, 'La contribution des chemins de fer au développement touristique d'Arcachon de 1841 au second conflit mondial', in *D'Arcachon à Andernos: regards sur le Bassin*, actes du XLVIIIe Congrès d'études régionales de la Fédération historique du sud-ouest tenu à Arcachon et Andernos, avril 1996 (Bordeaux, 1997), 277.
10. Maud Tixier, 'Comparaison de l'usage', *Humanisme et Entreprise*, vol. 5, no. 300, 17–36. doi:10.3917/hume.300.0017, accessed 15 December 2023.
11. Correspondence in the AFP between family members emanates from all the properties in family ownership. The correspondence of Charles and Félicie Sarchi with their daughter also contains much of interest in

Sociability, entertainment, real estate, and servants 155

this context, *Lettres*, Vol. 1 (1862–68), Vol. 2 (1869–75), Vol. 3 (1876–78). Also relevant is Charton, *Correspondance générale (1824–1890)*, Vol. 1 (1824–59), Vol. 2 (1860–90).

12 Grange, *Une élite parisienne*, 332.
13 Ibid., 323–7.
14 For an account of domestic architecture typically constructed for the *grande bourgeoisie* in nineteenth-century Paris, I am indebted to Linda D. Stevenson, 'The Urban Mansion in Nineteenth-Century Paris: Tradition, Invention and Spectacle' (PhD diss., University of Florida, 2011). Here she is quoting François Loyer, trans. Charles Lynn Clark, *Paris: Nineteenth-Century Architecture and Urbanism* (New York, 1981), 161.
15 Stevenson, 'The Urban Mansion', passim; and Diane de Saint-André, '35–37 Hôtel Pereire', in Béatrice de Andia and Dominique Fernandès (eds), *Rue du Faubourg Saint-Honoré* (Paris, 1994), 132–4.
16 Stevenson, 'The Urban Mansion', 46.
17 *Journal de Genève*, 1 April 1858 (JDG_1858_04_01_pdg downloaded 6 September 2020).
18 de Saint-André, '35–37 Hôtel Pereire', 132–6.
19 AFP, 'Payements faits pour construction de l'hôtel faubourg St Honore jusqu'au 29 février 1860'. This document contains a line item 'Terrains, enregistrement et frais accessoires' amounting to 1,814,217.84. Of this sum we know from other documents that the cost of purchasing the mansion was 1,600,000 francs and assume the greater part of the remaining sum would have covered the cost of purchasing the land extending to the rue Gabriel, i.e. 214,217 francs.
20 Grange, *Une élite parisienne*, 377–80. Grange is dealing with musical concerts and salons of a later period, but his comment is as relevant for the Second Empire.
21 Schor, *Baroness Betty de Rothschild*, chap. 2.
22 *Le Figaro*, 13 February 1859.
23 Ibid.
24 Ibid.
25 Ibid.
26 'Courrier de Paris', *Le Monde illustré*, 16 May 1857.
27 AFP, Cécile Rhoné, Paris to Henry Pereire, Egypt, 25 January 1865.
28 On Tardier de Malleville, see Katharine Ellis, 'Female Pianists and Their Male Critics in Nineteenth-Century Paris', *Journal of the American Musicological Society*, vol. 50, no. 2/3, Summer–Autumn 1997, esp. 361, fn. 23; on Christine Nilsson, see the entry 'Nilsson, Christine [Kristina Törnerheljm]', *The Grove Book of Opera Singers*, 2nd ed. (online, 2009); on Victor Warot, *The Diaries of Giacomo Meyerbeer*:

The Last Years 1857–1864, ed. and trans. Robert Ignatius Letellier (Madison, NJ, 1999).
29 Anthony B. North Peat, *Gossip from Paris during the Second Empire: Correspondence 1864–1869* (London, 1903), 169.
30 AFP, letters all in 1865 written from Paris to Henry Pereire in Egypt: Herminie Pereire to Henry Pereire, 27 January, 16 March and 17 March; Cécile Rhoné to Henry Pereire, undated and 25 January and 17 February; Gustave Pereire to Henry Pereire, 18 January; Suzanne Chevalier Pereire to Henry Pereire, 28 January.
31 *Le Monde illustré*, 10 November 1860.
32 Ibid., 24 November 1860. Historians now consider Sardanapalus to have been a wise and powerful leader and not the self-indulgent tyrant of popular legend, as *Le Monde illustré* seems to be suggesting here.
33 *La Vie parisienne*, 7 January 1865. All three were well-known Italian singers of the time. The reference to M Fouquet is most likely to Nicolas Fouquet, Louis XIV's Superintendent of Finance, whose lavish ball at his newly inaugurated palace Vaux-le-Vicomte led to his incarceration in prison for life by his employer.
34 *La Vie parisienne*, 7 January 1865.
35 Charton, *Correspondance générale*, Edouard Charton, Paris, to Hortense Charton, probably Versailles, 13 March 1863, vol. II, letter 63–49, 1353.
36 See for instance letter from Fanny on behalf of Isaac Pereire to 'Messieurs et amis', undated and requesting the recipients to forward an invitation to Prosper Enfantin to attend a soirée on 11 April, year not nominated. BNF-A, Fonds Enfantin, 7769/98.
37 Sarchi, *Lettres*, Charles Sarchi, Milan, to Hélène Van Tieghem, Paris, 30 November 1874, vol. III, letter 602, 383.
38 *The Best of Emile Waldteufel*, volume 7, Naxos Records online, downloaded 18 August 2018.
39 Macknight, *Aristocratic Families*, 66.
40 Mark Girouard, *Life in the French Country House* (New York, 2000), 261–2.
41 Le Bret, *Les frères d'Eichthal*, 554.
42 Hervé Le Bret, 'Correspondance entre George Sand et Édouard Rodrigues (1862–1876)', *Bulletin de la Société Historique de Rueil-Malmaison*, no. 22, December 1997, 32.
43 Le Bret, *Les frères d'Eichthal*, 556–8.
44 Frédéric Barbier, *Finance et politique: la dynastie des Fould XVIIIe-XXe siècle* (Paris, 1991), 268.
45 Ferguson, *The World's Banker*, 555.

46 AFP, letter Charles Dumas, Paris, to Emile Pereire, Paris, 5 September 1854.
47 Rondo Cameron, 'Une lettre inédite de Persigny (1855) à Napoléon III: à propos de la rivalité Rothschild–Pereire', *Revue historique*, no. 230, 1963, 91–6.
48 Alfred Pereire, *Je suis dilettante* (Paris, 1955), 14–15.
49 AFP, Emile Pereire, Arcachon, to Emile Pereire II, Paris, 24 July 1873.
50 Leora Auslander, 'The Modern Country House as a Jewish Form: A Proposition', *Journal of Modern Jewish Studies*, vol. 18, no. 4, 2019, 466–88. This issue of the *Journal* represented the outcomes from a conference held at Oxford University in March 2018, an event that led to a 4-year project on the Jewish Country House.
51 AFP, 'Inventaire 1888'.
52 Ibid., Herminie Pereire, Armainvilliers, to Emile Pereire, travelling in southern France, 18 October 1863.
53 Sarchi, *Lettres*, Félicie Sarchi, Milan, to Hélène Van Tieghem, Paris, 18 May 1868, vol. 1, letter 299, 456; AFP, Cécile Rhoné, Armainvilliers, to Henry Pereire, address unknown, 29 May 1864.
54 Pauline Prevost-Marcilhacy, 'The Castle of Ferrières: An Emblematic House', paper delivered to Jewish Country House Conference, University of Oxford, 5–6 March 2018.
55 'Galignani', 'A Curious Law Suit', *The New York Times*, 12 August 1863.
56 See for instance David S. Barnes, *The Making of a Social Disease: Tuberculosis in Nineteenth-Century France* (Berkeley, CA, 1995).
57 Robert Aufan, *La Naissance d'Arcachon (1823–1857): 'de la forêt à la ville'* (Arcachon, 1994), 60.
58 The best reference on the history of Arcachon is Alice Garner, *A Shifting Shore: Locals, Outsiders, and the Transformation of a French Fishing Town, 1823–2000* (Ithaca, NY, 2005).
59 Bouneau, 'La Contribution des chemins de fer', esp. 265–75.
60 Davies, 'Living with Asthma in Nineteenth-Century France'.
61 Autin, *Les frères Pereire*, 226–31.
62 Ferguson, *The World's Banker*, 620–1.
63 AFP, Emile Pereire II, Arcachon, to his father, Emile Pereire, Paris, 1 August 1865.
64 Ibid., Fanny Pereire, Arcachon, to Isaac Pereire, Paris, 22 August 1864.
65 Ibid., Herminie Pereire, Armainvilliers, to Henry Pereire, address unknown, 1 June 1864.
66 Ibid., letters from various sources show Fanny and her daughters to have been at Pau in December 1870, May–June 1871, and November 1871.

67 Ibid., Herminie Pereire, Arcachon, to Henry Pereire, Paris, 15 June 1871.
68 Ibid., 'Partage entre Mr Isaac Pereire et les enfants Mr Emile Pereire: Même date – Établissement de propriété, 3 Août 1876'.
69 Davies, *Emile and Isaac Pereire*, 179–80.
70 AFP, sales of Château Palmer wine through Pereire companies.
71 Perrot, 'The Family Triumphant', 232.
72 Charles Sowerwine, *France since 1870: Culture, Society and the Making of the Republic* (2nd edition, Basingstoke, 2009), 7.
73 Kaplan, *The Making of the Jewish Middle Class*, 118.
74 Macknight, *Aristocratic Families*, chap. 4.
75 Schor, *Baroness Betty de Rothschild*, 33 for the Rothschild livery; Macknight, *Aristocratic Families*, 97 for the Potocki; and 113, fn. 8 for the de Broglie.
76 David Cohen, *La Promotion des Juifs en France à l'époque du Second Empire* (Aix-en-Provence, 1980), 546.
77 I have dealt with this in Davies, *Emile and Isaac Pereire*, 155–6.
78 AFP, Herminie Pereire, Paris, to Henry Pereire, address unknown, 30 April 1864.
79 Ibid., document 'République Française, Laissez Passer, Pereire, Henry et un domestique', Paris, 1 February 1871.
80 Ibid., 'Passe-Port à L'Étranger', 1857.
81 Perrot, 'The Family Triumphant', 239.
82 Macknight, *Aristocratic Families*, 95–6.
83 AFP, Charles Rhoné, Paris, to Henry Pereire, address unknown, 5 October 1864.
84 Ibid., 'Inventaire J. P. Armainvilliers', hand-written document containing a complete inventory compiled over the years 1879, 1881, 1883 and 1889.
85 AFP, Camille Desrochers, 'Journal d'une Femme de Chambre pendant le siège de Paris', 46 pp. typescript, and 'Lettres de Camille, 21 Mai–27 Mai 1871', 19 pp. typescript.
86 Ibid., Herminie Pereire, Arcachon, to Henry and Emile Pereire II, Paris, 11 September 1870.
87 Ibid., 'Dispositions testamentaires de mon père [Emile Pereire] 21 décembre 1874'.
88 Ibid.
89 Ibid., Herminie Pereire, Paris, to Henry Pereire, address unknown, 23 May [1864].
90 Ibid., Fanny Pereire, Arcachon, to Henry Pereire, Paris, 8 September 1870.
91 Ibid., Desrochers, 'Journal', 9 October 1870, 6.

Sociability, entertainment, real estate, and servants

92 Ibid., 2 January 1871, 22.
93 Ibid., 'Provisions 16 janvier 1871 Armainvilliers'.
94 Ibid., Desrochers, 'Journal', 29 November 1870, 11.
95 Ibid., 'Règlement de service applicable à l'entretien du Parc et de ses dépendances'.
96 Ibid., 'Nouveau Livre à Madame Emile Pereire 1869'.
97 I am comparing here figures to be found in AFP, 'Forêts d'Armainvilliers État Approximatif des dépenses pour le mois de Juillet 1871', with Macknight, *Aristocratic Families*, 98, in which she compares annual wages of individual categories of staff for each of the Wagram and Murat households.
98 Perrot, 'Roles and Characters', 236.
99 Girouard, *Life in the French Country House*, 261.
100 Anne Martin-Fugier, *La place des bonnes: La domesticité féminine à Paris en 1900* (Paris, 2004), 77. Macknight in her *Aristocratic Families*, 99–100, also testified to the place of married couples in the households she studied.
101 AFP, Desrochers, 'Journal': 'If Isabelle could know that her husband has not been called up [for the National Guard] she would be a little less tormented.'
102 AFP, 3 documents, 'Forêts d'Armainvilliers État approximatif'; 'Dépenses approximatifs du Parc, Potager etc pour 1871'; and 'Règlement de service applicable à l'entretien du Parc et de ses dépendances'.
103 Elizabeth C. Macknight, *Nobility and Patrimony in Modern France* (Manchester, 2018), 134.
104 Mary Keen, *Paradise and Plenty: A Rothschild Family Garden* (London, 2015), 13 and 17. The garden was called 'Eythrope'.
105 AFP, Herminie Pereire, Armainvilliers, to Henry Pereire, Paris, 23 May [1864?].
106 The conciergerie is noted in https://inventaire.nouvelle-aquitaine.fr/dossier/villa-ou-chalet-pereire downloaded 13 November 2022.
107 AFP, letters Isaac Pereire, Paris, to Henry Pereire, Château Palmer, 13, 23, 24, 25, 26 March 1871.

5

Conspicuous consumption, again 'because fortune obliges it'

The *Gazette de Lausanne* reported in May 1856 that 'Mme Pereire has deigned to visit the curiosities with her sons', going on to note that Herminie was staying at the Hôtel de Fribourg where everything about her was reported to an avid public: when she had breakfast, where she had lunch and dinner, the places she visited. It was as if she was the Empress Eugénie visiting the provinces, the report concluded.[1] In their representation of the family name, women of the Pereire family expected to be treated, and were treated, as celebrities. Presenting themselves accordingly was a continuing and necessary task.

We have seen in the previous chapter the manner in which Herminie and Fanny mounted social entertainments that by their splendour brought the family's name, reputation, and wealth into public view. Herminie and Fanny Pereire were also individual consumers, and their conspicuous consumption added to the mystique of these women and to their families. Clothing and jewellery captured in portraits and photographs were powerful means of female self-representation, attracting prestige for the wearer through depiction of adornment, finery, and demonstrable wealth. Yet there were other ways through which, as consumers, Herminie and Fanny acquired kudos for the Pereire name, some of which the press and contemporary commentators acknowledged and much of which they did not.

Examining patterns of consumption by these women of the *grande bourgeoisie* thus will also highlight some of the ways in which the construct of 'separate spheres' was laden with ambiguity, shaped on the one hand by assumptions about gender, tempered on

the other by a slow but inexorable evolution towards female autonomy that eroded gendered prescriptions. These nuances emerge when we examine the different elements of consumption. Aside from clothing, jewellery, and the various ways in which personal appearance was employed and interpreted, as the custodians of the home, the tastefulness of its furnishings was attributed to women, a fact that was increasingly acknowledged in the press and through commentary.

Seen through the lens of the Crystal Palace exhibition of 1851, historian Whitney Walton suggested a 'breakdown' in the notion of an 'exclusively' female private or domestic role in consumption, showing that bourgeois 'women had to venture into the public space of the market-place, where they influenced the "male" realm of production through their demand for unique, tasteful, and hand made goods'.[2]

Nevertheless, in the case of Herminie and Fanny, it was not the furnishings of the hôtel Pereire or the chateau at Armainvilliers that received attention; it was the magnificence of the decoration, the gilded ornamentation, the colourful frescoes, the fine sculptures. In other words, the wealth and taste on display were attributed to the Pereire brothers rather than to their wives. And, again, while the collections of artworks accumulated by Emile and Isaac Pereire, who each had a notable gallery in the Paris mansion, were described in awe-struck terms by journalists, that Herminie or Fanny may also have been collectors or even had an influence on the works purchased by their respective husbands seems never to have been considered by the press or other commentators.

In summary, women of the *grande bourgeoisie* were expected to present themselves fashionably and were given credit for doing so. But elements of personality involving taste and discernment in cultural terms, as collectors of works of art, for instance, were attributed almost invariably to men, leaving little acknowledgement of female agency. As Tom Stammers has summarised, collecting 'was perceived as the antithesis of feminine consumption'.[3]

The Pereires long held a reputation for modesty, discretion, gravitas in their personal lives, virtues which sat comfortably alongside the public accounts of their charitable actions and gifts, which we are coming to. Nonetheless, this reputation seems at odds with their ownership of many valuable properties; the descriptions of

lavish balls and other public events held in their Paris mansion; the clothes and jewellery Herminie and Fanny bought and with which they adorned themselves; and the Pereires' reputation as collectors of priceless works of art and precious objects. Perhaps 'Jacques Reynaud' (otherwise Gabrielle de Saint Mars), whose favourable judgement of the Pereires we encountered previously, explained this apparent contradiction best when she said simply that, in the case of the Pereires, 'They give *fêtes* because fortune obliges it.'[4] The sociologist Thorstein Veblen was more forthright: 'The basis on which good repute in any highly organised industrial community ultimately rests is pecuniary strength; and the means of showing pecuniary strength, and so of gaining or retaining a good name, are leisure and a conspicuous consumption of goods.'[5] It was expected.

Conspicuous consumption was a hallmark of the Second Empire. And when it came to it, wives and mistresses provided most useful vehicles for the display. Leisure in Veblen's terms was far from the experience of the Pereire brothers, given the diversity and size of their business empire and the effort needed to sustain it, but their wives more often than not compensated in the sums spent on representation of the family name.

First of all, personal appearance was the pre-eminent medium through which Herminie and Fanny personally drew attention to the Pereire family identity. They not only mounted fabulous occasions at home; as *grandes bourgeoises* it was expected that they attend similar events elsewhere: at imperial palaces and noble dwellings, at the homes of other wealthy people, at the theatre and opera. There were even more occasions that brought them to the attention of the public. There were drives in carriages through the Bois de Boulogne and walks in gardens and parks. There were visits to relatives and friends. There was travel within France and abroad.

While all these activities required extensive wardrobes of the most luxurious and fashionable kind, one particular event recalls most vividly the demands placed on *grandes bourgeoises* to make an impression and live up to the part.

In November 1865, Herminie and Emile Pereire received an invitation from Comte Félix Bacciochi, Premier Chamberlain to the Emperor Napoleon III, to attend one of the imperial 'séries de Compiègne'. Compiègne, with its large forested areas so ideal for hunting, was the favourite palace of the Emperor. It was here that

he had instituted the famed event which took place on average four times per year between the months of October and December. One hundred or so people plus retinue were invited to pass a week, as informally as was possible, with the imperial couple. Those who received invitations were expected to be 'talented and illustrious people or simply important' – in other words, celebrities.[6] Invariably these recipients were male, with the exception of ladies-in-waiting who attended the Empress Eugénie. Wives did not necessarily accompany their husbands. Indeed, Emile Pereire had already been invited to attend the 'séries' in 1862 and he attended without Herminie. On this occasion in 1865, however, not only Herminie but their nephew Eugène was also invited with his wife Juliette and the Pereire attendants accommodated in adjoining apartments.[7]

Among others who were present from 30 November to 6 December was a mix of artists, literary figures, politicians, diplomats, and scientists. They included the Barbizon painter Théodore Rousseau; the architect and restorer of ancient buildings Eugène Viollet-le-Duc; Lord Cowley, the Ambassador of Great Britain; baron de Budberg, the Russian Ambassador; the Prussian Ambassador, the comte de Goltz; the engineer and Paris city planner Adolphe Alphand; Achille Fould, then ministre des Finances; the duc de Magenta, Maréchal de France; and the scientist Louis Pasteur.[8]

Pasteur, whose wife Marie did not attend, wrote a series of letters to her concerning his stay at Compiègne, in which he detailed the programme for each day. It was replete with formal occasions, theatrical entertainments, informal teas and conversations, visits to the mediaeval Château de Pierrefonds to observe progress with the restoration undertaken by Viollet-le-Duc, and observing or participating in the hunts in the forest of Compiègne.[9]

For the women, a week spent at Compiègne necessitated a variety of 'dresses, jewels, hats and because of the season, capes, shawls, furs that at times the invitees did not have in sufficient quantity'. Phillipe Perrot has commented that 'At Compiègne sumptuary exigence took on the aspect of tyranny, and the guests – the emperor and the empress frowned on wearing the same attire more than three times – had to bring a nearly complete wardrobe.'[10] The wealthy American woman Lillie Moulton, in 1866 took with her to Compiègne 'Eight day costumes (counting my travelling suit), the green cloth dress for the hunt, which I was told was absolutely

necessary, seven ball dresses, five gowns for tea', most of which had been created for her at enormous expense by the leading couturier of the day, Frederick Charles Worth.[11] Some women had difficulty in affording the wardrobe required for the event, one of them expostulating 'I am invited to Compiègne. I sold a mill.'[12] While we do not know the details of the wardrobe Herminie took with her to Compiègne, we can be confident she had no problem in paying for it.

Pasteur's titbits of information concerning the women present are as telling as his description of the activities in which he engaged there. He commented on 'the admirable dress' in which the Empress appeared each evening and admired the *tenue* of other women, as well as the jewels they were wearing.[13] On one occasion a lady-in-waiting confided to Pasteur about the necklace worn by the charming new 19-year-old wife of the fabulously wealthy Englishman, the first Lord Dudley, of 'five rows of huge pearls, the effect of which was magnificent and cost seven hundred thousand francs. Her husband has three million in *rentes*.'[14] Napoleon III's Chef de Cabinet disclosed to Pasteur that the diadem worn to dinner one evening by Lady Cowley, wife of the British Ambassador, was 'worth 600,000 francs'.[15]

It is possible, of course, that Louis Pasteur was asked by his wife to report such details back to her, but through his descriptions it is apparent that he was more than up to the task and more than interested in the fine detail of dress and the value of jewels. That members of the court believed their comments on the cost of items worn by guest to be significant and passed them on to other guests at Compiègne also illustrates the importance of making a show of luxury in finery at these and other events. In either case, while Emile and Eugène Pereire were both mentioned in Pasteur's letters, Herminie and Juliette were not. The occasion is recalled here as the kind of spectacle for which Herminie and Fanny needed to be prepared.

As Honoré Balzac noted in *Une fille d'Eve*: 'For all women dress is a constant manifestation of inner thought, a language, a symbol.'[16] The style of the *grande bourgeoise* was carefully crafted to convey wealth, style, and an elegance that mirrored the latest Parisian fashion. Herminie and Fanny were no less fastidious in their self-presentation. Every aspect of their appearance was brought into play:

their clothing, their jewels, their coiffure, the incidental accompaniments such as combs and fans. No less than any other women of their class, they were expected to exhibit tangible evidence of the importance and status of their husbands. From all the evidence, the Pereire women worked hard at this and with success.

The *grande bourgeoise* required a multiplicity of clothes to see her through the day, from the hour of rising to the time for slumber. *Peignoirs*, morning dresses, tea dresses, costumes for visiting, costumes for riding in the *bois*, indoor dresses, ball gowns, night attire, and more – these were all necessities of bourgeois splendour and show, although, as Philippe Perrot has clearly demonstrated, every single costume had its rules and significance.[17]

> To bring her toilette into harmony ... with her wealth and rank in society, with social events, hours of the day, and yearly seasonal changes, in other words with all the space she traversed, was the prime mystery of sartorial propriety, the laws of which minutely controlled the time and space of 'society' – the ideal standard and absolute reference point of all manuals.[18]

The numerous occasions on which Herminie and Fanny were required to present themselves well are exemplified in a letter Herminie wrote to her son, Henry, in December 1862. On Monday that week, she told him, she and Emile had attended the Paris Opéra. On Tuesday they went to the theatre to see the 'thousandth performance of *La Dame Blanche*' by François-Adrien Boildieu. Thursday it was to a performance of Charles Gounod's opera *Faust*, and Friday to see Vincenzo Bellini's *La Sonnambula*.[19]

What they wore was particularly important when wives accompanied their husbands. Perrot has remarked that the increasingly austere black suits affected by bourgeois men needed to be offset by their wives or mistresses, who were expected to provide a decorative foil in colour and allure. 'As signs of wealth and ornamental objects, women replaced the lace and jewels banished from men's clothing by the Revolution.'[20] Another historian of fashion, Valerie Steele, has also commented that 'For nineteenth-century men, the link between black and power rested predominantly on issues of class in a rapidly changing society. However, since meaning in fashion is always relational, to the extent that black was becoming increasingly associated with men, it also signified masculine power.'[21]

The Second Empire was a time when dress, especially dress worn by *grandes bourgeoises*, also fascinated artists and writers. Portrait painters and even the Impressionists were particularly concerned to capture their sitters in the latest styles. Jean Auguste Dominique Ingres and Franz Xaver Winterhalter invariably painted portraits of women in fashionable ball gowns.[22] Literary figures Charles Baudelaire and Théophile Gautier wrote in defence of fashionable dress as an indication of modernity, and novelists, too, appropriated fashion in the service of plot and character development.[23] Emile Zola's novel *La Curée*, set during the Second Empire, illustrated the catastrophic decline of its heroine, Renée Saccard, with detailed references to the costumes she wore at each stage. Renée, who had survived an incestuous affair with her stepson, Maxime, died in the throes of huge debts (257,000 francs) owed to the couturier, Worms, the barely disguised fictionalised Charles Frederick Worth. As Zola well knew, female dress was of common interest and laden with coded meanings, especially during the Second Empire.

One particular artefact used frequently to reinforce the relationship between men and women, social class and 'pecuniary strength', was the portrait. In this respect, we have a painting of Herminie (see plate 1), a portrait in oils painted by Alexandre Cabanel (1823–89) probably in the 1850s and possibly commissioned at the time of the inauguration of the hôtel Pereire, when Herminie was fifty-four years old. The work was sold sometime late in the last century and, like many of Cabanel's works, has since been lost. Cabanel's portrait of Herminie and her appearance are thus known to us through a photograph of a copy which lacks a certain clarity. Nevertheless, there is sufficient in the portrait to indicate the luxury with which Herminie surrounded herself.

She stands relaxed against a dark background, leaning on a brocaded chair, her hands loosely clasped. She is in evening dress, a dark red ball gown. Around her she has gathered a dark blue stole of diaphanous material. The gown reveals a low décolletage. If there is little more one can say about her dress, her jewellery is more forthcoming. On each wrist she wears a bracelet: on the left this appears to be of emeralds of which three are visible, set in gold; a heavy gold chain bracelet encircles her right wrist. On her ring finger she wears a large, possibly emerald, ring, at her bosom a large gold brooch. In her hair, which flows freely, she appears to have a

large clasp, most likely of gold. She does not wear a necklace. A quantity of gold and emeralds thus convey a powerful image of the wealth of the Pereire family.

The portrait of Herminie is one of Cabanel's comparatively early pieces, painted long before he became the darling of wealthy American women of the 'Gilded Age' who crossed the Atlantic Ocean simply to have their portraits painted by him.

Cabanel's portrait of Fanny Pereire, painted in 1859 (see plate 3), is more useful for what it tells us of the way the Pereire women wished to be displayed, simply because the image is clearer. This was one of five family portraits commissioned over time by Isaac Pereire following Cabanel's very successful decoration of the ceiling of the *grand salon* of the hôtel Pereire, his 'Allegory of the Five Senses', a work which pleased Isaac enormously. Cabanel, whose academic style of art is now described as *pompier*, extravagant and over-blown, was a rising star who had won the coveted Prix de Rome at the age of 22. He had already been commissioned to decorate a salon in Paris's Hôtel de Ville and was to become much *en vue*, going on to paint portraits of Napoleon III and members of the imperial court as well as the erotically charged *Birth of Venus* which was exhibited at the Salon of 1863 and purchased by the Emperor for his personal collection. The choice of Cabanel to paint the portraits of Pereire family members was typical of their striving for status: identifying a rising star early in his career and thus appearing to exhibit superior cultural perception, taste, and refinement, reaping kudos for the discovery thereafter.[24]

It has been said of this portrait that Cabanel 'insisted on the details of the costume' but, nevertheless, Fanny would have had some influence over the manner of her display, ensuring an appropriate mix of opulence with modesty commensurate with Pereire tradition.[25] The thirty-four-year-old is seated serenely on a pink silk-covered couch, a Persian throw placed casually over its arm. She is posed against marble walls with classical panelling. One might speculate that the portrait was as much about the hôtel Pereire as it was about one of its owners, the inauguration having taken place comparatively recently. Fanny's gaze is direct. She is in sumptuous evening dress of white silk, a wide border of the same silk banded by white lace frames the low décolletage. Her shoulders are bare. A sky-blue silk shawl with broad stripes of gold, the family colours,

and a watered rose reverse is placed around her. Her head is bare, parted in the centre with full waves over her ears, a plait across the crown. The style is reminiscent of that favoured by the Empress, one of many implicit compliments Herminie and Fanny were to pay to Eugénie.[26] Fanny holds a closed fan and wears a bracelet of what appear to be rubies on her right wrist, on her left is a wide cuff of gold. A gold pendant with a large emerald at its centre and smaller emeralds suspended on gold threads is pinned to the neckline of her dress. As with Herminie's portrait by Cabanel, there is no necklace.

Considering Cabanel's portrait of Fanny in all its sumptuousness, and in the light of comments made by Perrot and Steele, it is interesting to draw attention to the portrait of her husband, Isaac Pereire, by the Bayonnais painter Léon Bonnat (see plate 4). The significance to male attire of a black suit of the sort worn by Isaac in this portrait comes irresistibly to mind, as does the corresponding glamour of Fanny's dress and jewellery in hers.[27] While painted some twenty years after Cabanel's portrait of Fanny, Bonnat's work described Isaac as the quintessential business figure in dark evening dress and white shirt; the red ribbon of the insignia of Officier du Légion d'honneur (1863) and, perhaps unusually for the time, his gold wedding ring the only colour in his attire. Isaac regards the viewer gravely, exuding authority, dignity, and patriarchy. His left arm rests on the armchair in which he is posed, his right hand on a table bearing a clock with an allegorical figure of work. Isaac's grandson was to say of this portrait that when Bonnat asked how he would like to be posed, Isaac replied: 'Like Bertin the elder', founder of the *Journal des Débats* for which Isaac had once written, and painted by Ingres.[28] Fanny and Isaac thus presented themselves in stereotypical guise: she as a leading figure of the *grande bourgeoisie*, he as a *patron* of the Second Empire.

It is no accident that during the nineteenth century, the clothing adopted for portraiture by women of the *grande bourgeoisie* was invariably a sumptuous evening gown with glittering jewels, when they appeared at their most desirable and in settings where they would attract the most positive attention to their husbands. Jewellery was as important as dress since, as we know from Louis Pasteur's letters to his wife, appearance and cost were most likely to be remarked upon, and the value of jewels worn by the wife was a useful indication of the wealth of the husband.

While we know about the jewels of Herminie and Fanny from their portraits by Cabanel and from references in the daily press, other evidence of their taste in these costly articles exists. One very public way of demonstrating great wealth was through purchases made at Paris's world fairs, the Expositions universelles, where luxury items were on display and the prices rapidly became public knowledge. It was in these circumstances at the Exposition of 1855 that Fanny's name unusually was recorded as the purchaser from the illustrious goldsmith, François-Désiré Froment-Meurice, of a 'sumptuous' gold bracelet, the centrepiece of which was described by the contemporary art historian Philippe Burty as 'two enamelled figurines alongside an enormous emerald'. Clustered around the centrepiece, a quantity of different-sized pearls 'added to its richness'.[29] Four smaller but by no means insignificant emeralds were set in the bracelet in elaborate gold filigree. The price of this important piece and the exact size of the precious stones are unknown but would have been the stuff of much gossip to those who attended the Exposition where it was displayed.

Although it is the Pereire brothers to whom such patronage is usually attributed, Fanny Pereire continued to frequent the most renowned and innovative jewellers in Paris in her own right. But this form of patronage was only recognised later in her life. On Isaac Pereire's death, she commissioned Lucien Falize of the prestigious firm Bapst et Falize to create an enamelled commemorative bracelet in the family colours of blue and gold, showing Isaac's initials and the dates and places of his birth and death, and containing his photo and a lock of hair.[30] She also commissioned pieces for herself and her daughters, including a significant gold and gem-set necklace presented to her daughter Jeanne on her marriage to Edoardo Philipson in 1881.[31] Similarly, documents show that she purchased luxury items from the equally fashionable Veuve Hippolyte Nattan, a maker and seller of fine jewels including by Frédéric Boucheron.[32] Both jewellers were highly regarded for their innovation: Falize as a leading French proponent of the nascent *art nouveau* movement in jewellery, Boucheron for the combination of precious stones in his designs. Fanny Pereire's patronage stamped her taste for the *avant garde*.

The Second Empire, 'la fête impériale', was a time for masked balls and other entertainments which encouraged women to present

themselves in yet another, more exotic light. For women, a masked ball was 'a new occasion to compete with splendour and audacity'.[33] Such entertainments were frequent at the imperial palace, in the homes of the nobility, and in diplomatic circles. Ballrooms were lavishly furnished and decorated for the occasion and garnished with exotic flowers from the hothouses of Paris. The *grande bourgeoisie* adopted the custom enthusiastically. 'No question of improvising a dress, the couturiers and usual suppliers were put to work weeks before.'[34] Princesse Pauline de Metternich, wife of the Austro-Hungarian Ambassador to France during the Second Empire, presided over such occasions, which she described as 'amusing and presented a unique aspect of luxury and of elegance'.[35]

If women and men of the *grande bourgeoisie* (and of the nobility if it comes to that) took the opportunity to explore other identities in costume, Jews in particular 'explored and articulated their self-image group identity by appropriating others' history and culture in public and private dressing-up amusements. Fancy dress ... enabled Jews to question who they wanted to be and communicate their desires to their Jewish and non-Jewish peers.'[36] It was one among several means by which to demonstrate not only wealth but identification with the history of the nation that had made them citizens.

Costumes from earlier times and frequently with reference to royalty, from Louis XIV to Louis XVI, found favour, as well as costumes which fantasised the dress of exotic countries. The Empress Eugénie herself enjoyed the novelty of these balls and liked to dress herself in costumes of the *ancien régime*.[37] Pauline de Metternich described one such ball gown 'in the fashion of Louis XV' copied from a painting of that time and made for her by Worth, costing a fortune.[38] Men, too, were expected to rise to the occasion, one of the few when they could exchange their sober, black suits for something more exuberant. At a ball in the mansion of the duc de Morny, President of the Corps législatif, the Emperor affected the costume of a Berber with *burnous* and white turban; imitation precious stones decorated a knife in his belt.[39]

Édouard Charton, the Pereires' friend, recorded such a masked ball at the Pereire mansion in Paris in March 1863 on which Herminie and Fanny expended considerable amounts on costumes for themselves and their family. They issued a multitude of invitations. Lavish quantities of flowers and plants festooned the place

for the occasion. Charton described the event in a letter to his wife, Hortense, but not without a certain distaste. He had resolved not to attend, having no costume and no wish to incur the expense of buying one. Fanny held one in reserve, however, thus removing his excuse. But for Charton: 'I was weighed down by a sadness which meant that I took no great pleasure and that nothing astonished me.'[40]

Mme Halphen, the wife of a descendant of a significant diamond merchant, Charton noted, had dressed as the Empress of China in a costume 'carrying millions in diamonds'. Herminie and Fanny each dressed in a costume derived from the *ancien régime*, Louis XIV in the case of Herminie and Fanny in the style of the French Renaissance. Cécile Rhoné and her brothers Emile II and Henry each adopted dress that pointed to another country: Cécile's referred to Greece, while Emile the younger went as a Montenegrin and his younger brother Henry as an Italian. The most original costumes, according to Charton, were worn by Gustave Doré, as Spring, and 'de Braga' [unknown to the author] as Summer.[41]

It is only in photographs, the technology of which developed principally in France and was particularly taken up by the Pereire family, that Pereire women are depicted in dress other than evening clothes. These images, captured in a *carte de visite*, were destined for wider family consumption and frequently sent with brief messages like postcards. The *carte de visite* became the rage, and Adolphe-André Disdéri, who patented the application, achieved renown and was much sought after, employing ninety staff in 1860 and issuing two thousand proofs per day.[42]

That photographs of the Pereires exist in plenty and that they patronised particular photographers also speaks to the family's need to be seen as trendsetters of the elite class. Indeed, all the photographers who captured images of members of the Pereire family were well-regarded and innovative in the way they employed and advanced the new medium. The emphasis within Saint-Simonianism on industry and technology had created in family members a great interest in this novel process of creating images, and they used it advantageously to draw attention to the family name.

They invested considerably in the *atélier* of Gaspard-Félix Tournachon, known as Nadar, financial support that Nadar acknowledged gratefully and publicly.[43] Hippolyte Bayard, who has

now been credited ahead of Louis Daguerre with inventing photography (in 1839), was another who recorded pictures of the Pereire women. One of the best-known of those whose photographs of Pereire family members have survived is perhaps Robert Jefferson Bingham, among the first to use the wet plate collodion process, which was particularly suited to portraiture. An Englishman who worked principally in Paris, Bingham was also among the first to exploit the commercial possibilities of photographing significant figures. His work included photos of Queen Victoria and he worked under her patronage.[44] Pereire family members were thus very publicly in distinguished company as well as in the vanguard of technology when it came to self-presentation by this means.

Bingham photographed Fanny with her daughters, Henriette and Jeanne, in Paris in the mid-1860s at about the same period as he was taking photos of Queen Victoria and her court. The photograph captures a very domestic scene. Fanny, the proud though pensive mother, holds her two little girls protectively in an embrace, all three dressed in the height of fashion according to their age. The younger of the two, Jeanne, leans her head on her mother's lap; Henriette looks mischievously at the camera. Fanny's day dress is of moiré taffeta, an expensive material. On her head, a bonnet tied with lace under the chin reveals her dark hair parted in the middle in a style similar to that in Cabanel's portrait. A head covering was *de rigueur* for bourgeois women when appearing outdoors. She wears a *paletot*, an outer garment fashionable at that period, over the dress. The girls are clothed in identical short-sleeved dresses decorated with cord in what appears to be a variation of the Greek key pattern, much in vogue at the time. Underneath they wear pantaloons edged with lace, and leather ankle boots. Possibly because she was the elder of the two, Henriette also wears a pearl necklace. The photograph carries the inscription 'Mme Pereire and her daughters'.[45]

Photographs and *cartes de visite* were significant to the *grande bourgeoisie*, capturing as they did a more familial, intimate existence. While their comparative price was immaterial to Herminie and Fanny Pereire, *cartes de visite* opened up a much wider audience for the images, both extending and consolidating the circle of family members and friends scattered over a long distance who were to receive them. Historians of photography have drawn attention to

the ways in which elite women choreographed the posing assumed and the message conveyed by these early images. In Fanny's use of them, she clearly wished to be seen in her role as mother and protector of her girls, presenting an alternative to the glamorous social being referred to in the press and projecting a domestic image of the Pereire family of the sort that they valued and cultivated.[46]

Dress and jewellery were not the only markers of luxury and status in personal appearance. Coiffure also played a role in that it showed the woman as having some distinction and sophistication, in step with the latest fashion, aside from providing yet another opportunity to display affluence. Styling the coiffure of their mistresses was an expected element in the duties of the *femmes de chambre* of both Herminie and Fanny. But coiffure could also carry some political message. In 1865, Herminie and Fanny with their husbands received an invitation to dine with the Emperor's cousin, Prince Jérôme Napoléon Bonaparte, better-known as 'Plon-Plon', and his wife Princess Marie Clotilde of Savoy at Plon-Plon's exotic Maison Pompéienne in the avenue Montaigne. Herminie was seated to the left of the Prince and Mme. Michel Chevalier on his right. Fanny, according to her sister Cécile, looked ravishing with a hairstyle 'à la grecque'.[47] In its reference to a style popular during the Empire of Napoleon I, small curls around the face and longer hair bound in a chignon behind, sometimes bejewelled, Fanny paid tribute to the Emperor Napoleon III who had constructed his popularity, his legitimacy, and his reign on the legacy of his ancestor.[48]

On another occasion, *Le Monde illustré* described Fanny's appearance at a ball at the imperial palace, the Tuileries, in 1867 thus: 'Mme Pereire, quite simply in white and admirably coiffed, had ... a comb of diamonds in her hair. Such are the toilettes of the court that one finds again in the same elegant style in all the great Parisian salons.'[49] As an imperial event over which the Empress herself presided, Fanny's appearance was being compared with that of the noble ladies of the court of which she would have been aware. As the wife of a hugely successful banker, it was to be expected, and from the report in *Le Monde illustré* she was up to the comparison.[50]

Aside from their appearance in the wearing of clothing and jewellery, the coiffure, and the purchase of items of personal adornment, the agency of Herminie and Fanny Pereire in consumption becomes less distinct. Nevertheless, Whitney Walton has argued

that the Great Exhibition of 1851 in London saw a turning point in feminine influence, particularly of French manufactured goods for the home. She saw this as 'elucidating contradictions in the nineteenth-century ideal of feminine domesticity by showing how women as consumers disturbed the separation of spheres through their influence on the "male" realms of production and capital accumulation'.[51] This was true of Herminie and Fanny Pereire. Leora Auslander makes a similar point, but she also noted that these gendered constructs could exhibit some fluidity.[52]

For the elite family, however, the home was a showpiece of wealth and solidity, designed to demonstrate the significance of the male owner and his successful activities in the public sphere outside of it. But it was also a haven constructed by the woman of the family for the peaceful rest and recreation of the husband and the raising of children. In this respect, Walton drew attention to the expectation that the woman of the house, associated with the home as she was, was the arbiter of taste in its furnishing – that it was she who made the decisions about display, fabrics, colour, and design of items.[53]

Indeed, from the evidence in the Pereire archive, Herminie and Fanny Pereire were solely responsible for the furnishing of the hôtel Pereire and the Château Pereire at Armainvilliers. Purchases Herminie and Fanny made for the various family abodes drew attention to the opulence in which the Pereires lived and was on show to the public gatherings they mounted.

We cannot establish precisely what sources inspired them in the furnishing of these places. In her account of the rise of the French interior decoration profession, Anca I. Lasc has nominated a number of prominent nineteenth-century practitioners.[54] But there is nothing in the family archive to connect members of this new profession with the decoration of the family homes. Women's magazines came to exert an influence on bourgeois taste, although again, we find no evidence that Herminie or Fanny Pereire were keen readers of fashion magazines.[55]

A detailed accounting of the sums paid for renovation of the hôtel Pereire covers surface decoration – frescoes, sculpture, marble work and plastering, looking glasses and mirrors. It does not include furnishings. We know that the architect, Alfred Armand, who designed both the major extension to the Pereire family mansion in Paris and the construction of the Château Pereire at

Armainvilliers and was paid 95,000 francs for his services to the hôtel Pereire alone, was responsible for the design and decoration of the interiors of these buildings.[56] Further, Armand was personally associated and on very friendly terms with several of the artists employed, including Alexandre Cabanel, Auguste Gendron, and Charles Jalabert, who painted allegorical frescoes and panels, and the sculptor Jules Klagman. But while Armand may have provided advice informally to Herminie and Fanny, it is more than likely that they had a hand in the interior design, especially of their own apartments. And Armand's advice evidently did not extend to the purchase and placement of furnishings.

That the Pereires had a financial stake in the department store the Grands magasins du Louvre which developed an advisory service on interiors may draw us closer, but according to Lasc these services developed late in the century, after Herminie and Fanny had started to buy fine furnishings.[57] There is one source of inspiration we do know about, however, simply from the provenance of the furnishings they collected: that was the *ancien régime*.

The mores, possessions, trappings, and behaviour of the nobility, particularly those of elite nobles with a pedigree anchored in the ancient past and relationship to the royal courts, provided members of the *grande bourgeoisie* with exemplars they were anxious to imitate. In the case of some Jewish members of the elite, the temptation to copy the French nobility became irresistible. Cyril Grange, in quoting the art historian Albert Boime, has noted that upper-class Jews, as newcomers to citizenship in the French nation, aimed to emulate in their style of living: 'the respectability and elegance along the model of the landed aristocracy'.[58] To achieve this ambition they bought up huge quantities of furniture and artworks that entered the market after the Revolution through the seizing of Church property and the decimation of the nobility. Jews established reputations as collectors of fine art, reputations that were almost solely identified with men, however.

In 1867, the year of Emile and Isaac Pereire's enforced resignation from the Crédit mobilier, Fanny acquired a magnificent boudoir table which was the focal point of Christofle et Cie's display at the Exposition universelle of that year. This was one of the relatively few occasions on which the press identified her as the purchaser even though her husband paid for the item; perhaps this

was because, like clothing and jewellery, it was a piece that was recognisably feminine. Christofle, specialising in fine silverware and gold *objets d'art*, was already well-known to the Pereires since the company had produced all the fine tableware for ships of their Compagnie général transatlantique line and *surtouts de table* for the two Pereire hotels, the Grand Hôtel du Louvre and the Grand Hôtel. More importantly, the Pereires were among Christofle's most important private clients.[59]

Christofle's chief designer, Emile Reiber, designed the boudoir table, which was embellished with sculptures by the well-known Albert-Ernest Carrier-Belleuse and Gustave-Joseph Chéret, brother of the painter, Jules Chéret. Fanny's purchase employed the most modern technology. Made of gilded bronze and mahogany, much lapis lazuli, red jasper, and silver gilt adorned it, as well as caryatides, *putti*, and garlands of flowers.[60] Yet it drew inspiration from the *style Louis XVI* and, indeed, was modelled after an earlier writing table designed for Marie-Antoinette by the master cabinet-maker Adam Weisweiler (in 1784).[61]

Marie-Antoinette's table did not feature in the special exhibition of objects that had once belonged to the late Queen and which was held at Le Petit Trianon in tandem with the Exposition in 1867, a special exhibition inspired by and under the patronage of the Empress. The Spanish-born Eugénie was a great admirer of Marie-Antoinette, seeing herself similarly as a foreigner needing to overcome the prejudice of the French and identifying with her predecessor in a myriad of ways. Indeed, Eugénie later purchased the Weisweiler writing table.[62]

This brings us to an important influence on Herminie and Fanny's consumption and collecting: they followed the lead set by Eugénie, the Second Empire style-setter who launched a trend in collecting antiques of the *ancien régime* that had started to come onto the market after the Revolution. The *style Louis XVI* was one of her favourites, but artworks and fine furnishings of earlier Bourbon eras were also favoured. This rendered the Christofle boudoir table that Fanny purchased all the more appealing to its new owner. Significantly, several decades after Fanny's death, when the contents of her home in the rue du Faubourg Saint-Honoré went to auction in 1937, 'Objets d'Art et d'Ameublement' were for the most part identified as in the *style Louis XVI*.[63] That this was regarded as

a feminine style and one employed more frequently in private areas identified with women (the *chambre*, for example), tells us something more of the preferences of these two women.[64]

In adopting the fashion for *Louis Seize* and, to a lesser extent, *Louis Quinze*, in which they imitated the Empress, Herminie and Fanny Pereire were also promoting their family's identification with the regime of Napoleon III. There were many ways in which they demonstrated this allegiance, and it was acknowledged by the Emperor and his wife. Among family documents are two handwritten letters from Eugénie to Emile Pereire: one thanking him for a letter of condolence on the death of Napoleon III in 1873, the other a message of condolence on the death of Herminie in 1874. They provide clear evidence of the warm relationship between the imperial household and the Pereires.

Yet it was not only an act of fealty that caused the Pereires to purchase artworks and other items from the *ancien régime*: just as they had eagerly adopted fancy-dress festivities, it was also a manner of establishing a relationship with the past, of appropriating the history of a nation in which as Jews they had only recently become citizens. Tom Stammers wrote of Isaac de Camondo, the Sephardic banker and collector originally from Istanbul, that he shared 'an obsession with provenance and the allure of historical association'.[65] James McAuley in his *House of Fragile Things* speaks of Moïse de Camondo, Isaac's brother, as a fastidious and obsessive collector of objects *Louis Seize*.[66] In collecting Louis XVI, Herminie and Fanny Pereire were ahead of their time. And while they were following the lead of Eugénie, they were, not unlike the Camondos, similarly identifying with France and staking their own place in its future.

As with Fanny's purchase of the Louis XVI-inspired boudoir table, so, too, did Herminie purchase items which resonated with France's royal history. Various accounts sent to her in 1867 indicate that several Louis XVI candlesticks ['flambeaux'] with sconces in ormolu, heavily decorated with swags of garlands and laurel, found their way to Armainvilliers. Nor was it only furniture that Herminie purchased, for whole sections that had likely once been part of a royal palace or chateau were included on another account rendered to her. Stammers has remarked that the demolition of such buildings and selling the parts was common practice in Paris

during the Second Empire.[67] Indeed, one wonders whether some of the elements finding their way to the Pereire residences may not have resulted from the wholesale demolitions carried out by the Pereires' urban development company, the Compagnie immobilière, as part of the 'Haussmannisation' of Paris throughout the 1860s. Thus, on Herminie's account, a large ormolu Louis XVI balustrade was also installed at Armainvilliers at the same time as the Louis XVI 'flambeaux'.[68]

An extensive undated account in the name of 'Mme I. Pereire' appears to have related principally to furnishings for the hôtel Pereire, although there were also specific references to items intended for Armainvilliers, which was finished later. The Pereires were known to patronise the renowned *maison Fourdinois*, father and son *ébénistes* who worked in neo-classical style as well as the *style Louis XVI* among others.[69] It is possible also that this account did include some items bought at the Grands magasins du Louvre, given the Pereires' commercial interest in the department store. Certainly, from other sources, we know that this store provided a favourite shopping expedition for the two women.

The list gives an indication of Second Empire taste for interior decoration among the *grande bourgeoisie* and that of Fanny in particular, illustrating her active role in the matter of furnishing the dwellings in which she and Isaac principally lived. It also provides an indication of the nature and quantities of items considered essential by elite Parisiennes in the efficient running of their homes. At a total cost of 129,380 francs, the account itemised articles for each of the dining room, the *grand salon*, the small salon, the library, galleries, the *serre*, and bedrooms, the greater number of *ancien régime* provenance.[70]

Many of the items of general furniture are unremarkable from the bare descriptions. Only the quantities are noteworthy, and this would suggest that the items were purchased soon after completion of the hôtel Pereire and close to the moment when the family took up residence. They included seating of different types, for instance, dining chairs (26), and other chairs (30), *fauteuils* (25), *bergères* (4), *canapés* large and small, and *banquettes*, as well as consoles, tables for different purposes, bedroom furniture, commodes, and *armoires*.

There were also several 'Smyrna' carpets most likely of seventeenth- or eighteenth-century provenance. Tableware included

altogether 160 knives, 132 forks, and 115 spoons, as well as serving utensils, a set of Christofle plates, and chinaware (50 pieces). Fanny paid more than two thousand francs for the *batterie de cuisine* for the hôtel and a further thousand francs for one to serve Armainvilliers. Just as Herminie had purchased parts of interiors, Fanny did likewise. Ten casement windows of unknown provenance featured on the list to be installed at various points of the hôtel Pereire, in the *grand salon*, the *petit salon*, and in one of the bedrooms.

Despite the everyday nature of many listed, there was a number of clearly luxurious items, nevertheless. And here Fanny's taste and interest in collecting *objets d'art* is clearer. The most expensive were chandeliers to appear in every room, each one costing between 2,000 and 2,500 francs. There were eight altogether. Two clocks with candelabra at three thousand francs each, for the grand salon and for one of the bedrooms, featured also.[71]

It is not until late in the century and into the twentieth that the public record began to single out certain women as significant collectors. Clearly this was because women did not pay the bills; their husband's signature obliterated them from any part in the transaction. The Empress Eugénie was one who invested considerable energy in collecting works of art, yet that interest has consistently been overlooked or dismissed as insignificant.[72] Historians of collecting have encountered the same problem which seems to deny women any role or interest in assembling the visual arts.[73] But there has been increasing interest in the contributions individual women made both as collectors and as patrons, unpeeling the layers of sometimes assiduous and informed collecting and addressing this invisibility.[74] Among these, women of the Rothschild family employed their enormous wealth in the interests of artists and public artistic institutions, providing some indication of their knowledge and expertise in the fine arts. Charlotte de Rothschild, the Baroness Nathaniel, made noteworthy donations to the Musée de Cluny and the Musée d'art et d'histoire du Judaïsme;[75] Julie de Rothschild gave an astonishing variety of precious objects to the Louvre and the Musée des arts décoratifs;[76] Thérèse de Rothschild became an important collector of illuminated manuscripts following the death of her husband James Édouard, who had initiated the collection, and presented them to the Bibliothèque nationale de France.[77]

If the undated list attributed to Fanny Pereire contains items that can be associated readily with elite women, such as the furniture noted, it also includes works of art under a heading 'Silverware and diverse' that were rarely identified with them. Of particular significance were paintings of 'Saint Cecilia' (two thousand francs) and of 'The Transfiguration' (three thousand francs), for which neither authorship nor provenance were specified; and a statue by a well-known sculptor of the Second Empire, Pierre Loison, at five thousand francs.

Itemised here also is a silver punchbowl costing 7,500 francs, the work of the eminent silversmith Henri Duponchel.[78] In an article by Paul Mantz that appeared in the *Gazette des beaux-arts* of 1863, he noted that a tea service in the style of Louis XIV had been produced by Duponchel and destined for 'l'hôtel de M Péreire [*sic*]', ignoring any role Fanny may have played in this purchase.[79] On the evidence that she had purchased the silver punchbowl by Duponchel, she may well have commissioned the tea service from the same silversmith.

This brings us to the Pereire collection of paintings, a collection considered at the time to exhibit exceptional taste and discernment and thus within the domain of Emile and Isaac Pereire alone.

From the moment an article by Théophile Thoré-Bürger appeared in the *Gazette des beaux-arts* in 1864, references were made to the respective galleries of the two brothers, the magnificence of them, the expense involved in acquisitions, and their fine taste in collecting.[80] Every article published in the contemporary press that referred to works of art in these galleries identified the brothers as the purchasers and collectors. When, in order to pay some of the legal bills associated with the collapse of their bank and the Compagnie immobilière, they together put their extensive art collections on the market in 1872, this was also in the name of MM. Pereire. In the absence of evidence to provide a more nuanced perspective, it might seem that it was indeed Emile and Isaac who were solely responsible for buying works of art for the various galleries in their principal residences. Yet given the ambiguity of the evidence, this may not have been the case.

That it was Fanny who initiated some of these purchases is the more plausible and even likely when considering the evidence of purchases of works of art she made directly from certain artists,

evidence that she was a collector. In a letter from the Czech painter Jaroslav Čermák in relation to Fanny's acquisition of his work *Young Croat peasant and his child* of 1860, he told her that: 'Having completed your painting … I want to ask your permission to exhibit this painting that I consider the most successful work that I have done up to the present.'[81] We find this painting presented at auction in 1872 in the sale from the galleries of MM Pereire; ownership was thus attributed to them rather than to her.[82]

Fanny had dealings with the artist Rosa Bonheur, who invited her to attend her studio to examine some canvasses in progress with a view to a possible sale. This was in response to a direct approach from Fanny. In addition, there are records of her purchase of two paintings exhibited by Jean-Baptiste Clésinger at the salon of 1864, *Shore of the Tiber, Rome countryside* and *Shore of the Tiber, morning, Rome countryside*.[83]

Fanny was thus indisputably a patron who commissioned and purchased works of art. Her patronage might be further tested if we consider whether it was feasible that Isaac Pereire was the purchaser of all the works of art to which his name was attached. Many of these purchases continued to be made when he was extremely ill and blind. In December 1879, at the auction house Hôtel Drouot in Paris, he was reported to have purchased a painting by Léon Bonnat, *Scherzo*, for 44,500 francs, the highest price paid at that sale, the 'vente Garfunkel'.[84] A very significant auction took place in March 1880 at the Villa San Donato in Florence, the great sale of works of art from the collection of the Russian industrialist Prince Demidov, containing, ironically, some works of art that Demidov had purchased previously from the Pereire auction of 1872. From several sources we find Isaac Pereire again nominated as a buyer, even though by then he was dying and had only four months to live. One item was Rembrandt's *Portrait of a young woman*, nominated as being possibly of the artist's first wife, Saskia, purchased for 137,500 francs.[85] *Le Figaro* also counted further purchases by Isaac Pereire from the same auction: two magnificent marble vases by Clodion sculpted for the Palace of Versailles in 1782 together with Carrara marble bases, as well as a reproduction of Ghiberti's bronze doors for the Baptistry in Florence, manufactured by Ferdinand Barbedienne for the 1855 Exposition universelle.[86] In view of Isaac's infirmity and knowing that Fanny had at least some background in

collecting fine art, it is arguable that Fanny herself played the major role in these acquisitions.

Fanny also had a demonstrable interest in engraving. A letter of 1861 from the renowned engraver Louis Henriquel Dupont offered her a series of portraits that were to be included in the book by Alcide de Beauchesne, *Louis XVII: Sa vie, son agonie, sa mort: Captivité de la famille*.[87] In 1868 she was one of the founding members of the Société française de gravure, along with Napoleon III, baron Haussmann, Edmond de Rothschild, and the duc d'Aumale. As a subscribing member, Fanny received unlettered proofs.[88] This interest led her to commission engravings after paintings in the Pereire collection. In January 1879, a book of prints by Eugène Fromentin including engravings on Algeria, *Sahara et Sahel*, was published, to which Fanny contributed one of the artist's paintings. This was the only occasion in Isaac's lifetime that the press went so far as to attribute ownership of a work of art to her. The journal *Le XIXe Siècle* reported of this painting that it was 'owned' by her and loaned for its rendition as an engraving.[89] It was therefore undeniably in her possession rather than his. Conceivably the painting was Fromentin's *Fording the passage*, which appeared in the catalogue of the auction of Fanny's possessions held in June 1937 (see above) at the Galerie Jean Charpentier in Paris.

When it came to commissioning *objets d'art*, aside from those articles listed in the account of 'Mme I. Pereire' referred to earlier, documents again confirm Fanny as the originator of several important pieces that have otherwise been attributed to her husband. In August 1857, she was in direct negotiation with the painter and theatre designer Charles Séchan, who discussed with the sculptor Antoine-Louis Barye on her behalf the casting of a clock ['pendule']. A letter from Séchan makes clear that Fanny was engaged in collecting and commissioning these works. 'I have seen Mme Pereire', he wrote, 'and here is her proposition. She is offering 12,000 francs to have her pendule made by you.' Apparently, Fanny wanted a unique piece, and Séchan advised Barye as to the means of accommodating this demand within the budget proposed. 'You already have the candelabra to make which would be paid outside of this figure.'[90] Again, the commissioning of two elaborate bronze candelabras with *pendules*, including the 'Chariot of Apollo' by Barye, has always been attributed to Isaac Pereire. Yet a letter of

February 1862 from Fanny to the sculptor suggests that she was at least equally engaged in arranging the production of these beautiful objects for the family mansion and for the Château Pereire at Armainvilliers:

> I received your candelabras [she wrote, but] there was a problem with one of [them] which was unstable and encroached dangerously on the clock. ... It will be necessary to rectify it for the good effect of the whole setting. I would be very obliged if you could come tomorrow towards eleven to see what can be done to secure the whole.[91]

Here we may recall Fanny's purchase of two clocks with candelabra for the Château Pereire at Armainvilliers referred to earlier which may be, or may have included, the items noted here.

Significantly, sometime later after Isaac's death, Fanny was reported in the *Revue des arts décoratifs* to have loaned Barye's 'Chariot of Apollo' from its home at Armainvilliers for a special exhibition of the sculptor's work.[92]

On the death of Isaac in July 1880, many works of art were now indisputably hers. She took an active part in maintaining and extending that collection, demonstrated by the sales at auction in 1937 and 1938 referred to of paintings and other objects 'provenant de l'Hôtel de Madame I.P.' (the identity of whom was no secret). Even here, however, the Metropolitan Museum of Art in New York continues to attribute to Isaac Pereire a purchase made in 1884, four years after his death, of a sketch for *The Sultan of Morocco and his Entourage* by Delacroix. The sketch was listed in the 1937 catalogue of works of art belonging to 'Madame I. P.'

At the same time, Fanny encouraged the public exhibition of works in her possession. Aside from the loan of Barye's *Chariot of Apollo* to the special exhibition at the École des beaux-arts already noted, in May 1884, an 'Exposition Meissonier' opened in Paris at the Galerie Petit to which she contributed the artist's *Reconnoitring in the snow*.[93] Several years later she was recorded as lending another Meissonnier, *Flute player*, to a retrospective exhibition in Paris.[94] In these acts of benevolence to public institutions, added to her engagement in the Société française de gravure, Fanny was anticipating a role attributed generally to a later generation principally of elite Jewish men, a role that drew together the Jewish elite with non-Jewish *amateurs*.[95]

The manner in which Herminie and Fanny Pereire presented themselves, added to their acquisition of objects of high culture, demonstrate how they employed conspicuous consumption as both a means of self-fashioning and also to draw attention and bring credit to the family name. First, they used their appearance and the luxurious qualities of clothing, jewellery, and other items to demonstrate wealth. This was recorded through portraiture and through photographs and reported in the press. It was a manner of feminine public display entirely acceptable and expected of *grandes bourgeoises* in nineteenth-century France.

Second, the furnishings and other objects of a domestic nature that evidence confirms they purchased shows they exercised some elegance and cultivation. These items found their way into the homes they made for themselves, homes invariably described, however, as the domain of the Pereire brothers and thus the items within more likely to have been attributed to *their* taste and refinement rather than to their wives'.

Finally, they were active in consumption usually identified with men and rarely if ever attributed to women, elements that involved characteristics of taste and discrimination in cultural pursuits and in collecting. The gendered narrative through which perceptions of consumption emerged is drawn out when we consider how 'MM. Pereire' were credited at the time with possessing among the finest collections of artworks and *objets d'art* of their class. Yet Fanny Pereire at least had a clear interest and direct involvement as a patron in purchases otherwise attributed to her husband. Fanny was undeniably a collector.

Notes

1 *Gazette de Lausanne*, 3 May 1856.
2 Walton, *France at the Crystal Palace*, 69.
3 T. Stammers, 'Women Collectors and Cultural Philanthropy, c. 1850–1920', *19: Interdisciplinary Studies in the Long Nineteenth Century*, no. 31, 2020. doi: https://doi.org/10.16995/ntn.3347
4 'Reynaud', 'Portraits Contemporains: Isaac et Emile Pereire', *Le Figaro*, 23 July 1859.
5 Thorstein Veblen, *The Theory of the Leisure Class*, ed. Martha Banta (Oxford, 2009), 59. ProQuest Ebook Central. http://ebookcentral

.proquest.com/lib/unimelb/detail.action?docID=415975, downloaded 14 March 2020.
6 Jean des Cars, ´Les "séries" de Compiègne', *Napoléon III: Le magazine du Second Empire*, no. 7, 2009, 7.
7 I thank Mme. Sandrine Grignon Dumoulin, Documentation/Régie, Musées et Domaine Nationaux du Château de Compiègne, for this information by email, 13 March 2012.
8 Société Historique de Compiègne, 'Louis Pasteur à Compiègne (30 novembre–6 décembre 1865)', www.histoire-compiègne.com/isoalbum/pasteurbassedf.pdf, downloaded 6 March 2020.
9 Ibid. See also Jean-François Lemaire, 'Napoléon III et Pasteur', *Revue du Souvenir Napoléonien*, no. 47, May 1996, 19–27. Pasteur and the Emperor were mutual admirers.
10 Philippe Perrot, *Fashioning the Bourgeoisie: A History of Clothing in the Nineteenth Century*, trans. Richard Bienvenu (Princeton, NJ, 1994), 177.
11 Valerie Steele, *Paris Fashion: A Cultural History* (rev. ed., New York, 2017), 123, where Steele is quoting Lillie de Hegermann-Lindencrone, *In the Courts of Memory* (New York, 1980), 188–9.
12 George Poisson, 'Napoléon III en Vacances', *Napoléon III: Le magazine du Second Empire*, no. 29, Décembre-Janvier-Février 2015, 38.
13 'Louis Pasteur à Compiègne', letter to Marie Pasteur, 3 December 1865, 6.
14 Ibid., 7.
15 Ibid., 4 December 1865, 8.
16 Carol Rifelj, *Coiffures: Hair in Nineteenth-Century French Literature and Culture* (Newark, DE, 2010), 32, quoting Honoré de Balzac, *Une fille d'Eve* (Paris, 1842), vol. 2, 328.
17 Perrot, *Fashioning the Bourgeoisie*, 91–112.
18 Ibid., 91.
19 AFP, Herminie Pereire, Paris, to Henry Pereire, Egypt, 20 December 1862.
20 Perrot, *Fashioning the Bourgeoisie*, 35.
21 Steele, *Paris Fashion*, 86.
22 See for instance Gloria Groom (ed.), *Impressionism, Fashion and Modernity* (New Haven, CT, 2012), 4.
23 Ibid.
24 The portrait remained in the collection of a descendant of Fanny Pereire until it was sold, together with many remaining artworks, furnishings, and *objets d'art*, at an auction at Drouot-Richelieu, 5 June 2015. Ferri & Associés. *Ancienne collection Pereire* (Paris, 2015).
25 Jobert Barthélemy and Pascal Torrès, 'Isaac Pereire, créateur de la banque modern', *Histoire par l'image* (Online). http://histoire-image.org/de/comment/reply/5427, downloaded 12 July 2020.

26 Françoise Ravell, *Fastes et Rayonnement du Second Empire* (Paris, 2016), 37.
27 The original of this portrait is in the Musée national du Château de Versailles. A copy by Léon Daniel Saubes was sold at the same auction as the Cabanel portrait of Fanny Pereire noted in n. 24 above.
28 Alfred Pereire, *Je suis dilettante*, 131.
29 Philippe Burty, F. D. *Froment-Meurice, argentier de la ville, 1802–1855*, 29 and 69. http://gallica.bnf.fr/ark:/12148/bpt6k5701255n, downloaded 11 January 2012.
30 Katherine Purcell, *Falize: A Dynasty of Jewelers* (London, 1999), 108, picture 156.
31 wartski@wartski.com 'Collection'.
32 AFP, Invoice from 'Vve. Hpe. Nattan, Fabrique de Joaillerie & Bijouterie à Madame Isaac Pereire 12 August 1870, 1 Boite Orfèvrerie 1199,45 [francs]'.
33 Nathalie Harran, *La Femme sous le Second Empire* (Paris, 2010), 26.
34 Ibid.
35 Princesse Pauline de Metternich, *'Je ne suis pas jolie, je suis pire': Souvenirs 1859–1871*, Introduction et Notes de Georges Poisson (Paris, 2008; originally published 1922), 79–80.
36 Michele Klein, 'Louis XIII, Richard I, and the Duchess of Devonshire: Nineteenth-Century Jews in Fancy Dress Costume', *Images*, 22 December 2020. https://doi.org/10.1163/18718000–12340136, downloaded 18 February 2022.
37 Alison McQueen, *Empress Eugénie and the Arts: Politics and Visual Culture in the Nineteenth Century* (Farnham, 2011), 123–35.
38 Metternich, *'Je ne suis pas jolie'*, 78–9.
39 Ibid., 83.
40 Charton, *Correspondance générale*, Édouard Charton, Paris, to Hortense Charton, Versailles, 13 March 1863, vol. II, 1350–3.
41 Ibid., 11, 12, 13 March 1863, 1353.
42 Thierry Dehan and Sandrine Sénéchal, *Les Français sous le Second Empire* (Paris, 2006), 36–7.
43 Nadar, *A terre et en l'air … Mémoires du Géant* (Paris, 1865), 199–200. Letters in the AFP show that by 1875, Nadar was indebted to Gustave Pereire, a noted afficionado of photography, to the extent of twenty-four thousand francs.
44 Laure Boyer, 'Robert J. Bingham. Photographe du monde de l'art sous le Second Empire', *Études photographiques*, November 2002, 127–47.
45 The photo is reproduced in my *Emile and Isaac Pereire*, 171.
46 Jillian Lerner makes this point in her *Experimental Self-Portraits in Early French Photography* (London, 2021), with special reference in

chap. 3 to photographs of Napoleon III's mistress, the Comtesse de Castiglione.
47 AFP, Cécile Rhoné, Paris, to Henry Pereire, Egypt, 8 January 1865.
48 Rifelj, *Coiffures*, 37.
49 Vicomtesse de Renneville, 'Courrier de la Mode', in *Le Monde Illustré*, 23 February 1867.
50 AFP, Cécile Rhoné, Paris, to Henry Pereire, Egypt, 8 January 1865.
51 Walton, *France at the Crystal Palace*, 50–1.
52 Leora Auslander, *Taste and Power: Furnishing Modern France* (Berkeley, CA, 1996), chap. 7.
53 Walton, *France at the Crystal Palace*, chap. 3.
54 Anca I. Lasc, *Interior Decorating in Nineteenth-Century France: The Visual Culture of a New Profession* (Manchester, 2018).
55 Auslander, *Taste and Power*, 224.
56 AFP, 'Payements faits pour construction de l'hôtel faubourg St. Honoré jusqu'au 29 février 1860'.
57 Lasc, *Interior Decorating*, esp. 158–9 and 172–4.
58 Grange, *Une élite parisienne*, 385, quoting Albert Boime, 'Les hommes d'affaires et les arts en France au XIXe siècle', *Actes de la Recherche en Sciences Sociales*, no. 28, June 1979, 62.
59 Claudia Kanowski, 'Les surtouts de table d'orfèvrerie', in Isabelle Paresys (ed.), *Paraître et apparences en Europe occidentale du Moyen Âge à nos jours* (Villeneuve d'Ascq, 2008), 51–2.
60 François Mathey (ed.), *Chefs-d'oeuvres du Musée des arts décoratifs* (Paris, 1985), 'Table de toilette 1867', 132–3.
61 Auslander, *Taste and Power*, 262 and 266, draws attention to the Weisweiler desk also and compares it with other items of furniture similarly influenced.
62 Mathey, *Chefs-d'oeuvres du Musée des arts décoratifs*, 132.
63 *Objets d'Art et d'Ameublement ... provenant de l'Hôtel de Madame I. P.*, Catalogue, 15 February 1937, Hôtel Drouot, Paris.
64 Auslander, *Taste and Power*, 284–5.
65 Tom Stammers, *The Purchase of the Past: Collecting Culture in Post-Revolutionary Paris* (Cambridge, 2020), 240.
66 McAuley, *The House of Fragile Things*, 123–7.
67 Stammers, *Purchase of the Past*, chap. 5.
68 AFP, various accounts in the name of Mme. Emile Pereire.
69 Olivier Gabet, 'La maison Fourdinois: néo-styles et néo-Renaissance dans les arts décoratifs en France dans la seconde moitié du XIXe siècle' (thèse, Diplôme de l'École nationale des chartes, Paris, 2000). Gabet noted in chap. II that the Pereire brothers ordered a great deal of furnishings for their dwellings from this *maison* and that in turn they influenced the Fourdinois through their Saint-Simonian ideas.

70 AFP, 'Compte de Mme I. Pereire', handwritten, undated.
71 Ibid. While this account may have related to purchases for the hôtel Pereire prior to its inauguration in 1859, given the large quantities of furnishings itemised, reference is also made to Armainvilliers, which was not completed until 1864. The purpose of the account thus remains something of a mystery.
72 Similarly, McQueen, *Empress Eugénie*, 150, noted that 'Eugénie's interest in art has been minimized and in many cases entirely denied by biographers and historians'.
73 Stammers, *Purchase of the Past*, 23, explained that 'The relative absence of women from this study reflects the systemic denigration of their pretensions to be collectors outside of gendered parameters.'
74 This revision in the historiography has been explored in a special edition of the journal *19: Interdisciplinary Studies in the Long Nineteenth Century*, no. 31, 2001, 'Women Collectors: Taste, Legacy, and Cultural Philanthropy c. 1850–1920'. See especially the introduction by Tom Stammers.
75 Pauline Prevost-Marcilhacy (ed.), *Les Rothschild: Une dynastie de mécènes en France* (Paris, 2016), vol. 1, 1873–1922, 29–30 and 184–235.
76 Ibid., 29–30 and 238–47.
77 Ibid., 29–30 and 282–99.
78 AFP, 'Compte de Mme I. Pereire'.
79 Paul Mantz, 'L'Orfèvrerie Française', *Gazette des beaux-arts*, 1863/01, vol. 14 – 1863–1906, 538.
80 W. Bürger, 'Galerie de MM. Pereire, Extrait de la *Gazette des beaux-arts*' (Paris, 1864, reprint 2017).
81 Pauline Prevost-Marcilhacy, 'La collection de tableaux modernes des frères Pereire', in Leika El-Wakil, Stefanie Pallini, and Lada Umstätter-Mamedova (eds), *Études transversales: Mélanges en l'honneur de Pierre Vaisse* (Lyon, 2005), 155, fn. 84.
82 *Galerie de MM. Pereire: Catalogue des tableaux anciens et modernes des diverses écoles dont la vente aura lieu Boulevard des Italiens, No. 26 les 6, 7, 8 et 9 mars* (Paris, 1872).
83 Prevost-Marcilhacy, 'La collection de tableaux modernes', 155, fn. 84.
84 *Le XIXe Siècle*, 9 December 1879.
85 Ibid., 20 March 1880.
86 *Le Figaro*, 13 July 1880.
87 Prevost-Marcilhacy, 'La collection de tableaux modernes', 155, fn. 84.
88 Elizabeth Anne McCauley, *Industrial Madness: Commercial Photography in Paris, 1848–1871* (New Haven, CT, 1994), 298.
89 *Le XIXe Siècle*, 14 January 1879.

90 Charles Séchan, letter, 'Collections Jacques Doucet', Num. Archives 166/2/101/001–002, Institut National de l'Histoire de l 'Art (hereafter INHA).
91 Fanny Pereire, letter, 'Correspondance du vivant d'Antoine-Louis Barye', Num. Archives 166/1/2/89, INHA.
92 *Revue des arts décoratifs*, 1889, A9-T9.
93 *Le Figaro*, 17 May, 1884.
94 *La Revue mondaine illustrée*, March 1893, 'Exposition Meissonier', Galerie Georges Petit.
95 Grange, *Une élite parisienne*, 390–1.

6

Sedaca, charity, philanthropy

If conspicuous consumption, demonstrable extravagance, and luxurious display in the lives of *grandes bourgeoises* was a given, so too was the practice of charity. Like the noble families from whom elite women had appropriated the activity, 'charity was a way … to demonstrate their membership of high society' and at the same time 'to absolve [them] from charges of personal extravagance even as it reinforced pecuniary status'. Charity also provided wealthy women the chance to show that their lives had some purpose other than mere pleasure.[1]

Yet charity and philanthropy also facilitated the acquisition of expertise in particular worthy fields, providing opportunity for independent action for the public good and in the public domain. Increasingly over the century women were to initiate and provide financial support to welfare infrastructure – hospitals, clinics, schools – and related programmes. These initiatives came to be described and discussed in the press and elite women recognised for the role they played in implementing them. Thus was Fanny Pereire to receive universal credit for her resourcefulness when, as a widow, she implemented several significant programs in public health.

This chapter will draw out the significance of charity and philanthropy in the lives of the very wealthy Herminie and Fanny Pereire. And here it is noticeable that in their acts of generosity, the two women covered the gamut of possibilities as they unfolded over the nineteenth century: extending kindness towards their coreligionnaires as the obligation of *sedaca* commanded; giving to charitable causes of all kinds in the interests of the poor; and establishing infrastructure for the provision of particular welfare services – all in the family name. The

chapter will show how charitable activities became the means through which they attracted honour to the family, enabling them to demonstrate at once allegiance to France and gratitude for the gift of citizenship to their men. In the case of Fanny Pereire, philanthropy was also a tool in combating an encroaching antisemitism as well as a means to exercise control, agency, over her legacy. The chapter will dwell first on the particular family context in which this charity was extended.

The related topics of charity and philanthropy in nineteenth-century France have been a focus of interest in historical enquiry. But this has been addressed principally from a religious point of view, and a Christian one at that. It has drawn on the expectation that bourgeois women would perform good works as part of Christian duties springing from Christian teachings about obligation to others and within the strictures and structures of the Church. In this respect, the role of elite women has been recognised as innovative and important in the development of approaches to poverty, especially in those areas where women were expected to have acquired some expertise: in education, child welfare, and family support.

To be sure, wealthy and devout Catholic and Protestant women were extremely active in bringing charity to those in need. The activities of Jewish women may not have attracted the same degree of interest, however, even though numbers of elite Jewish women founded and funded significant welfare enterprises over the century.

Overall, and as a result of the family's charitable ethos, Herminie and Fanny Pereire were extremely active in their giving. They frequently joined with other members of the *grande bourgeoisie* in supporting worthy causes when the fabulous wealth of the Pereires was seen to be placed both at the disposal of a higher moral purpose and in exalted company. Ironically, the press often congratulated Herminie and Fanny on the reticence and self-effacement with which their good deeds were carried out while at the same time eulogising their beneficence. This was equally typical of the *bourgeoises* of Bonnie G. Smith's Nord department, who were similarly expected to perform charitable acts with 'perfect discretion' for which they received much praise.[2]

The French Revolution had destroyed the society in which *noblesse oblige* flourished, yet for a large part of the century which followed, responsibility for the provision of charity was still thrust

on the individual or on religious congregations and institutions. Paradoxically, *noblesse oblige* itself continued to exist as the old nobility sought to re-invent and entrench itself in a new society and a new order.[3] At the same time, the Revolution, with its spotlight beamed upon human rights and citizenship, drew attention to individuals and groups who had previously missed out, requiring ever more need for assistance: the poor, the sick and the infirm, girls and women among them.

Industrialisation and urbanisation, which throughout the nineteenth century proceeded to consume much of the human and material resources available and were to cause considerable human misery, increasingly demanded the application of services which were still only being provided by wealthy individuals or families and religious societies.[4] This conjunction of intensifying social need with accelerating Jewish assimilation and wealth was to encourage Jewish philanthropists to spearhead major contributions to charitable and philanthropic causes.

Indeed, the *longue durée* was a period when Jewish philanthropic gifts far exceeded those made by non-Jews. One study showed that during the century, Jews gave 9.5 francs per head to charitable causes as against 1.6 francs per head by Catholics.[5] Through philanthropy, Jews thus made a contribution to France in a very public manner. As Céline Leglaive-Perani explained, 'Philanthropy addressed to all the French, without distinction of [religious] confession, is a proclamation of belonging and of attachment to France and plays an integrating role.'[6] It was another marker of acculturation.

Among the first of the Jewish philanthropists, the Rothschild family initiated a remarkable series of gifts when in 1847, during a serious grain shortage, James attempted to purchase Russian wheat to tide over the starving people of France. This venture was unsuccessful, but even more substantial and successful bequests from the Rothschilds were to follow, a new hospital in 1852 for indigent Jews in the rue Picpus being an early notable example.[7] Over the next half-century, the Rothschilds continued to make significant philanthropic contributions to France, as did the Fould, Furtado-Heine, Hirsch, and Veil-Picard families. The Sephardic Daniel Iffla in 1907 left the greater part of his fortune, some thirty-six million francs, to the Institut Pasteur after numerous other acts of beneficence to the French people, including purchasing the Empress Josephine's

former home, the Château Malmaison, in 1896 and presenting it to the nation.[8]

The context for the Pereires' charity was complex, for while it was not unusual to find wives of the elite sharing charitable endeavours or ideas with their husbands, what is significant in the case of Herminie and Fanny is the particularly strong influence their husbands brought to bear on their activities, indeed their whole approach to charity. It is useful to explore this dimension first to gain an understanding of the considerations at work on the nature and rationale of activities Herminie and Fanny pursued.

Sedaca, or *tzedakah* as it is known in the Ashkenazi rite, the moral imperative to extend benevolence to fellow Jews, is at the heart of Judaism. It was thus at the heart of organised life in the Bordeaux Sephardic community, the birthplace of Emile and Isaac Pereire. This imperative remained with the brothers throughout their lives, for the essence of *sedaca*, to help an individual achieve self-reliance through a gift or a loan, saved them and their widowed mother from the harsh effects of poverty in that city. The Sephardic community came to their rescue on the death of their father in 1806, supporting their mother in her haberdashery until it failed in 1813 and providing Emile with employment when he came of age in 1815. Eventually, in 1822 when their uncle, Rodrigues *fils*, persuaded their mother to send her sons to Paris, he found positions for them in the nascent banking and financial enterprises. Emile and Isaac rapidly achieved self-reliance as a result of Rodrigues' own act of *sedaca*.[9]

During their lifetime, these Jewish men continued to extend generosity to individuals. At first it was directed principally towards family and friends in Bordeaux, giving financial help to the needy and assistance in finding jobs, even when they themselves were far from established in the capital. Well before they made their fortune, they performed favours for impoverished relatives. They provided money to their uncle Jacob Lopès Fonseca to move to Paris.[10] They gave loans and extended credit in circumstances of necessity. In 1830, a fellow Bordelais, Jules Mirès, who in the end became an implacable foe of the Pereires, received money to tide him over a bad period and later referred to Emile Pereire as the 'guardian angel of my family'.[11]

In examining their giving over a large part of the century, the Pereire brothers' contributions also illustrate the changing nature

of charity and philanthropy. An exponential increase in their own wealth enabled them also to respond to a complex set of social and industrial circumstances, influenced by Saint-Simonian philosophies about the central problem: how to address poverty. Although throughout their lives, Jewish causes continued to have some importance for the brothers – they provided large sums to the Sephardic communities of Bordeaux and Paris, including bequests in their wills, and contributed towards the salary of the Chief Rabbi of France – after some time they began to direct their charitable resources to the general population. One example was their construction in 1865 of accommodation in the rue Boursault and in Batignolles for single male workers. This did not prove popular with the target population at the time and eventually the buildings were converted into apartments available to all. Ironically, however, the idea showed yet again the prescience of the Pereires as it resurfaced late in the century, taken up by the Rothschild Foundation in 1904 with a gift of ten million francs for social housing.[12]

At the end of the century, over three thousand welfare establishments of all kinds existed in Paris.[13] As the historian Lee Shai Weissbach has shown, the philanthropic actions of these organisations were directed increasingly towards particular problems of society. Jewish societies responded accordingly. Weissbach proposed that up until the First World War, the nature of Jewish philanthropy mirrored that of French society generally thus: 'What Jewish philanthropists wanted to instil in those who came under their influence was, in fact, not so much a particularly Jewish system of values, but rather a French bourgeois system.'[14]

Dealing with poverty, which was recognised as the crux of many social problems, was a dominant theme in the society and politics of nineteenth-century France, one with which the Pereire brothers wrestled for a good part of their lives. Their objective differed from that of many in the Catholic faith in that they aimed firmly to overcome poverty rather than to encourage the poor to learn to live with it. As early as 1831, Isaac Pereire delivered four lectures, 'Lessons on Industry and Finance', to a theatre packed with Saint-Simonians, in which he dealt powerfully with the disparity between rich and poor.[15] The writings of Emile Pereire for *Le Globe* and *Le National* in the early 1830s were similarly engaged in analysing and finding

solutions to the issue of poverty.[16] In his prison at Ham in 1844, Prince Louis-Napoleon Bonaparte wrote a treatise on *L'Extinction du paupérisme* which canvassed questions of cause and effect and made recommendations to address it, including establishing agricultural communities and credit incentives.[17] The compatibility of their interests helped the Pereires establish a solid relationship with Bonaparte after his *coup d'état* and self-proclamation as Emperor Napoleon III in 1852.

The issue of poverty remained significant for the brothers to the end, however. In the last year of his life, Isaac Pereire established a prize of one hundred thousand francs, the Concours Pereire, twenty-five thousand francs of which was to go towards the best essay on eliminating 'paupérisme'. Fourteen prominent academicians, senators, deputies, and journalists adjudicated the 443 entries when the Concours was first advertised in 1881 after Isaac's death.[18] Not without importance, it was Isaac's widow Fanny who promoted and managed the Concours and saw it through to completion. She commissioned a series of chased silver plaques designed by Lucien Falize and bearing the inscription 'Le paupérisme: solution', with which she rewarded each of the adjudicators.[19]

For Herminie and Fanny Pereire, then, charity was central to the family ethos and led by the example of their husbands, a generosity recognised by the public and in the press. As an assistant to the mayor of the eighth *arrondissement* was to say in response to one particular gift in 1880, 'The poor of Paris have known for a long time the charity of the Pereire family.'[20]

Much of the foregoing concerns particular men who gave to charitable and philanthropic causes, but historians have frequently observed that the provision of charity more generally was largely the domain of women. Bonnie G. Smith tells us that: 'During the nineteenth century [women of the department of the Nord] continued ... traditions of *noblesse oblige* by visiting those of their neighbours in temporary distress or by holding "days" once a month on which the poor passed through their courtyards to receive money, clothing, or food.'[21] Susan K. Foley described a similar scene and reflected that: 'Women's charitable activities were ... understood as a form of "social motherhood".'[22] Both historians referred to an underlying assumption common among elite Catholic women that poverty was a given in society and that only with 'moral reform'

could its worst manifestations be conquered. Both historians also ascribed this form of charity to Christian tradition.

The press frequently reported on the charitable actions of Herminie and Fanny Pereire. Gabrielle de Saint Mars, writing as 'Jacques Reynaud', recorded of them in *Le Figaro* that

> Charity is the sole occupation of mother and daughter; they do not bother with either their toilettes or their trinkets with which the brains of rich women are usually filled. The poor are their children, their brothers; with them there is neither calculation nor vanity, they do not make any noise about it at all, the journals do not record the number of their bequests, they are modest in their kindness.[23]

Some of this statement is ironic, having laid out in the previous chapter the manifestations of conspicuous consumption associated with Herminie and Fanny. And while 'Jacques Reynaud' and others reported what they saw as reluctance in this mother and daughter to advertise their generosity, nevertheless the press frequently noted the presence of both at charitable events associated with the *grande bourgeoisie* and their magnanimity at these events. On a number of such occasions, members of the imperial family were also among the patrons of the charities involved. Thus, the names of the *mesdames* Pereire featured alongside those of government ministers, ambassadors and, importantly, members of the Rothschild family. Herminie and Fanny each gave one hundred francs towards poor and necessitous workers of the eighth *arrondissement* at a large fête which took place in December 1855 in the Opera House under the patronage of the Emperor and Empress.[24] A concert given in March 1869 in the theatre of the lycée Louis-le-Grand in aid of poor and elderly female school teachers was another opportunity to promote the Pereire name.[25] Again, there were times when the opportunity for such promotion of necessity overcame what was described as their reticence in advertising the generosity.

The charities supported by Herminie and Fanny also came to include specifically Jewish causes, however. As an example, along with other Jewish women – of the families Rothschild, Furtado, Zadoc Kahn, and Deutsch de la Meurthe, among them – they purchased tickets in and contributed attractive prizes to the lotteries of the Comité de bienfaisance Israélite, the pre-eminent Jewish social welfare institution in France.[26]

While they were donors to Jewish causes, it is at least curious that when in 1842 Betty de Rothschild took the reins of the society of Dames patronesses, which Nanci Rodrigues had founded in the early 1820s under the aegis of the Consistoire Israélite de Paris and that Betty de Rothschild re-named the Société pour l'établissement des jeunes filles israélites, neither Herminie nor Fanny appears to have had any involvement. There was no enmity or competitiveness of the sort that later came to characterise relations between the two families; indeed, at that very moment, the Pereire husbands were working in tandem and harmoniously with James de Rothchild towards the launch of the Nord rail line. But the women who joined the baronne were wives of prominent members of the Jewish community, of the Consistoire central Israélite, the Consistoire Israélite de Paris, and the Portuguese Synagogue. It is more probable, then, that this close affiliation with organised Jewish life in France excluded Herminie and Fanny, whose husbands were not so closely allied. Nor at that stage did they have the wealth of those whose wives gathered in the home of the baronne to plan the aims and activities of this society.[27]

Herminie Pereire's individual acts of charity are not as visible as those of her daughter. There were no monuments. She gave substantially to a 'maison de secours' in the ninth *arrondissement* opened by the Archbishop of Paris in March 1866, in which a female religious order raised orphans.[28] There is also evidence from about 1863 that she was a patroness of the Société de bienfaisance de dames polonaises, set up to support Polish women refugees.[29]

Herminie's charity began at home, largely centred on family, friends, and acquaintances, taking care of them in times of need. She drew a warm, protective shield around her sisters, providing hospitality at all times. When finance was needed, she made it available to them, particularly since in most cases her sisters outlived their husbands and some became necessitous. When Aunt Baud became immobile, Herminie had a sedan chair constructed for her.[30] Aunt Lévy's continued stays in the clinic of the early psychiatrist Dr Emile Blanche, doctor to Guy de Maupassant and Gérard de Nerval, were supported by Herminie.[31] Recipients of these charitable actions were principally Jewish.

She ministered assiduously to the sick, as we know from her letters. When a family friend died, the mother of two young children,

Herminie took the children into her own home where they slept in her chamber.[32] Friends frequently called upon her to assist with sick children and to give advice, in which she seemed to have been unusually proficient. Her charity was thus more akin to the *sedaca* of earlier days, similar in many ways to the charity directed towards other Jews so noticeable in the acts of kindness extended by her husband, Emile.

One of the few occasions on which Herminie received any written attention in relation to charity came in 1864 from the Goncourt brothers, whose attitude towards the Pereire family was confounded with the growing anti-Jewish stance of the day.

> Feydeau [the writer and father of the dramatist, Georges] told me that Mme Pereire goes out, every day, to do charity for four hours. I find something horrible in this regularity, in this punctuality of pity, in this daily function of assistance. One senses too much in that a banking fortune which disarms God for four hours each day.[33]

This most uncharitable assessment of Herminie's charitable acts was born of an antisemitic attitude to the whole Pereire family, apparent in other comments in the Goncourt diaries.[34]

The Franco-Prussian War presented some Jewish women with a significant opportunity to establish charitable and philanthropic activities addressed to an imminent danger and threat to the nation. Leglaive-Perani reported that 'philanthropy … gave an image of patriots worthy of the title of French men and French women', demonstrating the extent to which Jews were working in the service of the nation.[35] She referred especially to several elite Jewish women who in 1870 performed patriotic services for France. Betty de Rothschild turned over her home in Paris as a hospital for convalescing soldiers. Through the Red Cross, Cécile Furtado-Heine funded several ambulances to bring wounded soldiers back from the battlefields to Paris. Coralie Cahen nursed wounded soldiers and repatriated them from Germany, becoming a chevalier of the Légion d'honneur in 1888 in recognition.[36]

Evidence of similar involvement by either Herminie or Fanny in philanthropic activities in the immediate period is unclear, although the Pereire family too pitched in to support the war effort. We cannot speak of their direct involvement during or after the War, whether they instigated the aid that flowed in the family name, for

both had kept well away from the fighting. Herminie stayed principally in Arcachon and Fanny in Pau and various other places in the southwest. Nevertheless, they contributed to the impetus behind several actions even if they were not present to realise them.

The family put together an 'ambulance' to serve in the War, as in December 1870, Fanny's son Gustave was in Madrid where he was reported to be making various purchases to draw one together.[37] The term 'ambulance' at that time was not limited to a vehicle to transport the wounded but included 'improvised field hospitals usually of more than six beds'. The ambulances of Cécile Furtado-Heine noted already were of this dimension. The activity was contingent on the Geneva Convention of 1864, which allowed voluntary contributions to be made to care for the wounded.[38] Putting together an ambulance was thus a considerable and an expensive undertaking.

Fanny in a letter to Gustave followed her son's progress with pleasure. She mentioned that she had heard of his success from a Doctor Meunier who assisted Gustave in sourcing the necessary components. As the tone of her letter makes clear, she was fully aware of the project and lauded Gustave, encouraging him in what he had been able to achieve.[39]

It is only in the journal of Camille Desrochers, Fanny's *femme de chambre*, however, that we learn that the salon of the Pereire mansion in Paris had been turned over to a hospital where eight soldiers at a time were treated for a variety of illnesses, including typhoid. The family arranged for the renowned Doctor Archambault to call on them every day, and their nursing care was placed in the hands of three nurses and a religious.[40] When Herminie's granddaughter, Marguerite Rhoné, wrote to her uncle Henry about the bandages she was making 'for the poor wounded', they may have been destined for the 'Pereire hospital'.[41]

In addition to the initiatives taken by certain Jewish women at a time of war in 1870–71, there are many other examples of philanthropic acts recorded during the second half of the nineteenth century. Female charity and philanthropy had traditionally been driven by women's own perceived maternal virtues and experience as mothers of children: assisting the very poor with money; education, including apprentice education; crèches; orphanages; and aid to single mothers. Cécile Furtado-Heine, a descendant of the Bayonne Furtado family on her father's side, of the Foulds on her

mother's, and who married into the wealthy German banking family, Heine, in 1884 established a hospice for children in the fourteenth *arrondissement*. For this and other philanthropic works, she was created a Chevalier de la Légion d'honneur in 1886 and an Officier in 1896.[42] On a different plane, Furtado-Heine and other Jewish women, Clara de Hirsch among them, gave most generously to the establishment by the wealthy Jewish philanthropist, Daniel Iffla, of the Institut Pasteur in 1888.[43] A succession of Jewish women, including Betty de Rothschild, had even established hospitals serving various special needs.

A commitment to charity Herminie passed on to her daughter. It was one of the duties of an elite bourgeois mother, to teach her daughter the importance of giving time towards ministering to the poor, the sick, and the infirm. Smith recounted how wealthy women of the Nord department encouraged their daughters to make savings to give to the poor.[44] Similarly, Foley noted that from adolescence, girls were encouraged to make donations and to visit poor people.[45] Again, Leglaive-Perani described the donation to Jewish charitable causes as a family enterprise, the practice passed down above all 'from mother to daughter'.[46] So, too, was Fanny encouraged by her mother to contribute to the greater good from an early age.

Unlike Betty de Rothschild, Fanny's *raison d'être* in philanthropy was not to establish a public role for herself as a 'Jewish woman philanthropist', in the terms of Rothschild's biographer. Fanny Pereire identified as Jewish, but she did not imbue her efforts with an overt mission to achieve acceptance of Jewish women in that role.[47] And she certainly did not work within the auspices of the Consistoire Israélite de Paris as Betty de Rothschild frequently did.

Undoubtedly, Fanny's philanthropy was rooted in the aspirations of Paris's Jewish community – to achieve recognition as patriots of France, to demonstrate through tangible ventures the acculturation they had achieved. But her ambition encompassed several personal elements as well: to regain positive recognition for the family name after it had gone through a difficult period, particularly for her husband; and to allow full rein to her management talents. The fall of the Crédit mobilier had created considerable ill-will among shareholders and the public at large. Many had lost huge sums of money, a significant number their life savings. While Isaac had battled heroically to restore the family's reputation and had stemmed

the erosion of influence from some of the enterprises they still controlled, antisemitism was on the rise.

Fanny Pereire's charitable activities and later philanthropy were in evidence more publicly than those of her mother. Certainly, throughout her life she extended acts of generosity towards families and individuals similar to Herminie's, deeds that were recorded in letters of the extended family together with the gratitude of recipients. The Sarchi couple, Félicie and Charles, commented about money Fanny gave spontaneously on several occasions to their friends, the needy Giacomelli family of Venice.[48] The financial support given to the Guyanese Saint-Simonian Ismail Urbain by Isaac Pereire, which included a paid position writing for his newspaper, *La Liberté*, Fanny continued after Isaac's death in 1880, when she settled a pension of two thousand francs on Urbain's wife and assisted his son in winning a *bourse* at a leading *lycée*. In his will, Urbain emphasised his gratitude to Fanny Pereire for her generosity.[49] Fanny was thus a well-known and well-regarded benefactor.

Feminist historians point to one of the paradoxes of 'separate spheres' in which the domestic and maternal lives of upper-class French women during the nineteenth century led them inexorably into charitable activities focused on women and children in which, as a result of their own priorities as mistress of the home and family, they were expected to have some expertise and considerable emotional investment. Over time, these charitable pursuits propelled them even further into areas of public discourse and policy concerning women and children. While 'the ideal woman of the elite turned her maternal virtues … to the benefit of the less fortunate', as Foley noted, she also 'broadened the boundaries of her "separate sphere" to carve out roles which gave her a "social sphere" of increasing significance'.[50]

Here we should consider the numerous references to Fanny's organising ability. The Sarchi correspondence recorded instances when it was taken for granted that Fanny could sort out particular mundane problems: how to get the mail through during the Franco-Prussian War; how to retrieve a lost item from a department store.[51] But there were other, more weighty matters requiring her support. These organisational skills naturally found considerable employment in the home and as the wife of the eminent *patron*, Isaac Pereire, especially after the deaths of her parents.

Managing different and expensive properties, servants, family and children, dealing with business colleagues, business activities, entertaining, arranging social occasions, all these responsibilities which we have already noted brought her management talents to the fore. It is not surprising to find her acting as a secretary to Isaac when he took over ownership and direction of *La Liberté* newspaper in 1876.[52]

While in 1861 the Château Pereire was under construction at Armainvilliers, surveillance of the works was for a time left to Fanny. Writing of this to her son, Henry, Herminie reported, 'As you know Fanny will acquit herself very well.'[53] One of Fanny's soirées in March 1865, to which eight hundred invitations had been extended, coincided with the day the duc de Morny died. Fanny rapidly organised notices of cancellation to all invitees, and only five people arrived at the *porte-cochère* of the Pereire mansion in Paris. Again, Herminie spoke with pride of her daughter, whose prompt action 'was a tour de force'.[54] On this occasion, however, *Le Petit Journal* reported that 'M. Isaac Pereire will not be receiving this evening because of the death of the President of the Corps législatif', thus ignoring the role played by Mme. Pereire in averting this social calamity and rendering her efficiency invisible to all but her immediate family.[55]

With these skills and attributes, however, together with the particular circumstances in which she had been raised, it was perhaps inevitable that she should take the opportunity, once afforded, to expand her influence to a larger, more complex, and more public sphere. In this task, press commentary, nevertheless, sometimes rendered her actions as invisible as they had been in relation to the organising of extravagant social events or to her significance as a collector.

The first evidence we have for this is when Fanny turned her attention to indigent Parisians in the deadly winter of 1879–80, when for fourteen days the thermometer did not rise above freezing point and 10 December 1879 was (and remains to this date) the coldest day ever recorded there (–23.9°C or –11°F). The front page of the Sunday literary supplement to *Le Figaro* of 14 December led off with the stark assessment: 'The cold and the snow persist, the poor are suffering, and the misery increases every day.'[56] Fifty people were to die of cold in Paris during that winter.

Both Fanny and Isaac contributed directly to alleviating this misery. He gave fifty thousand francs to the mayors of Paris and to the Caisse des écoles, a public education resource for school children, to be distributed among the poor in dealing with the effects of the intense cold. Isaac was particularly proud of what his wife achieved, however, as he noted privately to his friend, Francesco Vigano: 'Today my wife served 1,800 clients' in a *fourneau*, or canteen, serving meals to the poor.[57]

Once more Fanny's role in this endeavour was muted by newspapers, including Isaac Pereire's own, which ascribed the initiation of this benevolent but organisationally challenging action to Isaac Pereire himself rather than to his wife. On 15 March 1880, *La Liberté* reported that the *fourneau* was 'Founded and administered by a man whose name is always associated with all the initiatives of true progress and true philanthropy, M. Isaac Pereire.'[58] The Republican daily newspaper, *Le XIXe siècle*, also referred to 'the fourneau founded by M. Isaac Pereire' while ignoring the source of the idea and the challenges of its operation.[59] Under the headline 'Public emergency services', the daily newspaper, *Le Temps*, using exactly the same words, reported on 5 January 1880 on 'the fourneau founded by M. Isaac Pereire'.[60]

The kitchen, noted as 'well-furnished and even better served', provided meals daily for up to 2,400 impoverished Parisians, either at lunch or at dinner. 'These are full meals that the kitchen founded by M. Isaac Pereire serves to them. Mlle. Pereire [Fanny's youngest daughter Jeanne] distributes to each one a good soup, some vegetables, a portion of meat, some wine and some bread.' *Le Temps* described Fanny's role in vague terms: 'Mme Pereire presides over it all.'[61] The newspaper did go on to note, however, that Fanny had enlisted other female members of the family, her daughters Jeanne and Henriette particularly, to support her in opening this free restaurant at no. 20 rue Anjou-Saint-Honoré, in the immediate neighbourhood of the family home.

On New Year's Day 1880, Fanny also provided oranges for all who came to the *fourneau*, toys for the children, and clothes for the needy. *Le XIXe siècle* reported that 'It was a real family celebration.'[62] Fanny's kitchen appears to have been in operation for at least several months as the two occasions upon which it was mentioned in the press were ten weeks apart. The organisational

and management tasks involved were immense by anybody's reckoning. Indeed, several years later, one highly impressed Republican commentator proposed the Pereire *fourneau* as a model for feeding Paris's industrial population.[63]

On Isaac's death in July 1880, an obituary published in the journal, *l'Avenir d'Arcachon*, made special mention of the relationship between Fanny and Isaac in the context of their charitable works. 'Mme Isaac Pereire and her husband mutually hid from each other the good that they did [wrote Albert Deprit]. There are households where it is the bad that one hides; those where one has the modesty of one's generosity.' The writer went on to say that a characteristic gift of this family was kindness. 'Men and women there are simple, gentle, intelligent and charitable.'[64] As with the obituaries to elite women of the Nord department referred to by Smith, no opportunity to refer to the reticence of the charitable giver was ignored, no matter how public or important the gifts.[65]

Fanny was to be a widow for another thirty years. It was only then on Isaac's death that she became a philanthropist in her own right, establishing several local hospitals, *dispensaires*, each one in the name of the Fondation Isaac-Pereire, entities that she created specifically for the purpose. Céline Leglaive-Perani has suggested that the nature of this action was not so unusual among elite Jewish women, indeed among female philanthropists generally, who had been influenced by their husbands in the sort of philanthropic measure they instituted or who followed their spouse's example or instruction.[66] And in describing the particular interest in philanthropy existing among Jewish women, Leglaive-Perani saw little difference in the explanations given for that of the involvement of Jewish men. That is, establishing philanthropic foundations or institutions in nineteenth-century France carried with it many opportunities to promote the family name, providing a public way of demonstrating acculturation in French society. Even though women did not become citizens at the Revolution, they had acquired a deep sense of gratitude to the nation for what they had received.[67]

One may add, given the period when Fanny was initiating her philanthropic institutions – just after the collapse of the Union générale Banque in 1882 with its fallacious implications of manipulation by Jewish banks and with the publication of Drumont's *La France juive* in 1886 – it was likely a rejoinder to the gathering

antisemitism. From the initiation of her first venture and throughout that of her second, for the greater part of the rest of her life, in fact, she witnessed bitter divisiveness targeted against Jews.

Leglaive-Perani also allowed for specific motivations in individual women – that there were other, personal, reasons why specific forms of philanthropy were taken up by certain of them. While she mentioned Fanny Pereire in her analysis, it was in the context of 'conjugal collaboration', in this case that Isaac had asked Fanny to set up the foundation after his death or, possibly, was giving consideration to such a foundation himself before he died.[68] Certainly, from family documents the evidence shows plainly that Fanny 'wanted to attempt the realisation of the ideas shared by Isaac Pereire with [the doctor] Professor Trousseau'.[69] And even more clearly, Fanny wished to draw attention to her husband and her family in the naming of the hospitals. The ignominy of the Crédit mobilier's collapse in 1867 casting a blight on the family and its reputation, to be partially restored by Isaac in his reconquest of the Compagnie générale transatlantique and success in stabilising the Spanish railway, must also have played a part in her decision.

These speculations are reasonable and defensible conclusions to draw. But it is more important here to recognise Fanny's own hand and initiative in the endeavour and her skills in setting up the Fondations Isaac-Pereire. As much as anything else, the Fondations and the hospitals to which they gave rise saw Fanny operating well outside any limits that may have been imposed by notional 'separate spheres', doing so in a public space and in a manner that established her own individuality, self-confidence, and assertiveness.

Fanny and Isaac Pereire had long been friendly with the eminent physician Armand Trousseau, possibly, in Isaac's case, through Saint-Simonianism as we find reference to an association as early as 1835.[70] Trousseau and Fanny's father Emile Pereire had been acquainted even earlier, from at least 1832.[71] The hospital system in Paris was a centralised network of large teaching hospitals that had developed exponentially after the French Revolution, employing several hundred doctors and surgeons.[72] Over time, while Trousseau became the Pereires' family doctor, he became renowned for his more public roles, most significantly as professor of the Clinique médicale at the Faculté de Paris, doctor-in-chief of Paris's Hôtel-Dieu, and a member of the Académie de médicine. By the 1860s,

the Paris Faculté was the largest in the world, with twenty-four full professors and twenty-six chairs devoted to twenty different disciplines.[73]

Trousseau was critical of the size and location of these hospitals in Paris, believing that the system was becoming unmanageable and inadequate to serve those in need. In particular, he deplored the huge sums then proposed to be poured into medical and surgical facilities at the Hôtel-Dieu, the hospital to which he was attached. He argued for a series of smaller institutions, 'dispensaires', in locations easily accessible for working-class residents of the outer Parisian suburbs. From the documents, it seems that in about 1855 he discussed this possibility with Fanny and Isaac, a proposition that combined a practical step in public health care and that targeted the poorest and most numerous class.[74]

This obviously appealed to the Pereire couple although, since Trousseau died in 1867 and Isaac Pereire in 1880, it was some time afterwards that implementation of Trousseau's plan came into effect. Indeed, the establishment of the first *dispensaire* so long after the death of Trousseau and four years after Isaac's leads to the view that Fanny herself was the more important figure in its evolution.

Fanny's first significant philanthropic venture was to purchase a property at Tournan, a commune in the Seine-et-Marne department, for the purpose of establishing a free community hospital with seventeen beds. It opened in 1884. *Le Figaro* reported that the municipal council had also offered a financial contribution towards the hospital's establishment, which Fanny turned down, 'wishing before all to be mistress of her gift', according to the Catholic Superior in charge of the nursing staff.[75] From this time, Fanny 'owned' her philanthropy. And despite the attachment of Isaac Pereire's name to the Fondations, the press accepted her ownership.

The location was one she knew well since it neighboured the Pereire chateau at Armainvilliers. It was also accessible by the Pereires' Est rail line, an essential requirement because Fanny played a major role in the oversight of the place and attended it regularly. Rail also facilitated the attendance at the hospital of the medical staff from Paris. Fanny's involvement was not uncommon among philanthropists as the historiography tells us that 'seldom did philanthropic organisations carry on their work without the direct participation of at least some of their lay supporters'.[76] This

was further borne out by the nursing Superior in charge, whom *Le Figaro* reported as speaking 'with touching gratitude' of the frequent visits Fanny made to Tournan 'and of the maternal attentions that this intelligent and charitable woman multiplies to improve the lot of those who suffer'.[77]

One other element of the establishment of the hospital at Tournan is reminiscent also of the tradition of *noblesse oblige* in which, both before the Revolution and afterwards, noble families continued to distribute aid and assistance to those in need living in the vicinity of their estates.[78] In this case, through her regular residence at Armainvilliers, Fanny had known the area well for over twenty years. *Le Figaro* noted that 'Mme. Isaac Pereire ... is particularly popular in Tournan' where her hospital provided care for the sick of the whole region.[79] Served by six part-time doctors, Fanny's hospital included a specialist in each of surgery, ophthalmology, urology, and dentistry. There were two general practitioners. All these medical professionals were at the leading edge of their areas of speciality.

The community of Tournan and surrounding localities welcomed the hospital for its accessibility and the extent of its medical services.[80] Indeed, the grounds became a place of relaxation even for local residents who had no need of medical care. Contemporary photographs show an extensive park and charming garden in which everyone could take pleasure since the hospital was only two hundred metres from the village of Tournan. It had the aspect of a 'cheerful villa' described further as a 'peaceful refuge', calm, elegant, and comfortable.[81]

Fanny quickly put to good use the experience she gained in establishing the hospital at Tournan by creating another. In November 1886, she again opened a *dispensaire* with free medical consultations, operations, and medical equipment at no. 107, rue Gide in Levallois-Perret, a northwestern suburb of Paris. Now an expensive area, it was then largely industrial and close to the railway workshops of the Paris–St Germain and Versailles (Rive Droite) rail lines, both founded by the Pereire brothers.[82] This location was thus another which held some resonance for the Pereire family and for Fanny. In the process, she established the vehicle to manage the hospital, the Fondation Isaac-Pereire, words that were carved into the façade. In assuming the role of 'Présidente', Fanny was emulating aristocratic women who traditionally held this position in

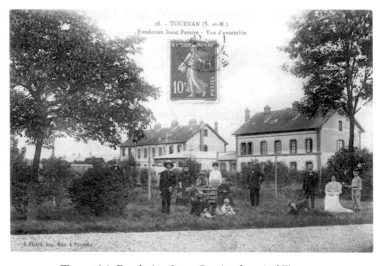

Figure 6.1 Fondation Isaac-Pereire, hospital Tournan

philanthropic organisations.[83] Leglaive-Perani has added that taking on this role permitted the elite woman 'at once to validate and consolidate her social status [and] also to obtain a form of power'.[84] No doubt these considerations were also on Fanny's mind, as well as the wish to honour her late husband in this particularly public way.

The inauguration of the hospital at Levallois-Perret received extensive coverage in the national daily newspapers. That the services it provided were free was a topic of keen interest, Le Petit journal considering that the Fondation Isaac-Pereire should serve as a model for other local hospitals, particularly within the more densely populated areas of Paris and the 'banlieue'.[85]

Another newspaper noted that 'the sick will have the greatest ease in profiting from this generous and useful foundation, which is called, in particular, to provide services to the working population'.[86] The choice of renowned centralien Emile Lavezzari to design the 'Isaac Pereire' hospital was not without significance either. Lavezzari was the architect behind the Rothschild-initiated and funded Hôpital maritime de Berck in the Pas de Calais department, a highly regarded public facility that won for its creator a medal at the Exposition universelle of 1878.[87]

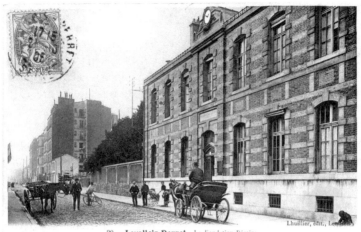

Figure 6.2 Fondation Isaac-Pereire, hospital Levallois-Perret, Paris

It was evident that Fanny had given the new hospital a great deal of thought and determined that it would want for nothing. There are hints even of a Saint-Simonian predilection for innovative advanced technology. It was a subject of interest to many, but particularly to medical specialists, political commentators, and economists. *Le Petit parisien* reported in April 1892 that the sixth Congrès français de chirurgie had made a special visit to observe the operation of the Fondation Isaac-Pereire together with that established for children by Cécile Furtado-Heine (in 1884).[88] *La Liberté* in July 1895 recorded that the annual meeting in Paris of the Congrès d'assainissement et de salubrité ['sanitisation and healthiness'] visited the *dispensaire* as a 'model installation'.[89]

The building of two storeys with seventeen beds at Levallois-Perret was a simple construction. Downstairs, *Le Petit journal* reported, there were 'vast waiting rooms, consulting rooms supplied with all the necessary equipment, bathrooms, laundries, and with that, some beds'.[90] There was also a pharmacy, an operating theatre, and a refectory for the nursing sisters. Patient rooms were located on the first floor.[91] The *dispensaire* contained every modern element necessary for efficient functioning: heating, hot water, cooling, ventilation, a bathroom and room for hydrotherapy, double-glazing at

the windows, and flushing toilets among them.[92] There was also a mortuary and autopsy room.

Finally, an element common to both the establishment at Tournan and at Levallois-Perret was a large kitchen garden, making fresh fruit and vegetables available to patients as well as to health workers. These innovations won the Fondation Isaac-Pereire a gold medal at the Expositions universelles of 1889 and 1900.[93]

How effective was the *dispensaire* at Levallois-Perret? In 1888, a young assistant surgeon, Alphonse Leriche, prepared a detailed report on the first two years of surgical cases at the Fondation as a doctoral thesis in medicine, which he presented to the Paris Faculté de médicine. From the point of view of Trousseau's objective to draw working-class people to local hospitals, Leriche noted the ideal location. 'The situation of the hospital, near to the railway station, which brings the poor from Paris and neighbouring stations, and above all between the two areas heavily populated with poor workers, Levallois and Clichy, could not be better chosen for the throng of clients.'[94]

There were, however, certain difficulties that were problematic for the hospital's mission, he noted: 'from the point of view of surgical hygiene, the neighbouring main sewer and of all sorts of insalubrious establishments, [and] the building [constructed] on a terrain low and damp'.[95] Leriche was also somewhat apologetic about the comparatively mundane operations performed at the Isaac Pereire hospital, and on which he was reporting. Yet these were precisely the reason for its existence, suggesting that it was doing the job as Trousseau envisaged and as Fanny intended, providing respite for locals with comparatively treatable illnesses and thus reserving the large teaching hospitals for serious health issues often involving complex treatment or surgery.

The Levallois-Perret hospital was an instant success in dealing with ill health in the local community. In its first two months of existence, it received 1,218 patients. In the eleven years to 1897, just under a quarter of a million passed through its doors, an average of 1,854 each month.[96] By 1911, the year after Fanny's death, the number of consultations conducted had reached half a million.[97]

The use of antiseptics was a feature of the new hospital and used to promote its services. Leriche asserted that the daily application of the theories of Louis Pasteur and Joseph Lister to even mundane

surgical practices must not be devoid of significance in the context of his report.[98] Fanny Pereire herself was to write with pride that 'All the operations are done with the greatest care and we have brought into the operating rooms all the latest progress in antiseptic science.'[99] Local anaesthesia using chloroform was also practised.

On 30 November 1891, Fanny Pereire wrote to a prospective patient, a gentleman who had enquired about cataract surgery at the Fondation Isaac-Pereire in Levallois-Perret. The letter, which was handwritten by her, is interesting on several levels for what it says about Fanny's direct involvement in the working of the hospital as much as for her description of the services it could provide to the enquirer. There was no charge for consultation or surgery, only for a hospital stay, from three francs per day for a double room to six francs for a single room, she wrote. All expenses were accommodated in this price, including meals. For eye surgery, they had the services of the eminent ophthalmologist, Armand Henri Trousseau, 'grandson of our friend', Armand Trousseau. Trousseau the younger was associated with the prestigious national ophthalmological hospital, Hôpital Quatre Vingts. 'His hands are very safe', Fanny assured her reader. 'I hope that you will give me the pleasure of welcoming you to the Fondation. All the doctors who come there are excellent.'[100] She then noted the presence of Dr Guyon, a prominent professor of surgical pathology and member of the Paris Faculté de médicine, demonstrating that the Isaac Pereire hospitals were indeed able to attract the leading clinicians of the day.[101]

Thus, Fanny also established a link to the past, not only in memorialising her husband in the naming of her hospitals but in the attention paid to ophthalmological services and in the engagement of Trousseau's grandson to provide them, for at the end of their lives, both her mother and her husband had become blind.

Finally, Fanny mentioned in her letter to the unnamed enquirer that a Catholic religious order, the Sisters of St Joseph of Cluny, managed the hospital. In this 'there are no gratuities involved, and all is run with an exquisite propriety'.[102] Indeed, a chapel had pride of place in the hospital. In 1888, seven sisters worked as nurses and were directed by a superior, managing the consultations, bandaging, and caring for the ill who were forced to stay.[103] The number was to rise over time to ten sisters.

The presence of women religious in Fanny's hospital is not surprising for there were relatively few otherwise trained nurses in the paid workforce. Although in the year of the establishment at Levallois-Perret, 1886, the sisters were being driven from teaching positions by anti-clericalism to be replaced by qualified lay teachers, nursing training had lagged behind teacher education. For the most part, nursing sisters were tolerated because there were no alternatives.[104] Even so, anti-clericalism was not entirely missing from the nursing scene, as one reporter recalled in 1886 that 'the local Paris council is chasing the sisters from the laicised hospice for dying children'. This was possibly the hospice established in 1884 by Cécile Furtado-Heine referred to earlier in this chapter. In these circumstances, he went on, 'I blessed from the bottom of my heart the good Mme Isaac Pereire to give to our radical atheists such a noble example of tolerance and charity.'[105]

At the same time, the nineteenth century saw a substantial increase in the number of female religious orders devoted to the caring professions. It was not gender or the idealising of domesticity and feminine virtues that drove them so much as a quest for independence in the service of God, giving women, frequently working-class, agency in their chosen worlds otherwise denied them in the cloister. There was thus no shortage of women willing to undertake largely unpaid employment as, for instance, teachers, nurses, or social welfare workers in orphanages.[106] The Sisters of St Joseph of Cluny formed in 1807 a comparatively new branch, which rapidly took on a missionary zeal.

The order was already managing the hospital at Tournan.[107] Thus, in the absence up to that time of a cadre of professionally trained women, Fanny's selection of the Sisters of St Joseph of Cluny to minister to the patients in her hospital was not unusual. She may also have been influenced by her sister, Cécile Rhoné, a Catholic convert, who had much to do with the order.[108]

Fanny's direct involvement in the management of the hospital so evident in the letter she wrote to the unidentified enquirer was confirmed by others. A report on activities at Levallois-Perret in 1898 noted that every day the sisters drew up a summary of all the consultations that had occurred, indicating the illnesses treated and any continuing ministration necessary and that a copy of this went daily to Fanny. She was thus immersed in all the activities in the

hospital, taking a personal interest in each case. The comparatively small number of surgical cases requiring subsequent hospitalisation was said 'to fully justify the principle which inspired the creation of the Fondation'.[109]

At some point, the department store in which the Pereires held a significant share, the Grands magasins du Louvre, which in 1898 became the Société du Louvre, also contributed to the Fondation Isaac-Pereire at Tournan. Both Fanny's brothers, Emile II and Henry, were on the board of the Société du Louvre and of its predecessor, which may help to explain this development, although the creation and management of hospitals was some distance from the remit of both company manifestations (it was to move from retailing into hotel development and management but had nothing to do with health services). Fanny was clearly endeavouring to draw the other side of the family into her philanthropy, persuading her brothers and their families to contribute and to take some ownership through establishing the Hôpital du Louvre adjacent to the Tournan hospital and connected to it by a gallery. This seventeen-bed hospital was to be managed and served by the Fondation Isaac-Pereire, with the involvement of the Société du Louvre confined to maintenance of the building and the associated parkland.[110]

To place all these establishments on a more solid foundation, Fanny in 1903 initiated a Société civile des fondations Isaac-Pereire. This legal device drew together the hospitals at Levallois-Perret and at Tournan as well as the Hôpital du Louvre, those at the first two locations having operated independently of each other until that point and the Hôpital du Louvre having been operated by the administration at Tournan. She vested the properties that she had purchased and developed in this Société as did the Société du Louvre so consign its hospital. She established a familial Conseil d'administration in which she was president and her son, Gustave, chief executive ('Administrateur délégué'). Gustave's son, Alfred, was an administrator. The family connection did not end there. On setting up the foundation, Fanny called on her brothers and Emile II's son Maurice as 'comparants', people expected to appear at meetings. All became shareholders in the Société civile des fondations Isaac-Pereire, with Fanny having the largest shareholding. Thus, on Fanny's initiative, the *dispensaires* had become a Pereire family enterprise.[111]

Fanny's action showed foresight. She was then nearing eighty years of age and clearly wished to see the Fondations continue the project she had instigated but with support from across the family. The role of chief executive confirmed her son, Gustave, as the day-to-day manager in charge and her successor as president. By also including her grandson Alfred and nephew Maurice among the shareholders, she was reaching out to a younger generation. Her brothers' involvement ensured not only that the Hôpital du Louvre remained an integral part of the new Société civile but that Emile II and Henry Pereire were bound to keep an eye on the enterprise as a whole.

Just as importantly, however, was the leading role now unequivocally accorded her by the statutes of the new Société civile. These now referred specifically to 'les fondations de Madame Isaac Pereire'.[112] Her initiative in establishing and presiding over them was clear. From the time of Isaac Pereire's death and the appearance of the *dispensaires*, it was Fanny who was indisputably the leader in this philanthropic enterprise. The hospitals were still functioning after she died in 1910 and were listed among the auxiliary military hospitals active during the 1914–18 War.[113]

Upon Fanny's death at the age of eighty-five, almost all the daily newspapers noted her passing and all referred specifically to her charitable and philanthropic works. An obituary appeared in *l'Avenir du bassin d'Arcachon*:

> A woman of great heart, she had been for her husband a veritable collaborator: Like him she was concerned with the great problem of *The extinction of poverty* [italic original] and for the past thirty years she had pursued alone the philanthropic work commenced together. Aside from these works, she helped discreetly a crowd of poor shamed people ['pauvres hontes'] and gave, in the greatest spirit, her most generous help to a great number of charitable works.[114]

This description of Fanny as 'collaborator' with Isaac at last recognised her individuality at the end of her life.

Charity and philanthropy were part of the armoury of the *grande bourgeoise*, but they came naturally to Herminie and Fanny Pereire. They were engrained in their ethos and psyche and covered a wide field. As the family wealth grew over the century, these were applied variously, initially to individuals, usually Jewish, and in keeping with

the teachings of *sedaca*. Later they committed to a more general set of needs available to all. Taking the lead from their husbands, they spontaneously gave large sums to worthy causes. Herminie's activities here were not unlike those of many other *bourgeoises*. But Fanny's were much more ambitious, demanding considerable imagination and organising ability, as well as public presence.

Philanthropy was the means by which she established her own identity and contributed to the defence and, indeed, rehabilitation of the family name. Thus, the motivation for philanthropic ventures sprang from a variety of individual needs: they not only served to promote the family as responsible and patriotic citizens of France, they mounted an offensive against the forces that sought to deny that proposition. The Dreyfus Affair provided the environment against which Fanny persevered.

In a later chapter, we will explore further Fanny's response to the growing antisemitism of the 1880s that culminated in the Affair, placing the Fondations Isaac-Pereire at the centre of her response.

Notes

1 Sarah A. Curtis, 'Charitable Ladies: Gender, Class and Religion in Mid Nineteenth-Century Paris', *Past and Present*, no. 177, November 2002, 136.
2 Smith, *Ladies of the Leisure Class*, 147–9.
3 Macknight, 'Faith, Fortunes and Feminine Duty'.
4 Lee Shai Weissbach, 'The Nature of Philanthropy in Nineteenth-Century France and the *mentalité* of the Jewish Elite', *Jewish History*, vol. 8, no. 1/2, 1994, 192.
5 Céline Leglaive-Perani, 'De la charité à la philanthropie', *Archives Juives*, vol. 44, no. 1, 2011, 7, wherein is quoted Jean-Luc Marais, *Histoire du don en France de 1800 à 1900, dons et legs charitables, pieux et philanthropiques* (Rennes, 1999), 185.
6 Leglaive-Perani, 'De la charité', 5.
7 Ferguson, *The World's Banker*, 525.
8 Dominique Jarrassée, *Osiris: Mécène juif et Nationaliste français* (Brussels, 2008), 131 ff., 199–211.
9 Davies, *Emile and Isaac Pereire*, chap. 1.
10 AFP, letters Jacob Lopès Fonseca, Bordeaux, to Emile Pereire, Paris, 1834–35.

11 Ibid., Jules Mirès, Paris, to Emile Pereire, Paris, 25 December 1860.
12 Pauline Prevost-Marcilhacy, 'La Politique sociale des familles Juives à Paris aux XIXe et XXe siècles', in Max Polonovski (ed.), *Le Patrimoine Juif Européen: Actes du colloque tenu à Paris, au Musée d'art et d'histoire du Judaïsme, les 26, 27 et 28 avril 1999* (Paris-Louvain, 2002), 34–7.
13 Weissbach, 'Nature of Philanthropy', 192.
14 Ibid., 197–9.
15 Isaac Pereire, 'Leçons sur l'industrie et les finances', in *Écrits de Emile et Isaac Pereire* (Paris, 1905), vol. I, fasc.,1, 1–61.
16 Ibid., vol. IV, fasc., 1–4, 'Emile Pereire, Contributions au *National*, 1831–35'.
17 Fenton Bresler, *Napoleon III: A Life* (London, 2000), 177–8.
18 Comte d'Haussonville, 'Le Combat contre la misère', *Revue des Deux Mondes*, vol. 70, 1885, 61.
19 Purcell, *Falize*, 109, and fn. 107, 307.
20 Letter dated 12 August 1880 from P. Beurdelay, assistant to the Mayor, 8th arr., published in *Le Petit journal*, 14 August 1880.
21 Smith, *Ladies of the Leisure Class*, 136.
22 Foley, *Women in France*, 52.
23 'Jacques Reynaud', 'Portraits Contemporains', *Le Figaro*, 23 July 1859.
24 *Le Figaro*, 16 December 1855.
25 Ibid., 26 March 1869.
26 Céline Leglaive-Perani, 'Le judaïsme parisien et le Comité de Bienfaisance israélite (1830–1930)', *Archives Juives*, vol. 44, no. 1, 2011, 37–53.
27 Schor, *Baroness Betty de Rothschild*, 112–13.
28 *Le Monde illustré*, 17 March 1866.
29 AFP, notes on the Société's note-paper, undated.
30 Ibid., Cécile Rhoné, Paris, to Henry Pereire, Egypt, 8 January 1865.
31 Ibid., Herminie Pereire, Armainvilliers, to Henry Pereire, address unknown, 21 September 1864.
32 Charton, *Correspondance générale*, Edouard Charton, Paris, to Hortense Charton, probably Versailles, 21 and 23 March 1863, letters 63–28 and 63–30, vol. II, 1319 and 1323.
33 Edmond et Jules de Goncourt, *Journal: mémoires de la vie littéraire* (Paris: 1956), entry 14 February 1864, vol. II, 19.
34 Ibid., vol. 1, pp. 1155–7, where Jules de Goncourt recounts in vituperative, anti-Jewish language a train journey in the company of Eugène Pereire, with whom he had been at school, at the Collège Royal de Bourbon (now the Lycée Condorcet).

35 Céline Leglaive-Perani, 'Donner au féminin: Juives philanthropes en France (1830–1930)', *Archives Juives*, vol. 48, no. 2, 2015, 18.
36 Ibid., 16–17. Coralie Cahen did not receive her decoration until 28 December 1888. See AN, Base Léonore, LH/404/32.
37 AFP, Ernest Polack, Madrid, to Emile Pereire, Arcachon, 15 December 1870. Polack was to become President of the Pereires' Crédit mobilier espagnol.
38 Greg Seltzer, 'The American Ambulance in Paris, 1870–1871', *Madison Historical Review*: vol. 6, Article 3. https://commons.lib.jmu.edu/cgi/viewcontent,cgi?article=1028&context=mhr, downloaded 12 November 2020, 3.
39 AFP, Fanny Pereire, Pau, to Gustave Pereire, Madrid, 11 December 1870.
40 Ibid., 'Journal d'une Femme de Chambre', entry 20 December 1870.
41 Ibid., Marguerite Rhoné, address unknown, to Henry Pereire, Paris, undated.
42 AN, Base Léonore, LH/1046/4.
43 Jarrassé, *Osiris: Mécène juif*, 132–6.
44 Smith, *Ladies of the Leisure Class*, 136.
45 Foley, *Women in France*, 52.
46 Leglaive-Perani, 'Donner au féminin', 18.
47 Schor, *Baroness Betty de Rothschild*, 104. Chap. 4 deals at length with this aspect of Betty de Rothschild's life and career.
48 Sarchi, *Lettres*, Félicie Sarchi, Venice, to Hélène Van Tieghem, Paris, 27 January 1871, vol. II, letter 419, 173; Charles Sarchi, Venice, to Hélène Van Tieghem, Paris, 31 January 1877, vol. III, letter 778, 100.
49 Anne Levallois, *Les écrits autobiographiques d'Ismayl Urbain: Homme de couleur, saint-simonien et musulman (1812–1884)* (Paris, 2005), 128–30. Sadly, Urbain's son died before he could take up the offer of the *bourse*.
50 Foley, *Women in France*, 51.
51 Sarchi, *Lettres*, Charles Sarchi, Florence, to Hélène Van Tieghem, Paris, 31 January 1877, vol. III, letter 778, 100.
52 Pereire, *Écrits de Emile et Isaac Pereire*, vol. III, fasc. 2, 764.
53 AFP, Herminie Pereire, Paris, to Henry Pereire, address unknown, 21 August 1861.
54 Ibid., Herminie Pereire, Paris, to Henry Pereire, Egypt, 17 March 1865.
55 *Le Petit journal*, 11 March 1865.
56 *Le Figaro*, 'Supplément Litéraire du Dimanche', 14 December 1879, 1.
57 Francesco Vigano, *Hommage à la mémoire d'Isaac Pereire*, allocution prononcée par ... (Milan, 1880), 16. Isaac Pereire's pride in Fanny's work is further mentioned in Pereire, *Écrits*, 15 March 1880, vol. III, fasc., 3, fn. 1, 1951.

58 *La Liberté*, 15 March 1880.
59 *Le XIXe siècle*, 6 January 1880.
60 'Les secours publics', *Le Temps*, 5 January 1880.
61 Ibid.
62 *Le XIXe siècle*, 1 January 1880.
63 Ibid., 28 January 1886.
64 Albert Deprit, 'Nécrologie Isaac Pereire', *L'Avenir d'Arcachon*, 18 July 1880.
65 Smith, *Ladies of the Leisure Class*, 147–9.
66 Leglaive-Perani, 'Donner au féminin', 12.
67 Ibid., 16.
68 Ibid., 20.
69 AFP, Fondation Isaac-Pereire, *Quatre années de fonctionnement (1887–1890)*, 4.
70 Ibid., lease document for a property rented by Isaac Pereire on behalf of Armand Trousseau, among other doctors, 2 January 1835.
71 A. Trousseau, 'Asthme', *Clinique médicale de l'Hôtel-Dieu de Paris* (Paris, 1963), vol. II, 552–3.
72 E. H. Ackerknecht, *Medicine at the Paris Hospital, 1794–1848* (Baltimore, MD, 1967).
73 George Weisz, *Divide and Conquer: A Comparative History of Medical Specialization* (Oxford, 2006), 14.
74 AFP, Fondation Isaac-Pereire, *Quatre années*, 3–4.
75 'L'Hopital de Tournan', *Le Figaro*, 6 November 1886.
76 Weissbach, 'Nature of Philanthropy', 193.
77 'L'Hôpital de Tournan', *Le Figaro*, 6 November 1886.
78 Macknight, 'Faith, Fortunes and Feminine Duty', 490–1.
79 'L'Hôpital de Tournan', *Le Figaro*, 6 November 1886.
80 AFP, Sociéte Civile des Fondations Isaac-Pereire, 'Note complémentaire', typescript ms. prepared by the Secretary of the Conseil d'administration, M. Truchet, 15 October 1911.
81 'L'Hôpital de Tournan', *Le Figaro*, 6 November 1886.
82 Davies, *Emile and Isaac Pereire*, chap. 4.
83 Macknight, 'Faith, Fortunes and Feminine Duty', 485.
84 Leglaive-Perani, 'Donner au féminin', 16.
85 *Le Petit journal*, 26 November 1886.
86 AFP, La Fondation Isaac-Pereire, *Le Génie Civil: revue génerale des industries françaises et étrangères*, 13 November 1886, 35.
87 Victor Contamin, 'Discours prononcé sur la tombe de M. Lavezzari décédé à Berck-sur-Mer le 13 juillet 1887', *Mémoires et compte rendu des travaux de la Société des ingénieurs civils*, vol. 48, 1887 (2e semestre), 251–3.
88 *Le Petit parisien*, 19 April 1892.

89 *La Liberté*, 10 July 1895.
90 *Le Petit journal*, 26 November 1886.
91 AFP, *Le Génie civil*, 35.
92 The hospital was demolished some years ago.
93 AFP, Société Civile des Fondations Isaac-Pereire, 'Note complémentaire', 6.
94 Alphonse Leriche, *Statistique chirurgicale de deux années à l'hôpital Isaac Péreire à Levallois-Perret* (Paris, 1888), 7.
95 Ibid.
96 AFP, Société Civile des Fondations Isaac-Pereire, *Assemblée Générale Ordinaire du 5 mars 1904* (Paris, 1904), 26.
97 Ibid., Sociéte Civile des Fondations Isaac-Pereire, 'Note complémentaire', 1.
98 Leriche, *Statistique chirurgicale*, 25.
99 Fanny Pereire, Paris, to an unknown enquirer, Paris, 30 November 1891. Letter in the collection of the author.
100 Ibid.
101 Ibid.
102 Ibid.
103 AFP, Société Civile des Fondations Isaac-Pereire, 'Note complémentaire', 4.
104 Judith F. Stone, 'Anticlericals and *Bonnes Soeurs*: The rhetoric of the 1901 Law of Associations', *French Historical Studies* vol. 23, no. 1, 2000, 103–28.
105 'L'Hôpital de Tournan', *Le Figaro*, 6 November 1886.
106 See Claude Langlois, *Le Catholicisme au féminin: Les congrégations françaises à Supérieure Générale au XIXe siècle* (Paris, 1984); and Jennifer Popiel, 'The Hearth, the Cloister, and Beyond: Religion and the Nineteenth-Century Woman', *Journal of the Western Society for French History*, vol. 37, 2009.
107 Popiel, 'The Hearth, the Cloister'. See also Matthieu Brejon de Lavergnée, 'Catholic Sisters in Europe', *Encyclopédie d'histoire numérique de l'Europe* (online), ISSN 2677-6588, published 22 June 2020, https://ehne/fr/en/node/12462, accessed 17 December 2023.
108 See below Chapter 8 for mention of Cécile Rhoné's relationship with the sisters of the order of St Joseph of Cluny.
109 AFP, Société Civile des Fondations Isaac-Pereire, Assemblée Générale Ordinaire du 5 mars 1904, *Rapport du Conseil d'Administration*, 5.
110 Ibid., Sociéte Civile des Fondations Isaac-Pereire, 'Note complémentaire', 5.
111 Ibid., Société Civile des Fondations Isaac-Pereire, *Statuts* (Paris, [1904]).
112 Ibid., 15.

113 'Liste des Hôpitaux du Gouvernement Militaire de Paris, complémentaires, auxiliaires, bénévoles (1914–18 War)', *Historix: Histoire de la radiologie aux Hôpitaux de Paris, Service de santé, 1914–1918* (undated online source tsovorp.org/histoire/Sources/HopType.php, downloaded 22 November 2023).

114 *L'Avenir du bassin d'Arcachon: le grand jour du bassin*, 12 June 1910.

7

Children and marriage: becoming Christian or becoming Jewish?

In *Becoming Bourgeois*, Christopher H. Johnson's study of the Galles, Jollivet, and Le Ridant families from the Breton town of Vannes, he described the crucial role that bourgeois women played in the creation of 'the grids of kinship … critical to the making of the bourgeoisie'. Johnson itemised the myriad of activities they managed within the private life of the family, including creation of the settings in which appropriate matches could be nurtured and come to fruition, when and where potential marriages could be negotiated, the details sorted, the dowry agreed, and weddings take place in the most appropriate and stylish fashion.[1]

Herminie and Fanny Pereire were likewise immersed in the critical task of arranging suitable marriages for their children. Their husbands certainly entertained ideas on the subject and in particular the need to draw in the talent to provide for the future management of their businesses. And as was customary, once the future candidate emerged, Emile and Isaac dealt with the father and laid down the conditions for a marriage. But it was up to their wives to gather the names of suitable candidates in the first place, to ensure these candidates were given opportunity to become acquainted with their sons or daughters in appropriate social settings, to provide continuing advice to their children, and to arrange all the details leading to the marriage ceremony. Finally, they saw to the living arrangements for the newlyweds.

There were certain differences presented to Herminie and Fanny by the task compared with the *bourgeoises* of Johnson's study. First, there was the matter of being Jewish. In nineteenth-century France, when Jews of marriageable age sought a partner, there was much to

consider, although freedom of choice, love, and affection were only infrequent elements in the negotiations which took place. Religion, social class, and money were more pressing matters needing to be reconciled. The increasing wealth of the Pereires over time presented an attraction to, and a danger from, fortune-hunters, while the precise nature of the Pereires' attachment to Judaism raised questions in the minds of the families of potential suitors, Jewish and otherwise. Anyone daring to entertain ambitions to espouse a Pereire was to face particular challenges. At the same time, finding suitable partners for their offspring could be a complicated process for Herminie and Fanny.

This chapter will consider the nature of the marital relationships entered into by the second generation and the ways in which Herminie and Fanny were to accommodate the business interests of the Pereire brothers in fashioning the requirements for suitable spouses. We will take note of the role they played in arranging suitable liaisons, including the negotiation of religious affiliation. We will also note how the marriages that took place subtly altered the family situation in its religious and social outlook and in its dynamic.

The Pereire family's relationship with Judaism was relatively fixed by the 1840s when the first of the second generation was ready to marry. They identified as Jewish, they had not abjured the religion of their birth, they still supported Jewish causes and institutions, they still mixed within Jewish circles, and, perhaps most importantly, they were seen by others outside the family as Jewish. Nevertheless, there was a certain ambiguity in the elder Pereires' attachment to Judaism. They were no longer practising Jews and had not raised their children with any religious background. The sons were not circumcised, and neither they nor the daughters, with the possible exception of Fanny at a very young age and Eugène, whose mother at least before her marriage had been a practising Jew, had received any form of Jewish religious instruction. But nor did they convert. The concerns of clergy, or of some Gentiles who entertained a wish to marry into the family, thus remained alive for in their eyes the Pereires were unequivocally Jewish. Only with conversion, and/or with it the Christian upbringing of children, it was believed, could this immediate difficulty be overcome.

The possibility of intermarriage seems not to have presented Herminie or Fanny with any concerns about their daughters and

sons marrying non-Jews. But this was not necessarily a straightforward situation either. Over the course of the nineteenth century, the risk that Jews could be seduced into apostasy or intermarriage, marrying out, or both, was a subject for increasing debate. And to an extent this anxiety was not misplaced: Jews did marry non-Jews and did convert. From the 1820s onwards, there was a number of high-profile conversions, mainly, but not exclusively, of Jewish men, whose number included several associated with senior Jewish figures, religious and otherwise: the brothers Alphonse and Théodore Ratisbonne, sons of a leading Jewish citizen of Strasbourg; Simon Deutz and David Drach, the son and son-in-law respectively of the Chief Rabbi of France; and David Andrade and his family, son and grandchildren of the Chief Rabbi of Bordeaux.[2] But the total numbers of such conversions in Paris do not suggest an epidemic.

In the forty-odd years between 1833 and 1875, a period frequently regarded as more liberal towards Jews, only 315 were baptised in a total Jewish population which in 1861 had reached 2,500. The historian Philippe-Efraïm Landau noted that over the longer period 1792 to 1914, only about 877, or 8 per cent of the total 10,820 conversions to Catholicism in Paris, were Jews who were baptised.[3]

Yet the possibility of intermarriage between Jew and Catholic continued to tease the Gentile imagination as much as it worried the Jewish conscience, for intermarriage was a test of the Jews' willingness to become truly French men and women, to embrace the patriotic revolutionary principles inherent in emancipation. Napoleon had posed this as one of twelve questions to the Jewish Assemblée des notables he convened in 1806 – 'Is intermarriage with Christians permitted to Jews or does the law allow the Jews to marry *only* among themselves?' The Jews present were compelled to equivocate in their response: intermarriage was not forbidden but Christian priests found it no more 'religiously valid' than did Jewish rabbis, and so it was not encouraged by either.[4] As time went by and with the appearance of Jewish publications promoting the Jewish cause, disquiet was expressed increasingly in their pages about the effects of intermarriage. But the Jewish community of France, concerned above all to demonstrate its preparedness for assimilation, was ambivalent, seemingly incapable of confronting the issue in any meaningful way.[5]

At the same time, conversion did not always follow intermarriage. Some Jews were prepared to allow their children a Christian education while they themselves retained some attachment to Judaism. This was certainly the case with one of the Pereire offspring.

If conversions to Catholicism were less numerous than contemporaries believed, especially in the early years of the century, the number of people in nineteenth-century Paris who converted to Judaism is surprising: 497, over half the number who went the other way. It has always been possible to convert to Judaism but not always easy and not always welcomed by Jewish authorities. Landau concluded that the principal reason for these conversions, as with conversions to Catholicism or Protestantism, was marriage since many individuals, mostly Catholic, were young and single at the time of their conversion.[6] So, while some Jews married out, some Christians did too, encapsulating the dramatic and fluid nature of nineteenth-century French society at all levels.

Abandoning Judaism through intermarriage, however, caused the Pereires' Sephardic social circle and family in Bordeaux considerable anguish, which letters in the family archive confirm.[7] As Landau put it, 'When a Jew abandons the faith of his fathers, his act sets off a familial drama and a rupture, often definitive.'[8] In a letter of 1842, Nanci Rodrigues told her granddaughter, Cécile d'Eichthal, of her sadness that her conversion prevented her from ever returning to Bordeaux, of having fallen out with other family members as a result.[9] But the Catholic Church was no more receptive of intermarriage, particularly in those cases where a Catholic married a Jew. Popes Pius VIII (d. 1830) and Gregory XVI (d. 1846) both issued encyclicals which essentially concluded that mixed marriages were: 'a violation of both divine and natural law'.[10] Clearly, there were impediments both private and public, social and religious, strewn in the path of those contemplating intermarriage.

While Jews were caught in the crosshairs of intermarriage, marriage in bourgeois France more generally presented its problems. Money was clearly significant.[11] But marriage was as much a matter of family as of money. While it might contribute to or augment the capital of a family business, it could also add to a family's social standing.[12] For this reason, arranged marriages remained relatively common until later in the century.[13] In the Nord department, for

instance, children were cautioned to do as their parents directed, in most cases to marry partners with compatible 'connections'.[14]

Remarkably, the purposes of marriage among the French nobility as Elizabeth Macknight has defined them were construed along similar lines. Differences were only of degree. Marriage was about the structuring of alliances, the creation of a 'barrier to membership of the upper class', the furthering of financial interests, and the perpetuation of the line, considerations for the most part just as crucial to marriages contracted among the *grande bourgeoisie*.[15] And in the case of those of Jewish background, it was more complex again and frequently appeared even more desirable to find a partner considered suitable against so many of these competing criteria.

What of love and affection? Denise Z. Davidson, writing of bourgeois marriages in early nineteenth-century France, identified a transition to ideals of 'companionate marriage', in which the major objectives might remain familial and financial, the protection and augmentation of family wealth and status, but in which 'couples were [also] expected to lead their lives together and thus to be compatible, and preferably even to love each other'. Davidson concluded that 'What was perhaps new in this period was the idea that marriage should *also* be about love and passion, but this was a very bourgeois kind of love based on being satisfied with what one was given.'[16] Thus does the historiography of nineteenth-century marriage in France present a picture of some fluidity, with money, family, and suitability elements in the mix, to which there came to be added love and affection.

The brothers Emile and Isaac were themselves raised by a widowed mother in an orthodox household. Moving to Paris in the early nineteenth century, the marriages they contracted were typically Sephardic: they married cousins. Cousin marriage had been relatively commonplace among Jews in preceding centuries and it continued thereafter until towards the end of the nineteenth, particularly among the emerging Jewish bourgeoisie and the elite who saw it as a means of keeping the family fortune intact. Grange has pointed out that 75 per cent of Jewish families noted in the *Livre des Salons* between 1850–99 had 'cousinhood links based on marriages taking place' in those years.[17]

Commenting more generally on the process of *embourgeoisement* during the nineteenth century, Johnson emphasised that it was

in many respects related to and promoted increasingly by cousin marriage.[18] For much the same reasons, that of maintaining and enhancing the family's social and financial standing, there had been a similar dynamic at work among the Jewish community of Bordeaux, but over a much longer period.[19]

Family background and trust were for the most part significant elements in the marriage choices the second generation of Pereires made, or that were made for them. Money was less important to the Pereires, but could scarcely have been far from the thoughts of the families with whom they entered matrimony. That is to say, while many of the Pereire marriage partners were well off, none was able to match the wealth of the family they were marrying into. At the same time, wealthy Jews were likely to be a target for impoverished aristocrats, and this as much as anything was cause for self-protection by the Pereires.[20] Having scaled so speedily the heights of the elite, Herminie and Emile and Fanny and Isaac were concerned to consolidate their position and marry their children off with young men and women who, if not as wealthy as themselves, they regarded nevertheless as compatible, as having similar values. In the case of sons-in-law, there was the added expectation that they would evidence good prospects for advancement, for what was at stake was entry to the Pereire businesses, a move that was customary among Jewish commercial houses in Bordeaux.[21]

The need for trust, discretion, and intimacy Emile Pereire made apparent in a letter he wrote to Auguste Thurneyssen in 1853 on receiving advice that Auguste's son Georges, who was already employed in the Pereires' businesses, wished to propose marriage with Emile's youngest daughter, Claire. It was a union Herminie and he had thought ideal for some time, Emile wrote. But 'our private life, our family habits make it difficult for us in the choice of a son-in-law'. Georges, however, would be like 'a new son who is going to blend into our family where for almost five years he has been admitted as an intimate friend'. He, Emile, would exercise a paternal patronage over the son, and Herminie would be a second mother watching over Mme. Thurneyssen's beloved boy.[22] While the face the Pereire family presented to the public was one of extravagance and luxury, their manners and their demands for privacy in the domestic setting signalled considerably more modesty.

Children and marriage

For some time there was a purely practical consideration. Eugène Pereire (b. 1831), the son of Isaac's marriage with his cousin Laurence Lopès Fonseca, was the only male among the second generation of children of an age in the 1850s to play a role in the businesses. It would be some years before Herminie and Emile's sons, Emile II (b. 1840) and Henry (b. 1841) or Fanny and Isaac's son, Gustave (b. 1846), would be old enough to do so. The Pereire daughters therefore played a vital role in drawing into the family husbands who could make themselves useful to it.

Yet not only did marriage fulfil an overriding purpose concerned with reinforcing the family position and lineage, and in the case of the Pereires recruiting young men for the businesses; there was an expectation that it would also encourage love and companionship. Trust, after all, may be based around these virtues and is entirely compatible with them. Thus, in many Pereire marriages, love did grow over time and was certainly the case in the marriage of Fanny and her uncle, Isaac.[23]

Coming first to the family of Herminie and Emile Pereire, Fanny, in marrying her uncle, was the only one of Herminie and Emile's five surviving children to marry a Jew and the only one of the second generation to marry within the family. There would be no further marriages with cousins and certainly no more with closer relatives. While this consanguinity may have caused problems for Fanny's parents, as members of the current family attest, we do not know what plans Herminie may have had for their daughter. At fifteen and then sixteen years of age, as Isaac's courtship ensued, it is likely that Fanny was not quite of an age where this had become a pressing matter.

Whatever her mother's wish for Fanny, however, the remaining four children were to marry Christians, none of whom came originally from Jewish families (they were not converts). Cécile (b. 1829) married a Catholic, as did Emile II, while Claire (b. 1834) and Henry both married Protestants. Their age at marriage with one exception followed the average. Importantly, all the children of these four marriages were raised as Christians.

Johnson's description of the significant role of bourgeois women in arranging suitable marriages cited above is especially apposite here. Ever sensitive to the need to expand the family position and fortune, 'They created the context in which courtship could flourish.

They researched the suitability of potential spouses. They saw to the complicated process of establishing appropriate dowries and grooms' contribution.'[24] We note Herminie's considerable influence here through her careful construction of a circle of close acquaintances, through the choice of guests invited to the hôtel Pereire in Paris or to the family chateau just outside, and through the kinds of entertainment arranged – dinners, balls, many social events. She arranged invitations to the theatre and to concerts, weekends at the country house.

She was conscious of the merits of the young people around her, mentoring and coaching those she considered worthy of attention, even going so far as to arrange positions for some of them in Pereire companies. Thus, Herminie was to badger her husband to finalise a position with the Compagnie du Midi for Jules Charton, the son of their friend Édouard Charton, to whom she took a shine.[25] The sociability we have previously remarked had this additional purpose, apart from promotion of the family name: identifying marital partners for the Pereire children.

But Herminie's role (and Fanny's) was nothing if not subtle. It was not she who overtly canvassed possible partners for her children. That was the husband's role. It was he who wrote the exploratory letters setting out the terms of any engagement and nominating sums of money by way of dowry, all after discussion with his wife. Herminie then made the announcement on his behalf.

By the time their children were of marriageable age, Herminie was as relaxed about the possibility of intermarriage as was Emile. As we know she was born into a family that early signalled adherence to a different manner of being Jewish. Her parents had moved almost seamlessly into secular Jewish life, renouncing the practice of Judaism and enjoying non-Jewish culture and society while yet maintaining close friendships within Paris's Jewish community. Her brother Olinde had married a devout Catholic as early as 1817. Recalling that four of her seven surviving siblings married Christians and that her sister, Sophronie, who married David Andrade, converted to Catholicism with her whole family, there was history on Herminie's side. [26]

Intermarriage for the Pereires, therefore, was as much about the broader question of French citizenship, their wish to grasp it with all its potential and to manage all its ramifications. It provided a

palpable means of demonstrating their readiness to engage equally in the affairs of the nation. It was also a way of inviting approval and acceptance from the elite society in which they now moved.

What is evident from the families into which all but one of the children of Herminie and Emile Pereire married, however, is that the network of alliances from which spouses emerged and which Herminie cultivated was for the most part quite small. The families were well-known to them, sharing significant business and private interests accompanied by some status in Parisian society and the taste and discernment worthy of their class. A particular source of marital partners was the Saint-Simonian network which Herminie and members of her family had experienced personally, knew intimately, and, as we know, remained a close circle of friendship for her.

Following the marriage of Fanny and Isaac, which took place in 1841, Cécile, the second daughter of Herminie and Emile Pereire, was the next to wed, in 1846, at seventeen years of age. Her husband, Charles Rhoné, ten years her senior, was attractive on several counts. He had been associated with Saint-Simonianism through his brother, Léon, a Maître des Requêtes (senior legal counsel) to the top-level Conseil d'État.[27] Through Léon Rhoné, the Rhoné family had become part of the Pereires' inner circle. Charles was a *centralian*, a graduate of the École centrale des arts et métiers, the relatively new institution founded in 1829 by a Saint-Simonian, Alphonse Lavallée, to provide skilled engineers for a fledgling heavy industry, an alternative to the École polytechnique founded in 1795 to train engineers for large public infrastructure projects. This engineering background stamped him as one who could readily step into the family business. In addition, he came from a well-to-do, cultivated, bourgeois family of *négociants* from Valenciennes in France's north, the sale of whose significant art collection would provide many pieces for the Pereires' own.[28] Charles was a Catholic. Cécile became one also, a decision which presented no problems for her or for her parents. Rapidly, Charles Rhoné became an integral member of the Pereire family, one whom Herminie was wont to describe as her 'third son'.

Her confidence in him was fully justified. Charles Rhoné rapidly moved into a variety of significant posts in Pereire companies, becoming vice-president of the Compagnie parisienne de l'éclairage

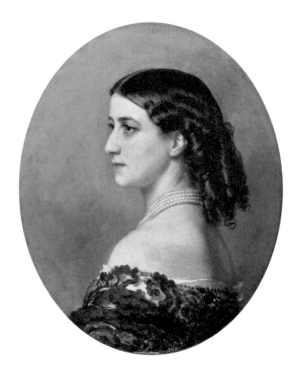

Figure 7.1 Cécile Pereire, portrait by Franz Xaver Winterhalter

et de chauffage par le gaz and joining the board of the Compagnie générale transatlantique of which he became president in 1861. He was also, with Emile Pereire himself, an inaugural director in 1852 of the Crédit Foncier, a new mortgage bank which was to become a mainstay of the Pereires' later urban development activities.

The ease with which Herminie and Emile's children moved into Christian marriages is more clearly demonstrated in the circumstances of the marriage of their third daughter, Claire. But here, the indeterminate situation of Herminie and Emile regarding religion was a thorn in the side of the Protestant Thurneyssen parents whose son, Georges, was the candidate for her hand. The patriarch, Auguste Thurneyssen, approached the Pereire couple by letter with the direct question as to their religious preferences. More than likely he was concerned to establish that, while the Pereires were Jews, the

marriage nevertheless would be conducted in the Protestant rite and any children raised accordingly. In these circumstances, it was Emile Pereire who replied, as was customary. He was to the point:

> Your wishes concerning religion will be satisfied. My daughter is not a Catholic. Not wanting to raise her in the religion in which I was born, we educated her from the start in the knowledge of the most advanced religions without forcing her to practice any of them. Her wedding will be celebrated according to the customs of her husband's faith, which will also be her children's.[29]

Herminie and Emile were in fact delighted to agree to this marriage for their daughter, as Emile had indicated in his response. The Pereire brothers, after all, had been associated with the Thurneyssen banking family for some time. The Frankfurt-born Auguste Thurneyssen was one of Emile Pereire's financial backers when in 1834 Pereire was attempting to raise sufficient capital to buy shares in his own company, the Paris–St Germain rail line. Thurneyssen the elder, whose son was already an employee, later joined the board of several Pereire businesses himself, including the Crédit mobilier, as well as the Paris–St Germain.[30]

Claire and Georges married in October 1853 in the *mairie* of the first *arrondissement*: she was nineteen years of age and he twenty-four. Georges' existing employment had already proven useful to the Pereire companies, but whereas in 1856 he was described in the *Bulletin des Lois* as a 'rentier', by 1869 he was an administrator of the Compagnie des chemins de fer du Midi.[31] While apparently having no professional qualification, Georges was, by the age of forty years, director of a very significant company.[32] In time, he too assumed even more important roles, as chief executive of the company du Midi and eventually, in 1898, vice-president.

The matter of Claire's dowry needed clarification before the marriage, and this was agreed with Herminie. Ironically, the explosion in the family's wealth following the launch of the Crédit mobilier was to cause a problem. Emile was upfront about it and gave us some insight into his wife's thinking and his own on this thorny subject.

> I count on giving her a dowry of 500,000 francs and my wife will take charge of the new household. I would have been able to do better but I needed not to establish too great a disproportion with the

dowries of my two older daughters who were married at a time when I had not reached the [financial] situation I now possess.[33]

If the young men whom the Pereire daughters took as husbands were chosen with an eye to their suitability as eventual leaders in the family businesses, in time the Pereire sons needed wives who would support and enhance their social and financial success, provide heirs to carry on the line, raise children with polished manners and social skills, preside over the family home, perform duties as exemplary hostesses and, eventually, find marriage partners for their progeny as their mother had done for them. The network providing possible marriage partners for these young men could be regarded as substantial, for the Pereire family wealth by the 1860s was immense through its ever-expanding business interests and extremely astute investments.

Thus, when the two sons of Herminie and Emile Pereire, Emile II and Henry, were in a position to marry, they would appear to have had many options. Active and attractive young men, both were engineers who had graduated from the same École centrale des arts et métiers as had their brother-in-law, Charles Rhoné.

Nevertheless, the marriage partner of Emile II, who was the first of their sons to marry, also emerged from within a comparatively small circle as had his sisters' husbands. His bride, Suzanne Chevalier, came with peerless Saint-Simonian and other credentials: her father Guillaume-Auguste Chevalier had been connected with the movement, was at one time *chef de cabinet* to the Prince-President, Louis-Napoléon, and was then secretary to the Crédit mobilier. Her uncle, Michel Chevalier, a friend of the Pereires from Saint-Simonian days, was a Senator, and, in 1860, was directly involved with Emile Pereire in negotiating the Anglo-French commercial treaty with William Bright.[34]

The marriage took place in August 1863 in the *mairie* of the eighth *arrondissement*, followed a month later by a mass at the Catholic Church, Saint-Philippe du Roule in the rue du Faubourg Saint-Honoré, which neighboured the Pereire family home.[35] This time, however, the Church actively criticised the marriage between the Catholic bride and the groom. Despite the elder Emile Pereire's statement to the Thurneyssens that none of his and Herminie's children had been raised in the Jewish religion, this cut no ice with

the papal nuncio. In a message to the Pope, he described Emile II unambiguously as a Jew.[36] Just the same, as Charles Sarchi wrote to his daughter, Hélène, in this case it was unlikely that religion presented much of a problem in reality, for 'money irons out many difficulties'.[37]

This marriage was not without its initial problems, however, problems that required Herminie's tact and organisational nous. There is a suggestion in the correspondence that Suzanne may not have entered the marriage of her own free will, that her father may have pressured her into it; that Auguste Chevalier had even insisted the young couple live with him and not with the Pereires. Emile Pereire's concern was that Auguste should not 'either directly or indirectly take any influence over the mind and the concerns of our son'. Herminie thus took the steps necessary to ensure Emile II and Suzanne were safely ensconced as comfortably as was possible in the hôtel Pereire.[38] Eighteen months later, Suzanne gave birth to her first child, Sarah, and Herminie immediately made an appeal to Henry who was travelling in the Middle East. 'We are still counting on the water from the Jordan [River] that you must bring back for her baptism', she wrote.[39] Thus did Herminie ensure that within the family at least, all was harmonious.

It was to be several years after the death of both his parents that the marriage of the second son Henry took place, although his uncle Isaac was still living. And here there was some divergence from the usual pattern of marital partners. There had been some disquiet about the time Henry had taken to find a suitable wife, and we may recall Michelle Perrot's note that the sanctification of heterosexual monogamous marriage carried with it 'the double rejection of the homosexual and the celibate'.[40] Henry's uncle, Charles Sarchi, for instance, wrote to his daughter in 1875, 'I think like you that the conjectures of your aunt [which aunt is not identified] on the subject of Henry would be unfounded.'[41] The substance of these 'conjectures' is also unknown but clearly, Henry, thirty-six years of age by the time of his wedding, had been in no hurry to marry.

How a young woman, born in Brazil but now living in Milan in unpretentious circumstances, came to be drawn to the attention of the wealthy Pereire family in Paris is curious, and the circumstances were and remained mysterious and romantic. At this point, however, we may identify a family circle that canvassed likely

candidates. It seems that Fanny Pereire's stepson, Eugène, through a third party, was intermediary in some delicate negotiations that eventually took place, and possibly at Fanny's instigation. Léontyne de Stoppani had not been without admirers, and her beauty and bearing caused a small sensation with her first foray into provincial French society, eliciting several approaches from potential marital partners. Being an extremely religious young Protestant woman, however, she could not allow the possibility of raising her children as Catholics.[42] Henry, whose religious preferences at that time were indeterminate, was easily persuaded to become a Protestant.

Despite any initial reluctance to marry, when Henry met her, he was overwhelmed with the possibilities of such a union.

> I sleep little and think all the night of what you will say when you see her [he wrote to 'My dear sisters']. I am so absolutely sure that you will love her that I have no disquiet in that respect. ... If you knew all the prospects of happiness which unfold before me, it seems to me that they are endless. She loves above all and almost uniquely the family life as I lead it with you. ... She is a pearl, I assure you. ... I see nothing but her, all my actions seem to me to be about her, and I am a stranger to all that she has not inspired.[43]

Before the union received family approval, Fanny Pereire hastened to meet her, for Léontyne brought neither financial nor social position to the proposed union. Léontyne needed to be checked out. As well, discussion about financial and other arrangements needed to take place with her guardian, a M. Morin, who had promised property to the value of forty thousand francs to be delivered after the wedding. Léontyne also brought objects for her own personal use to the value of twenty thousand francs. This did not compare, however, with Henry's contribution of one million francs.[44]

Fanny was charmed and probably relieved when she made the acquaintance of Léontyne, however, accepting her instantly. She wrote immediately to her two sisters Cécile and Claire with the happy news:

> Our little sister is above all that we could dream. She is an adorable young girl, simple, beautiful, dignified, and of an exquisite distinction ... My husband [Isaac] is very happy and now, I regret that we are not all close to her. ... Henry is well compensated, one can wait when one finds a family pearl.[45]

The marriage took place in September 1877.

Except for Fanny, then, the children of Herminie and Emile Pereire all married Christians. Aside from Léontyne de Stoppani, their partners were all affluent and of a similar class. But every one of them entertained similar social and financial expectations and aspirations for themselves and for their spouses. Through their marriages, these four children embraced the ideal of complete integration into French bourgeois society, increasingly influenced also perhaps by what the sociologist and historian Freddy Raphaël described as 'the incomparable seduction of French culture'.[46]

Eugène, the son of Isaac and his first wife, Laurence, was the first of Isaac's children to marry, in 1857, and this requires us to go back twenty years in time before the marriage of Henry and Léontyne. In considering this other side of the family, we should also remember that Eugène was older than his half-brother, Gustave, by fifteen years and of his half-sisters, Henriette (b. 1853), and Jeanne (b. 1856), by twenty-two and twenty-five years respectively. He was thus a kind of uncle to all three of them.

Religion or social circle, or even age at marriage for Eugène and for Fanny and Isaac's three surviving children, diverged substantially for the most part from those of their cousins. It is not altogether clear as to why this was so, particularly on the matter of religion. Although he was of Jewish origin, given the absence of religious instruction in his life to that date, for Eugène to marry a Jewish woman was not necessarily expected, particularly since his cousins Cécile and Claire had already married Christians. More significantly, however, the families of the betrothed couple had known each other for over thirty years. In this single respect, this marriage was not dissimilar to the unions entered into by Eugène's cousins, Cécile, Claire, and Emile II: the marriage partner emerged from a close circle.

The Foulds were among the first elite Jewish families to establish themselves in Paris.[47] Juliette Betzy was the daughter of Palmyre Oulman, of a prominent Ashkenazi family from Lorraine, and Emile Fould, the foremost notary in Paris, whose bureau accounted for most of the largest Jewish businesses, including the Pereires'. He was also a first cousin of the then ministre d'État, Achille Fould (who would himself become a Protestant in 1858), and of his brother, the eminent banker, Benoît Fould – a significant supporter

of the Crédit mobilier, and its first president. Once more the circle so closely linked around the Pereires provided the small pool from which a marriage partner was chosen. All that was different was religion.

Fanny, Eugène's stepmother, made the announcement writing to 'one of their oldest friends', Gustave d'Eichthal:

> My husband has asked that I announce the marriage of his son with Mlle. Juliette Fould, the elder daughter of M. Emile Fould. The young woman pleases Eugène greatly and since we have got to know her, we have thought that she will be able to bring Eugène happiness. We are all content with this solution and I hope that you will be able to share in it also.[48]

This invitation with its talk of the engagement as a 'solution' is intriguing. What solution? What was the problem? Were there difficulties in arranging a suitable partner for Eugène? He was after all no older than his peers in marrying at that time. Had he shown an interest in someone considered by his stepmother and father as 'unsuitable'? Or did he want to reaffirm, to consolidate his attachment to Judaism, to make a statement about his very identity?

Emile and Palmyre Fould were, with their immediate family, practising Jews. And so, despite an upbringing which seems to have lacked religious instruction of any kind and after adult circumcision, Eugène Pereire married Juliette Betzy Fould in the synagogue of the rue Notre-Dame de Nazareth. He was twenty-six years old and his bride was twenty.[49] If, as one historian contended, 'matrimonial witnesses can serve as a barometer for measuring the family and professional ties that linked witnesses and couples', the witnesses to this marriage were particularly impressive.[50] They included members of the Fould, Heine, Oppenheim, and Furtado families, Worms de Romilly, and Gustave d'Eichthal, together with the composer Fromental Halévy – all, including the Catholic convert, d'Eichthal, notable Jewish men. The witnesses also included two members of Napoleon III's nobility who were associated with Pereire companies: the duc de Glucksberg, a director of the Crédit mobilier espagnol and the Chemin de fer du nord de l'Espagne, in both of which Eugène was also employed; and the duc de Valmy, a significant shareholder in the Compagnie générale transatlantique and a director of the Chemin de fer du Dauphiné.[51]

The marriage not only brought together two families at the centre of business and politics under the Second Empire, but families with both Ashkenazi and Sephardic antecedents. Such a marriage would scarcely have been countenanced seventy years earlier. By the mid-nineteenth century, however, these differences between coreligionnaires no longer existed and certainly not in Paris.[52]

Eugène may have been influenced by any number of possibilities in his decision to marry a Jewish woman. Despite an underlying antisemitism throughout the century, the situation of Jews had become more favourable by the 1850s, generated in part by a wider public interest in, if not acceptance of, Jews and Judaism. The novels of Eugénie Foa and the opera *La Juive* of Fromental Halévy had depicted Jews and their circumstances in romantic and sensitive terms, gaining a ready public including among Christians.[53] There was an emerging Jewish solidarity evident in the appearance of Jewish newspapers and journals. Jewish tragedienne Elisabeth Félix, or Mlle. Rachel as she was popularly known, initiated a revival of enthusiasm for French classical drama, Corneille, Molière, and Racine, while promoting her own Jewish origins.[54] Closer to home, one of the Pereires' circle, the poet and critic Heinrich Heine, a Protestant convert had, comparatively recently in an article in *Revue des deux mondes* (1854), written publicly of his conversion back to Judaism.[55]

The support of Eugène's stepmother, Fanny, for this marriage was clearly important. In addition, circumstances had rendered it more acceptable to identify as Jewish and, naturally, his marriage partner fulfilled all the requirements beneficial to a young man in his situation: wealth, social position, and powerful connections. Eugène was thus responding to what one historian has described as 'the growing confidence of native-born French Jews in expressing identities beyond simply "French"'.[56] He joined the Consistoire central Israélite and thus made his commitment doubly public; that he remained committed could persuade us that his conversion was much desired on his part.

Thereafter, Fanny and Isaac's own children for the most part also married within the Jewish faith. The only one to marry a Christian was Henriette, whose marriage took place twenty years after that of Eugène and in the same year as that of her cousin Henry with Léontyne de Stoppani.

Henriette was twenty-four and of an age to marry. Indeed, she was at the upper limit of her cohort in first marriages. The groom, Eugène Mir, ten years her senior, was also older than the average age (of thirty) of first-time bridegrooms.[57] A lawyer and deputy for the Aude department in the Assemblée nationale, he was described by the journal *Le XIXe Siècle* as an 'excellent Catholic'.[58] The marriage took place in February 1877 at the Church of Saint Roch in the first *arrondissement*. As with the marriage of Emile II with Suzanne Chevalier, money was cited as the means of ensuring the marriage took place in the way that it did. Francisque Sarcey in *Le XIXe Siècle* wrote in a satirical piece, 'Juif et Catholique', that 'Mlle Pereire is, as all Paris knows, in a very tight position financially and that her father would never have had the means to pay the necessary expenses if one could only obtain them at a price of money.'[59]

This marriage thus expanded the boundaries of potential partners considerably. But while the marriage of Cécile Pereire with Charles Rhoné in 1846 came about through Saint-Simonian connections, as did that of Emile II with Suzanne Chevalier, the Saint-Simonian link may have continued to exert a residual influence through the marriage of Henriette with Mir. A long Saint-Simonian association between Isaac Pereire and Jacques Rességuier of Castelnaudary, stemming back to the late 1820s, almost certainly brought the Pereire family in touch with Mir, whose father, Gentil Mir, had been president of the civil tribunal of that town. The tight relationships between the Pereire family and their former Saint-Simonian colleagues are further confirmed in that Rességuier had married the sister of Michel Chevalier, and there was thus already a remote family connection with the Pereires through the marriage of Emile Pereire II with Chevalier's niece, Suzanne Chevalier.

But there were other equally powerful elements at work. First among them was the sudden and violent change in political structure that occurred in 1870 when the French Second Empire met its ignominious end at Sedan, giving way to the proclamation of the Third French Republic on 4 September 1870. The social and political allegiances that Emile and Isaac Pereire had so carefully constructed around them, depending as they did on their support for Napoleon III, were destroyed. Emile Pereire was a sick man and incapable of starting afresh. It was up to Isaac now, with Fanny's support and encouragement, to make what he could of a difficult

situation. Again, the Saint-Simonian connection proved useful. Their colleague, the Republican Hippolyte Carnot, had moved increasingly to the political left but he remained in touch. His son, Sadi Carnot, later to become President of the Republic, was a family friend cultivated especially by Herminie and then by Fanny. Thus was the political entrée assured.

Eugène Mir was not without resources of his own. He brought to the marriage a very extensive establishment, the Domaine de Cheminières in the commune of Castelnaudary, valued at one hundred and fifty thousand francs. It consisted of a chateau and outbuildings, a garden with a lake and canals, farm buildings, stables, vines, and arable land. That it was bordered by the canal du Midi and the rail line from Bordeaux to Cette (today Sète), both still within the Pereires' business portfolio, may give some further indication of the circumstances which drew Henriette and Eugène Mir together.[60] Henriette's dowry was vastly superior to that of Mir, however, despite what the press had to say: it included personal effects valued at fifty thousand francs and the sum of one million francs over ten years in advance of her inheritance, comprised variously of buildings, mortgages, *rentes*, shares, and bonds.[61]

Aside from the political connections cultivated by Fanny and Isaac, how did Eugène Mir, a politician from the provinces, come to be considered a suitable partner for their daughter? Politics certainly provided the context here, for this marriage took place at a difficult time in the life of the new Republic. The bride's father, Isaac Pereire, was much engaged with his newspaper, *La Liberté*, which he had purchased from Eugène de Girardin and over which he assumed complete control in 1876. He actively pursued a political agenda and indeed the motto on the masthead was authentically Saint-Simonian: 'All social institutions must have as their goal improvement in the moral, physical and intellectual condition of the most numerous and poorest class.' Politics in France were torn between the ambitions of the Republicans of Léon Gambetta and the defensiveness of a right-wing coalition of royalists and conservatives led by Patrice de MacMahon, Maréchal de France.[62] Pereire, through his newspaper, had supported MacMahon but later was forced to concede that MacMahon's political actions and style were not conducive to the social progress he espoused.[63] He greeted Jules

Grévy, who in early 1879 succeeded MacMahon as president of France, with more favour, 'without rancor and without distrust'.[64]

Eugène Mir had been secretary to Grévy and was of his Moderate Republican Party. Indeed, Grévy, then president of the Assemblée nationale and not yet president of France, was one of the witnesses to the marriage contract, as were Eugène Duclerc, vice-president of the Senate, and many deputies and senators. Sadi Carnot, who succeeded Grévy as president in 1887 was another distinguished witness. The number described as 'friends' and who signed the marriage contract was remarkable; they counted 104. Was Mir attempting to impress this extremely wealthy family with his political connections, to demonstrate his worthiness to marry into the *grande bourgeoisie*?[65]

Whatever the motivation, he, too, made himself useful in the service of the family businesses. While continuing to pursue his political career, first as a deputy and then as senator for the Aude department, he became in 1880, the year of his father-in-law's death, an administrator of the Chemin de fer du nord de l'Espagne in which he continued for many years; of L'Union et le Fénix Espagnol compagnie des assurances réunies until 1931; as well as of the public mortgage company, the Crédit Foncier.[66]

Further changes had taken place in French Jewry. In 1860, Adolphe Crémieux founded the Alliance Israélite universelle to encourage solidarity among Jews internationally. Over time, the Alliance developed a high profile.[67] Following the arrival of Lazare Isidor as Chief Rabbi of France in 1866 (he had been previously Chief Rabbi of Paris), new religious services, Jewish ceremonies, and procedures attested to a willingness to reform liturgical and other practices within Judaism now considered outmoded.[68] Isidor had been complicit with Crémieux in the abolition in 1848, when Crémieux was ministre de la Justice, of the antisemitic *more judaico*, the special oath required to be taken by Jews in legal matters. His standing in the French community was confirmed with the award of Chevalier de la Légion d'honneur in 1859 and his promotion to Officier in 1878. In addition, the professions, legal, medical, and engineering were now open to Jews, and there had been Jewish deputies in the parliament for over thirty years, including from 1863–69 the Pereire brothers themselves and Eugène. The Pereire family was well-known as a benefactor to the Chief Rabbi, having

assisted in a delicate situation concerning Isidor's salary, which they augmented.[69]

These more favourable circumstances may have encouraged Fanny and Isaac's son, Gustave, to seek a young Jewish woman as his wife. Marie Thérèse Amélie Emerique, known as Amélie, was the daughter of a practising Ashkenazi family of highly regarded money-changers with links to the Javals, who were prominent in textiles production.[70] It was not coincidental, either, that Amélie's paternal grandmother was a member of the Fould family and sister of the notary Emile Fould, father of Eugène's wife, Juliette Betzy.[71] The Jewish network of marital alliances was very much in evidence here.[72]

The obligations required of Gustave's parents were left to Fanny, for Isaac was by then almost totally blind and practically immobilised. This very likely accounted for his failure to make the expected call on the mother of his son's fiancée, her father having died when she was of a young age. A dinner at the hôtel Pereire was the first occasion on which he was to meet them. Even then he was nowhere in evidence upon their arrival, discovered only when the party moved to the dining room and found him already seated there. Further, dinner was interrupted constantly by staff bearing business communications for Isaac's signature or for discussion.[73] Fanny was left to smooth over the apparent rudeness, which she did with customary grace.

What occasioned this lack of courtesy is not clear – whether it was antipathy to his son's soon-to-be in-laws, or whether it was simply a sign of his ageing. It was probably the latter, as it is doubtful that Isaac was by then much concerned about his son marrying a Jewish woman: Eugène had done so without any fuss twenty-two years previously, and Isaac himself was to write with approval of the Jews and the Jewish religion in his second-last book, *La Question Religieuse*, in the year of the marriage.[74] In 1879, in his last work *La Question des Chemins de Fer*, he again praised the Jews for their intelligence and hard-working qualities which, in America, he wrote, had led to the growth of commerce and industry, finance, and general prosperity.[75]

Gustave also remained a practising Jew, succeeding his half-brother Eugène as a member of the Consistoire central Israélite, a position he held until his death in 1925.

Until the second half of the century, marriages within elite Jewish circles in France were more likely to be contracted between other French Jews. Both Eugène and Gustave had married young Jewish women born in Paris. But, later, a wider pool of potential partners from Europe was drawn into play.[76] The Pereires' business interests were international, and both Herminie and Fanny were inveterate travellers, facilitated by the family's own railways. And Fanny, despite the closeness of the social circle in which her parents moved, was of a more cosmopolitan disposition.

The younger daughter of Fanny and Isaac, Jeanne, at the age of twenty-four in 1881, married Edoardo Philipson, a Florentine engineer (b. 1857), whose Jewish banking family was originally from Livorno. Edoardo was to become a significant figure within the Florentine Jewish community. While he was from a family of bankers, we should also recall that the Pereires had established the Crédit mobilier italien after Italian unification, were involved in several Italian rail ventures, and were close to certain prominent Italians, the statesman, Camillo Benso, conte di Cavour, and Raffaele de Ferrari, duc de Galliera among them. The Pereires' brother-in-law, Charles Sarchi, was also in a position to introduce them to significant figures in Italian industry, financial, and intellectual circles, including the d'Ancona family, several of whom became witnesses to the marriage contract.[77]

Fanny and her family appear to have enjoyed Italy, since there were a number of voyages mentioned in letters from the family. Prior to the announcement of any engagement, she had travelled there with Jeanne on several occasions. Indeed, Charles Sarchi wrote to his daughter that he fully expected one of his own relatives from Trieste, Paul Morpurgo, would be the next son-in-law of Fanny and Isaac, so frequent were Fanny's trips to Italy.[78]

The marriage to Edoardo Philipson which she announced was to have taken place in November 1880 but was delayed with the death of Isaac in July of that year.[79] While the young couple proposed to live in Italy, their union was to be ruled in conformity with the French Code Civil. This had some significance since, while the groom brought 606,000 francs to the marriage, his bride's dowry contributed the handsome sum of 3,610,000 francs resulting from the deaths of Emile and Isaac, which led to rearrangements in the Pereire family trust, the Société universelle Pereire established by the brothers in 1857.[80]

At the time of the engagement, the press referred to him, rather romantically, as 'a young engineer of great talent, without fortune' (*Le XIXe Siècle*) and, rather less so, as 'an engineer attached to the railways of Upper Italy (*Le Figaro*)'.[81] We cannot assume from this that he was employed by the Pereires' Compagnie des chemins de fer François-Joseph, however, since the Rothschilds also held interests in railways serving northern Italy. But come what may, Edoardo also thereafter played a role in companies belonging to Pereire family concerns. He had an interest in the Crédit mobilier italien and was a director of the Compagnie madrilène d'éclairage et de chauffage par le gaz.[82] His address in Paris, as with all who now married into Fanny and Isaac's family, was the hôtel Pereire at number 35–37 rue du Faubourg Saint-Honoré.

That love and affection had over the century come to play a more significant role in determining a suitable marriage is perhaps borne out in this instance. For upon the death of Jeanne in 1899, Edoardo's grief was palpable. Writing from Florence to 'my dear uncle Henry' in which he referred to Fanny as 'maman', he described a visit to the marital home in Pistoia: 'a very deep emotion ... for me with such memories of our poor country home where each object was placed according to the wishes of my darling'.[83] Several days later he cried: 'the nights are terrible. I cannot sleep.'[84]

The Pereires over the *longue durée* thus provide a picture of a family in transition. Religious attachment was 'obligatory' in French society, as Emile Pereire himself acknowledged in a letter he had written to an uncle in 1826.[85] Yet the family was not united in the way in which it dealt with this attachment. If most of the children of Herminie and Emile conceived their destiny as assimilated French through intermarriage and, in three cases, conversion, their cousins, Isaac's son Eugène and at least two of Fanny and Isaac's three surviving children, saw an altogether different future. In their case, a new-found religious identity was not simply compatible with a social position within the *grande bourgeoisie*; being Jewish was an integral part of their civic and economic status. They were French men and women of the Jewish faith.

How do we explain the divergence between the cousins, the children of Herminie and Emile on the one hand and those of Fanny and Isaac on the other? Of all the children of Herminie and Emile, it is possible that Fanny, the firstborn, was the only one to receive any

instruction in the Jewish religion. She was born when her paternal grandmother, Rebecca Henriette, was still living, a woman devoted to Judaism and after whom – Fanny Rebecca – she was named. Perhaps for Eugène also, whose mother, Laurence, almost certainly practised her religion at some point and influenced her son in his childhood – he was six years old when she died – there existed a residual attachment to Judaism and a nostalgia for a long-lost family.

Finally, what were the implications for the Pereire family and the family businesses from these so different marriages?

First, the family was unable to carry on as it had in the past. Even from a practical point of view, the hôtel Pereire where they had all lived from 1859 could not accommodate an ever-expanding number of spouses and children. While initially all the married couples

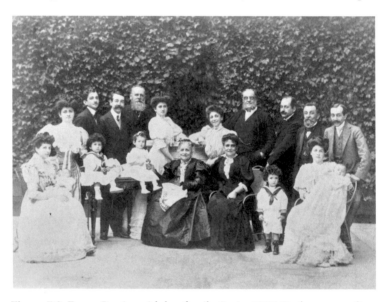

Figure 7.2 Fanny Pereire with her family, Paris, 1905. Back row standing: Mme. Guido Uzielli, daughter of Jeanne Pereire; Dino Philipson, son of Jeanne Pereire; Jacques Pereire; Edoardo Philipson; Margharita Philipson, daughter of Jeanne Pereire and future baronne Lévi; Amélie Emerique Pereire; Eugène Mir; Guido Uzielli; Gustave Pereire; Alfred Pereire. Front row seated: Mme. Jacques Pereire, holding Roger Pereire; Alberto Uzielli; Fanny Pereire, daughter of Alfred Pereire; Fanny Pereire; Henriette Pereire Mir; Giorgio Uzielli; Mme. Alfred Gomès Pereire, holding Michel Pereire

lived in the mansion, from 1873 they began to disperse. Eugène and Juliette were the first to go, but not very far: only a little further down the same street to 45 rue du Faubourg Saint-Honoré.[86] But then began the exodus to new areas of Paris opened up by Emile Pereire's purchase of the parc Monceau from the Orléans family in 1860. In 1876, upon the deaths of Herminie (in 1874) and Emile (in 1875) and in consideration of provisions in the family trust, all of their children were provided individually with houses in this quarter in a formal division of property between Fanny and Isaac on the one hand and the children of Herminie and Emile on the other.[87]

Thus, all four of Herminie and Emile's children moved from the hôtel Pereire to new homes of their own, not too far distant from it but not neighbouring either. In contrast, Fanny and Isaac and their children continued to inhabit the family mansion, even after Isaac's death in 1880.

The breakup of the Pereire family and the departure of several from the family home may have been merely a legal matter contingent on the deaths of Herminie and Emile, but we might also ask how much was it a wish on the part of their children to distance themselves after the death of their parents from the circumstance of having close relatives who publicly identified as Jews? For the moves away from the hôtel Pereire also took place after the collapse of the Pereires' bank, the Crédit mobilier which, while it did not generate the level of anti-Jewish antagonism experienced in the next few decades, certainly exposed the family to antisemites. Letters in the family archive attest to that. The gathering antisemitism following the collapse in 1882 of yet another bank, the Union générale banque, in which a number of significant Jewish bankers and financiers were implicated, albeit without proof, came to a head with the publication in 1886 of Edouard Drumont's *La France juive*.

Certainly, the extended family was now scandalised by conversions to Judaism, one of them noting the marriage of Gustave in a synagogue with considerable jaundice:

> The Jewish marriage of a son of Isaac is a great disgrace, & I am happy to see that this ridiculous ceremony will come about before my return to Paris [wrote Charles Sarchi to his daughter]. Everywhere, and this is sad, in families as elsewhere, it is the sentiments of the most idiotic members, that are assured of prevailing. Be completely imbecilic and one is assured of obtaining general approbation.[88]

But there may also have been tensions within the family caused by what appear to have been sincere religious difference. Both Isaac's sons Eugène and Gustave, as we have seen, became senior members of the French Jewish community. Their children married within the faith, as did the children of Jeanne and Edoardo Philipson.[89] On the other hand, while we do not know about the extent of religious devotion of Herminie and Emile's children, Emile II and Claire – although we do know that all their children were baptised – both their other children, Cécile and Henry, became practising Christians. Cécile counted high-level clerics among her circle.[90] Henry, in an undated draft of his will, instructed his heirs and successors that 'it is not adieu, but *au revoir*. May you be and remain always firmly Christians.'[91] Continued residence with Jewish cousins may not have made for comfortable relations.

The rift already evident in the 1870s crystallised in several ways. Over a long period, the Pereire family trust, established by Emile and Isaac to consolidate and expand the family's assets to the benefit of all, now came under sustained attack from the children of the next generation, who wished to sell off all the components and distribute the results. Fanny attempted valiantly in 1899 to caution her brothers (her sisters were now both dead, Cécile in 1885 and Claire in 1887), her children, grandchildren, nieces and nephews, everyone who benefited from the trust, against any precipitate moves, especially as a large part of the holdings was in real estate and the true value could not be realised immediately. She reminded them that her father had justified the setting up of the family trust on the grounds that while there was no need for any written agreement between him and his brother, he wished to assure the future peace and prosperity of the family by doing so.

> Do not forget [she wrote] that the Société Pereire has not only permitted us to traverse difficult days, of which the memory is still present for several of us, but that we owe to it all that we possess. Do not let us rush to sell properties which have not yet reached their true value. Let us make for our children and grandchildren what our parents have made for us.[92]

She attempted to have inserted in any future agreement a clause demanding that 'the realisation of assets must be pursued with a wise prudence, to permit time for the properties to reach the profit

that a near future makes us hope for'.[93] Her plea was in vain. The family trust became a limited liability company in 1903 with the objective 'to liquidate all the ... assets of the Société [Pereire] by sale, exchange or other means' and not to take on any further acquisitions. Total liquidation was achieved well before the projected date of 1969.[94]

There were certain elements of the Pereires' business empire which remained, however: a number of their companies. While the impending bankruptcy of the Crédit mobilier had forced Emile and Isaac Pereire to resign from the bank and their urban development company, the Compagnie immobilière, there continued to be family involvement in others.[95] Here, too, divisions became increasingly evident throughout the rest of the century. Before his death, Isaac had rescued the shipping company from the hands of competitors, and his son Eugène became president into the twentieth century. For a time, Emile's son, Emile II, also sat on the board. But their association ended in 1882 following a nasty public boardroom row between Eugène and Emile II that saw the latter resign in anger.[96]

High emotion, to which religious difference at a time of increasing antisemitism may have contributed, thus initiated a parting of the ways for what remained of the Pereire family. Eugène, Gustave, and Eugène Mir, all related to Isaac and to Fanny and Isaac, served the Spanish interests, while Herminie and Emile's sons and sons-in-law took on the Midi rail and the Paris-based businesses. The collaboration engineered by Fanny that saw Emile II, Henry, and Maurice Pereire contribute to the Fondations Isaac-Pereire was one of the few occasions the family was able to rejoin forces. They only rarely shared business interests again.[97] Thus the Pereire family, who at the outset of the nineteenth century had been so united, so coherent in their living arrangements, and exhibiting such familial solidarity in their business relations, by century's end was a house divided.

While the French historian Michelle Perrot in *The History of Private Life* has described the nuclear family in nineteenth-century France as 'triumphant', and other French historians also point to the century as one in which the family became the powerful social unit, Perrot also questioned the fragility of that triumph. In commenting, Thomas Kselman noted that 'the choice of marriage partners and the control of family wealth could be divisive issues, as could decisions about religion'.[98]

In the era which preceded the advent of the professional manager, trust and its attendant, loyalty, were essential commodities in the sound management of business enterprises, especially those with multi-national ambitions such as the Pereires entertained. This was apparent in the small social circle out of which marriage partners for the second generation for the most part emerged. Whereas trust and loyalty would once have been considered compatible only with endogamous marriage in the Jewish community, the opening of citizenship to Jews also opened the way to fuller integration in business with other citizens of France or elsewhere.

The Pereire brothers themselves did not convert and remained nominally Jewish, unlike some other elite families of Jewish origin who converted to Catholicism quite early: in the 1820s in the case of Nanci Rodrigues' sons, Édouard and Henri; earlier in the case of the d'Eichthals, Gustave and Adolphe. On the other hand, the Pereires were also unlike the Rothschild family, who remained firmly within the Jewish fold, for whom intra-family marriage was family policy among the second generation. Fifteen children of the five sons of the patriarch Amschel Mayer Rothschild of Frankfurt married each other.[99] This close endogamy, when added to the strong and continuing attachment to Judaism which fortified the Rothschilds, was notably missing in the Pereires' story.

While the first generation of Pereires led in their youth what appears to have been a normal Sephardic life, their later attraction to Saint-Simonianism gave them entrée to an extended intellectual family and a manner of living which drew them inexorably away from Judaism. As a result, the second generation had inherited more freedom to take marriage partners who were either Christian or Jewish, since marriage was about making one's way in French bourgeois society. Even so, none of the second generation married into the aristocracy, an occurrence which became increasingly common, especially among women of the Parisian Jewish elite.[100]

Through its very idiosyncrasies, however, the Pereire family over the nineteenth century illustrates the full array of marital possibilities opened to Jews following the French Revolution. But whether entering Christian or Jewish marriage, fulfilling the bourgeois dream required husbands who could take their place with ease and contribute considerable loyalty to the family business; and wives

who would add lustre to the family name while raising children who would carry the name forward.

In the process of analysing family firms, economic historians have noted the 'numerous accounts of family businesses brought down by bitter feuds among family members, disappointed expectations between generations, and tragic sagas of later generations unable to manage their wealth'.[101] The hostility between Eugène Pereire and Emile Pereire II seems to have cut deep among the second generation. Further, the expectations of descendants of the entrepreneurial Pereire brothers were likely dashed by a mismatch of business ability among later family members. Finally, the dissipation of the family wealth through its family trust severely reduced the financial resources necessary for survival. Ultimately, the Pereire family and the family's businesses suffered from each of these calamities – feuds, expectations based on poor business acumen, and squandering of financial resources – exacerbated no doubt by the different paths taken in marriage, where becoming Christian or becoming Jewish presented irreconcilable and enduring differences.

Notes

1 Johnson, *Becoming Bourgeois*, 26.
2 Historiography is abundant on Jewish conversions to Catholicism, including especially Thomas Kselman, 'Turbulent Souls in Modern France: Jewish Conversion and the Terquem Affair', *Historical Reflections/Réflexions historiques*, vol. 32, no. 1, 2006, 83–104; Julie Kalman, *Rethinking Antisemitism in Nineteenth-Century France* (New York, 2010); Todd Endelman, *Leaving the Jewish Fold*; Thomas Kselman, *Conscience and Conversion: Religious Liberty in Post-Revolutionary France* (New Haven, CT, 2018), esp. chap. 3. On the other hand, the Andrade affair has received little scholarly attention.
3 Philippe-Efraïm Landau, 'Se convertir à Paris au XIXe siècle', *Archives Juives*, vol. 35, no. 1, 2002, 27–43.
4 Benbassa, *The Jews of France*, 87–8.
5 Phoebe Maltz Bovy deals with the subject of intermarriage in France at length in her 'Embrasser les Juifs: Jews and Intermarriage in Nineteenth-Century France (1792–1906)' (PhD diss., New York University, September 2013).
6 Landau, 'Se convertir', 36.

7 As noted in Chapter 1, the Andrade affair was particularly painful for the extended family in Bordeaux whose members were close to the father of David Andrade, the Chief Rabbi of Bordeaux. Over the years 1822–28, Emile Pereire received fifty letters from his uncle Seba, some of which dealt with this episode.
8 Landau, 'Se convertir', 33.
9 BNF-A, fonds d'Eichthal, 13750/109, Nanci Rodrigues, Paris, to Cécile d'Eichthal, Rueil, 28 May 1842.
10 Kselman, *Conscience and Conversion*, 64.
11 Adeline Daumard, 'Affaire, amour, affection: le mariage dans la société bourgeoise au XIXe siècle', *Romantisme*, no. 68, 1990, 33–47.
12 Foley, *Women in France*, 38.
13 Patricia Mainardi, *Husbands, Wives, and Lovers: Marriage and Its Discontents in Nineteenth-Century France* (New Haven, CT, 2003), 152.
14 Smith, *Ladies of the Leisure Class*, 59.
15 Macknight, *Aristocratic Families*, 43 ff.
16 Davidson, '"Happy" Marriages in Early Nineteenth-Century France', 23–35.
17 Cyril Grange, 'Matrimonial Networks of the French Jewish Upper Class in Paris: 19th Century – 1950'. Paper presented at the IUSSP Seminar 'New Haven of Kinship', Paris, 1–2 October 2004, 19.
18 Johnson *Becoming Bourgeois*.
19 Grange, *Une élite parisienne*, 204–16.
20 Ibid., 230–2.
21 Jean Cavignac, *Les Israélites Bordelais de 1780 à 1850: Autour de l'émancipation* (Paris, 1991), 265–9.
22 AFP, Emile Pereire, Paris, to Auguste Thurneyssen, Paris, 20 July 1853.
23 This is apparent in the letters between Fanny Pereire and Isaac dealt with in Chapter 3.
24 Johnson, *Becoming Bourgeois*, 25–6.
25 AFP, Herminie Pereire, Arcachon, to Henry Pereire, Paris, 8 September 1864, where she noted that Jules Charton's position with the Compagnie du Midi had finally been arranged.
26 Paul Siméon, 'Origines, Ascendances, Alliances, de la famille Rodrigues-Henriques'.
27 Sarchi, *Lettres*, Félicie Sarchi, Néris, to Hélène Van Tieghem, Paris, 1 June 1864, vol. 1, letter 28, 54.
28 Details of this marriage are contained in AN/MC/VIII/1625, '13 Août 1846, Mariage entre Rhoné et Mdlle Pereire: Me Fould, notaire de Paris'. Reference is made to the Rhoné sale in W Bürger, 'Galerie de MM. Pereire', *Gazette des beaux-Arts*, vol. XVI, 1 January 1864, passim.

29 AFP, Emile Pereire, Paris, to Auguste Thurneyssen, Paris, 20 July 1853.
30 Davies, *Emile and Isaac Pereire*, 151.
31 *Bulletin des Lois*, no. 312, Acte du 11 August 1856 in which he is recorded as receiving shares in the Pereires' insurance company, 'La Paternelle'.
32 Ibid., no. 1548, 'Acte du 17 février 1869'. As the child of German parents, he was authorised to 'establish his domicile in France and to enjoy civil rights while he continued to live there'. *Bulletin des Lois*, no. 2449 of 3 April 1872 recorded that he had become a French citizen.
33 AFP, Emile Pereire, Paris, to Auguste Thurneyssen, Paris, 20 July 1853. The marriage contract is at AN/MC/ET/VIII/1661, maître Fould, 3 October 1853.
34 Davies, *Emile and Isaac Pereire*, 198.
35 This church was popular among mixed marriages because of its location. Grange, *Une élite parisienne*, 272.
36 For an account of this episode see Vincent Gourdon and Cyril Grange, 'L'union d'Émile Pereire II et Suzanne Chevalier, À propos des mariages mixtes sous le Second Empire', *Archives Juives*, vol. 42, 2009, 33–50.
37 Sarchi, *Lettres*, Charles Sarchi, Milan, to Hélène Van Tieghem, Paris, 13 May 1875, vol. III, letter no. 636, 414–15.
38 AFP, Emile Pereire, Bayonne, to Herminie Pereire, Paris, 13 September 1863.
39 Ibid., Herminie Pereire, Paris, to Henry Pereire, Egypt, 28 February 1865.
40 Michelle Perrot, 'Figures et Rôles', in Ariès and Duby (eds), *L'Histoire de la vie privée*, vol. 4, 133.
41 Sarchi, *Lettres*, Charles Sarchi, Milan, to Hélène van Tieghem, Paris, 13 May 1875, vol. III. letter no. 636, 414–15.
42 AFP, letters to Eugène Pereire, Paris, from M. Morin, Dieulefit, 8 October 1876 and 18 August 1877.
43 Ibid., Henry Pereire, Turin, to his sisters, Paris, 5 July 1877.
44 Ibid., 'Contrat de Mariage, 6 Octobre 1877, Cabinet de Me Armand, notaire de Dieulefit, Drôme'.
45 Ibid., Fanny Pereire, Lyon, to her sister, Claire Thurneyssen, Paris, 10 September 1877.
46 Grange, *Une élite parisienne*, 11, fn. 22 and fn. 23.
47 Ibid., 19–20. The Foulds were resident in Paris from the end of the eighteenth century.
48 BNF-A, fonds d'Eichthal, 13752/116, Fanny Pereire, Paris, to Gustave d'Eichthal, Paris, undated 'mercredi matin'.

49 Frédéric Barbier, 'Les origins de la maison Fould: Berr Léon et Bénédict Fould (vers 1740–1864)', *Revue historique*, vol. I, 1989, 188.
50 Cyril Grange, 'The Choice of Matrimonial Witnesses by Parisian Jews: Integration into Greater Society and Socio-Professional Cohesion (1875–1914)', *The History of the Family: An International Quarterly*, vol. 10, no. 1, 2005, 38.
51 Barbier, 'Les origines de la maison Fould', 188.
52 Grange, 'Matrimonial Networks', 3, where he wrote: 'The separation between the Ashkenazy [sic] and Sephardic worlds does not exist at the level of the elite classes.'
53 Lisa Moses Leff, *Sacred Bonds of Solidarity: The Rise of Jewish Internationalism in Nineteenth-Century France* (Stanford, CA, 2006), 102–16.
54 Julie Kalman, 'Thinking the Jew through the Turbulent Century: The Idea of Rachel', chap. 11 in Zvi Jonathan Kaplan and Nadia Malinovich (eds), *The Jews of Modern France*. Chap. 2 of Maurice Samuels' *The Right to Difference: French Universalism and the Jews* (Chicago, IL, 2016), deals at length with Rachel's public affirmation of her Jewish origins.
55 Heinrich Heine, 'Les aveux d'un poète', *Revue des deux mondes*, no. 24, September 1854, 1169–1206. For an extensive discussion of Heine's progress see Kselman, *Conscience and Conversion*, 71–9.
56 Bovy, 'Jews and Intermarriage', 47–8.
57 Grange, *Une élite parisienne*, 176.
58 Francisque Sarcey, 'Juif et catholique', *Le XIXe Siècle*, 11 March 1877.
59 Ibid.
60 AN, MC/ET/VIII/1807, '15 Février 1877: Contrat de Mariage entre Monsieur Mir et Mademoiselle Henriette Pereire, Me Fould, Notaire de Paris'.
61 Ibid.
62 See for instance Sowerwine, *France since 1870*, chap. 3.
63 The 8-volume *Écrits de Emile et Isaac Pereire* (Paris, 1900–9) contain the principal writings by Isaac Pereire for *La Liberté*. See vol. III, fascicules II and III, 761 ff. for writings 1876–77.
64 Ibid., 1575.
65 AN, MC/ET/VIII/1807, 'Contrat de marriage', Eugène Mir and Henriette Pereire.
66 A particularly useful source of information on French investment in Spain, and thus of the Pereires' investments, is Teresa Tortella, *A Guide to Sources of Information on Foreign Investment in Spain 1780–1940* (Amsterdam, 2000).
67 Leff, *Sacred Bonds of Solidarity*.

68 Phyllis Cohen Albert, 'Non-Orthodox Attitudes in Nineteenth-Century French Judaism', in Frances Malino and Phyllis Cohen Albert (eds), *Essays in Modern Jewish History: A Tribute to Ben Halpern* (East Brunswick, NJ, 1982), 132–6.
69 AFP, file of 'Correspondance avec le Consistoire Israélite'.
70 According to Francis Hervé in his book *How to Enjoy Paris in 1842* (reprint London, 2007), 262, Mme. Emerique, who carried on her business at no. 32, Palais-Royal, 'was a most respected money changer in Paris and the most liberal and just of any … The office of Madame Emerique is the longest established of any, and the high respectability of her family and connexions are a certain guarantee for the foreigner against being imposed upon.'
71 Grange, *Une élite parisienne*, 104, fn. 48.
72 Grange, 'Matrimonial Networks'.
73 This anecdote is derived from Jean Autin, *Les frères Pereire: Le bonheur d'entreprendre* (Paris, 1984), 335–7.
74 Isaac Pereire, *La Question religieuse* (Paris, 1878), 72.
75 Isaac Pereire, *La Question des chemins de fer* (Paris, 1879), 146.
76 Grange, *Une élite parisienne*, 161.
77 AN, MC/ET/VIII/1837, 'Contrat de marriage entre M. Philipson et Mlle. Rodrigues-Pereire, 15 janvier 1881, Georges Bertrand, Notaire de Paris, rue Saint-Maur, no. 24'.
78 Sarchi, *Lettres*, Charles Sarchi, Venice, to Hélène Van Tieghem, Paris, 4 January 1877, vol. III, letter 752, 60.
79 *Le XIXe Siècle*, 2 November 1880.
80 AN, MC/ET/VIII/1837, 'Contrat de marriage', Edoardo Philipson and Jeanne Rodrigues Pereire.
81 *Le XIXe Siècle*, 17 October 1880; *Le Figaro*, 18 October 1880.
82 AFP, Edoardo Philipson, Florence, to Gustave Pereire, Paris, 28 March 1993; *La Liberté*, 19 July 1895.
83 Ibid., Edoardo Philipson, Florence, to Henry Pereire, Paris, 25 April 1899.
84 Ibid., Edoardo Philipson, Florence, to Henry Pereire, Paris, 28 April 1899.
85 Ibid., Emile Pereire, Paris, to Jacob Lopès Fonseca, Bordeaux, 4 August 1826, when he wrote that a religious identity in France was 'obligatory' and since he had been brought up in the Jewish faith, there he would remain!
86 Ibid., 'Vente par la Société Civile Pereire', 1899.
87 Ibid., 'Partage entre Mr. Isaac Pereire et les enfants de Mr. Emile Pereire: Même date – Établissement de propriété, 3 Août 1876'.
88 Sarchi, *Lettres*, Charles Sarchi, Venice, to Hélène Van Tieghem, Paris, 22 April 1878, vol. III, letter 1014, 354–5.

89 Henriette and Eugène Mir had one son who died at the age of three.
90 AFP. These included the Abbé Xavier Mouls of Arcachon.
91 Ibid., Henry Pereire's undated draft will.
92 Ibid., 'Société Pereire', 1899.
93 Ibid.
94 Ibid., Société Pereire, *Société anonyme constituée au capital de 18,000,000 francs* (Paris, 1903).
95 This family disaster is covered fully in Davies, *Emile and Isaac Pereire*, chap. 8.
96 Marthe Barbance, *Histoire de la Compagnie générale transatlantique* (Paris, 1955), 94–5.
97 Grange, *Une élite parisienne*, Annexe No. 2.1, 'Présence des descendants des frères Pereire dans les sociétés Pereire selon leur branche d'appartenance', 472–6.
98 Kselman, 'Turbulent Souls', 101.
99 Ferguson, *The World's Banker*, 195–201.
100 There were, however, two such unions in the third generation of Pereires, both female descendants of Herminie and Emile Pereire. Cécile Rhoné's daughter Marguerite married the comte de Lariboisière; Henry Pereire's daughter Jenny married the baron de Neufville. In the fourth generation, Eugène and Juliette's granddaughter, Noémie Halphon, married baron Maurice de Rothschild, an intra-confessional marriage of a *grande bourgeoise* whose husband's family had been ennobled by the Hapsburg Emperor in 1817. Marriage between Jewish women and male members of the aristocracy who were Christian was more common than marriage between Jewish men and aristocratic Christian women. See Grange, *Une élite parisienne*, 225.
101 Marianne Bertrand and Antoinette Shaw, 'The Role of Family in Family Firms', *Journal of Economic Perspectives*, vol. 20, no. 3, 2006, 73.

8

Being Jewish

In an article appearing in *Le Figaro* on 6 November 1886, the Superior of St Joseph of Cluny, who presided over Fanny Pereire's medical clinic at Tournan, had cause to reflect on the presence of the Catholic oratory there. By way of explanation, she noted that Fanny 'did not fear to say to us that for her there was no distinction between Israélites and Christians. She has only one desire, that is that the God we have in common be respected and adored by all those who penetrate into her refuge.'[1] This arrangement may well have been *quid pro quo* for the opportunity afforded the religious order to provide nursing services to the Hôpital Isaac-Pereire, but it also tells us that at this stage of her life, at sixty-one years of age and a widow, Fanny Pereire identified herself unequivocally as Jewish.

That Fanny Pereire was recognised as Jewish was borne out on 5 June 1910 when, three days after her death, France's Chief Rabbi, Alfred Lévy, delivered the eulogy at her funeral. That a personage of such consequence in the Jewish community should undertake the task and do so with apparent reverence for his subject speaks volumes for the intricate relationship the Pereire family had woven with the religion of their birth and the accommodation that they had reached over the long nineteenth century.

> After having, in her youth lavished on her greatly-loved parents, her brothers and her sisters, the most touching proofs of filial piety and fraternal affection, she was for her noble husband, who preceded her in immortality some years ago, the faithful companion who becomes the joy, the pride, the support of the husband. Assisting him powerfully by her high intelligence, her activity full of charm, her constancy in the midst of trials inherent to existence, she was for him

that guardian angel that God sends to man on the path of life to render the crossing happy and easy.[2]

This enumeration of Fanny's attributes fell well within the rule-books of feminine behaviour: subservient, loving, faithful, charming. Similar terms were used at the funeral of the banker Meyer Joseph Cahen d'Anvers in 1881, when the then Chief Rabbi of Paris, Zadoc Kahn, said of Cahen d'Anvers' wife Clara Bischoffsheim that 'God had given him as a companion a holy and noble woman, a model of all virtues, who was the charm of his existence and the ornament of his home.'[3]

James McAuley in his remarkable evocation of Jewish elites in late nineteenth-century France, *The House of Fragile Things*, goes on to point out that from this eulogy a woman of the *grande bourgeoisie* was 'an art object, to be admired and to remain, in relation to a male spouse, merely a decorative embellishment'.[4]

Yet in Alfred Lévy's eulogy of Fanny, there was nevertheless some appreciation that she was not simply in the mould of typical elite Jewish womanhood; that her intelligence, resilience, and strength, placed her somewhat *hors norme*. Added to the description of her as a 'collaborator' with Isaac that we have noted in a previous chapter, we gain a sense that at the end of her life Fanny was accepted as a Jewish woman of independence and spirit.[5]

The tiny Jewish community of Paris which in 1789 amounted to little more than five hundred souls had grown to forty thousand by 1880.[6] Much of this population growth as we know was a product of migration. An emerging bourgeoisie in the early nineteenth century had, by the later date, given rise to an elite of bankers, financiers, industrialists. This too was constituted by emigrant families, from within provincial France to begin but increasingly from Germany, Russia, and the Austro-Hungarian and Ottoman Empires. This highly visible, powerful, and cosmopolitan community could no longer be defined by religiosity. Rather, historians agree, the distinctiveness of the Jewish *grande bourgeoisie* over the century had come to rest on ethnicity and concomitant social and cultural ties, sustained by a low rate of inter-marriage and conversion, by a sharing of ethnic institutions, and by primary association with other Jews.[7]

What did it mean to be Jewish? We commenced this study with the early and somewhat precocious acculturation of the Rodrigues

family, of Isaac *fils* and Sara Sophie, one which saw them abandon Jewish religious practice altogether and begin the process of acculturation in French society. Their nephews Emile and Isaac Pereire, who had been raised in a practising Sephardic family in Bordeaux, came to find this position persuasive.

This chapter looks at the evolution of Herminie and Fanny Pereire's relation to religious practice and the manner in which they defined their identity, a journey in which acculturation and *embourgeoisement* led them both, albeit differently, to an accommodation, of being both French and Jewish. That journey was infused with many elements, historical, social, cultural, and economic, as well as religious. It is with death that we begin to unravel them.

Burial in consecrated ground according to Judaic rites had been essential to the spiritual comfort of the Sephardic residents of Paris – indeed, of Jews of any town or village in France. Thomas Kselman reminded us that until the French Revolution, the dead of any persuasion were usually buried in the local churchyard and thus subject to the jurisdiction of the Catholic Church. Neither Jews nor Protestants for that matter were entirely free to bury their dead within their own ground or according to their own cult.[8]

For the Jews of the southwest, this had represented a harrowing circumstance of their lives as 'nouveaux Chrétiens' and crypto-Jews. The nineteenth-century historian of Bayonne Henri Léon noted that when the Sephardim finally emerged from this condition of extreme ambiguity, the cult of the dead was at the forefront of their religious institutions.[9] Indeed, Gérard Nahon asserted as the reason for the open protestation of Judaism in the seventeenth century by so many Sephardim who previously had been forcibly converted to Catholicism, a recognition of their compelling need to make their peace with the God of Israel before death.[10] Dedicated cemeteries were essential to this purpose.

Aside from the broader historical context of Jewish burial in France, which rendered the treatment of death a critical religious moment in the passage of Jews, the Pereires' own family history tied them closely to this narrative. In 1780, Jacob Rodrigues Pereire, as agent of the Sephardic Jews of Bordeaux and Bayonne, acquired for the Sephardim, after considerable negotiation, space for a cemetery at what is today 44 rue de Flandre in the La Villette district of Paris.[11] Two years before Rodrigues Pereire achieved his goal in

Paris, the president of the Jewish council of St Esprit-lès-Bayonne in the far southwest of France, Mardochée Lopès Fonseca, raised money to extend land on behalf of his community for a similar purpose. Indeed, Lopès Fonseca was active in several cities of the southwest, described by a senior Sephardic figure in Toulouse as 'the preserver of our cemeteries', and having played a role in preserving the Jewish cemetery in Bordeaux for the use of those 'professing the Jewish religion'.[12]

Jacob Rodrigues Pereire was the paternal grandfather of Emile and Isaac Pereire. Their mother, from St Esprit-lès-Bayonne, was the daughter of Mardochée Lopès Fonseca, and he was the Pereires' maternal grandfather. Through another daughter, Sara Sophie, Lopès Fonseca was also the maternal grandfather of Herminie. The histories of both the Rodrigues and the Pereire families were thus inextricably bound to this quest by the Sephardic Jews for respectful, segregated burial within the rites of their religion.

In the early nineteenth century, churchyards in Paris gave way to cemeteries as places for burial of the dead; Père Lachaise to the east (in 1804), Montparnasse to the south (in 1824), and Montmartre to the north (in 1825).[13] Different religious denominations sought and were granted rights to burial in discrete areas of these public cemeteries, within *enclos*. The cemetery in Montmartre accorded the Jews burial in the third division, overlooked by the rue Joseph de Maistre and bounded by the chemin Halévy.

In life, the Pereire family had not been devoted practicants of Judaism. There were moments when a holy day or religious event drew them to a synagogue, but this was rare. Fanny's father's position was ambiguous at best. When in Bayonne, where he stayed with the observant Léon family, Emile was frequently invited to attend synagogue on High Holy Days, occasions he recalled with nostalgic pleasure in letters home to Herminie. Yet having declared as a young man that a religious attachment of some sort was necessary for social and cultural reasons and that his children would therefore be raised as Jews, we recall that in middle age he confessed to Auguste Thurneyssen, father of the then prospective husband of their youngest daughter, Claire, that by choice Herminie and he had decided none of their children should receive a religious upbringing.[14] In the space of less than thirty years, Emile's conviction had changed utterly.

In Isaac's case, neither of his marriages entertained any religious content at all, and the only occasions on which he crossed the threshold of a synagogue was for the marriages of his sons, Eugène and Gustave.[15] Nevertheless, unlike Herminie and Emile's children, Fanny and Isaac's were evidently inclined to the possibility of Jewish marriage and, as the Superior at the Hôpital Isaac Pereire at Tournan commented, Fanny seemed to welcome opportunities to witness their faith.

In spite of this ambiguity of religious belief, however, the Pereire family was in contact and on extremely cordial terms over a long period not only with senior Jewish religious figures in Paris, but also in Bordeaux, where they contributed handsomely to the rebuilding after fire in 1873 of the Bordeaux synagogue.[16] Indeed, in all these cases, letters in the Pereire family archive concern significant financial contributions the Pereires had made to Jewish causes.

Giving thanks, Lazare Isidor, Chief Rabbi of Paris (1847–67) and later of France (1867–88), was moved to address Emile Pereire on more than one occasion as 'Monsieur and honorable coreligionnaire'.[17] The Pereire family was recognised by official Jewry, gratefully, as Jewish.

When dealing with religious practices among Paris's elite Jewry, Cyril Grange drew attention to the large number hewing to the practice of marriage in the synagogue. He quoted one interviewee who said that 'It was a bourgeoisie detached from religion but which got married religiously.'[18] A similar thought may have been in play in relation to the Pereires' wishes on death. Judaic religious practice was not a constant presence in their lives, but it provided the ultimate consolation at death.

Both Herminie and Fanny Pereire were knitted into this family history of a Sephardic past. At their passing, each requested a Sephardic Jewish service with prayer for the dead, signalling a continuing connection to the religion into which they had been born. If they were not otherwise constant, nor did they resile.

Herminie Pereire was the first of her generation to depart this life, on 25 January 1874. More than a thousand people from all ranks of Parisian society attended at the hôtel Pereire but, *La Liberté* noted, represented there in particular was 'all the haute banque of Paris … witnessing to her family the sentiments of respect and sympathy that Herminie had inspired in them'. The funeral procession

proceeded to the Jewish cemetery at Père Lachaise in Paris's east, where Lazare Isidor, now Chief Rabbi of France, conducted a service in 'the Portuguese' or Sephardic rite in Judaism. According to Isaac Pereire's newspaper, *La Liberté*, this was her explicit wish.[19] While this dying request demonstrates powerfully Herminie's identification with her ancestry and her religious past, it is doubtful that it meant she had returned to Judaism in any significant way. And what the Sephardic rite in the event of death meant in practice is not entirely clear either, although current-day practices may give some clues: Sephardic funeral services are shorter, the mourners stand for the greater part, certain prayers and portions of the Bible are read.

That Herminie's last request should concern Sephardic religious practice is striking, since one of the most notable aspects of Judaism in France in the nineteenth century was the decline in difference between those who practised according to the Sephardic rite and those conforming to the Ashkenazi. What had once been in France a chasm between these two pillars of Judaism was no longer of any significance. Indeed, the wish of the deceased woman is doubly interesting in that the presiding Chief Rabbi Lazare Isidor was Ashkenazi, as were the overwhelming majority of those who were to be appointed to senior roles in French Judaism during the nineteenth century.[20]

Père Lachaise was not to be Herminie's final resting place, however, for in the same year and possibly in recognition of her death, a concession in perpetuity for a grave site at Montmartre cemetery was accorded the Pereire family.[21] Granting a plot in perpetuity was greatly prized by bourgeois Parisians. Aside from the kudos this afforded the family name, it enabled the family to bring together in death those who had been increasingly separated in life by the demands of a new economic order.[22] Such a concession was particularly prized by Jews since it allowed the living the comfort of continued occupancy in death of their particular grave.

One year after the death of Herminie, thousands lined the streets along which the cortège of Emile Pereire proceeded, his mortal remains transported to this new tomb in the Jewish section of Montmartre cemetery bordered internally by the chemin des Israélites. Indeed, when the cortège arrived, masons were still at work, causing a brief hiatus. The Chief Rabbi of Paris, Zadoc Kahn, recited the Hebrew prayers for the dead, and Lazard Isidor spoke

warmly, albeit curiously, of the deceased banker's life: 'a pious child of Israel'. Emile's old friend and mentor, Adolphe d'Eichthal, also made an emotional eulogy.[23] Emile Pereire was the first occupant of the tomb.

From the time of Herminie's death, considerable thought had gone into the use of this family grave. Only days later her remains were transferred there also, to be followed by those of Jacob Rodrigues Pereire and his eight-year-old son, Samuel, both of whom had died in 1780. Those of the Pereires' mother, Henriette, and the infant Marie were re-interred from Père Lachaise the following day, and Fanny and Isaac's son Edouard transferred from Mortefontaine the following year, in 1876. So, too were the remains of their infant children, Jules and Lucien, transferred from Père Lachaise although not until 1898.[24]

From the outset the Pereires used their grave to draw together those separated by time as well as space. Importantly, the names of the Pereires' father and their brother, Télèphe, while both were buried in Bordeaux, were recorded on the gravestone as if to assert the more emphatically the Rodrigues Pereire family name and history. *Le Figaro* was to declare that in purchasing the burial plot, Emile Pereire 'had vowed that all those that he loved should repose near him'.[25]

This family grave in the Montmartre cemetery speaks eloquently of elements in the history of nineteenth-century French Jews: emancipation, acculturation, apostasy, *embourgeoisement*, antisemitism among them. But it also tells the story of a very particular Sephardic family. Indeed, the headstone invites attention to the 'Famille Rodrigues Pereire', reasserting the name 'Rodrigues' after nearly a century. This re-insertion into the public record amplified the family's wish to be associated once more with a Sephardic past. One might speculate that the very public engagement of their ancestors in securing respectable and segregated Jewish burial for the Sephardim, a circumstance that was well-known in the family, had some influence.

The tomb designed by William Bouwens van den Boijen, the prominent architect who had designed several mansions in the plaine Monceau, including 45 rue de Monceau for Isaac Pereire, is a simple one. At a time when bourgeois Parisians were dedicating flamboyantly sculpted and over-ornamented neo-Gothic chapels

to themselves, to be copied in Jewish places of burial, the Pereire grave exhibits considerable reticence. One has only to compare it with the elaborate tomb of Jules Mirès, his daughter the princesse de Polignac, and her husband, the prince Alphonse, located elsewhere in the cemetery outside of the Jewish *enclos*, to recognise its restrained elegance; or that of the philanthropist, Daniel Iffla, who arranged for a life-sized bronze copy of Michelangelo's Moses in the church of San Pietro in Vincoli, Rome, to sit ponderously on his grave.[26] But this is of a piece with the Pereires' approach to their wealth. Despite the fabulous *soirées*, the numerous places of habitation, the extravagant expenses on *objets* and works of art, understatement in many other respects was to be the key, and particularly at the very end of life.

This relatively unpretentious grave remained up to this century the last resting place of many of the Pereire family. Not all, however. Of those who had converted, Henry was the only one among the second generation choosing to be buried here, his attachment to his parents and possibly to an underlying sense of Jewish identity remaining with him to the end.

So, what is particularly significant on first coming upon the grave is the primacy accorded the brothers' grandfather, Jacob Rodrigues Pereire, his mortal remains transferred rapidly on 26 January 1875

Figure 8.1 Pereire family grave, Montmartre, Paris

from the Sephardic cemetery (in what is now the arts and cultural precinct) at La Villette that he had brought into being.

Jacob's name occupies the head of the central column of the headstone at Montmartre with details of his birth and death, his claims to national significance immortalised in stone.

> First teacher of deaf-mutes in France
> Agent of the Portuguese Jewish nation of Bordeaux and Bayonne
> Member of The Royal Society of London
> Interpreter and pensioner of the King

The roll-call of achievements sheeted home to the Pereire grandfather had been as much as anything else a constant reminder to Emile and Isaac of their lofty origins, a point that their mother had frequently reinforced, as well as of their religious antecedents. In contrast, Emile and Isaac Pereire, whose full names follow that of their grandfather in descending order, that is, 'Jacob Emile Rodrigues Pereire' and 'Isaac Rodrigues Pereire', are then recalled by their more usual names: 'Emile Pereire' and 'Isaac Pereire'. They were notably modest about their own achievements, revealing nothing of their considerable initiatives in the service of the French nation. Herminie's interment is recorded at the head of the right-hand column, beside that of Jacob Rodrigues Pereire, and Fanny's recorded immediately beneath that of her mother.

Here Isaac too was buried in July 1880. His body had been laid out in his *cabinet de travail* at the hôtel Pereire, where members of the Paris Consistory stood guard. Their presence owed something to his sons, Eugène and Gustave, the former now a member of the Consistoire central Israélite and the latter who was to become so. Three thousand accompanied the procession to the cemetery where rabbis waited at the entrance; two of them then recited prayers in Hebrew and a third, rabbi Joseph Mayer, gave a brief but, it was said, moving eulogy.[27]

Isaac's son, Eugène, was to follow some years later in 1908, the *obsèques* taking place at his home, 45 rue du Faubourg Saint-Honoré, and Kaddish being said by Israel Lévi, then Deputy Chief Rabbi of France and Rabbi David Haguenau, at that time rabbi of the Notre-Dame de Nazareth Synagogue. Among those in attendance were Jacques-Henri Dreyfuss, the Chief Rabbi of Paris.[28]

Fanny's death in 1910 we know to have been reported widely in the press, her philanthropic activities rendering her community service highly visible. The Chief Rabbi of France, Alfred Lévy, together with Rabbi Haguenau, celebrated the *obsèques* at 35 rue du Faubourg Saint-Honoré and saw her to her final resting place in Montmartre.

While the rabbinate presided over the funerals of all those of the first and second generations buried in the Pereire family grave, except for Henry, we should consider how other family members ordained their departure from this world. Two of them chose a funeral in a Christian church. The funeral of the Catholic convert Cécile Rhoné, for instance, who died in February 1885, was elaborate compared with those of her parents, her uncle, and her sister, Fanny. A chapel set up in the entrance to her home provided a place of prayer for sisters of the order of St Joseph of Cluny. The church of Saint-François-de-Sales in the 17th arrondissement where the funeral mass took place, conducted by the vicar, abbé Sébert, was overwhelmed by the size of the congregation. The music of Beethoven, Handel, and Gounod provided the accompaniment, while the coffin was accompanied to Montmartre cemetery by fifty young girls of the St Joseph refuge.[29]

The funeral of Cécile's sister, Claire Thurneyssen, about which we know considerably less, took place two years later at the Protestant Church of l'Étoile, a member of the Reformed Church and constructed in the neo-Gothic style in 1874 in the avenue de la Grande Armée.[30] These two sisters who converted on marriage remained steadfastly faithful to their new religious calling.

The funeral of Emile II was different again. While he had married a Catholic in a church and raised his children in Catholicism, Kaddish was recited on 27 August 1913 by the Chief Rabbi, Alfred Lévy, at Emile's home in the rue Alfred de Vigny and at the cemetery by Rabbi Metzger. *Le Figaro* went on to say that Emile II was buried at Montmartre, although this was not in the family vault.

Like his half-brother, Eugène, Gustave Pereire had been a member of the Consistoire central Israélite for some years by the time of his death on 3 February 1925. *L'Univers Israélite* recorded that the now Chief Rabbi of France, Israel Lévi, had recited Kaddish at Montmartre cemetery after departure from the hôtel Pereire, where Gustave had died.

Rabbi Julien Weill, later to become the Chief Rabbi of Paris and a leading figure of the Jews of Paris during the Nazi era, officiated at the death of Henriette Mir before her burial at Montmartre in 1927. Finally, as to Henry, the family archivist who died several years later in 1932, a religious service which we must assume was conducted according to Protestant rite – remembering that he had admonished his children firmly to 'remain Christian always' – took place in his home, 33 boulevard de Courcelles, followed by interment in the family grave at Montmartre.[31]

While some in the family had been transported into this grave from other cemeteries, others were for various reasons transported out of it. Disinterment is not encouraged within Judaism, since a peaceful final resting place is greatly desired. But certain allowances may be made for reasons of family, and these may have been advanced here to justify several cases.

Thus did Eugène Mir arrange for his wife Henriette Pereire and infant son Jean, who died at the age of three years, to be re-interred in the cemetery of his home town of Castelnaudary. The estranged wife of Gustave's son Alfred Pereire, Maria Gomès, also appears to have been re-interred, in 1949 in Bayonne where she was born. More curious were the circumstances surrounding the exhumation in October 1942, when the deportation of Jews from Paris to Auschwitz was well underway, of Guido Uzielli, son-in-law of Jeanne Pereire and Edoardo Philipson, and his subsequent reburial in Florence. While the disinterment and transport to the city of his birth may not be so unusual, the times in which it took place are more difficult to explain given the logistical problems it would have presented.[32]

Detailing at length the funeral and burial arrangements entered into by members of the Pereire family shows us that even for several members of Herminie and Emile's family who had married non-Jews, and for Henriette, the sole member of Fanny and Isaac's family who had done so, some identification with the Jewish faith remained a powerful legacy. This was to be demonstrated either through a wish to have the Kaddish prayer recited by senior Jewish religious figures, or by burial in the family grave on the chemin Halévy, or, as in the case of Henriette briefly, both of these. Further, the only member of Fanny and Isaac's family who was not at some time buried at Montmartre was Jeanne, who had died in Florence and was buried in the Jewish cemetery there.

For all the members of the Pereire family, then, death was a defining moment in relation to their religious identification.

There are several lessons we may draw from these funerals. The first is the evident communication by the Pereire family with the highest level of Jewish community figures. Except for the funerals of Cécile Rhoné, Claire Thurneyssen, and Henry Pereire, every one we have noted engaged senior rabbis to officiate. Herminie was seen to her grave by the Chief Rabbi of France. So, too, were Emile, Fanny, Emile II, and Gustave. The Chief Rabbi of Paris also officiated at Emile's funeral. The Deputy Chief Rabbi of France, who was later elected to the senior role, recited Kaddish at Eugène's. Two other rabbis who officiated at Pereire funerals were later to become Chief Rabbi of Paris: Julien Weill for the funeral of Henriette, and David Haguenau for those of Fanny and Eugène. Finally, the rabbi who reportedly spoke so movingly at Isaac's funeral, rabbi Joseph Mayer, was then Director of the Séminaire Israélite de France (later the École Rabbinique de Paris), the training school for orthodox rabbis and in which Gustave had taken a particular interest. The Pereire family was thus well-known to and well-respected by the senior rabbinate of France.

While they were recognised as Jewish by Jewish religious, the second point to explore in the context of their religious identification concerns how Herminie and Fanny and their families were perceived by other elite Jews. One measure might be the attendance of members of the Jewish *grande bourgeoisie* at the funerals we have described. If the standing of witnesses to a marriage was a measure of the significance of the bridal couple and of their parents, as historians have pointed out, in the same vein we might consider the presence of Jews at events commemorating the deaths of coreligionnaires.[33] Such attendance was a particular indication of respect but in some cases may have provided witness to a family connection with the deceased.

In all cases, attendees at the Pereire funerals we have discussed included top-ranking Jewish business and political leaders and their wives. One need not provide a roll-call of all those listed in newspaper accounts, but the example of Fanny Pereire gives a sufficient indication of the family's standing within the elite French Jewish community. Those attending her *obsèques* at the hôtel Pereire included six members of the Rothschild family, Mme. Emile

Being Jewish 267

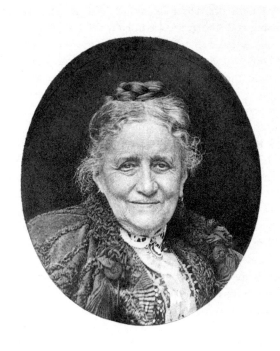

Figure 8.2 Fanny Pereire, 1905

Deutsch de la Meurthe, M. Henry Deutsch de la Meurthe, Mme. Adolphe Oppenheim, baron and baroness Eugène Fould-Springer, M. Georges Heine, M. and Mme. Théodore Reinach, the comte Moïse de Camondo, M. and Mme. Emile Halphen, M. Robert Cahen d'Anvers, M. and Mme. William d'Eichthal, M. and Mme. Paul Goldschmidt, baron Emmanuel Léonino, M. Arthur Weisweiller, M. Edgard Stern, Mme. Emile Javal, M. Henri Goudchaux, M. Gaston Calman-Levy, M. Léon Fould, M. Jules de Morpurgo, M. Albert Elissen, M. Alfred Bechman, and M. and Mme. Worms de Romilly. Not only were these members of the Jewish elite, many were associated also with organised French Jewry, notably with the Consistoire central Israélite and with Jewish welfare associations. They stood alongside non-Jewish luminaries: nobles from France and elsewhere in Europe, the Spanish ambassador to France, the Prefect of the Seine, the engineer Gustave Eiffel, the historian Gustave

Schlumberger, the politician Raymond Poincaré, the art dealer Paul Durand-Ruel, and André and Léon Falize of the jewellery establishment we encountered in a previous chapter.[34]

Indeed, only infrequently during their lifetime was the Pereires' attachment to the Jewish religion called into question. Marriage between those members of the family who married non-Jews sometimes provided the pretext. 'Agrippa' noted in an article, 'Les Conversions en France', that appeared in *Le Figaro* of 22 May 1896, at a time when the Dreyfus Affair was on the mind of the public and articles dwelling on the place of Jews in French society were common, that Henriette Mir had converted to Catholicism after her marriage to the deputy Eugène Mir. Although Henriette was certainly married in a Catholic church, this claim seems to be disputed by the evidence outlined above, namely, that Kaddish was said by a distinguished rabbi at Henriette's funeral and that she was interred initially in the family grave at Montmartre. Cécile, Claire, and Henry were also mentioned more accurately in this article as converts, the point of which being that 'the religious problem continues to torment consciences and sometimes leads them to this precise point where they are obliged to say with Michelet: "Tradition is my mother; liberty is mine"'.[35] At the same time, we may recall that when Emile II married Suzanne Chevalier, the papal nuncio in Paris took exception to it – a Catholic marrying a Jew in a Catholic church.

Some later historians have nevertheless drawn the conclusion erroneously that conversion was for the Pereire brothers a necessary stage in the process of assimilation and upward mobility. Pierre Birnbaum, in the context of his thesis on the emergence of state Jews from court Jews, speaks of 'the Pereires, Rodrigues, and Eicthal [*sic*] families [who] had extended their assimilation through conversion to both rationalism and Christianity'.[36] Again, in noting the pervasiveness of Catholicism among *conseillers généraux*, he names 'Pereire', Alphonse de Rothschild, and 'Fould' as having converted.[37]

The evidence laid out so far tells us that the relationship of the Pereire family to Judaism was more complex. Emile and Isaac's attachment to the Sephardic community of Bordeaux may not have resulted in their continuing to be religious, but the towering figure in their lives, their grandfather, kept them within the fold. His

importance to his coreligionnaires and to the nation, reinforced constantly by their mother, remained a potent inspiration in their own lives. Emile in particular retained an emotional connectedness with the Sephardi southwest throughout. And while Isaac did not carry this same affection, he came to regard the Jews as significant and benevolent players in nineteenth-century economies with whom late in life he was pleased to identify.

Which brings us to the less happy recognition of the Pereire family by anti-Jewish commentators and, later, by antisemites. As we have seen, from the moment of emancipation the fitness of the Jews for citizenship in the French nation had been contested. We noted that in 1806, Nanci Rodrigues had herself written a strong defence against an anti-Jewish diatribe published by Louis de Bonald in the *Mercure de France*. So, too, did Herminie's father, Rodrigues *fils* respond to that article.[38] The Rodrigues and Pereire families were not unused to attacks against themselves and the Jewish community.

The year 1846 was to see the start of a continuing campaign of openly anti-Jewish aggression, however, from the right as well as the political left, all seemingly brought on by the prominence of James de Rothschild. How did Herminie and Fanny respond to attacks against the family then? In Herminie's case, these attacks may have been muted but they were persistent. From the moment the Pereires became public figures as railway entrepreneurs, they became the targets of anti-Jewish pamphleteers, their association with James de Rothschild the spark that ignited the fire.

In July 1846 the Nord rail line from Paris to Brussels was opened, to great public interest. Scarcely a month later, a train was derailed *en route* at Fampoux in which fourteen people were killed, a figure disputed by anti-Jewish commentators as under-reported, and over forty injured. This accident sparked publication of a series of violent anti-Jewish attacks. In the same year as the Fampoux tragedy, Georges Mathieu-Dairnvaell wrote *Histoire édifiante et curieuse de Rotschild 1er, roi des juifs* in which he made a number of accusations about 'The incredible negligence of the 10th July [that] proves the abominable lack of foresight of the Jewish agents of the Jews Rothschild and Pereire. Let one not however weigh all the faults on the unfortunate employees, the guilty ones are the chiefs of the administration [namely, Rothschild and Pereire].'[39] Later, Pereire was named 'the accomplice' of Rothschild.[40] Dairnvaell's opus was

followed by the reissue of Alphonse Toussenel's two-volume *Les Juifs, rois de l'époque: histoire de la féodalité financière*. Toussenel's teacher, Charles Fourier, Pierre-Joseph Proudhon, and the Pereires' former Saint-Simonian colleague, Pierre Leroux, mounted further rabid attacks on the Jews of France.

While on the surface the July Monarchy and the Second Empire were periods of relative calm and acceptance of Jews and Jewish enterprise in its various forms, times when Jews began confidently to assume citizenship and even to gain election to the Corps législatif, these diatribes provided an undercurrent of anti-Jewish abuse.[41]

Herminie's defence against attack of any kind was, as we have seen, to draw the family closely together. The family home was its fortress. And even though its doors were thrown open to many and in a very public manner, it was within a very close circle of friends and family that Herminie took shelter. Had she survived to witness the Dreyfus Affair, her defences would have been sorely tested.

The anti-Jewish attacks that she and Fanny experienced were painful and personal nevertheless. Fanny was buffeted particularly by sustained attacks against Isaac coming from the Catholic Church when in 1863 he decided to contest the election to the Corps législatif for a seat in the Pyrénées-Orientales against the incumbent Justin Durand, a Catholic whose brother was a regent of the Banque de France.[42]

Isaac represented all that was anathema to Catholicism in the Pyrenees, uniting in his candidacy most of the elements bound to confront and threaten the local Church. He was a successful, highly visible business figure whose enterprises epitomised for a mostly rural department the growing industrialisation and urbanisation of France. A Saint-Simonian, he was politically and socially dangerous, perceived perhaps as capable of reinvigorating the republican vote in a conservative seat. The brother of one of the principal proponents of free trade in France, he shared his brother's views. He was also a brilliant and irritating critic of the Banque de France. But that he was a Jew, foreign to the Catholic Church in the Pyrénées-Orientales in every sense, crystallised all his other perceived flaws and offences.

The nature of the attack against Isaac Pereire disturbed the emerging consensus of organised Jewry in France which recognised a new and threatening element in the discourse. The Damascus

Affair of 1840 and the Mortara Affair in 1860 had led to a coalition of prominent French Jews founding the Alliance Israélite universelle, and while its purpose was to encourage Jewish solidarity internationally, its presence heightened the community's consciousness of anti-Jewish attacks within France.[43] The Alliance rose in defence of Isaac. Writers in the journal *l'Univers israélite* comprehended that this case in the Pyrénées-Orientales was not simply the crusade 'of an obscure fanatic against the Israélites', but evidence of a 'monstrous doctrine of exclusion, inciting hatred and contempt for a class of citizens, French Israélites'.[44] The attack on a Jewish public figure articulated a level of prejudice and was expressed with such violent invective it should not be ignored. The newspaper urged the Consistoire central Israélite to defend Jews against this attack before it spread uncontrollably like wildfire.[45] Thus did organised Jewry come to the aid of another Jew.

The attacks were now coming directly from the Catholic Church and those associated with clerical causes, including the local press. They resorted to base rumours, reminding the electorate of the Damascus Affair, in which a Jew had been accused of murdering a Capuchin friar and his Christian servant in Damascus and using their blood to make unleavened bread for the Passover. As a Jew, Pereire did not believe in the divinity of Jesus Christ, the virgin birth, or the Immaculate Conception. Voting for him had thus become a mortal sin. They urged him to seek a seat elsewhere, proposing the Lower Rhine in Alsace where twenty thousand Jews lived rather than the Pyrénées-Orientales, fortunate to be a country of the Inquisition where 'in fact we no longer count a single Jew'.[46]

Durand having decided not to contest the election, Isaac Pereire won 28,494 votes, nearly 100 per cent of those cast, although abstention was high at just under 40 per cent. As was customary with all election results at that time, however, this one required ratification by the Corps législatif itself.[47] Durand and his supporters prepared letters of protest which gained sixteen hundred signatures, claiming that Pereire had won the election through fraudulent means: 'seduction, intimidation, and corruption'.[48]

The election result was struck out and a fresh ballot called, at which point Justin Durand resolved that he would stand despite the government again failing to endorse either man as the official candidate. But the second election in December 1863 saw Isaac Pereire

returned with over 21,000 votes, 58 per cent of the total cast, to Durand's 14,869.[49] In January 1864, Pereire finally took his place among the deputies in the Corps législatif, together with his brother and his son Eugène, who had stood for different electorates (Emile in the Gironde and Eugène in Tarn).

For Fanny, this was clearly a very painful episode. But it was to be repeated six years later when Isaac stood for a different seat, in the Aude department. His opponent Léonce de Guiraud raised the collapse of the Crédit mobilier as a reason not to vote for Isaac. 'The crédit mobilier is the trunk of a tree carrying branches that have only produced poisoned fruit.'[50] Again, the Catholic Church too stood firmly against his candidature, the Vicar General of Montauriol writing to all of the *curés* in the electorate: 'Do not doubt the profound repulsion of your clergy for the candidature of the Jew of which the election would be shameful for the arrondissement of Limoux.'[51] Certainly, there were others who defended Isaac against these attacks just as the Alliance Israélite universelle had done in 1863, but ultimately the result was the same, and Isaac was prevented from taking his seat. This time there was no happy ending, and he lost the re-election.

Fanny's experience of Isaac's long-drawn-out struggles for election prepared her well for what was to follow. While electoral circumstances in France's southeast might be seen as specific to that region, in the next decade the Third Republic saw a gathering of forces that led to outright and widespread antisemitism. With Isaac's death in 1880, she was to face these trials alone. A combination of right-wing Catholic antipathy to Jews as the murderers of Christ coalesced with what had been a long-standing left-wing paranoia about the power of Jewish bankers and financiers.[52] Together these strands of anti-Jewish sentiment were to produce a toxic, widely publicised theory of the Jew as belonging to a race inferior to the Aryan, one whose power was at once stealthy and increasingly malevolent. In 1881 the first openly antisemitic journal appeared, entitled explicitly *L'Anti-Juifs*, to be followed in 1883 by *L'Antisémitique* (1883–84). Others quickly emerged, including the successor to *L'Anti-sémitique*, *Le péril social*.[53]

One of the ironies in this instance was the presence in the inner circle of Isaac Pereire's newspaper, *La Liberté*, of the man who was to become the embodiment of antisemitism. Édouard Drumont was

employed as a journalist there from 1874 until December 1885, during which period the journal's policy was unequivocally opposed to antisemitism.[54] And indeed, Drumont was to write a moving tribute on the death of Emile Pereire in 1875.[55] But while working for *La Liberté* for more than a decade, he was also working steadily and, one might say, stealthily, on the avowedly antisemitic work *La France juive*. With the support of Alphonse Daudet, he published the book four months after he quit *La Liberté*. It was an immediate best-seller.[56]

La France juive brought a new impetus to antisemitism, directing slander and calumny not only towards the Jewish community as a whole but against almost every prominent Jew, and members of the Rothschild family in particular. Antisemitic violence against the Parisian Jewish elite came to a head in May 1892 when, at the Great Synagogue in the rue de la Victoire, Juliette, the daughter of Gustave de Rothschild, married the baron Emmanuel Léonino to an accompaniment of screamed abuse and physical attack on the bridal party. The young couple was well-known to Fanny Pereire.

But *La France juive* strangely is at once equivocal, at times almost deferential, towards Isaac Pereire. Drumont described his former, now deceased proprietor as, for example: 'a man of great merit ["haute valeur"]. With the handsome head of a patriarch, his manners at once supple and dignified, he had the look of a descendant of David.' But, he went on, 'only his hands, rapacious and claw-like, betrayed his race'.[57] Drumont recalled in another work, *La France Juive devant l'opinion*, that he had no regrets in working for Isaac and his son, Gustave: 'I was the intellectual employee of the Pereires', since 'the expression of my opinions was in accord with the line adopted by the board'. Again, 'I found in the Pereires men [who were] perfectly polite.'[58]

Nevertheless, he affirmed that he held no affection for Isaac, claiming that Isaac had been mean towards his journalists, taking advantage of them and stingy in rewarding them. Isaac Pereire 'never thought to do anything for those who worked for him'.[59] In view of the Pereires' well-known and, for the time, advanced work practices towards employees, this charge is at least questionable.[60] But Drumont never allowed the truth to stand in the way of an opportunity to attack the Jews.[61]

A further irony of this connection between Drumont and the Pereires was to be played out in 1941 with France under the heel

of the Nazis and the Vichy Government a totally compliant junior partner. On 16 December, Captain Paul Sézille, Secretaire-Général of the Institut d'études des questions Juives, wrote to his Commissaire-Général, Xavier Vallat, with a proposition. Since all traces of Jewish names were to be expunged from the streets of Paris, Sézille zealously urged Vallat to consider replacing the name of the boulevard Pereire (of which there is a branch to the north and another to the south) with boulevard Drumont![62] There was considerable support for this coming notably from the antisemitic press of the day but, for whatever reason, the change did not occur. Nor were the names of other significant Pereire landmarks, the Pereire metro and the place Pereire, effaced from the Parisian streetscape.[63]

Following Isaac's death, Fanny thus continued to suffer increasing attacks on her family. But it was the wrongful accusation of treason against a Jewish army officer, Captain Alfred Dreyfus in 1894, one that came to involve the complicity of the high command of the French army, that provided clearer focus for the assaults. With the advent of the Dreyfus Affair, Fanny was to witness increasingly virulent and specific attacks very close to home, targeted against her stepson, Eugène, and her son, Gustave. Eugène and Gustave were of course fully aware of the attacks on Isaac during the elections of 1863 and 1869. They had experience of antisemitism and the animus of the Catholic Church and would appear from the beginning to have understood that these were at the core of the attack on Captain Alfred Dreyfus.

A constant theme of the press, which from 1892 included Drumont's own aggressively antisemitic newspaper, *La Libre parole*, together with the staunchly Catholic *La Croix*, was the insidiousness of the Jew's insertion into France's *grande bourgeoisie*. Fanny's step-son Eugène Pereire, as a prominent business person, banker, and financier – president of the Compagnie générale transatlantique, founder and president of the Banque transatlantique, president of the Banque Tunisie – became an easy target.

The family archive is almost completely silent about this period, however. While we know that the Pereires were subjected to verbal assault because the antisemitic press told us so, the effects on the family are contained in a single mention much later. That was from Fanny's grandson, Alfred Pereire, who spoke of his father Gustave having been forced to give up ['ayant cédé'] *La Liberté* 'at the time

of the Dreyfus Affair'.[64] It appears that this occurred in 1898 with an episode that we shall come to. But since Gustave Pereire had inherited the newspaper from his own father, 'ceding' *La Liberté* could not have been easy either for him or for Fanny who, we may recall, was much more than the wife of the proprietor; she had also worked with Isaac on the paper and thus had a personal as well as an emotional stake in it.

The reason for this paucity of reference to the Dreyfus Affair among family papers may well return us to Henry, the family archivist and converted Christian, not wishing to retain painful reminders of a difficult time. It is inconceivable that Henry escaped the invective himself for, ironically, the anti-Dreyfusard historian and numismatist Gustave Schlumberger, who famously fell out with the prominent Jewish *salonnière* and Dreyfusard, Geneviève Straus, the niece of Nanci Rodrigues, was later to reflect that some of his best friends had been Jews, including Henry Pereire. As he recalled in his memoirs:

> I was never, before the Affair, an antisemite at all, and two of my most intimate friends, Henri [sic] Pereire and Salomon Reinach were of the Israelite race. I had never doubted an instant up until then that all Israelites were not as passionately French as all the Catholics or all the protestants.[65]

Schlumberger's stance was somewhat ambiguous, the more so since he attended Fanny's funeral in 1910 when he paid his respects. Whether or not he later regained a sense of proportion in the debate sufficient to change his mind is far from clear.

The Pereires owned two publications active during the Affair – *La Liberté* by Gustave Pereire until 1898 and *La Lanterne* of which his half-brother Eugène became proprietor in 1896. What were their policies in relation to it? How did they respond to antisemitic attacks? What might they tell us of the Pereire family's attitude?

In the early days of the Affair, *La Liberté's* reportage was ambivalent. The newspaper accepted that a crime of high treason appeared to have been committed but stressed the frequency with which Dreyfus declared his innocence. Following the trial that found Dreyfus guilty and forced him to endure a ceremony of 'degradation', stripped of every sign of rank, his sword broken, *La Liberté* described the accused man as walking with assurance, crying: 'I am

innocent, vive la France!', and 'One doesn't insult an innocent man. Vive la France!' A subsequent three-hour meeting with his wife the newspaper reported as 'most heart-breaking'.[66] While not at that stage attempting a defence of Dreyfus, then, *La Liberté* was clearly framing Dreyfus' innocence as a possibility and pleading for some balance in public opinion.

The end of the Pereire family's ownership of *La Liberté* was more tragic than Alfred Pereire had been willing to concede, however. Indeed, the pressures over time had become so intense that the newspaper's director, Jules Frank, who was Jewish, committed suicide in August 1898. Before he took his own life he was reported to have left a letter for Gustave, although the contents remain unknown. The antisemitic press suggested that Frank had money troubles, even that he had embezzled from his employer.[67] *La Croix*, however, proposed more accurately that 'The Dreyfus Affair, in which he had taken the side of the revision [the successful re-opening of Dreyfus' trial of 1894] had greatly over-excited him.' On 27 November, *La Liberté* announced that the journal had changed hands 'definitively'.[68] Thus having relinquished the publication, Gustave Pereire devoted his efforts towards another, bringing together in eight volumes the collected works of Emile and Isaac Pereire. In perhaps the most significant of these *Écrits*, Gustave presented to the public all the documents concerning his father Isaac's experience of the 1863 and 1869 elections and, in particular, the anti-Jewish nature of the attacks made on him. They appeared in 1902. It is difficult to avoid the conclusion that Gustave was responding to the antisemitic circumstances of the Affair, and even that Fanny had encouraged his action.[69]

The other Pereire paper, *La Lanterne*, at the outset and before Eugène Pereire assumed ownership reacted like many Jewish organisations, believing that Dreyfus the French soldier was a traitor and should be punished. The paper even called for the death penalty. Historians have described *La Lanterne* nevertheless as 'the more moderate left-wing' during the period. Eugène took over, however, at the time of the 'revision', and articles became increasingly critical of the army and Catholic Church in the role it had played.[70] He now employed several socialists who were convinced of Dreyfus' innocence: Alexander Millerand, Aristide Briand, and René Viviani, all of whom were to become political leaders of the Third Republic.

Drumont did not allow Eugène Pereire's entry into press ownership to pass without a broadside:

> The truly guilty one [in the Dreyfus Affair] is the Jew Pereire who, proprietor of La Lanterne, has demanded that it become a dreyfusard organ ... La Lanterne will be able to write every day that the army officers are forgers, Eugène Pereire will continue to be admirably received in all the salons by the parents, the mothers, the wives, the sisters of these officers that one outrages every day.[71]

Eugène hit back at the Catholic Church. The lead story on page one of *La Lanterne* of 22 August 1899, written by the journalist Maurice Allard, who later became editor of Jean Jaurès' *L'Humanité* and a significant anti-clerical politician, attacked General Mercier and the former ministre de la Guerre, Godefroy Cavaignac (son of the politician and General Louis-Eugène Cavaignac) as having no evidence of Dreyfus's guilt and not wishing to find any. The influence of the religious orders was even more sinister, Allard describing them as 'the centre of putrefaction that poisons the country. ... The main thing is to purge them from the soil of the Republic.'[72]

Thus it seems that at various stages of the Dreyfus Affair, members of the Pereire family through their newspapers attempted to present an alternative case in support of the wronged Captain. Their efforts mirror the course of the trials that he experienced. Gustave, through *La Liberté*, seemed to believe in Dreyfus' innocence at the outset and certainly gave some prominence to his protestations of innocence; Eugène, in *La Lanterne*, went much further at a time when the evidence was emerging inexorably in Dreyfus's favour. And in the face of the antisemitism that was at the heart of the case, Eugène was prepared to attack the entrenched interests of the Catholic Church.

None of this confirms what Fanny Pereire felt about the antisemitism that raged, nor even whether she believed in Alfred Dreyfus' innocence. But her personal exposure to Isaac's unhappy experiences in 1863 and again in 1869 had a significant influence on her opinions, which attacks focused on members of her own family throughout the Affair could only have exacerbated. She was far from immune to the situation as it unfolded. Given that both her son and her stepson supported the wronged Captain, and that they not only believed in his innocence but also saw that antisemitism

was at the core of the Affair, this gives a powerful indication that she too was the more likely to have been a Dreyfusard.

In any case, Jewish women did not escape the onslaught of antisemitism, which verged on the prurient. The anthropologist Ivan Kalmar has referred to tropes common in nineteenth-century discourse, the odalisque and the harem, both of which were related to the figure of the Jewish woman. He drew particular attention to Ingres' *Odalisque with Slave* of 1839 as the embodiment of the Jewish woman of male fantasy.[73] Édouard Drumont was to draw an even closer relation between a fantasised oriental past and contemporary Jewish women whom he described as 'lascivious, futile'. He went on: 'the [Jewish] women of the wealthy class [who] lives à l'orientale, even in Paris, has a siesta in the afternoon, keeps I do not know what closed and drowsy ["somnolent"]'.[74]

How Jewish women responded to this diatribe is difficult to imagine. Parisian society had been quickly and bitterly divided between Dreyfusards and anti-Dreyfusards, the two camps including women as well as men. Geneviève Straus, who took up the cause of Captain Alfred Dreyfus through her salon, was to suffer socially for her passionate defence of him.[75] Other Jewish *salonnières* of the period suffered similarly, Léontine Arman de Caillavet among them. Opinion among non-Jewish women varied. Sibylle de Mirabeau, comtesse de Martel de Janville, wrote violently antisemitic books and newspaper columns throughout under the pen name Gyp. Marguerite Durand's feminist journal, *La Fronde*, founded in 1897 and supported financially by Gustave de Rothschild, was pro-Dreyfus but having invited Gyp to contribute Durand was finally forced to sever any ties with her: Gyp had insisted on maintaining the freedom to express her antisemitic views in the pages of *La Fronde*.[76] On the other hand, letters written to Emile Zola by women, which increased in number as the Affair unfolded, also tell us that many responded with some outrage to the injustice of the case.[77]

While individual Jewish men were at the heart of Dreyfus' support – notably Bernard Lazare, Joseph Reinach, and Captain Dreyfus's brother, Mathieu – and despite the presence of Jewish *salonnières* among them, many elite families were less convinced of the Captain's innocence. Cyril Grange writes of the 'passivity of families in the Jewish *grande bourgeoisie*', that they took no action publicly in his defence.[78] While most ultimately came to believe

in Dreyfus's innocence, this consensus evolved over the course of events. Organised Jewry also attempted initially to remain above the affray, the Consistoire central Israélite of which Fanny's stepson Eugène was then a member taking some time to formally acknowledge that antisemitism was at the core of the Affair. But the journals *l'Univers israélite* and *Archives israélites* were under no illusions and recognised its nature early, believing nevertheless, and naively, that Jews were protected from the worst of this form of attack by the 'principles of 1789'.[79]

In the previous chapter we noted that through her philanthropy Fanny continued her husband's mission to revive the good name of the Pereires following the collapse of the Crédit mobilier and the enforced resignation by his brother and himself from many of their companies. Indeed, it was during the entire period from the publication of Drumont's book to the conclusion of the Dreyfus Affair that Fanny's philanthropy came to the fore. She continued her work stoically in the face of increasing violence. From 1884, when she initiated the Fondation Isaac-Pereire, the free medical clinic went from strength to strength. Late in the year that saw the publication of *La France juive*, she inaugurated the second. In these initiatives she was successful. The number of patients treated by her clinics grew exponentially throughout: a quarter of a million by 1897, double that by the year following her death. Favourable reception by the public as we know was matched by the press, including by popular journals *Le Figaro*, *Le Petit journal*, *Le Temps*, *Le Petit parisien*. Thus, any association with the Jewish ownership of the Hôpitals Isaac-Pereire seems not to have been problematic, and this at a time when their Jewish ownership could scarcely have been more visible to the public.

What then, by the end of their lives, did being Jewish mean for Herminie and her daughter Fanny Pereire? We recall that Herminie was born into a Sephardic family that had already ceased to observe religious practices. Fanny's upbringing was a little different at the beginning but she too essentially was raised in a non-practising Jewish household. Nevertheless, the social and cultural ties of both women resided firmly within the Jewish community throughout.

Herminie attached significance to her Sephardic past without seeing the need to assume a more active stance in relation to it. While her primary social circle revolved around her sisters,

Sophronie, Anaïs, Félicie, Mélanie, and Amélie, constant reminders of a Sephardic legacy even if it was not rooted in the Judaism of Bordeaux, that all her children with the exception of Fanny married out is a strong indication of the flexibility of her ties. Three of these four children appear to have become practising Christians. Fanny on the other hand seemed progressively to have become the more engaged with Judaism and to have claimed the more overtly her Jewish heritage. Two of her three children and her stepson married Jews and were to remain faithful to a religion in which for all practical purposes they had received scant instruction.

Finally, it is arguable that the anti-Jewish invective heaped on Fanny's husband by the Catholic Church in 1863 and again in 1869 induced a reaction and a closer reconciliation with Judaism; that is, in her later life she wore proudly and publicly being Jewish as a defence against the antisemitism that had been heaped on the Pereire family. Her son Gustave's publication of the documents concerning Isaac's tribulations might confirm this. Herminie's response was forged in gentler times.

Notes

1 'L'Hôpital de Tournan', *Le Figaro*, 6 November 1886. This article was written on the opening of the hospital at Levallois-Perret.
2 *En souvenir de Madame Isaac Pereire*, M. D. CCCC. X, 'discours prononcé par Monsieur Alfred Lévy Grand Rabbin de France à la mémoire de Mme Isaac Pereire le 5 Juin 1910', 9.
3 James McAuley in *The House of Fragile Things*, 26–7, quotes from *Discours prononcés aux obsèques de M. le Comte Cahen (d'Anvers)* (Paris, 1881), 11.
4 McCauley, *The House of Fragile Things*, 27.
5 Julie Kalman has pointed out to me in a personal communication the similarities between the two speeches and the proverb Eshet Chayil, 'A Woman of Valour', *Proverbs* 31:10. More than likely this proverb served as a model for discourse at the funerals of bourgeois Jewish women.
6 Michel Roblin, *Les Juifs de Paris: Démographie – Économie – Culture* (Paris, 1952), 51, 64–7.
7 Several historians make this point, among them: Phyllis Cohen Albert, 'Ethnicity and Jewish Solidarity in Nineteenth-Century France', in

Jehuda Reinhardt and Daniel Schwetsinski (eds), *Mystics, Philosophers and Politicians: Essays in Jewish Intellectual History in Honor of Alexander Altmann* (Durham, NC, 1982), 249–74; Hyman, *Jews of Modern France*, chap. 4; Benbassa, *Jews of France*, 124–5; Grange, *Une élite parisienne*, 315–18.

8 Thomas A. Kselman, *Death and the Afterlife in Modern France* (Princeton, NJ, 1993).
9 Léon, *Histoire des Juifs de Bayonne*, 93–222.
10 Gérard Nahon, *Métropoles et Périphéries: Séfarades d'Occident* (Paris, 1993), 265–7.
11 La Rochelle, *Jacob Rodrigues Pereire*, 445–54, and 458, fn.1.
12 Dominique Jarrassé, *Guide du patrimoine juif parisien* (Paris, 2003), 143; Léon, *Histoire des Juifs de Bayonne*, 204; AFP, Numa Lameyra, 'Maison de la Prophète', Toulouse, to Emile Pereire, Paris, 20 May 1873; 'Mémoire à consulter et consultation: pour les citoyens Français professant le culte judaïque à Bordeaux, connus sous nom de Juifs Portugais et Avignonnais', 8/1868 (Bordeaux, 1799).
13 Kselman, *Death and the Afterlife*, 170–2. Here Kselman draws our attention to the history of these cemeteries and the reasons for their establishment. All had been outside the Paris city walls but were integrated in 1860 with the annexation of the *banlieue parisienne*.
14 AFP, Emile Pereire, Paris, to Auguste Thurneyssen, Paris, 20 July 1853.
15 Recalling that Isaac Pereire had died just before the scheduled marriage of Jeanne Pereire with Edoardo Philipson, which was thus delayed. This marriage was eventually celebrated in the Great Synagogue, rue de la Victoire, Paris.
16 AFP, Emile Pereire, Paris, to the President of the Bordeaux Consistoire, Bordeaux, 11 August 1874.
17 Ibid., 'Correspondance avec le Consistoire Israélite'. A file of letters between Emile Pereire and senior figures in the Jewish community.
18 Grange, *Une élite parisienne*, 31.
19 *La Liberté*, 27 January 1874, and *Le Gaulois*, 28 January 1874.
20 Abraham (Vita) de Cologna was the only nineteenth-century Sephardic Chief Rabbi of France. Born in Mantua, he was the rabbi of that city but following Napoleon I's Grand Sanhedrin was elected its vice-president. From 1812 to 1826 he was President of France's Central Consistory and was therefore considered Chief Rabbi of France.
21 This is recorded on the gravestone.
22 Kselman, *Death and the Afterlife*, 205.
23 *Le Figaro*, 9 January 1875.
24 My understanding of the history of the Pereire tomb is based on a detailed document in the AFP, hand-written at various times,

'Emplacement de la Sépulture'. The document appears to have emanated from the cemetery of Montmartre rather than from the Pereire family as it is detailed by date of burial, name of deceased, payment of funeral tax, placement of the coffin in the tomb, and former burial place when relevant.
25 *Le Figaro*, 9 January 1875.
26 Jarrassé, *Guide du patrimoine juif*, 149.
27 *Le Figaro*, 16 July 1880.
28 Ibid., 24 March 1908.
29 *La Liberté*, 13 February 1885. Although the newspaper reported that Cécile Rhoné had been buried in the 'caveau de famille', this was not in the Pereire family grave.
30 *Le Temps*, 30 September 1887.
31 *Le Temps*, 26 August 1932.
32 See note 24.
33 Cyril Grange, 'The Choice of Matrimonial Witnesses', *The History of the Family*, vol. 10, no. 1, 2005, 38.
34 *Le Figaro*, 6 June 1910.
35 'Agrippa', 'Les conversions en France', *Le Figaro*, 22 May 1896.
36 Pierre Birnbaum, 'Between Social and Political Assimilation: Remarks on the History of the Jews in France', in Pierre Birnbaum and Ira Katznelson (eds), trans. Jacqueline Kay, *Paths of Emancipation: Jews, States, and Citizenship* (Princeton, NJ, 1995), 103.
37 Ibid., 106.
38 See Chapter 1.
39 Georges-Marie Mathieu Dairnvaell, *Histoire édifiante et curieuse de Rothschild 1er, roi des juifs, par Satan* (Paris, 1846), 31.
40 Ibid., 35.
41 Julie Kalman in *Rethinking Antisemitism* deals with the anti-Jewish writers of the mid-nineteenth century. See especially chap. 5.
42 I have written of Isaac Pereire's election to the Corps législatif in Helen M. Davies, 'Séduction, intimidation, corruption, et antisémitisme: l'élection de 1863 dans les Pyrénées-Orientales', *Domitia* [Perpignan], vol. 12, 2011, 183–95.
43 Lisa Moses Leff, *Sacred Bonds of Solidarity*, especially chap. 5.
44 *L'Univers israélite*, no. 5, January 1864, p. 194, and no. 6, February 1864, 242.
45 Ibid., no. 5, January 1864, 195. It is not clear that the Consistoire took any notice.
46 Pereire, 'Députation: (Deuxième Partie)', in Emile and Isaac Pereire, *Écrits*, vol. III, fascicule 1, 409.
47 Davies, 'Séduction, intimidation, corruption, et antisémitisme', 183.

48 Pereire, 'Corps législatif: Séance du 24 novembre 1863', in *Écrits*, vol. III, fascicule 1, 435–58.
49 Ibid., 'Députation: Élection de M. Isaac Pereire … (Troisième Partie)', in Emile et Isaac Pereire, *Écrits*, vol. III, fascicule 1, 460. There were 47,410 electors, of whom 36,308 voted. Durand benefited from about seven thousand votes previously not cast and eight thousand originally cast for Isaac Pereire. For detailed results of the first ballot see Archives départementales des Pyrénées-Orientales (hereafter ADPO), 'Élection d'un député, élection du 31 mai et 1er juin' ; and for the report of the second, ADPO *Élection d'un député au Corps législatif, Procès-Verbal du Recensement général des votes, émis dans la circonscription électorale du département des Pyrénées-Orientales* [December 1863] (Paris, 1863).
50 AFP, pamphlet by Léonce de Guiraud, 'Aux lecteurs de la Troisième Circonscription de l'Aude' (Toulouse, 1869).
51 AFP, copy of letter from Rigal, Vicaire Général Montauriol, to Monsieur le Curé, Limoux, 14 May 1869. Rigal noted at the foot of the letter: 'This letter is addressed at the same time to all the senior curés of the 3rd district of the Aude.'
52 Benbassa, *Jews of France*, 137.
53 Grégoire Kauffmann, *Édouard Drumont* (Paris, 2008), 79–80.
54 Ibid., p. 69. Kauffmann noted that *La Liberté* was vigorously against all forms of antisemitism, citing a first page article of 24 September 1882 in which the journal roundly condemned an international anti-Jewish congress to be held in Dresden.
55 *La Liberté*, 9 January 1875.
56 Kauffmann, *Édouard Drumont*, 9–10.
57 Édouard Drumont, *La France Juive* (Paris, 1912), vol. I, 354.
58 Édouard Drumont, *La France Juive devant l'opinion* (Paris, 1886), 176–7.
59 Ibid., 179.
60 I cover the employment practices followed in the Pereire companies in *Emile and Isaac Pereire*, 155–6. Remuneration was relatively high but they also included profit-sharing, shares and bonuses, long-service leave, sick leave and salary maintenance during illness, superannuation, and company shops with discounted goods. In some cases, these provisions were also available to wives and families, as well as free education for children. Drumont's accusation about Isaac Pereire does not sit well with what we know of these practices.
61 In his biography of Drumont, Kauffmann draws a strange conclusion from a passage that Drumont wrote in an article for the satirical journal *Le Pilori* of 12 December 1886. In 'Comment j'ai fait la France

juive', Drumont wrote of a newspaper proprietor: 'he has never opened a book, he is a stranger to all culture, to all letters: they [his journalists] have devoured thousands of books, accumulated innumerable intellectual documents. He is their master, however, they are his slaves'. Kauffmann claims that the subject of this vilification was Isaac Pereire, although Drumont did not make that accusation directly. If it is true, however, it is at odds with Isaac's well-known and vast erudition. That this could not have been written of Isaac Pereire seems to be confirmed when we look to the beginning of the passage which Kauffmann omitted and that specifically said: 'He is the son of German Jews and still jabbers in Yiddish.'

62 Mémorial de la Shoah Documentation Centre, Côte: xif-34a, CDJC, letter Paul Sézille, to Xavier Vallat, 16 December 1941.
63 Kyra E. T. Schulman refers to this episode in her paper 'The Dreyfus Affair in Vichy France: An Afterlife', 75, published online through *Undergraduate Humanities Forum 2017–2018, Afterlives*. repository.upenn.edu/cgi?article=1003&context=uhf_2018, downloaded 18 April 2022. Place Pereire had a name change in 1973 to become place du Maréchal-Juin; the RER station 'Pereire-Levallois' was so named in 1988 having been formerly the 'gare Courcelles-Levallois'.
64 Alfred Pereire, *Je suis dilettante*, 39.
65 Gustave Schlumberger, *Mes Souvenirs 1844–1928* (Paris, 1934), vol. 1, 308.
66 See particularly *La Liberté*, 5 and 6 January 1895.
67 *La Liberté*, 12 August 1898, refuted these suggestions but did not propose any other reason for the suicide.
68 Ibid., notice re Jules Frank's suicide 11 August 1898; his funeral conducted by Rabbi Seligmann Lowy at Montparnasse cemetery on 12 August 1898; and the announcement of the final takeover of the newspaper on 27 November 1898.
69 The *Écrits de Emile et Isaac Pereire* were edited personally by Gustave Pereire in eight volumes, further divided into discrete sections, or *fascicules*. The section dealing with Isaac Pereire's election experiences was in volume III, *premier fascicule* (1902). Gustave later appointed the former *La Liberté* writer, Laurent de Villedeuil, to edit a more extensive collection. These were published as the *Oeuvres de Emile et Isaac Pereire*, divided into ten volumes and were to have been further sub-divided into twenty-eight *fascicules*. There are only six volumes of the *Oeuvres* in the Bibliothèque nationale de France and in the family archive. Whether any other volumes saw the light of day is unclear, although an original advertisement suggested that one volume, 'Série A – Vie et travaux

d'Emile et Isaac Pereire – Leçons et Doctrines' which I have been unable to locate, had already appeared.
70 William I. Brustein and Louisa Roberts, *The Socialism of Fools: Leftist Origins of Modern Anti-Semitism*, online by Cambridge University Press. https://doi.org/10.1017/CBO9781139046848.003
71 Drumont was writing in his own newspaper *La Parole libre* but quoted in *La Croix*, 27 September, 1898.
72 *La Lanterne*, 22 August 1899.
73 Ivan Kalmar, 'The Jew and the Odalisque: Two Tropes Lost on the Way from Classic Orientalism to Islamophobia', *ReOrient*, vol. 4, no. 2, 2019. Ironically, a fine, detailed drawing of this work, possibly by Ingres himself, entered the private gallery of Gustave Pereire in 1911. The drawing now belongs to the Fogg Museum, Harvard University. Harvardartmuseums.org/art/299806, downloaded 15 April 2022.
74 Drumont, *La France juive*, vol. 1, 104, 106.
75 Joyce Block Lazarus, *Geneviève Straus: A Parisian Life* (Leiden, 2017), chap. 5.
76 Willa K. Silverman, *The Notorious Life of Gyp: Right-Wing Anarchist in Fin-de-Siècle France* (New York, 1995) esp. 127–8.
77 Jeanne Humphries, 'The Dreyfus Affair: A Woman's Affair', *Historical Reflections/Réflexions Historiques*, vol. 31, no. 3, Fall 2005, 433–43.
78 Grange, *Une élite parisienne*, 438.
79 Kauffmann, *Édouard Drumont*, 80.

Conclusion

Thursday 9 October 1890 was a clear, cool, autumn day in north-central France, an average temperature of 13°F. On that day, Clément Ader, an engineer and inventor, achieved an extraordinary feat. He had created a lightweight (300 kg) flying machine powered by a steam engine of his own design. It was shaped rather like a bat. He had called the machine Éole after Aeolus, the Greek god of wind. Needing a place to test his invention, Ader found a willing sponsor. While the Éole rose a mere twenty centimetres in the air, it flew for fifty metres: the first unaided flight above ground in history. The use of the technology that powered the machine was not to be the wave of the future, but it remained a major event in the history of flight, preceding that of Wilbur and Orville Wright at Kitty Hawk by a decade.[1]

The test flight took off from the Château Pereire, Armainvilliers, and Fanny Pereire, who now owned the chateau, had given Ader unqualified support for him to make the run on a clear piece of ground attached to her domain.[2] There was some symmetry in this. While her father and husband were inspired by and played such a strong part in implementing the steam technology of the nineteenth century, creating major developments and possibilities in land and sea transport, it was appropriate although not unexpected that Fanny should play a role in the next stage, the conquering of the sky.

This book proposed that Herminie (1805–74) and Fanny Pereire (1825–1910) played essential but often unremarked roles in the lives and the ultimately spectacular businesses of their husbands,

respectively, Emile and Isaac Pereire. For Herminie and Fanny not only provided a family life that was at once supportive, calm, stable, and united, and contributed substantially to the public face their husbands enjoyed and that enabled the Pereire businesses to flourish – as was expected of women of their class – they played an often-unacknowledged role in those businesses.

Kinship was the bedrock of the Pereires' business success. If Emile and Isaac Pereire were the masterminds and geniuses behind each one of their enterprises, family was what provided the solid foundation on which it depended, supporting and propelling a financial and industrial empire. Pereire kinship was moulded and reinforced by shared living arrangements and mutual family obligation, an outcome of Sephardic practice, typical of Sephardic family life in Bordeaux and Bayonne from which the Pereire brothers had emerged.

As Emile and Isaac Pereire became increasingly powerful financially, industrially, and politically, it was demanded of Herminie in particular that she acquire skills and habits customary to the *grande bourgeoisie*, aptitudes for which her life to that date had not prepared her. Fanny on the other hand grew up accustomed to exhibiting such attributes, fitting comfortably into elite French society.

But the collapse of the Pereire business world towards the end of the Second Empire with the bankruptcy of the Crédit mobilier in 1867 and the end of the Empire itself with the decisive victory of Prussia over France in 1870–71 had a profound effect on the family, not least on Herminie. Her health declined rapidly and she died in January 1874. Emile's health, always precarious, could not sustain the tragedies of failure and grief. He died almost a year later in January 1875. Isaac valiantly dealt the family back into the game, though not quite to the extent that it had once been as a major player. On his death in 1880, Fanny was fifty-five years old and faced another thirty years alone, during which she navigated the radically different social and political landscape of the Third French Republic and a rising antisemitism, as well as the fracturing of family unity.

To distil some thoughts on the lives of Herminie and Fanny Pereire, we see at their simplest not so much a continuum as an evolution in female agency, independence, and action, from mother to daughter. Both played a role in presenting the Pereire family as a

significant actor in *le tout Paris*, albeit with different degrees of confidence. They each engaged in appropriate self-fashioning in support of their sociability. To varying degrees, they engaged in charitable pursuits. But it was the daughter who became the initiator, taking into the public domain ideas shaped in discussion with her husband.

The Saint-Simonianism of Herminie, her husband, and her brother-in-law, with its concern for the poorest and most numerous class, influenced the charity and philanthropy of my subjects. Both women gave generously to certain causes, to alleviate poverty and to provide assistance in community catastrophes. Herminie spent a considerable part of her time providing help to family members and to those close to home as well as supporting worthy charities. Fanny had inherited recognisable organisational talent and, as the century developed, took the opportunity to play a public role through her own philanthropic ventures.

Herminie's experience of the relatively acculturated Sephardic Rodrigues family with its intellectual interests, its association with the Berlin Haskalah, and its Saint-Simonian engagement, gave her a perspective that was at once removed from Judaism while remaining rooted in the culture of the Jewish community. The Rodrigues household gave her a certain independence but it also shaped her preoccupations, notably those revolving around the centrality of family and the implantation of family loyalty and devotion among its members. This was typical in the construction of gender, separate spheres, as historians of *bourgeoises* in nineteenth-century France have long proposed. It was also typical of the expected role for women promoted by figures in the Jewish community in the quest for acceptance post-emancipation. We have seen that the circle Herminie enjoyed most, though, was the one she herself had brought together: immediate family, extended family, friends of long duration. While recognised publicly as a *grande bourgeoise*, that was not the role in which she took most comfort.

One further element needing to be remarked is that Herminie and her husband and Fanny and hers were all French-born. They were among the first generations of emancipated Jews in Europe, members of a minority granted citizenship by an edict that promoted French universalism.

While Herminie grew up with a clear idea of what it was to be at once Jewish and French, nevertheless, she was hardly immune to

the anti-Jewish sentiments that began to circulate as her husband and Isaac were making their mark on the country that had accorded them citizenship. There is a hint of defiance possibly resulting from this in a letter to Henry written when both Emile and Isaac Pereire, together with Isaac's son, Eugène, stood successfully for election in 1863 as deputies to the Corps législatif. She wrote, 'I rejoice and take my part with pride in the welcome made in all the departments to the name of Pereire.'[3]

Herminie had adhered to established precepts in the upbringing of her first child. Fanny had received a sound education, at least for the time; she had been taught to care for others, starting with her own siblings, and to acquire feminine skills and graces. Nevertheless, she had been raised under different circumstances from her mother. She saw the world differently. There was increasing wealth from a comparatively early time and her father and her uncle were both becoming public figures in July Monarchy France. The whole family was in the public eye.

Fanny was no less devoted to the Rodrigues and Pereire families than her mother had been, confirmed by the Sarchi letters. But it was her marriage to her uncle that provided the solid springboard to the world outside. She began to engage fully, eventually forging a place for herself that was at once both public and representative of the family name. At the same time, she acknowledged her Jewish heritage in a public manner and in a way that Herminie only appeared to do at the very end of her life.

Although at its peak, Emile's fortune amounted to some two hundred million francs, in their last years the Pereire brothers had spent a major share of their considerable fortune fighting their way out of incessant lawsuits.[4] Even so, a reasonable part of that fortune remained. Aside from their private shareholdings in the companies that survived, the large swathes of real estate accumulated by the family trust gave them a buffer. Emile was to die leaving a fortune of sixteen million francs. Isaac achieved more after successfully fighting to regain control of the Compagnie générale transatlantique. His fortune at death amounted to just under thirty-three million francs.[5]

Isaac with great tenacity and guile had saved several of the Pereire businesses and, in so doing, helped restore the good name of the family. It was clear from the press coverage on his death in 1880

that the Pereires had, to some extent, recovered from the ignominy of financial collapse. But Fanny, through her philanthropic establishments, was equally the author of the family's renewed reputation, although at a time of mounting aggression against elite Jews.

The matriarchal role played by Herminie as we have seen it was not taken up by her daughter. The experience of Sephardic Bordeaux that had provided a template for the Pereire family's co-habitation in Paris as much as anything brought Herminie's role into clear focus, one with which she was completely attuned. Living together under one roof as the Pereires did, she was matriarch of the whole Pereire family, of Isaac's as well as Emile's. As to Fanny, complications caused by her marriage with Isaac confused relations with siblings, especially with her brothers Emile II and Henry. Financial decisions demanded by the deaths of Herminie and Emile following so closely together, in 1874 and 1875 respectively, also intervened. These decisions saw the departure from the hôtel Pereire of all Fanny's siblings, her sisters Cécile and Claire as well as her brothers with their families, necessarily bringing about rupture. While her influence outside her own family was now limited, Fanny did, however, engineer a closer relationship between family members with the re-organisation of the *dispensaires* she had established in Isaac's name. Perhaps this was another attempt to draw the extended family together, to re-establish unity among members of now very different religious persuasions and business interests.

What of the Pereire family after the deaths of Herminie and Fanny?

Historians frequently lament the difficulty in writing about Jews and the Jewish family of the *longue durée* while evading the lens of the twentieth century. Knowing what happened in the years leading up to and including the Second World War can shed a cloak of inevitability over the historical narrative.[6] This conundrum is the more powerful when members of nineteenth-century families had been vilified and mortified by the antisemitism that erupted at century's end. I have certainly encountered this paradox in writing the story of Herminie and Fanny Pereire. Nevertheless, the history of the Pereire family after these remarkable women had died is not entirely consistent with the story of other elite Jewish families.

Herminie's offspring as we know left the family mansion to establish nuclear families of their own. Eugène having pre-deceased

Fanny, Juliette Pereire, her daughters and their families continued to live at 45 rue du Faubourg Saint-Honoré, a stone's throw away from the hôtel Pereire, Juliette dying in 1913. But for the most part, the hôtel Pereire continued to be central to Fanny's children: Gustave and Amélie Pereire and their sons Jacques and Alfred; Henriette and Eugène Mir; Jeanne (until her death in 1899) and Edoardo Philipson and their children, Elisa, Marguerite, and Dino, all continued to call the hôtel Pereire their Paris home. The progeny of Gustave and Jeanne also remained firmly within the network of other elite European Jewish families, Dupont, Gomès, Uzielli, Wildenstein, and Lévi. Eugène's similarly married into the Halfon (Rumanian), Halphen, and Rothschild families.

Many Jewish men served France faithfully during the First World War, members of the Pereire family among them. Eugène Pereire's son-in-law, Captain Jules Halphen, was a highly decorated career army officer, squadron leader of artillery and created Officier de la Légion d'honneur.[7] Both of Gustave Pereire's sons, Jacques and Alfred, served in the French Army, Alfred after a distinguished service throughout and serving in the general headquarters of Marshall Pétain himself, Jacques serving as an interpreter and major. They also were inducted into the Légion d'honneur. Maurice Pereire, son of Emile II, was awarded Chevalier de la Légion d'honneur for service as captain and squadron leader.[8]

Elite Jewish women also played a role during the Great War similar to the one they had played during the Franco-Prussian War. They established hospitals. Just as the Pereire family turned over part of the hôtel Pereire to this purpose in 1870–71, so, too, did Eugene's daughter, Laurence Alice Pereire Halfon, turn 45 rue du Faubourg Saint-Honoré into Auxiliary Hospital no. 284. For this she received in 1921 the citation of Chevalier de la Légion d'honneur, which commended her as the hospital's founder and director, responsible for all its costs during the entirety of the war years and the year following the Armistice. Laurence Halfon also received the Médaille d'honneur des épidémies, an award granted to those who with great courage had been exposed to contamination from contagious diseases in caring for the sick – in her case from victims of the Spanish Flu epidemic in 1921.[9] In this humanitarian work, she combined the charity towards people afflicted so dear to Herminie with the public generosity of Fanny.

The fate of Jews in France thereafter and during the Second World War is a tragedy known only too well, however. In James McAuley's account of four elite families present in the lives of the Pereire family – Camondo, Reinach, Cahen d'Anvers, and Rothschild – all bequeathed to France great riches and exquisite works of art only to fall victim to the Nazis. *The House of Fragile Things* recounts their acquisition of beautiful objects and the motivation behind the collections, the wish to appropriate and to identify with French culture through precious French material objects. For the Rothschilds, for instance, 'the mastery and manipulation of material culture was something of a native language, a vocabulary of both self-expression and public presentation'.[10] All had sons who fought for France in the First World War and some made the ultimate sacrifice. The book goes on to recount the eventual outcome of this beneficence and sacrifice on the altar of the French nation: murder through the agency and with the assistance of Vichy France.

The Pereire story is different. From the time of Fanny's fervent appeal for prudence in disposing of the assets held in the family trust, its beneficiaries proceeded to divest themselves of a large part. They started with the parcels of Parisian real estate gathered so diligently by Emile and Isaac, culminating in 1937–38 with the sale of Fanny's collection of artworks, noted in Chapter 6. The sale of the Château Palmer to several Bordeaux interests, two of whom, the Sichel and Mähler-Besse families, continue to own the *vignoble*, occurred at this time also.[11] Armainvilliers became French national property, again in 1937.[12]

Certainly, Pereire descendants donated works of art to public art galleries but with not nearly the munificence of those families documented in McAuley's study.[13] Earlier, Isaac Pereire had presented a work by Luis Tristàn, *The Vision of Saint Francis of Assisi*, to the Louvre Museum, and Fanny seems to have engineered the purchase in 1908 by the Louvre of another, *Christ on the Cross adored by two donors* by El Greco that Isaac had originally presented to the Tribunal of Prades in the Pyrénées-Orientales department.[14] Into the twentieth century, Henry Pereire's son André donated a number of important works to the Louvre that had been bequeathed to him by his father, including by Brueghel, Canaletto, Fragonard, Guardi, Rembrandt, and Vernet.[15] In 1938, Alfred and Jacques Pereire presented Fanny's boudoir table by Christofle to the Musée des arts

décoratifs in Paris. Curiously, they made the presentation 'in memory of their grandparents, Émile and Isaac Pereire, and their parents, M. and Mme. Gustave Pereire', again without reference to Fanny, whose purchase at the Exposition universelle of 1867 it had been.[16]

None of this compares with the bequest to the Louvre by Isaac de Camondo, who upon his death in April 1911, left his entire collection of artworks and furniture requiring special installation in several rooms;[17] nor the presentation to the French nation by his brother Moïse of the meticulously reimagined Musée Nissim de Camondo with its immense collection of eighteenth-century furniture and works of art; nor the gift to the Louvre in 1935 made by Edmond de Rothschild (1845–1934), encompassing forty thousand prints and six thousand drawings.[18]

Fanny's grandson Jacques Pereire placed the family mansion, 35–37 rue du Faubourg Saint-Honoré, on the market in 1937, calling on the British Government to purchase the property. The location, adjacent to the home of the British Ambassador, l'hôtel Charost, was a clear selling point. But the price of £100,000 was considerably higher than the British Government was prepared to pay. Jacques Pereire rented the hôtel Pereire instead to the Vichy ministry of youth until the allied invasion in June 1944 when negotiations resumed with the incoming British Ambassador, Duff Cooper. At a price of £242,000, the sale finally went through in 1947, ten years after Jacques Pereire's initial foray into the market, when the hôtel Pereire became the Chancery of the British Embassy.[19]

The only casualty of the Second World War was the destruction of the Château Pereire at Armainvilliers, bombed mistakenly but with unerring accuracy by the US Air Force in 1944 in its attempt to create havoc with the Est rail line into Germany. This is now a golf course, Golf Clément Ader, situated in the Domaine Château Pereire.

The final divesting of Fanny's inheritance did not take place, however, until 5 June 2015, with an auction in Paris at Drouot-Richelieu of the 'Ancienne collection Pereire'.[20] It was here that the Musée de Compiègne purchased Cabanel's portrait of Fanny.

Several of the Pereire family descendants served in the armed services during the Second World War. Gustave's grandson Gérard fought in both the French and US armies and François in the French army with a period as liaison between Maréchal Alphonse Juin and

General Mark Clark in North Africa.[21] All mercifully survived the Nazi regime, though not entirely unscathed. Herminie's grandson André, the son of Henry, on 21 January 1944 was held briefly at Drancy, the suburb north of Paris that served as a transit centre for Jews before deportation to the Auschwitz-Birkenau or Sobibor concentration camps. He was 'liberated' three days later.[22] If the experience of his cousin and Fanny's grandson, Alfred Pereire, was typical, however, family members lived in great fear throughout, as documents written by Alfred and located in the Mémorial de la Shoah in Paris confirm.[23] Another of Fanny's grandsons, Alfred's cousin Dino Philipson, a committed anti-fascist, was held for several years in internal exile at various remote locations in Italy, including Eboli. On returning to Rome, he was for a short time under-secretary to Prime Minister Badoglio and after the War a member of the Italian government.[24]

So, the stories of Herminie and Fanny Pereire give us much more than a rounding-out of the history of a significant family in nineteenth-century Paris. They bring us into close, personal relations with broad and weighty themes that continued to resonate into the century that followed: the aftermath of the French Revolution, emancipation, the move from city to country, the rise of a powerful *grande bourgeoisie*, the playing out of Clermont-Tonnerre's demand confronting French and Jewish citizens alike with the challenge of universalism.

The lives of Herminie and Fanny thus touch on major shifts in the economic life of France, where innovation in industry and finance led to huge fortunes and extravagant lifestyles as well as urban poverty hitherto unknown. Social life moved from the rural to the urban. At the same time, French political life was like a revolving door when regime change became the norm, the legacy of the French Revolution tested and tested again. Nowhere were these shifts more influential than in the lives of Jews as they dealt with the opportunities and challenges presented by citizenship. And nowhere were these shifts more evident than in the lives of Jewish women.

The gathering coalescence of economic, political, and social forces in France demonstrated the fragility of the freedom achieved through the Revolution, when these two women were at once as threatened as they were powerful. But despite the vicissitudes

presented to them, over the long century and showing great resilience, confidence, resourcefulness, and courage, they forged their own path as French women of the Jewish faith.

Notes

1 René de Narbonne, 'Clément Ader pionnier méconnu', *L'Air: revue mensuelle: organe de la Ligue nationale populaire de l'aviation*, 1 January 1943, 2–3.
2 Charles Harvard Gibbs-Smith, 'Clément Ader. His flight claims and his place in history', *Aeronautical Engineers* (London, 1968), 214.
3 AFP, Herminie Pereire, Paris, to Henry Pereire, unknown address, 22 May 1863. We noted in Chapter 8 that Isaac was forced to a second election for his seat.
4 Stoskopf, *Banquiers et Financiers*, 281.
5 Ibid., 287.
6 Michael R. Marrus, for example, has said that 'History should not be read backwards, and the Jews should be understood like everyone else, in the light of their times.' See 'European Jewry and the Politics of Assimilation: Assessment and Reassessment', *Journal of Modern History*, vol. 49, no. 1, March 1977, 96.
7 AN, Base Léonore, L 1260051.
8 Ibid., c-202524, Jacques Rodrigues Pereire; c-202525, Alfred Rodrigues Pereire; c-148750 Maurice Pereire.
9 Ibid., L 1259026. Reference to the Médaille is to be found at Image 15 of the file. Further information concerning the medal may be found at the website: tracesofwar.com/awards/3152/Médaille-d'honneur-des-épidémies.htm, accessed 15 December 2023.
10 McAuley, *House of Fragile Things*, 164.
11 Château Palmer official site.
12 de Narbonne, 'Clément Ader', 2.
13 McAuley, *House of Fragile Things*, deals with these gifts throughout, but chap. 7 is devoted to Jewish donations to public museums.
14 Gary Tinterow and Geneviève Lacambre (eds), *Manet/Velazquez: The Taste for Spanish painting* (New York, 2003), 398; and Louvre Museum Official Website, 'Collections'.
15 Louvre Museum Official Website, 'Collections'.
16 From the Musée des arts décoratifs website, 'Boudoir table'.
17 McAuley, *The House of Fragile Things*, 188–91.
18 Contained in the Rothschildarchive.org/family/philanthropy/arts-culture-libraries, downloaded 9 June 2022. The Archive notes further that

the family has within the last century donated sixty thousand works of art to over one hundred and fifty public institutions.
19 'Paris 4: Residence 1940–2014', *Room for Diplomacy: Catalogue of British Embassy and Consulate Buildings, 1800–2010*. https://roomfordiplomacy.com/paris-4-offices 1898–2014, downloaded 9 November 2018.
20 Ferri & Associates, *Catalogue: Ancienne Collection Pereire et à divers: Dessins, tableaux anciens et modernes, Argenterie, fusils, objets d'art, Mobilier et tapisseries* (Paris, 4 June 2015).
21 Two sources provide evidence of service in the French Armed Service of Jacques Pereire's sons, Gérard and François. In the case of Gérard, the reference is to an article in *The New York Times*, 4 June 1946: 'Miss Wildenstein married at home: Daughter of Art Critic Wed to Gerard R. Pereire, Veteran of French and U S Armies'. A private family document, authored by Annik [de Lacaze], 'Anita Pereire, c'est ta vie', August 2017, 30 pp., tells of François' war service. Anita Pereire was François' wife and Annik de Lacaze their youngest daughter.
22 Mémorial de la Shoah, Paris, Carnet de fouille de Drancy, 67. The official record is marked '11.843 Camp de Drancy'.
23 Other documents in the Mémorial de la Shoah contain an account of Alfred's efforts to remain free. Fonds CGQJ, Alfred Péreire, *Etude du 26/06/1941 d'Alfred Péreire sur les services rendus à la France par la famille Péreire, en vue d'obtenir une dérogation à la loi du 02/06/1941 portant Statut des Juifs*, Cannes 1941, 2, CXCV-1_008.
24 Giancarlo Fioretti, 'Dino Philipson: le peripezie di un liberale scomodo', *Valdinievole Oggi*, 3 April 2020.

Select bibliography

Archival sources

Archives communales de Bayonne
 'Enregistrement d'environ 221 mariages par le sieur rabbin de la nation juive du bourg de Saint Esprit près Bayonne; 1751–1787'.
 'Enregistrement des naissances, mariages et décès de la communauté juive de Saint-Esprit'.
Archives du Consistoire central de Paris
 GGI, 'Mariages célébrés dans le temple de la rue Notre-Dame de Nazareth à Paris'.
Archives de la famille Pereire.
Archives de Paris
 État civil de Paris, V3E/M 793, V3E/N 1768.
Archives départmentales de l'Oise
 'Recensement 1872'; 'Actes du décès, 29 November 1876'.
Archives départementales des Pyrénées-Atlantiques, III E 3484/89, notaire Paul Duhalde.
Archives nationales de France
 Base Léonore, L 1260051, L 1259026, LH/404/32, LH/1046/4, c-202524, c-202525.
 Minutier central des notaires de Paris, MC/ET/VIII/249, 1152, 1595, 1661, 1625, 1682, 1807 notaire Emile Fould; MC/ET/VIII/ 1837, 1838 notaire Georges Bertrand.
 'Dispenses pour mariage', BB/15/29, 322–33.
 'Eçoles primaires libres protestantes et israélites', F/17/12505–12524.
 Fonds Guizot (1560–1878), 42AP/1 – 42AP/392.
Archives nationales du monde du travail, 25 AQ, 1–2, Crédit mobilier.
Bibliothèque de Bordeaux
 Abraham Furtado, 'Mémoires d'un proscrit', Ms. 19146, MIC 1370.

Bibliothèque nationale de France
 Site Arsenal: Fonds Enfantin 7676/13, 7822/28.
 Fonds d'Eichthal 13750/109, 13752/116, 14804/13.
 Site Richelieu: Fonds Alfred Pereire 24601/12–15.
Bibliothèque Thiers-Dosne
 Fonds d'Eichthal, Carton V-A, 141.
Institut national de l'histoire de l'art
 Num. Archives 'Collections Jacques Doucet', 166/2/101/001–002.
 Num. Archives, 'Correspondance du vivant Antoine-Louis Barye', 166/1/2/89.
Mémorial de la Shoah, Documentation Centre
 'Carnet de fouille de Drancy, 67' record '11.843 Camp de Drancy'.
 Fonds CGQJ, Alfred Pereire, 'Étude du 26/06/1941 d'Alfred Pereire sur les services rendus à la France par la famille Péreire [sic], en vue d'obtenir une dérogation à la loi du 02/06/1941 portant Statut des Juifs', Cannes CXCV-1-008.
 Côte: xif-34a, CDJC, letter Paul Sézille to Xavier Vallat, Commissaire général aux questions juives.
Musée d'art et d'histoire du Judaïsme
Rothschild Archive

Primary sources, published

Baroche, Mme. Jules. *Notes et souvenirs* (Paris, 1921).
Charton, Édouard. *Correspondance générale (1824–1890)*, Marie-Laure Aurenche (ed.) (Paris, 2008), 2 vols.
Cohen, Julia Phillips and Sarah Abrevaya Stein. *Sephardi Lives: A Documentary History, 1700–1950* (Stanford, CA, 2014).
Dairnvaell, Georges-Marie Mathieu. *Histoire édifiante et curieuse de Rotschild 1er, roi des juifs, par Satan* (Paris, 1846).
Doctrine de Saint-Simon: Première année, exposition 1829 (Paris, 1830).
Drumont, Édouard. *La France juive* (Paris, 1912).
———. *La France juive devant l'opinion* (Paris, 1886).
Ginsburger, Ernest, Grand Rabbin. *Le Comité de surveillance de Jean-Jacques Rousseau Saint-Esprit-Lès-Bayonne: Procès-verbal et correspondance 11 octobre 1793 fructidor an II* (Paris, 1934).
de Goncourt, Edmond and Jules. *Journal: Mémoires de la vie littéraire* (Paris, 1956), 4 vols.
Halévy, Léon. *F. Halévy: Sa vie et ses oeuvres* (Paris, 1863).
Hensel, Sebastian. *The Mendelssohn Family, 1729–1847, from Letters and Journals* (New York, 1969; first published 1882).

Kahn, Léon. *Histoire des écoles communales et consistoriales israélites de Paris (1809–1884)* (Paris, 1884).
Leriche, Alphonse. *Statistique chirurgicale de deux années à l'hôpital Isaac Péreire à Levallois-Perret* (Paris, 1888).
Levallois, Anne. *Les écrits autobiographiques d'Ismayl Urbain: Homme de couleur, saint-simonien et musulman (1812–1884)* (Paris, 2005).
de Metternich, Princesse Pauline. *"Je ne suis pas jolie, je suis pire": Souvenirs 1859–1871* (Paris, 2008, first published Paris, 1922).
Nadar. *A terre et en l'air ... Mémoires du Géant* (Paris, 1865).
Nahon, Gérard (ed.). *Les 'Nations' juives portugaises du sud-ouest de la France (1684–1791): Documents* (Paris, 1981).
Peat, Anthony B. North. *Gossip from Paris during the Second Empire: Correspondence 1864–1869* (London, 1903).
Pereire, Alfred. *Je suis dilettante* (Paris, 1955).
Pereire, Emile and Isaac. *Œuvres de Emile & Isaac Pereire*, Pierre-Charles Laurent de Villedeuil (ed.) (Paris, 1913–23), 5 vols.
—— *Écrits de Emile et Isaac Pereire* (Paris, 1900–9), 8 vols.
Riot-Sarcey, Michèle (ed.). *De la liberté des femmes: 'Lettres de Dames' au Globe (1831–1832)* (Paris, 1992).
Rodrigues, Eugène. *Lettres sur la religion et la politique, 1829; suivies de l'éducation du genre humain de Lessing traduit de l'allemand* (Paris, 1831).
Sarchi, Charles and Félicie. *Lettres à Hélène: Correspondance de Charles et Félicie Sarchi à leur fille Mme. Van Tieghem*, Louis Bachy (ed.) (Montpellier, 2006), 3 vols.
Schlumberger, Gustave. *Mes souvenirs 1844–1928* (Paris, 1934).
Schwarzfuchs, Simon (ed.). *Le Registre des délibérations de la Nation juive portugaise de Bordeaux (1711–1787)* (Paris, 1981).
Tortella, Teresa. *A Guide to Sources of Information on Foreign Investment in Spain 1780–1940* (Amsterdam, 2000).

Journals

Archives de l'art
L'Art
L'Art et les artistes
L'Art pour tous
Chronique artistique
Le Collectionneur universel
Le Courrier de l'art
L'Echo des beaux-arts

L'Etoile artistique
Le Figaro
Gazette des beaux-arts
L'Illustration
L'Image
Journal des artistes
Journal des arts
Journal des beaux-arts
La Lanterne
La Liberté
Magasin pittoresque
Le Monde illustré
Moniteur des arts
Musée universel
Le Petit journal
Le Petit parisien
La Presse
Le Rappel
Revue artistique
La Revue de l'art ancien et moderne
La Revue mondaine illustrée
Le Salon
Le Temps
L'Univers israélite
La Vie parisienne
Le XIXe siècle

Secondary sources

Albert, Phyllis Cohen. 'Non-Orthodox Attitudes in Nineteenth-Century French Judaism', in Frances Malino and Phyllis Cohen Albert (eds) *Essays in Modern Jewish History: A Tribute to Ben Halpern* (East Brunswick, NJ, 1982), 249–74.
———. *The Modernization of French Jewry: Consistory and Community in the Nineteenth Century* (Hanover, NH, 1977).
Altmann, Simon and Eduardo L. Ortiz (eds). *Mathematics and Social Utopias in France: Olinde Rodrigues and His Times* (Providence, RI, 2007).
de Andia, Béatrice and Dominique Fernandès (eds). *Rue du Faubourg Saint-Honoré* (Paris, 1994).

Auslander, Léora. *Taste and Power: Furnishing Modern France* (Berkeley, Los Angeles, London, 1996).
——. 'The Modern Country House as a Jewish Form: A Proposition', *Journal of Modern Jewish Studies*, vol. 18, no. 4, 2019, 466–88.
Autin, Jean. *Les frères Pereire: Le bonheur d'entreprendre* (Paris, 1984).
Barbier, Frédéric. *Finance et Politique: La dynastie des Fould XVIIIe–XXe siècle* (Paris, 1991).
de Bellaigue, Christina. *Educating Women: Schooling and Identity in England and France, 1800–1867* (Oxford Scholarship Online, September 2007).
Bénard-Oukhemanou, Anne. *La Communauté juive de Bayonne au XIXe siècle* (Anglet, 2001).
Benbassa, Esther. *The Jews of France: A History from Antiquity to the Present* (Princeton, NJ, 1999).
Berkovitz, Jay R. *Rites and Passages: The Beginnings of Modern Jewish Culture in France, 1650–1860* (Philadelphia, PA, 2004).
——. *The Shaping of Jewish Identity in Nineteenth-Century France* (Detroit, MI, 1989).
Bilski, Emily D. and Emily Braun (eds). *Jewish Women and Their Salons* (New Haven, CT, 2005).
Birnbaum, Pierre and Ira Katznelson (eds), trans. Jacqueline Kay. *Paths of Emancipation: Jews, States, and Citizenship* (Princeton, NJ, 1995).
Bovy, Phoebe Maltz. 'Embrasser les Juifs: Jews and Intermarriage in Nineteenth-Century France (1792–1906)' (PhD diss., New York University, September 2013).
le Bret, Hervé. *Les frères d'Eichthal: Le saint-simonien et le financier au XIXe siècle* (Paris, 2012).
Carlisle, Robert B. *The Proffered Crown: Saint-Simonianism and the Doctrine of Hope* (Baltimore, MD, 1987).
des Cars, Jean. 'Les "séries" de Compiègne', *Napoléon III: Le magazine du Second Empire*, no. 7, 2009.
Cavaignac, Jean. *Les Israélites Bordelais de 1780 à 1850: Autour de l' émancipation* (Paris, 1991).
Cohen, David. *La Promotion des juifs en France à l'époque du Second Empire* (Aix-en-Provence, 1980).
Craig, Béatrice. *Female Enterprise Beyond the Discursive Veil in Nineteenth-Century Northern France* (London, 2017).
——. 'Where Have All the Businesswomen Gone? Images and Reality in the Life of Nineteenth-Century Middle-Class Women in Northern France', chap. 4 in Robert Beachy, Béatrice Craig, and Alastair Owens (eds), *Women, Business and Finance in Nineteenth-Century France* (Oxford, 2006).

Daumard, Adeline. 'Affaire, amour, affection: Le mariage dans la société bourgeoise au XIXe siècle', *Romantisme*, no. 68, 1990.

Davidoff, Leonore. *Thicker Than Water: Siblings and Their Relations, 1780–1920* (Oxford Scholarship Online, January 2012).

Davidson, Denise Z. '"Happy Marriages" in Early Nineteenth-Century France', *Journal of Family History*, vol. 37, no. 1, 2012, 23–35.

Davies, Helen M. 'Living with Asthma in Nineteenth-Century France: The Doctor, Armand Trousseau, and the Patient, Emile Pereire', *Journal of Medical Biography*, vol. 28, no. 1, 2020, 15–23.

———. *Emile and Isaac Pereire: Bankers, Socialists and Sephardic Jews in Nineteenth-Century France* (Manchester, 2015).

———. 'Séduction, intimidation, corruption, et antisémitisme: L'élection de 1863 dans les Pyrénées-Orientales', *Domitia* [Perpignan], vol. 12, 2011, 183–94.

Dehan, Thierry and Sandrine Sénéchal. *Les Français sous le Second Empire* (Paris, 2006).

Endelman, Todd. *Leaving the Jewish Fold: Conversion and Radical Assimilation in Modern Jewish History* (Princeton, NJ, 2015).

Fargette, Guy. *Émile et Isaac Pereire: L'esprit d'entreprise au XIXe siècle* (Paris, 2001).

Ferguson, Niall. *The World's Banker: The History of the House of Rothschild* (London, 1998).

Ferruta, Paola. 'Nineteenth-Century "New Marranism" and Jewish Universalism from the French-German Perspective', in Anna-Dorothea Ludewig, Hannah Lotte Lund, and Paola Ferruta (eds), *Versteckter Glaube oder doppelte Identität?/Concealed Faith or Double Identity?* (Hildesheim, 2011), 95–124.

Foley, Susan K. *Women in France since 1789: The Meaning of Difference* (Basingstoke, 2004).

Gardey, Philippe. *Négociants et marchands de Bordeaux: De la guerre d'Amérique à la Restauration (1780–1830)* (Paris, 2009).

Garner, Alice. *A Shifting Shore: Locals, Outsiders, and the Transformation of a French Fishing Town, 1823–2000* (Ithaca, NY, 2005).

Gourdon, Vincent and Cyril Grange. 'L'union d'Émile Pereire II et Suzanne Chevalier. À propos des mariages mixtes sous le Second Empire', *Archives Juives*, vol. 42, 2009, 33–50.

Grange, Cyril. *Une élite parisienne: Les familles de la grande bourgeoisie juive (1870–1939)* (Paris, 2016).

———. 'The Choice of Matrimonial Witnesses by Parisian Jews: Integration into Greater Society and Socio-Professional Cohesion (1875–1914)', *The History of the Family: An International Quarterly*, vol. 10, no. 1, 2005, 21–44.

———. 'Matrimonial Networks of the French Jewish Upper Class in Paris: 19th Century–1950', paper presented at IUSSP Seminar 'New Haven of Kinship', Paris, 1–2 October 2004.

Green, Nancy. 'La Femme Juive: Formation et transformations', in Geneviève Fraisse and Michelle Perrot (eds), *Histoire des femmes en Occident vol. IV, Le XIXe siècle* (Millau, 2001), 261–79.

Harran, Nathalie. *La Femme sous le Second Empire* (Paris, 2010).

Hertz, Deborah. *Jewish High Society in Old Regime Berlin* (New Haven, CT, 1988).

Humphries, Jeanne. 'The Dreyfus Affair: A Woman's Affair', *Historical Reflections/Réflexions Historiques*, vol. 31, no. 3, 2005, 433–43.

Hyman, Paula E. *Gender and Assimilation in Modern Jewish History: The Roles and Representations of Women* (Seattle, 1995).

———. 'Jewish Fertility in Nineteenth-Century France', in Paul Ritterband (ed.), *Modern Jewish Fertility* (Leiden, 1981), 78–93.

Jarrassé, Dominique. *Guide du patrimoine juif parisien* (Paris, 2003).

———. *Osiris: Mécène juif et Nationaliste français* (Brussels, 2008).

Johnson, Christopher H. *Becoming Bourgeois: Love, Kinship and Power in Provincial France, 1670–1880* (Ithaca, NY, 2015).

Kalman, Julie. *Rethinking Antisemitism in Nineteenth-Century France* (Cambridge, MA, 2010).

Kaplan, Marion A. *The Making of the Jewish Middle Class: Women, Family, and Identity in Imperial Germany* (New York, 1991).

Kauffmann, Grégoire. *Édouard Drumont* (Paris, 2008).

Kselman, Thomas. *Conscience and Conversion: Religious Liberty in Post-Revolutionary France* (New Haven, CT, 2018).

———. 'Turbulent Souls in Modern France: Jewish Conversion and the Terquem Affair', *Historical Reflections/Réflexions Historiques*, vol. 52, no. 1, 2006, 83–104.

———. *Death and the Afterlife in Modern France* (Princeton, NJ, 1993).

Landau, Philippe-Efraïm. 'Se convertir à Paris au XIXe siècle', *Archives Juives*, vol. 35, no. 1, 2002, 27–43.

Langlois, Claude. *Le Catholicisme au féminin; Les congrégations françaises à Supérieure Générale au XIXe siècle* (Paris, 1984).

Lasc, Anca L. *Interior Decorating in Nineteenth-Century France: The Visual Culture of a New Profession* (Manchester, 2018).

Lazarus, Joyce Block. *Geneviève Straus: A Parisian Life* (Leiden, 2017).

Leff, Lisa Moses. *Sacred Bonds of Solidarity: The Rise of Jewish Internationalism in Nineteenth-Century France* (Stanford, CA, 2006).

Legé, Alice S. 'Les Cahen d'Anvers en France et en Italie' (Institut Francophone pour la Justice et la Démocratie – Thèses, Bayonne, 2022).

Leglaive-Perani, Céline. 'Donner au féminin: Juives philanthropes en France (1830–1930)', *Archives Juives*, vol. 48, no. 2, 2015, 11–24.

———. 'Le judaïsme parisien et le Comité de Bienfaisance israélite (1830–1930), *Archives Juives*, vol. 44, no. 1, 2011, 37–53.

———. 'De la charité à la philanthropie', *Archives Juives*, vol. 44, no. 1, 2011, 4–16.

Léon, Henri. *Histoire des juifs de Bayonne* (Marseille, 1976) [reprint original publication, Paris, 1893].

Lhomme, Jean. *La Grande Bourgeoisie au Pouvoir (1830–1880)* (Paris, 1960).

Livingstone, Natalie. *The Women of Rothschild: The Untold Story of the World's Most Famous Dynasty* (London, 2021).

McAuley, James. *The House of Fragile Things: Jewish Art Collectors and the Fall of France* (New Haven, CT, 2021).

Macknight, Elizabeth C. *Nobility and Patrimony in Modern France* (Manchester, 2018).

———. *Aristocratic Families in Republican France, 1870–1940* (Manchester, 2012).

———. 'Faith, Fortunes and Feminine Duty: Charity in Parisian High Society 1880–1914', *Journal of Ecclesiastical History*, vol. 58, no. 3, 2007, 482–506.

McPhee, Peter. *Liberty or Death: The French Revolution* (New Haven, CT, 2016).

McQueen, Alison. *Empress Eugénie and the Arts: Politics and Visual Culture in the Nineteenth Century* (Farnham, 2011).

Malino, Frances. *The Sephardic Jews of Bordeaux: Assimilation and Emancipation in Revolutionary and Napoleonic France* (Tuscaloosa, AL, 1978).

Martin-Fugier, Anne. *La Place des bonnes: La domesticité féminine à Paris en 1900* (Paris, 2004).

———. *La vie élégante, ou la formation du Tout-Paris* (Paris, 1993).

Mayeur, Françoise. *L'Éducation des filles en France au XIXe siècle* (Paris, 1979).

Moses, Claire Goldberg. *French Feminism in the Nineteenth Century* (Albany, NY, 1984).

Muhlstein, Anka. *Baron James: The Rise of the French Rothschilds* (New York, 1984), 2016, 3 vols.

Nahon, Gérard. *Juifs et Judaïsme à Bordeaux* (Bordeaux, 2003).

———. *Métropoles et Périphéries: Séfarades d'Occident* (Paris, 1993).

Nicault, Catherine. 'Comment "en être"? Les juifs et la haute société dans la seconde moitié du XIXe siècle', *Archives Juives*, vol. 42, no. 1, 2009, 8–32.

Perrot, Michelle (ed.), trans. Arthur Goldhammer. *A History of Private Life, IV, From the Fires of Revolution to the Great War* (Cambridge, MA, 1990).
Perrot, Philippe, trans. Richard Bienvenu. *Fashioning the Bourgeoisie: A History of Clothing in the Nineteenth Century* (Princeton, NJ, 1994).
Piette, Christine. *Les Juifs de Paris (1808–1940): La marche vers l'assimilation* (Québec, 1983).
Pilbeam, Pamela. *Saint-Simonians in Nineteenth-Century France: From Free Love to Algeria* (London, 2014).
Pope, Barbara Corrrado. 'Mothers and Daughters in Nineteenth-Century Paris' (PhD diss., Columbia University, 1981).
Popiel, Jennifer. 'The Hearth and the Cloister, and Beyond: Religion and the Nineteenth-Century Woman', *Journal of the Western Society for French History*, vol. 37, 2009, 187–204.
Prevost-Marcilhacy, Pauline (ed.). *Les Rothschild: Une dynastie de mécènes en France* (Paris, 2016), 3 vols.
———. 'La collection de tableaux modernes des frères Pereire', in Leika El-Wakil, Stefanie Pallini, and Lada Umstatter-Mamedova (eds), *Études transversales: Mélanges en l'honneur de Pierre Vaisse* (Lyon, 2005), 139–58.
Ratcliffe, Barrie M. 'Some Jewish Problems in the Early Careers of Emile and Isaac Pereire', *Jewish Social Studies*, vol. XXLIV, no. 3, 1972, 189–206.
Rifelj, Carol. *Coiffures: Hair in Nineteenth-Century French Literature and Culture* (Newark, DE, 2010).
Roblin, Michel. *Les Juifs de Paris: Démographie – Économie – Culture* (Paris, 1952).
Samuels, Maurice: *Inventing the Israelite: Jewish Fiction in Nineteenth-Century France* (Stanford, CA, 2014).
Sartori, Jennifer. 'Reading, Writing and Religion: The Education of Working-Class Jewish Girls in Paris, 1822–1914', in Zvi Jonathan Kaplan and Nadia Malinovich (eds), *The Jews of Modern France: Images and Identities* (Brill Online, 2016), 62–81.
Schor, Laura S. *The Life and Legacy of Baroness Betty de Rothschild* (Brussels, 2006).
Smith, Bonnie G. *Ladies of the Leisure Class: The Bourgeoises of Northern France in the Nineteenth Century* (Princeton, NJ, 1981).
Sowerwine, Charles. *France since 1870: Culture, Society and the Making of the Republic* (2nd ed., Basingstoke, 2009).
Stammers, Tom. *The Purchase of the Past: Collecting Culture in Post-Revolutionary Paris* (Cambridge, 2020).
Stammers, T. 'Women Collectors and Cultural Philanthropy, c. 1850–1920', *19: Interdisciplinary Studies in the Long Nineteenth Century*, vol. 31, 2020, https://doi.org/10.16995/ntn.3347, downloaded 3 March 2022.

Steele, Valerie. *Paris Fashion: A Cultural History* (rev. ed., New York, 2017).
Stevenson, Linda D. 'The Urban Mansion in Nineteenth-Century Paris: Tradition, Invention and Spectacle' (PhD diss, University of Florida, 2011).
Stoskopf, Nicolas. *Les Patrons du Second Empire: Banquiers et financiers parisiens* (Paris, 2002).
Szajkowski, Zosa. *Jewish Education in France, 1789–1939*, Tobey B. Gitelle (ed.) (New York, 1980).
Walton, Whitney. *France at the Crystal Palace: Bourgeois Taste and Artisan Manufacture in the Nineteenth Century* (Berkeley, CA, 1992).
Weissbach, Lee Shai. 'The Nature of Philanthropy in Nineteenth-Century France and the *mentalité* of the Jewish Elite', *Jewish History*, vol. 8, no. 1/2, 1994, 191–204.
Weisz, George. *Divide and Conquer: A Comparative History of Medical Specialization* (Oxford, 2006).

Index

Note: 'n.' after a page reference indicates the number of a note on that page. Page numbers in italics refer to illustrations.

acculturation 9, 12–14, 23, 32, 132, 200, 204, 256–7
Ader, Clément 286, 293
Andrade, David 38–40, 223, 228
Andrade, Sophronie 35, 36, 38–40, 55, 57, 58, 73, 130, 228, 230
antisemitism *see* Catholic Church, antisemitism; Jews, antisemitism; Straus, Geneviève; Vichy France
apostasy *see* Andrade, David; Andrade, Sophronie; marriage, civil marriage; marriage, marrying out; religious conversion
Arcachon 17, 94, 96–8, 101, 121, 123–4, 138–42 *passim*, *138*, 146, 147, 152, 204
Armand, Alfred 121, 124, 126, 129, 131–5
artworks 175
 collections Pereire brothers 125, 127, 161, 180, 184, 185n.24
 women collectors 161, 179–84 *passim*, 292
 see also Rothschild family, artistic bequests

Baud, Henri, husband of Mélanie Rodrigues
 employed by Pereires 67
 marriage with Mélanie Rodrigues 38, 40, 43
Baud, Mélanie (née Rodrigues), sister of Herminie Pereire, wife of Henri Baud 36, 38, 40, 42–5, 46, 130, 136, 197
 Isaac Pereire infatuation 61, 96, 103
 see also Rodrigues family, sibling relations; Saint-Simonianism, family engagement with
Bayonne 257–8
 Lopès Fonseca family 28–31
 see also French Revolution; Rodrigues Pereire, Jacob
Bazard, Claire, wife of Saint-Amand Bazard 42, 66
 see also Saint-Simonianism, Saint-Simonian women
Bazard, Saint-Amand 41, 66
Bordeaux
 attachment of Pereire brothers to 1, 124, 193, 268–9

business connections of Pereire
 brothers 139, 140,
 239
family connections 65, 68–9,
 72, 224, 250n.7
see also French Revolution;
 Jews, Sephardim;
 Rodrigues Pereire, Jacob
Bourbon Restoration 62
 Catholic triumphalism 53, 61
 divorce 62

Cabanel, Alexandre 175
 celebrity painter 167
 portrait of Fanny Pereire 79,
 Plate 3, 167–8
 portrait of Herminie Pereire
 Plate 1, 166–7
Cahen, Coralie 198, 217n.36
Cahen d'Anvers, Meyer 6, 256
Camondo family bequests 177,
 292, 293
Catholic Church 257
 antisemitism 270–2, 274,
 276–7, 280
 marriages 268
 mixed marriages 224,
 232–3, 268
 see also religious conversion, to
 Catholicism
charity 190–3, 200, 214–15
 philanthropy 191–2, 194, 198,
 200–15 passim
 sedaca 193–5
 see also Fondations Isaac-Pereire
Charton, Édouard 94, 130,
 170–1, 228
Charton, Jules 228
Château Palmer 121, 124, 142–3,
 146, 152, 292
Château Pereire see grandes
 bourgeoises, chateau,
 Château Pereire,
 Armainvilliers
Chevalier, Michel
 Anglo-French commercial treaty
 1860 232
 falling out with Pereires 102

friendship 66, 68, 135, 136,
 238
see also Saint-Simonianism
Chevalier, Suzanne see Pereire,
 Suzanne
Compagnie générale
 transatlantique 205,
 229–30, 274, 289
Compagnie immobilière 82, 104,
 178
Crédit mobilier 82, 100, 102–4
 passim, 141, 200–1, 245,
 247, 272
 Crédit mobilier espagnol
 101, 247
 Crédit mobilier italien 242, 243

Dreyfus, Captain Alfred and
 Dreyfus Affair see Jews,
 antisemitism
Dreyfuss, Jacques-Henri, Chief
 Rabbi of Paris 263
Drumont, Édouard see Jews,
 antisemitism; La Liberté;
 Pereire, Eugène
Durand, Justin 270–1

education
 boys' 105, 199, 203
 École centrale des arts et métiers
 105, 229
 École nationale des ponts et
 chaussées 105
 girls' 55, 56, 74, 212
 Jewish boys' 26, 105–7
 Jewish girls' 3, 7, 8, 13, 25–6,
 28–9, 48n.11, 54
 lycées 105
 mother as teacher 55–6, 74–5
 Napoleon I and 74
 see also Rodrigues family, Nanci
 Rodrigues; 'separate
 spheres'
d'Eichthal banking family 6, 31,
 37, 91, 248
 Adolphe d'Eichthal 93, 112,
 133, 261
 Gustave d'Eichthal 133, 236

elections
 Corps législatif (1863) 123, 140, 270–2, 277, 280, 289
 Corps législatif (1869) 272, 276, 277, 280, 283n.49
 Louis-Napoleon, Prince-Président 82
Emerique, Amélie *see* Pereire, Amélie
endogamy 3–4, 234
 see also marriage, cousin marriage; marriage, marriage partners
Enfantin, Prosper 41–5 *passim*, 66, 67, 103
Eugénie, Empress of France
 admiration for Queen Marie-Antoinette 176
 collector of artworks 179, 188n.72
 friendship with Pereires 177
 influence on style 7, 168, 170, 176–7, 179
 '*séries*' at Compiègne 162–3
 see also Napoleon III, Emperor of France; Second Empire

Falize (Lucien) et Bapst 107, 169, 195, 268
Foa, Eugénie 26, 27, 237
 see also Rodrigues family
Fondations Isaac-Pereire
 administration 213–15
 Hôpital du Louvre 213
 Hôpital Levallois-Perret 207–11, *209*
 Hôpital Tournan *208*, 206–7, 210, 213
 see also charity
Fould, Achille 101, 163, 235
Fould, Benoît 37, 133, 235
Fould, Émile 235–6, 241
Fould, Juliette Betzy *see* Pereire, Juliette Betzy
Fournel, Cécile, wife of Henri Fournel 42–3, 66, 136
 see also Saint-Simonianism, friendships;
Saint-Simonianism, Saint-Simonian women
Fournel, Henri, husband of Cécile Fournel 42, 66, 68
 see also Saint-Simonianism, friendships
Franco-Prussian War *see* Pereire family
French Revolution 52, 132, 175, 191–2
 Girondins 29, 31
 Jacobins 29, 39
 see also Bayonne; Bordeaux; Jews, emancipation; marriage, civil marriage
furnishings 76, 122, 161, 173–8, 184, 185n.24, 187–8n.69, 188n.71
Furtado-Heine, Cécile 208

Gradis family 6, 23
grandes bourgeoises
 chateau
 Château Pereire, Armainvilliers *132*
 accounts for 122, 149–52
 Clément Ader trial run 286
 design and accommodation 134, 135
 destruction of 293
 interior and fittings 177–8, 183
 the Jewish country house 132–5
 leisure 123, 135–6, 143
 neighbours 137–8
 see also grandes bourgeoises, sociability; Saint-Simonianism, friendships; servants
 hôtel particulier
 hôtel Pereire 35–37 rue du Faubourg Saint-Honoré *125*
 central to children of Fanny and Isaac 243, 291
 design 124–6

Herminie and Emile's family disperses from 244–5
inauguration 126, 128
innovation 124–5, 127
interior decoration 174–5, 178–9
press reports 119, 128, 130
provenance 113, 124, 126
sale of 293
see also grandes bourgeoises, sociability; Pereire family, co-habitation
self-presentation
coiffure 164–5, 173
dress 76, 163–8 *passim*, 170–2
influences on 168, 176–7
jewellery 160, 164, 166–9, 184
photography 171–3, 186n.43
portraiture 166–8
see also Cabanel, Alexandre, portrait of Fanny Pereire; Cabanel, Alexandre, portrait of Herminie Pereire; Eugénie, Empress of France
sociability
at-homes 119, 123, 126–7, 130, 131, 228
male sociability, including hunting 123, 130, 134
masked balls 169–70
music and musicians 34, 50n.53, 127–9, 131, 153, 155n.20, 155n.28, 156n.33, 165, 264
see also Saint-Simonianism, friendships
Great War *see* Halfon, Laurence Alice; Halphen, Captain Jules; Pereire, Alfred; Pereire, Jacques
Gyp, Sybille de Mirabeau, comtesse de Martel de Janville 278

Haguenau, David, rabbi, then Chief Rabbi of Paris 263–4, 266
Halévy, Fromental, husband of Hannah Léonie Rodrigues Henriques 26, 36, 54, 69, 236, 237
Halévy, Hannah Léonie (née Rodrigues Henriques), wife of Fromental Halévy 26–7, 54
Halevy, Léon 69
Halfon, Laurence Alice, daughter of Eugène and Juliette Betzy Pereire; wife of Salomon Halfon 291
Halphen, Captain Jules, husband of Marie Herminie, daughter of Eugène and Juliette Pereire 291
Haskalah 8–9, 24, 37, 288
influence on Bordeaux Sephardim 8–9
Moses Mendelssohn 9, 23–4
see also Mendelssohn family
Haussmann, baron Georges-Eugène 82, 178, 182

Iffla, Daniel (Osiris) 20n.29, 192, 200, 262
intellectual disability *see* Pereire, Edouard
Isidore, Lazard, Chief Rabbi of Paris, then of France 240–1, 259, 260

Jews
anti-Jewish sentiment 2, 53, 198, 216n.34, 269–72 *passim*, 276, 280, 289
antisemitism 2, 3, 5, 10, 191, 204–5, 215, 245, 247, 272–80 *passim*, 283n.54, 283n.60, 283–4n.61, 290
Ashkenazim 2–4, 8
of Berlin 11–12

migration to Paris 52
problems with Sephardim 3, 8, 20n.20, 260
birth rate 68, 92
emancipation 4–5, 8, 12, 23–4, 30, 52, 53, 61–2, 67, 223, 269, 294
Judaism, practice of 28, 30, 91, 248
non-practising 23–4, 32, 38, 46, 228, 258
population
 Alsace-Lorraine 4, 271
 France 4, 86n.56
 Paris 4, 52, 71, 223, 256
 southwest France (inc. Avignonnais) 4, 49n.26
regeneration of religious practices 40, 53, 240
role of women 5, 10–13, 56–7, 144
women of independence 24–7
Sephardim 1–5 *passim*
 assimilation 9, 10, 43
 burial of 259–60, 262
 community of 23, 39, 193, 224
 and Enlightenment literature 8
see also acculturation; Bayonne; Bordeaux; Haskalah; Napoleon I, Emperor of France, Assemblée des notables; Napoleon I, Emperor of France, Grand Sanhédrin; Napoleon I, Emperor of France, and Jews; Saint-Simonianism, Jews and
July Monarchy 2, 6, 7, 63, 68, 74, 120, 127, 270, 289
see also Louis-Philippe, King of France

Kahn, Zadoc Chief Rabbi of France 196, 256, 260

La Lanterne see Jews, antisemitism; Pereire, Eugène
La Liberté 201–3, 239, 259–60, 272–7 *passim*, 283n.54, 284n.67
see also Jews, antisemitism; Pereire, Gustave
Landes, department of 139
see also Arcachon
Leriche, Alphonse 210
letters 15–18
affection in 33, 58, 89, 97
circulation 90, 98, 101
confidantes 98–102
control through 89
conventions in 89, 90
family news 89, 141, 201
friendship 89
instilling family pride 89, 202, 289
as ritual 90
see also education, girls'
Lévi, Israel, Deputy, later Chief, Rabbi of France 263, 264
Lévy, Alfred, Chief Rabbi of France 255–6, 264
Lopès Fonseca family
Lopès Fonseca, Jacob 28, 64, 71–2, 75, 193, 253n.85
Lopès Fonseca, Mardochée, father of Sara Sophie Rodrigues and Jacob Lopès Fonseca 28–31, 36, 39, 48n.21, 49n.27, 258
see also Rodrigues, Sara Sophie; Pereire, Laurence (née Lopès Fonseca)
Louis-Napoleon Bonaparte, Prince-President *see* Napoleon III, Emperor of France
Louis-Philippe, King of France 78, 82, 113

marriage
civil marriage 10, 61–2

consanguinity 77, 79–80, 111, 227
cousin marriage 39, 57–60 *passim*, 75–6, 225–6
love and affection 58, 70, 97, 225, 227, 234, 243
marriage partners 71, 226, 232, 247–8
marrying out 3–4, 13–14, 223–4, 227–35 *passim*, 237–40
see also endogamy; Pereire family; Rodrigues family; religious conversion
Mendelssohn family 12, 31, 35, 37, 41, 55, 64
see also Haskalah, Moses Mendelssohn
Mir, Eugène 238–40, *244*, 247, 265, 291
Mir, Henriette, daughter of Fanny and Isaac Pereire, wife of Eugène Mir 79, *109*, 126, 148, 172, 203, 237–40, *244*, 291
childhood illness 107–8, 141–2
death 265, 268
Mirès, Adolphe 75
Mirès, Jules 193, 262
Mocquard, Jean-François 135
Morny, Charles Auguste Louis Joseph, duc de 138, 170, 202
music see grandes bourgeoises, sociability, music and musicians

Nadar (Gaspard Félix Tournachon) 107, 171, 186n.43
Napoleon I, Emperor of France
Assemblée des notables 24, 32, 39
Code Civil 10, 24, 26, 56, 62, 132
marriage provisions 77–8
Consistories 25
Grand Sanhédrin 32, 39
and Jews 53, 61–2, 223
see also education, Napoleon I and

Napoleon III, Emperor of France 7
Arcachon visit 138–40
defeat at Sedan 147
relations with Pereires 82–3, 100, 139, 173, 177, 195, 238
see also Eugénie, Empress of France; Pereire family; Second Empire

Paris
cemeteries 257–8
education in 74
eighth *arrondissement* 124
hospital system 205–6
Jewish migration to 6–7, 25, 31, 37–8
Plaine Monceau 101, 245
population 52, 71–2
welfare 194
winter of 1879–80 202–4
see also Compagnie immobilière; Haussmann, baron Georges-Eugène
Pasteur, Louis 163–4, 192, 200, 211
Pereire, Alfred, son of Gustave and Amélie Pereire 274–5, 291, 294, 296n.23
Pereire, Amélie (née Emerique), wife of Gustave Pereire 241, *244*
Pereire, Cécile see Rhoné, Cécile (née Pereire)
Pereire, Claire see Thurneyssen, Claire (née Pereire)
Pereire, Edouard, son of Fanny and Isaac Pereire, intellectual disability 80, 108–11
Pereire, Emile, husband of Herminie Pereire *Plate 2*
asthma 94, 136–8, 236
business success 81–3
elected deputy 123, 140, 272, 289
marriage with Herminie 40, 57–61 *passim*, 94–8

Index

relations with brother Isaac 61, 103–4
religion 60, 64, 79, 222, 243–4, 258, 268–9
see also Arcachon; charity; Compagnie générale transatlantique; Compagnie immobilière; Crédit mobilier; marriage; Saint-Simonianism
Pereire, Emile II, son of Herminie and Emile Pereire, husband of Suzanne Chevalier 68, 130–1, 213–14
 difficulties with Fanny Pereire 88, 290
 education 106
 falling out with Eugène Pereire 247
 funeral 264
 marriage with Suzanne Chevalier 227, 232–3, 238
Pereire, Eugène, son of Isaac Pereire's first marriage with Laurence Lopès Fonseca, husband of Juliette Betzy Fould
 antisemitic attacks against 216n.34, 274–277
 death 265
 deputy 272
 education 105
 marriage with Juliette Betzy Fould 235–7
 member Consistoire central israélite 237, 241, 263, 279
 Pereire businesses 274
 proprietor *La Lanterne* 275–7
 relations with Fanny Pereire 92–3, 234
 see also Compagnie générale transatlantique
Pereire, François 293–4, 296n.21
Pereire, Gérard 293, 296n.21

Pereire, Gustave, son of Fanny and Isaac Pereire, husband of Amélie Emerique *108*, 244
 marriage with Amélie Emerique and conversion 241, 245, 246, 263, 264, 266, 291
 patron of Nadar 107, 186n.43
 proprietor *La Liberté* 106–7, 274–5, 277
 publishes Pereire brothers' *Écrits* and *Oeuvres* 106–7, 276, 284–5n.69
 see also Falize (Lucien) et Bapst; *La Liberté*
Pereire, Henriette see Mir, Henriette
Pereire, Henry, son of Herminie and Emile Pereire husband of Léontyne de Stoppani *16*, 68, 80, 94, 105–6, 145, 213–14, 268
 death and burial 262, 265
 family archivist 15–17, 275
 marriage with Léontyne de Stoppani and conversion 233–5
Pereire, Isaac, father of Emile and Isaac Pereire 27, 31, 57
Pereire, Isaac, husband of Fanny Pereire *Plate 4*
 affection in marriage 96–7
 antisemitic attacks against 270–2, 283–4n.61
 illness and death 181, 263
 marriage to Fanny Pereire 77–9
 marriage to Laurence Lopès Fonseca 76–7
 philanthropy 203–6
 politics 238–9
 on poverty 194–5
 see also Fondations Isaac-Pereire; *La Liberté*; Pereire family; Saint-Simonianism, continuing influence on Pereires; Saint-Simonianism, family engagement with

Pereire, Jacques, son of Gustave and Amélie Pereire 244, 291–3
Pereire, Jeanne *see* Philipson, Jeanne
Pereire, Juliette Betzy (née Fould), wife of Eugène Pereire 126, 163, 245, 291
 marriage with Eugène Pereire 235–7
Pereire, Laurence (née Lopès Fonseca), first wife of Isaac Pereire 75–7, 92, 244
Pereire, Laurence Alice *see* Halfon, Laurence Alice
Pereire, Léontyne (née de Stoppani), wife of Henry Pereire 234–5
Pereire, Rebecca Henriette, mother of Emile and Isaac Pereire 27, 28, 57
 arrival in Paris 60–1
 death 64–5, 75
Pereire, Suzanne (née Chevalier), wife of Emile Pereire II 232–3, 238
Pereire, Télèphe, brother of Emile and Isaac Pereire 103, 261
Pereire family 244, 262
 children and childhood 53–4, 67–8, 70, 73, 77, 79–81, 91–3, 129–30
 co-habitation 46, 68–9, 81, 125–6, 287, 290
 competitors with Rothschilds 121, 133
 consanguinity 77, 80, 227
 non-religious upbringing of children 60, 64, 79, 222, 243–4, 258, 268–9
 separation during Franco-Prussian War 17, 99, 110–11, 141, 147–9, 198–9
 see also marriage, cousin marriage; Saint-Simonianism, continuing influence on Pereires; Saint-Simonianism, family engagement with; Rothschild family, falling out with Pereires
Philipson, Dino, son of Jeanne and Edoardo Philipson 244, 294
Philipson, Edoardo, husband of Jeanne Pereire 169, 242–3, *244*, 246
Philipson, Jeanne, daughter of Fanny and Isaac Pereire, wife of Edoardo Philipson 80, 107–9, *109*, 147, 148, 169, 172
 death 243, 265, 291
 marriage with Edoardo Philipson 242–3, 246, 281n.15
photography 171–3

Regnauld, Paul 139
Reinach, Joseph 278
Reinach, Salomon 275
Reinach family 292
religious conversion
 to Catholicism 9, 13, 38, 43, 91, 223–4, 268
 to Judaism 224, 237, 245
 to Protestantism 37, 230–4
Rhoné, Cécile (née Pereire), daughter of Herminie and Emile Pereire, wife of Charles Rhoné 141, 142, 171, 212, *230*, 264, 282n.29
Rhoné, Charles, husband of Cécile Pereire 123, 229, 238
Rodrigues, Eugène, son of Sara Sophie and Jean Isaac Rodrigues 35, 40–2, 45, 65
Rodrigues, Euphrasie (née Martin), wife of Olinde Rodrigues 31, 40, 42, 43, 45, 54, 136
Rodrigues, Olinde, son of Sara Sophie and Jean Isaac Rodrigues, husband of Euphrasie 31, 32, 34–6,

38, 40, 42, 45, 66, 73, 136
Rodrigues, Sara Sophie (née Lopès Fonseca), wife of Jean Isaac Rodrigues *fils*, mother of Herminie Pereire 27
 affection of children 33–4
 dislike of Charles Sarchi 34
 education of children 34–5, 55–6
 love of Walter Scott novels 33–4
 marriage and companionship with Rodrigues *fils* 31–2
 music lessons for children 34, 55
 raising daughters 33, 57
 see also Lopès Fonseca family
Rodrigues family
 ancestry 23, 35–6
 Nanci Rodrigues 24–31 *passim*, 54, 56, 67, 69, 74, 112, 132, 197, 224, 248, 269, 275
 sibling relations 27, 33, 112, 279–80
 see also education, Jewish girls'; *grandes bourgeoises*, sociability, music and musicians
Rodrigues *fils*, Jean Isaac, husband of Sara Sophie Lopès Fonseca, father of Herminie Pereire
 employment with Paris Consistoire 32
 and Enlightenment 32, 36
 on Judaism 32
 mentor to Pereire brothers 57, 193
 naming of children 35–7
 salon 37–8
 see also acculturation; Rodrigues family
Rodrigues Henriques *see* Rodrigues family
Rodrigues Pereire *see* Pereire family
Rodrigues Pereire, Jacob, grandfather of Emile and Isaac Pereire 20n.20, 60, 74, 117n.67, 257–8, 261–3

Rothschild, baronne Betty de
 frequents court of King Louis-Philippe 113
 influence on Herminie 113
 philanthropy 198, 200
 sons' education 107
 style-setter 127
 see also education, Jewish girls'
Rothschild family
 artistic bequests 179, 292, 293, 295–6n.18
 falling out with Pereires 82–3, 119
 initial support of Pereires 69, 82
 Judaism 91, 248
 target of anti-Jewish, antisemitic attacks 269, 273
 women in family business 98

Saint-Simon, Claude Henri de Rouvroy, comte de 40
Saint-Simonianism
 continuing influence on Pereires 43, 66–7, 73, 194–5, 238, 288
 family engagement with 40–1, 43, 65
 friendships 68, 75–6, 79, 88, 106, 130, 135–6, 201, 229, 232, 238–9
 Jews and 40–42, 45
 Saint-Simonian women 41–6 *passim*, 67
 working-class women 43, 45, 67
 see also Chevalier, Michel; Enfantin, Prosper; Fournel, Henri
salonnières 9, 11–12, 21n.37, 278
Sarchi, Charles, husband of Félicie Rodrigues, Herminie Pereire's sister 17–18, 38, 40, 46, 67, 110–12, 131
 anti-Jewish 38, 245
 Catholic convert 38
 conduit to significant Italian figures 136, 242
Sarchi, Félicie (née Rodrigues), sister of Herminie Pereire, wife of Charles

Sarchi 17–18, 27, 33, 34, 36, 51n.85, 59, 70, 91, 102, 110, 112, 201, 280
 see also Saint-Simonianism, Saint-Simonian women
Schlumberger, Gustave 268, 275
Second Empire 7, 133, 162, 166, 170, 238
 see also Napoleon III, Emperor of France; Eugénie, Empress of France
sedaca see charity, sedaca; Fondations Isaac-Pereire
'separate spheres' 7, 10, 18, 56–7, 74, 160–1, 201, 205, 288
 see also education, girls'; Jews, role of women
Sephardim see Bayonne; Bordeaux; Jews, Sephardim
servants
 families in service 151
 hierarchy 147–8, 150
 livery 144–5
 management of 143, 149–50, 152–3
 mobility 146–7, 150
 numbers 145, 150
 salaries 145, 150–1, 153–4
 sign of status 144
 status 145–6
Societé universelle Pereire, family trust 242, 245–7, 249, 289, 292
Stoppani, Léontyne de see Pereire, Léontyne
Straus, Geneviève 27, 48n.14, 275, 278
 see also Jews, antisemitism; Schlumberger, Gustave

Third French Republic 14, 27, 62, 238–40, 272, 276, 287
 see also Jews, antisemitism
Thurneyssen, Auguste, father of Georges Thurneyssen 93, 129, 226, 230–1, 258
Thurneyssen, Claire (née Pereire), daughter of Herminie and Emile Pereire, wife of Georges Thurneyssen 66, 74, 93, 103, 122, 126, 127, 131, 141, 226, 227, 231–2, 234, 246, 264, 290
Thurneyssen, Georges, husband of Claire Pereire 17, 94, 126, 131, 141, 226, 230–2
Tieghem, Hélène Van, daughter of Félicie and Charles Sarchi, wife of Philippe Van Tieghem 17–18, 136
Tieghem, Philippe Van, husband of Hélène Van Tieghem 18, 36
Tournachon, Gasper-Félix see Nadar
Trousseau, Armand 94, 130, 205–6, 210, 211, 218n.70

Urbain, Ismayl 75, 79, 201, 217n.49
Uzielli, Guido 244, 265

Vichy France 274, 292, 293
Villa Pereire see Arcachon

Weill, Julien, Chief Rabbi of Paris 265